THE ART OF TOP COW

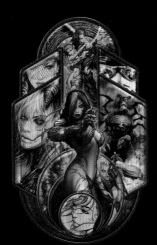

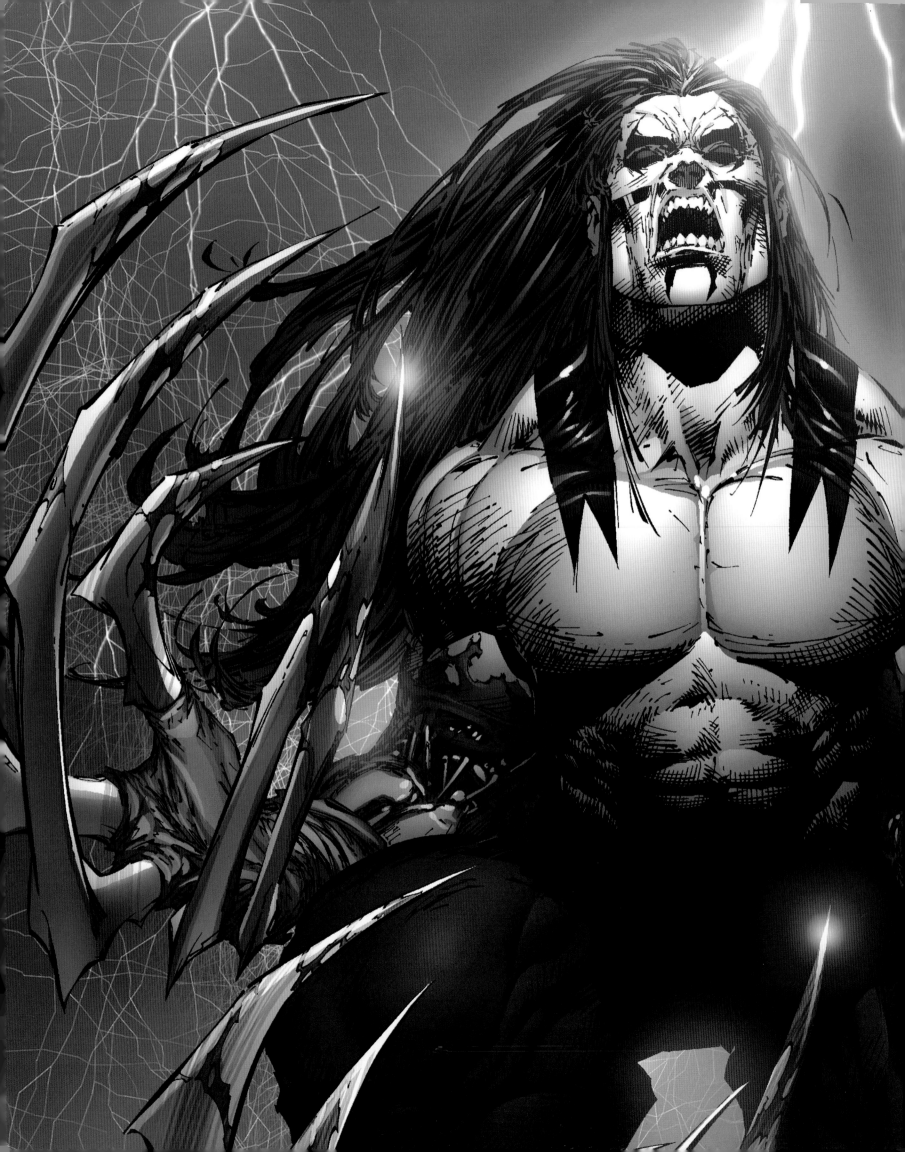

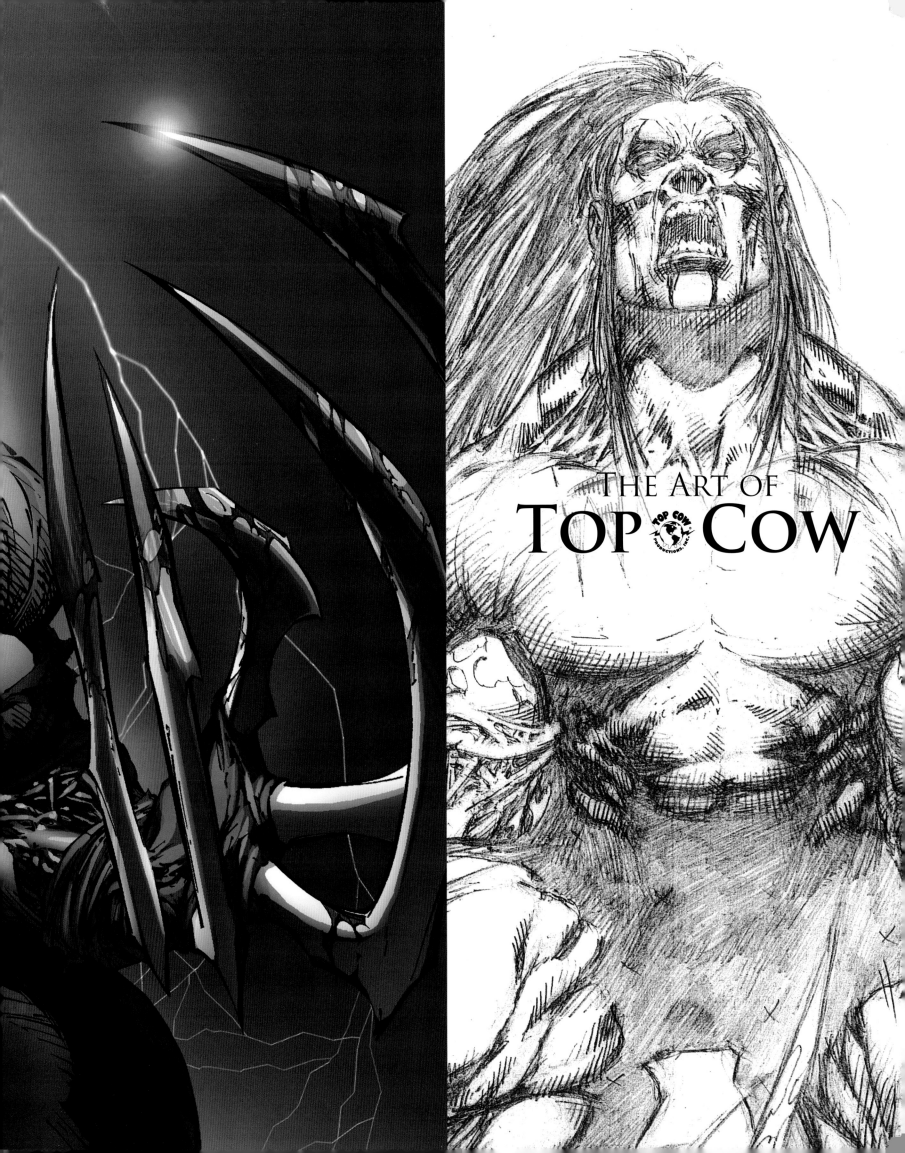

THE ART OF
TOP COW

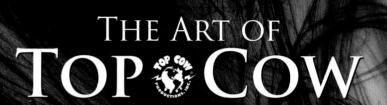

THE ART OF
TOP ☉ COW

For Top Cow Productions, Inc.:
Marc Silvestri - Chief Executive Officer
Matt Hawkins - President and Chief Operating Officer
Filip Sablik - Publisher
Chaz Riggs - Graphic Design
Phil Smith - Managing Editor
Adrian Nicita - Webmaster
Scott Newman - Production Lead
Jennifer Chow - Production Assistant
Bryan Rountree - Assistant to the Publisher
Rob Levin - Consulting Editor
Diana Siegel - Intern

Want more info? check out:
www.topcow.com and **www.topcowstore.com**
for news and exclusive Top Cow merchandise!

for *image* comics
publisher:
Eric Stephenson

to find the comic shop
nearest you call
1-888-COMICBOOK

For this edition
Edited and Designed by:
Phil Smith

The Art of Top Cow, volume 1, Art Collection
July 2009. FIRST PRINTING. Hardcover ISBN: 978-1-60706-055-0, $49.99 U.S.D.
July 2009. FIRST PRINTING. Softcover ISBN: 978-1-60706-099-4, $34.99 U.S.D.

TABLE OF CONTENTS
•
TOP COW UNIVERSE
- - - - -

•

OUTSIDE THE UNIVERSE
- - - - -

{WITCHBLADE}
Series Covers • Selected Works

MICHAEL TURNER

BRIAN

Witchblade issue #1 cover
art by: Michael Turner and Brian Haberlin

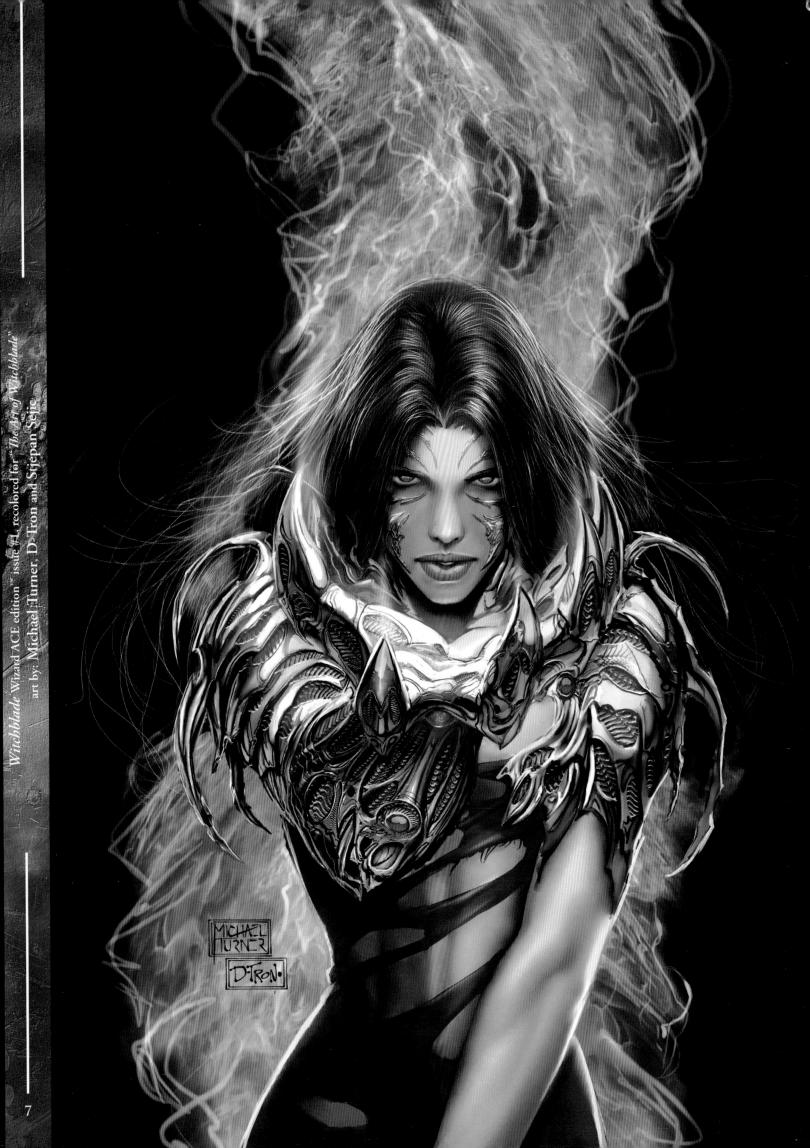

"Witchblade" Wizard Wizard AGE edition "issue #1, recolored for "The Art of Witchblade"
art by: Michael Turner, D-Tron and Stjepan Šejic

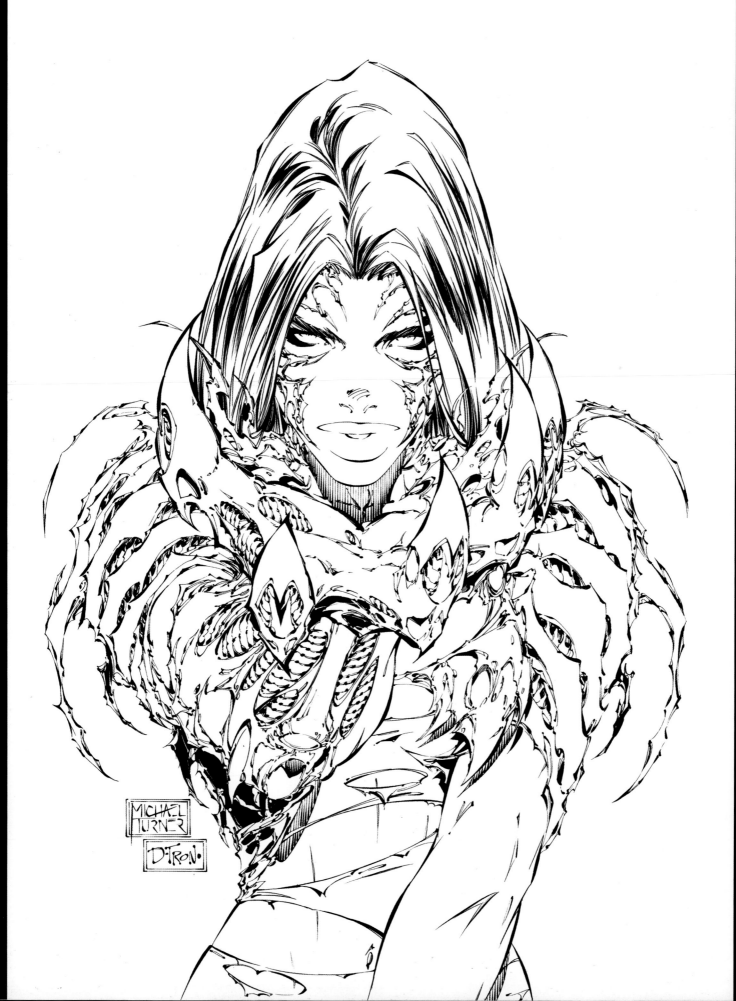

Witchblade: Wizard ACE edition ™ issue #1 cover inks
art by: Michael Turner and D-Tron

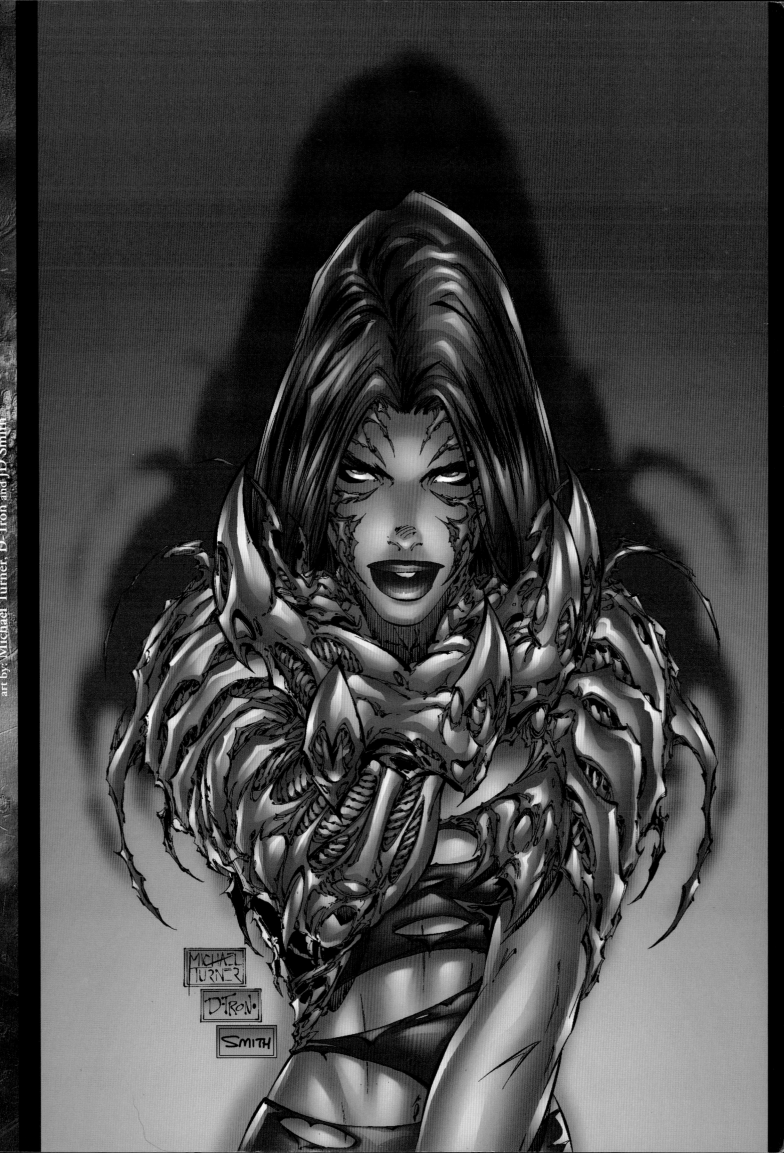

Witchblade Wizard ACE-edition™ issue #1 cover
art by: Michael Turner, D-Tron and JD Smith

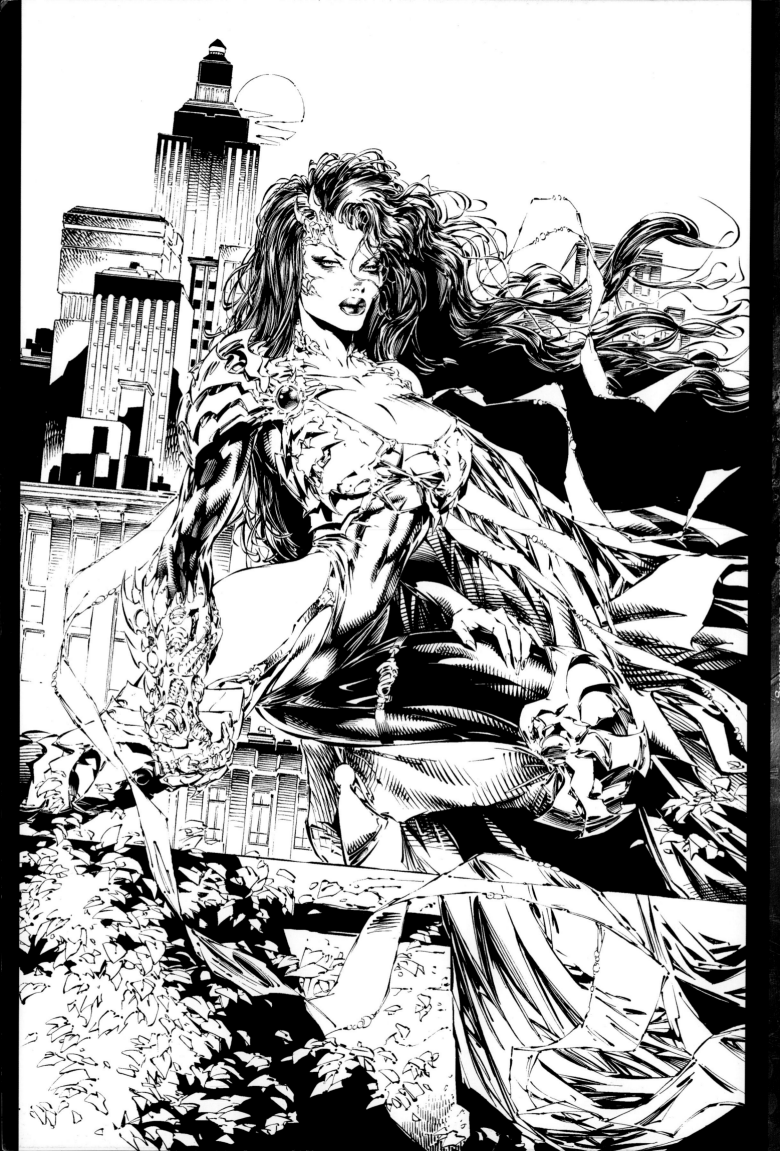

Witchblade first appearance *Cyblade/Shi* issue #1 art by Marc Silvestri and Matt "Batt" Banning.

Witchblade issue #1 cover.

art by: Michael Turner and Brian Haberlin

11

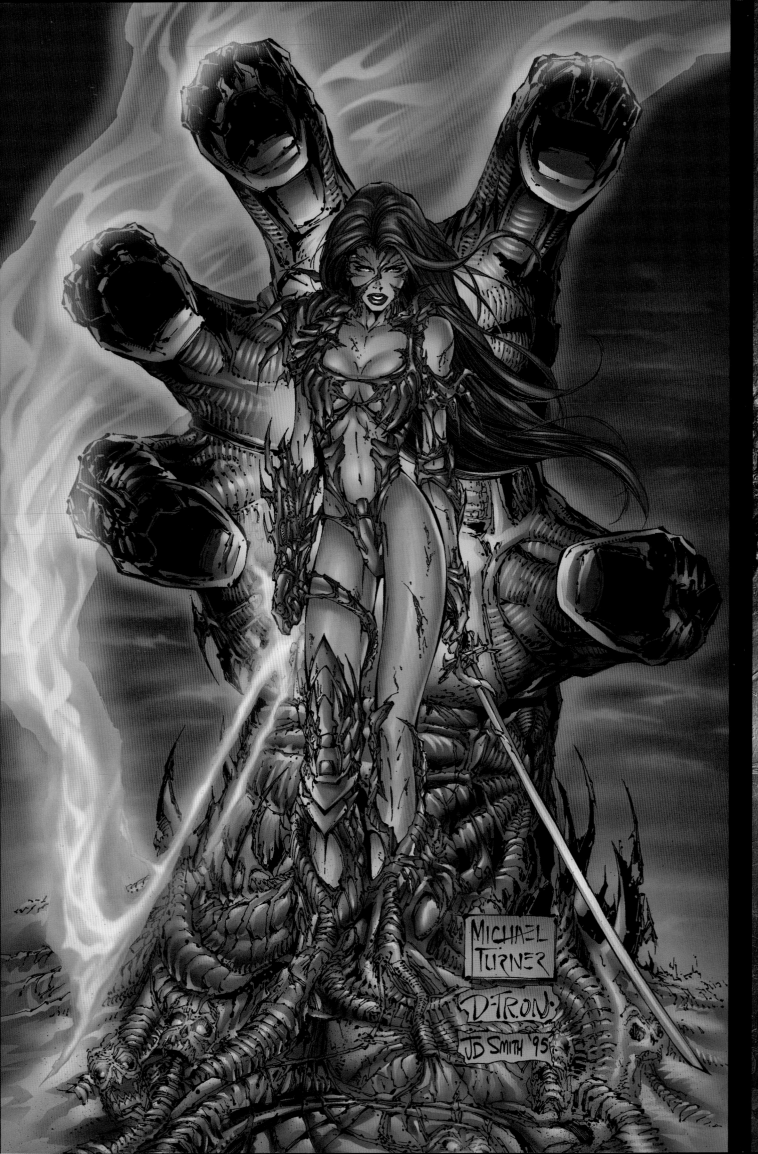

Witchblade issue #4 cover,
art by: Michael Turner, D-Tron and JD Smith

Witchblade issue #46 variant cover
art by: Keu Cha and Steve Firchow

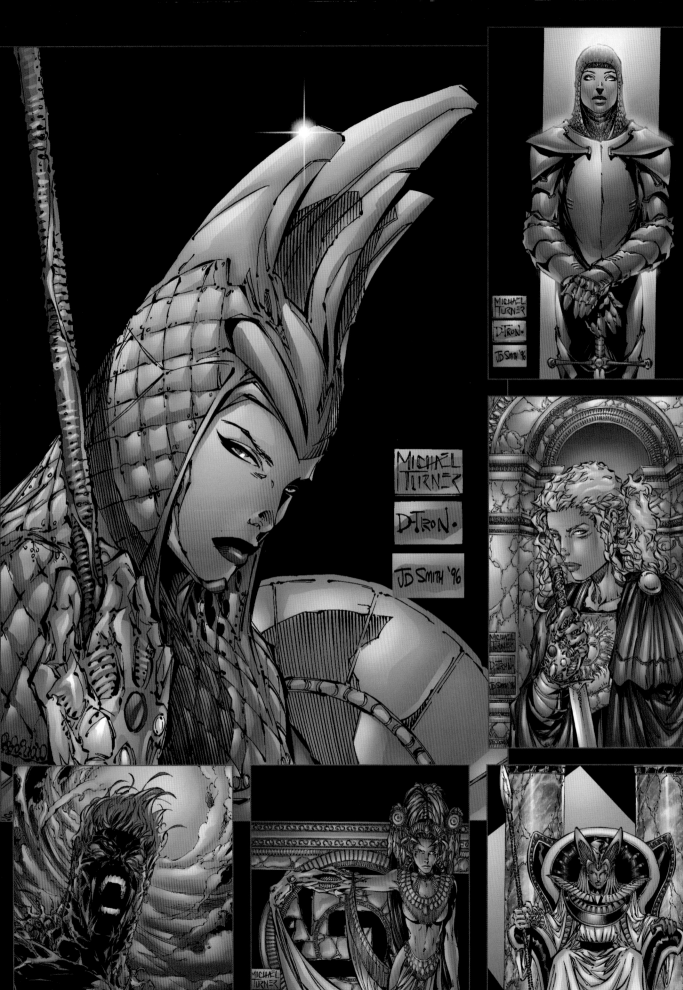

MICHAEL
TURNER

D-TRON.

JD SMITH '96

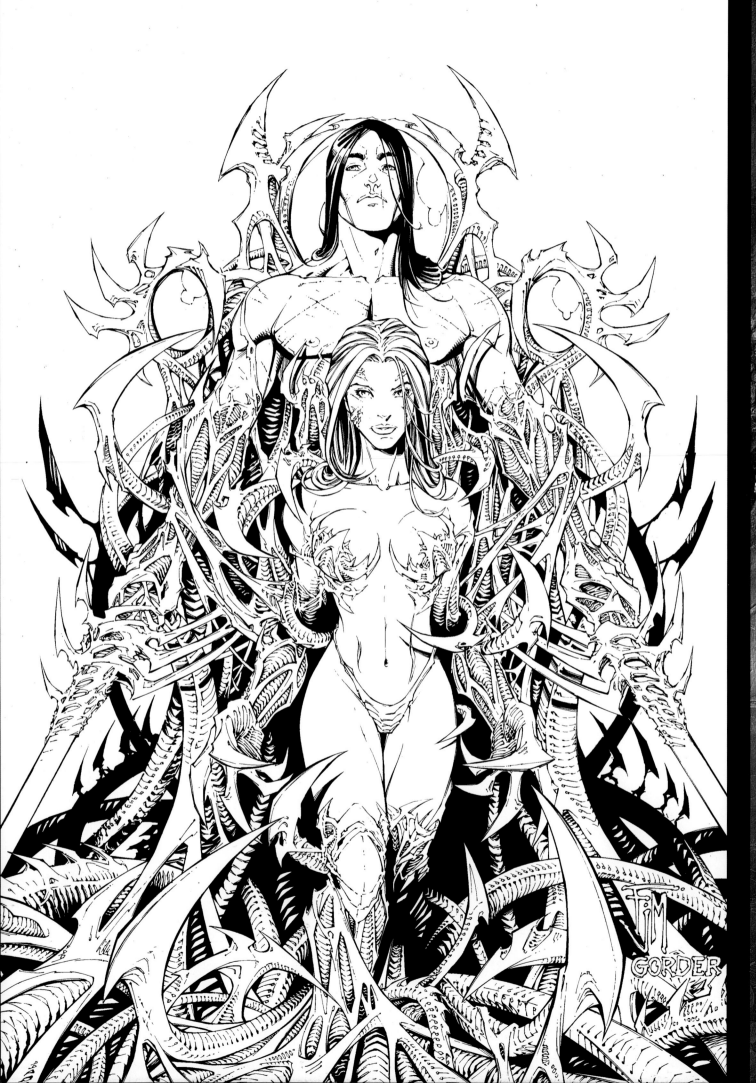

Witchblade issue #45 Dynamic Forces variant cover
art by: Francis Manapul and Jason Gorder

Witchblade issue #45 Dynamic Forces variant cover

art by: Francis Manapul, Jason Gorder and Steve Firchow

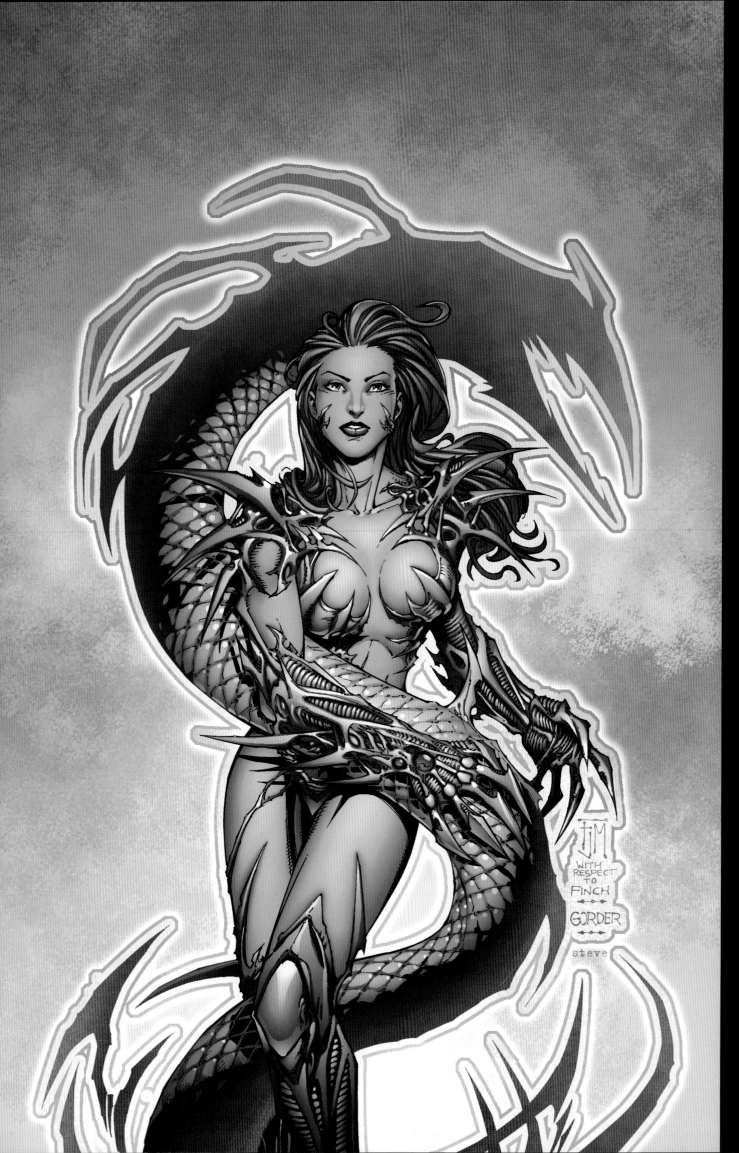

Witchblade issue #57 cover
art by: Francis Manapul, Jason Gorder and Steve Firchow

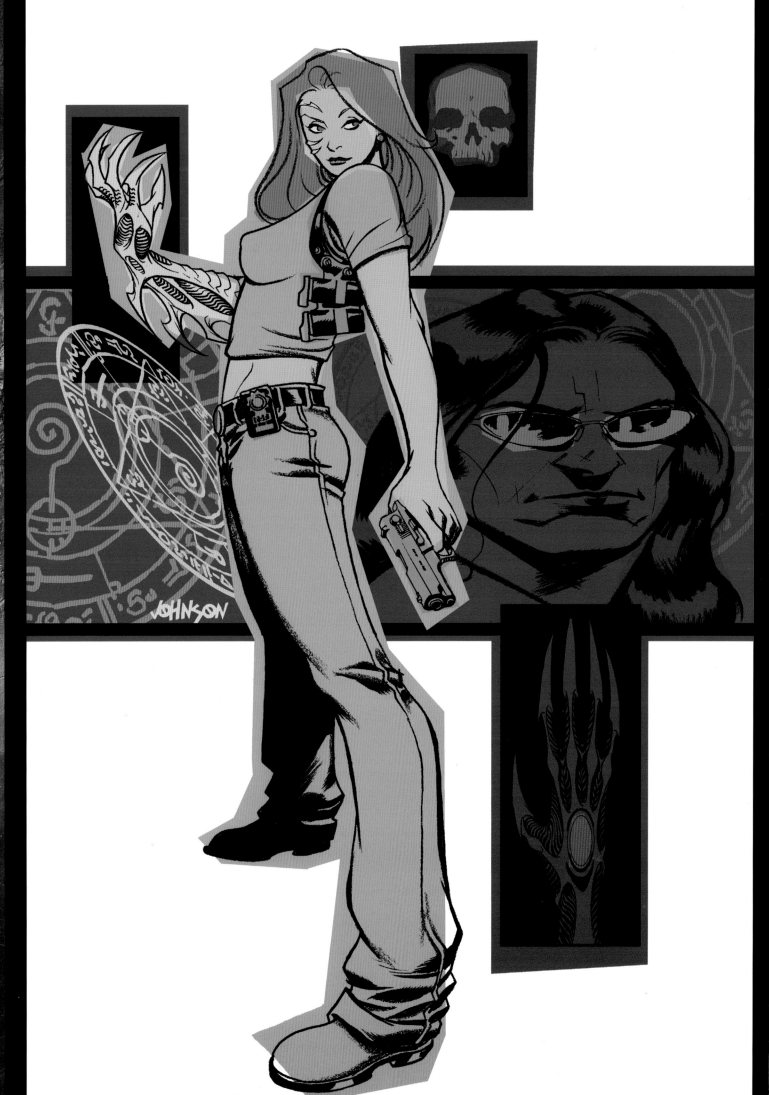

Witchblade issue #69 cover
art by: Dave Johnson

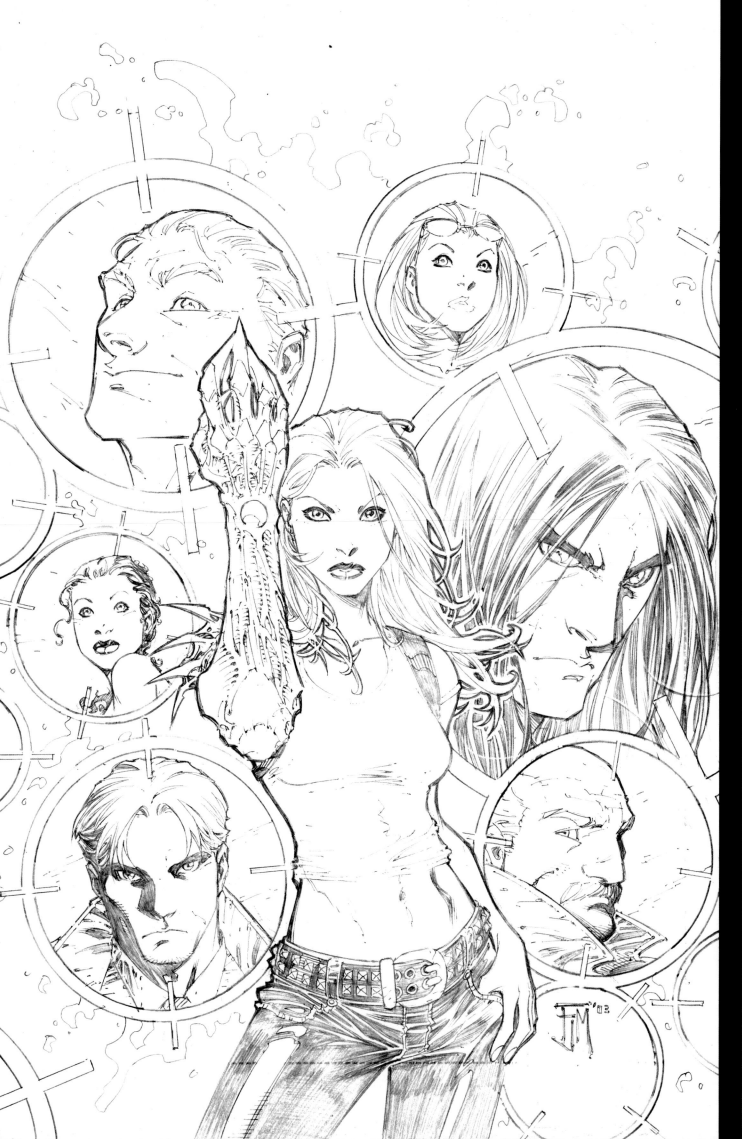

Witchblade issue #75 cover pencils
art by: Francis Manapul

Witchblade issue #75 cover
art by: Francis Manapul, Matt "Batt" Banning and Brian Buccellato

21

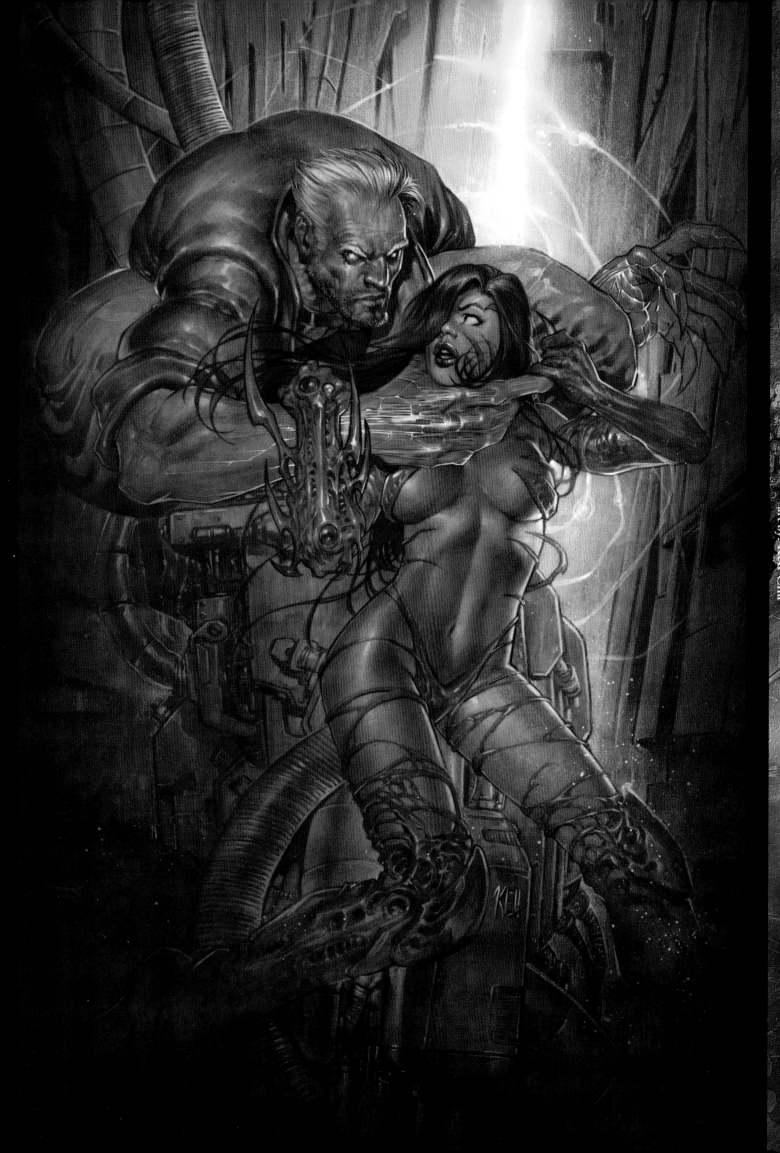

Witchblade issue #71 cover
art by: Keu Cha

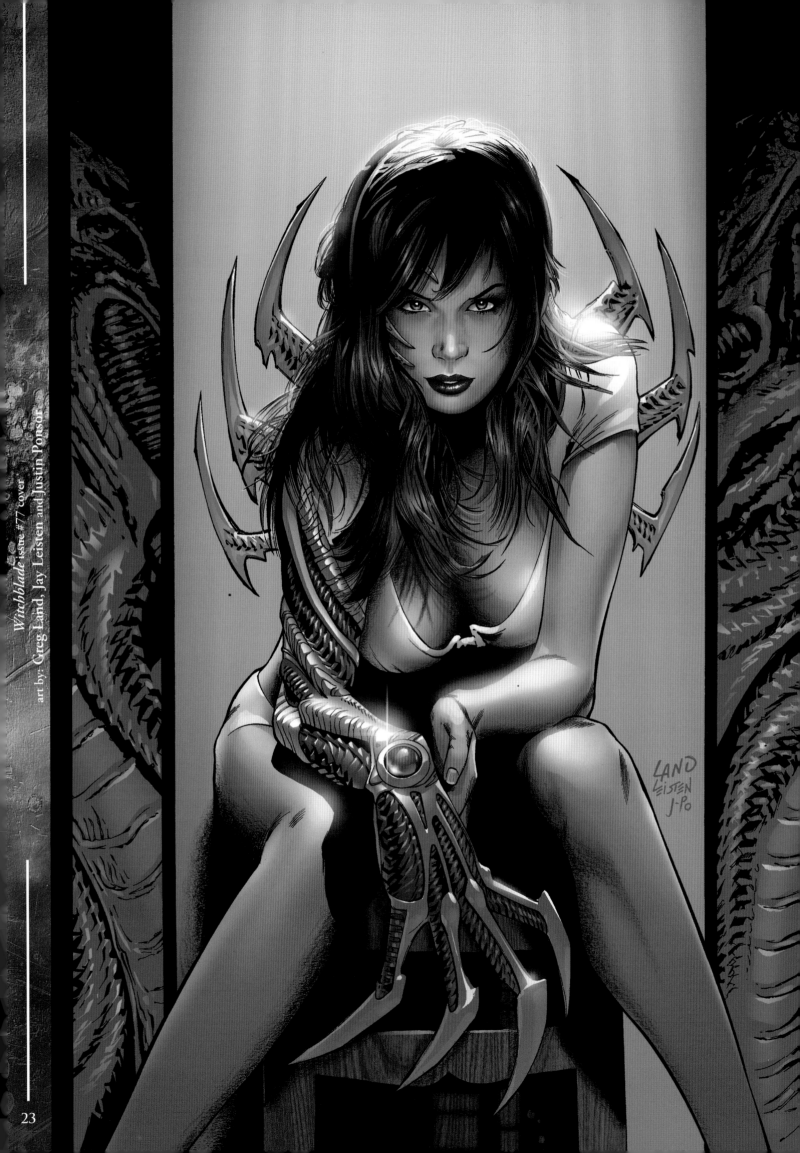

Witchblade issue #77 cover
art by: Greg Land, Jay Leisten and Justin Ponsor

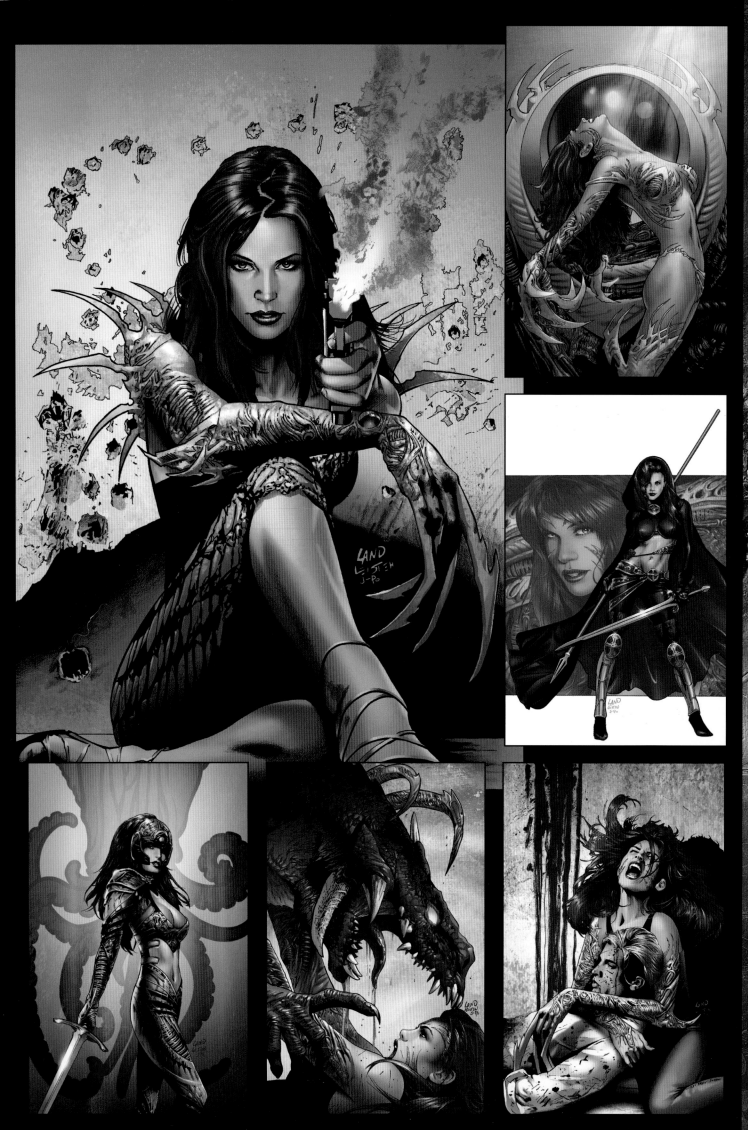

Witchblade issue #80-85 covers

art by: Greg Land, Jay Leisten and Justin Ponsor

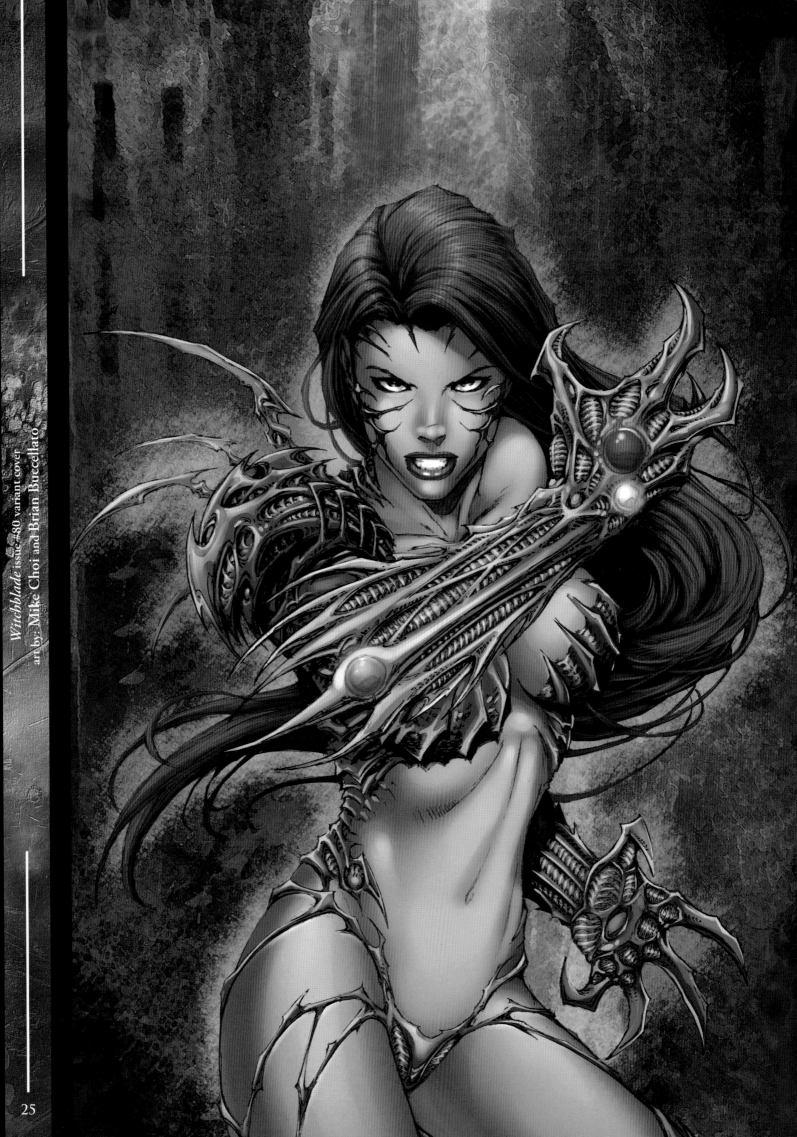

Witchblade issue #80 variant cover
art by: Mike Choi and Brian Buccellato

Witchblade issue #80 variant cover
art by: Frank Cho and Laura Martin

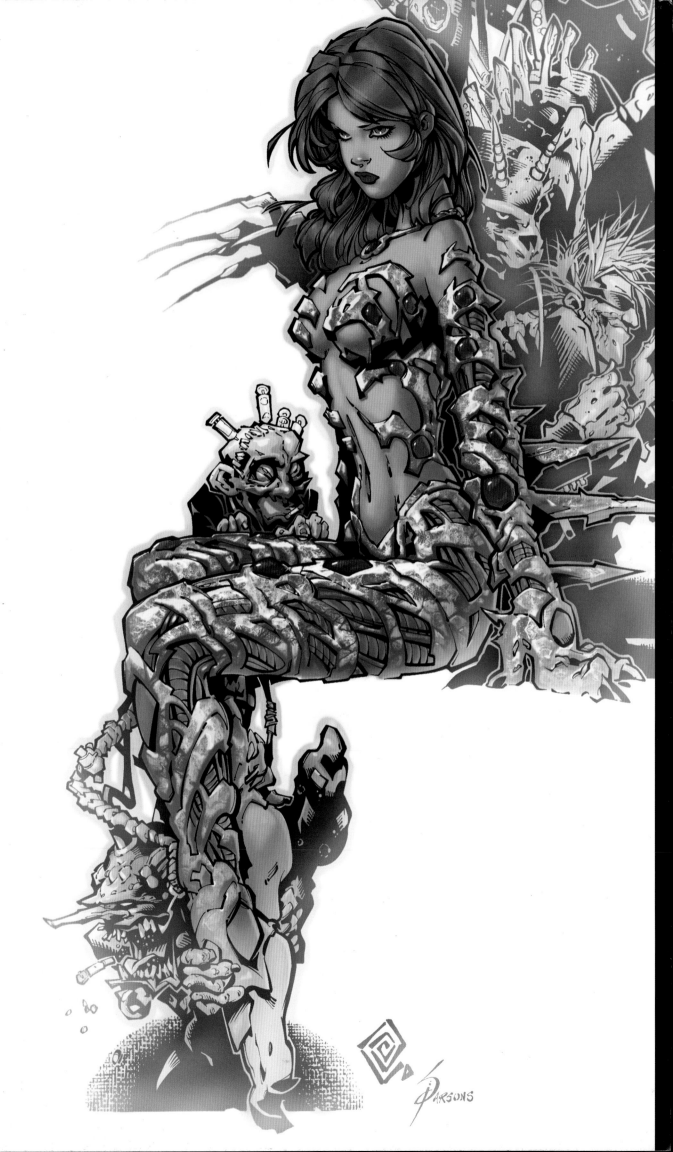

Witchblade issue #87 cover
art by: Chris Bachalo and Sean Parsons

Witchblade issue #88 cover
art by: Terry Dodson, Rachel Dodson and Edgar Delgado

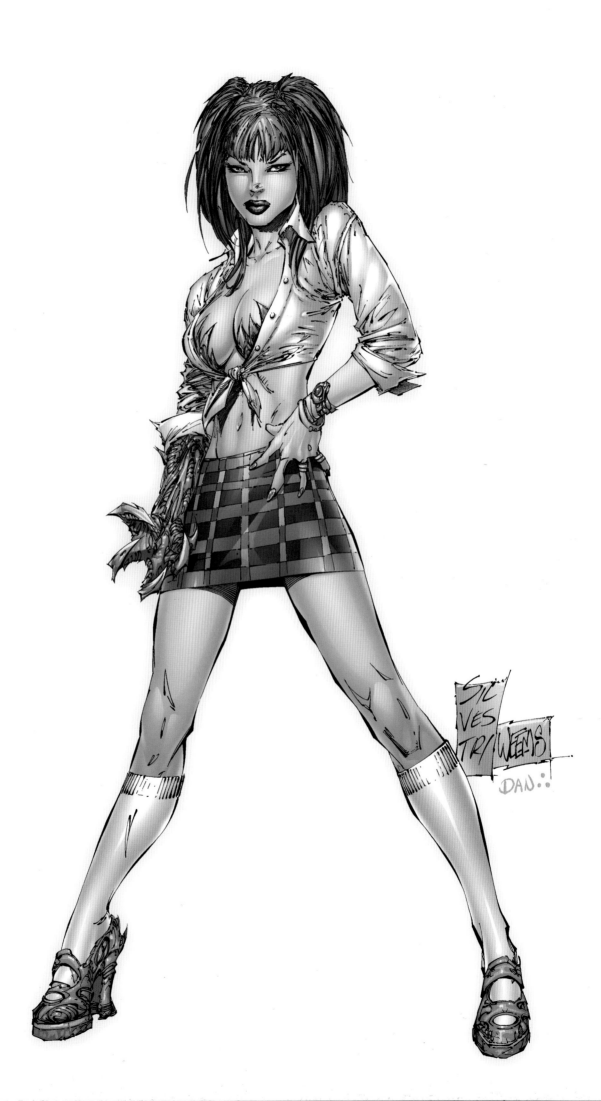

Witchblade issue #89 variant cover

art by: Marc Silvestri, Joe Weems V and Dan Panosian

Witchblade issue #92 cover
art by: Jay Anacleto and Steve Firchow

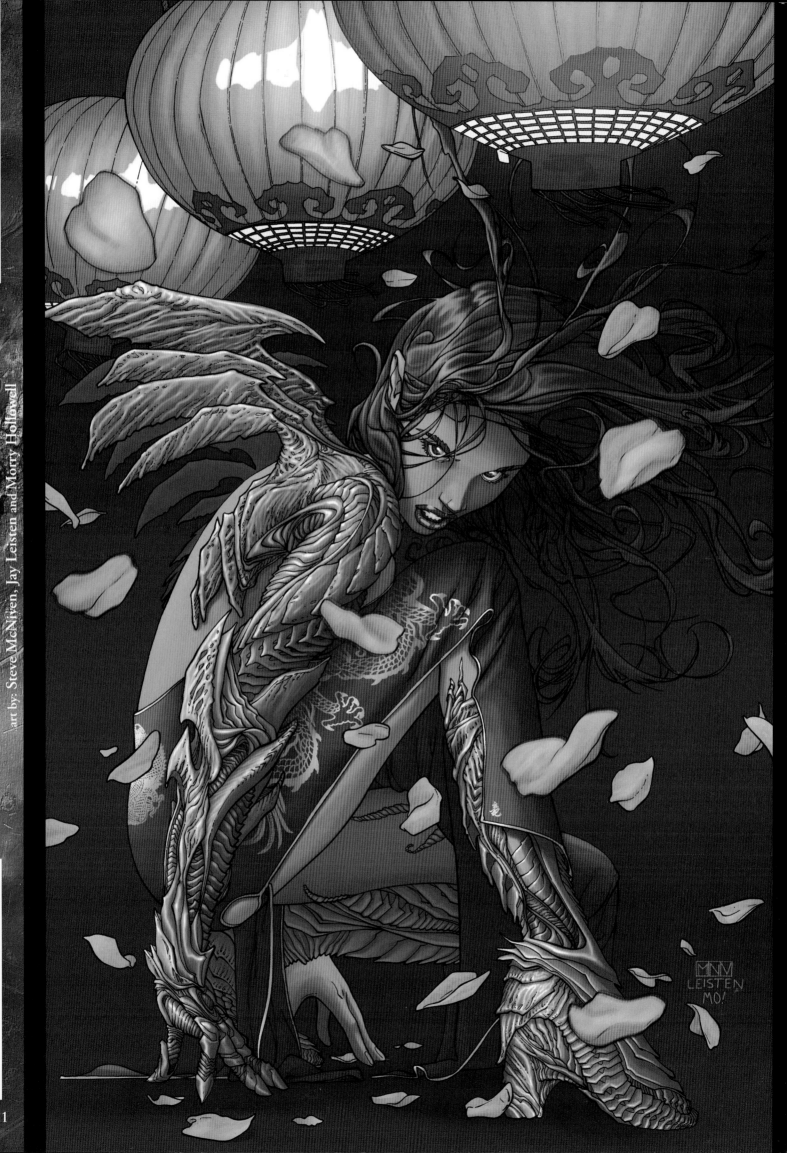

Witchblade issue #95 cover

art by: Steve McNiven, Jay Leisten and Morry Hollowell

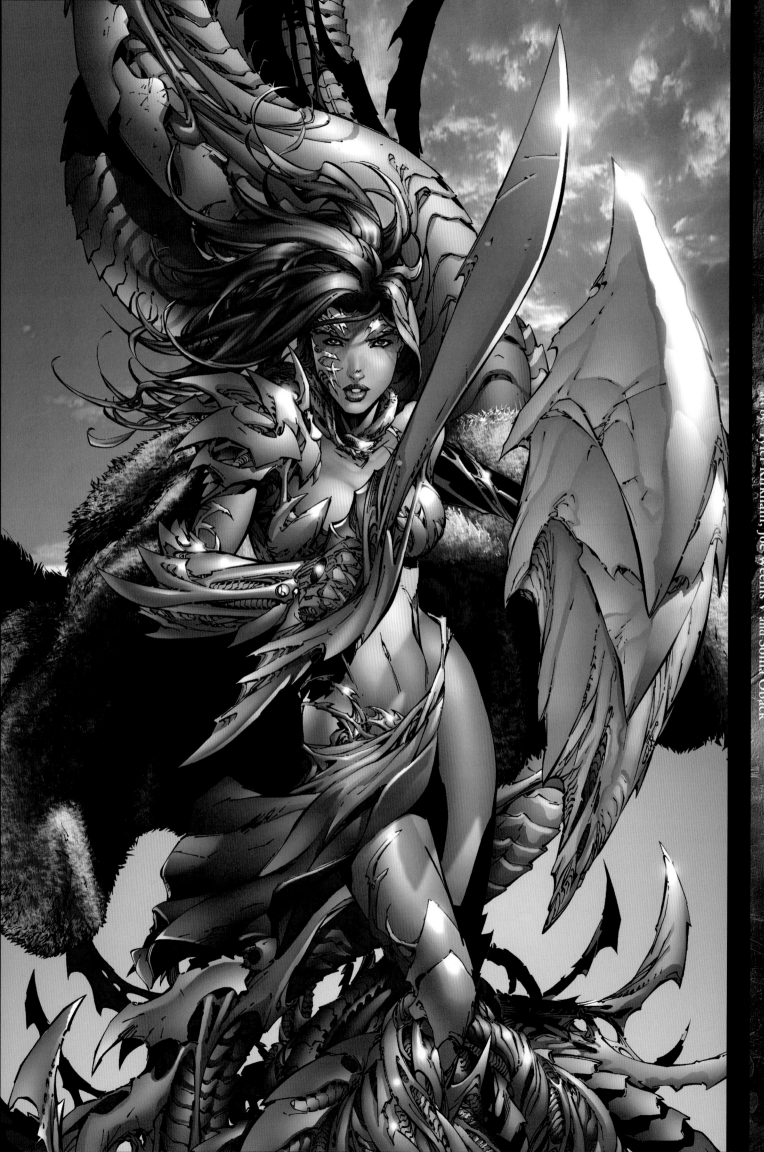

Witchblade issue #99 cover
art by: Adriana Melo and Sonia Oback

Witchblade issue #100 cover
art by Mike Choi and Sonia Oback

CHOI
OBACK
2006

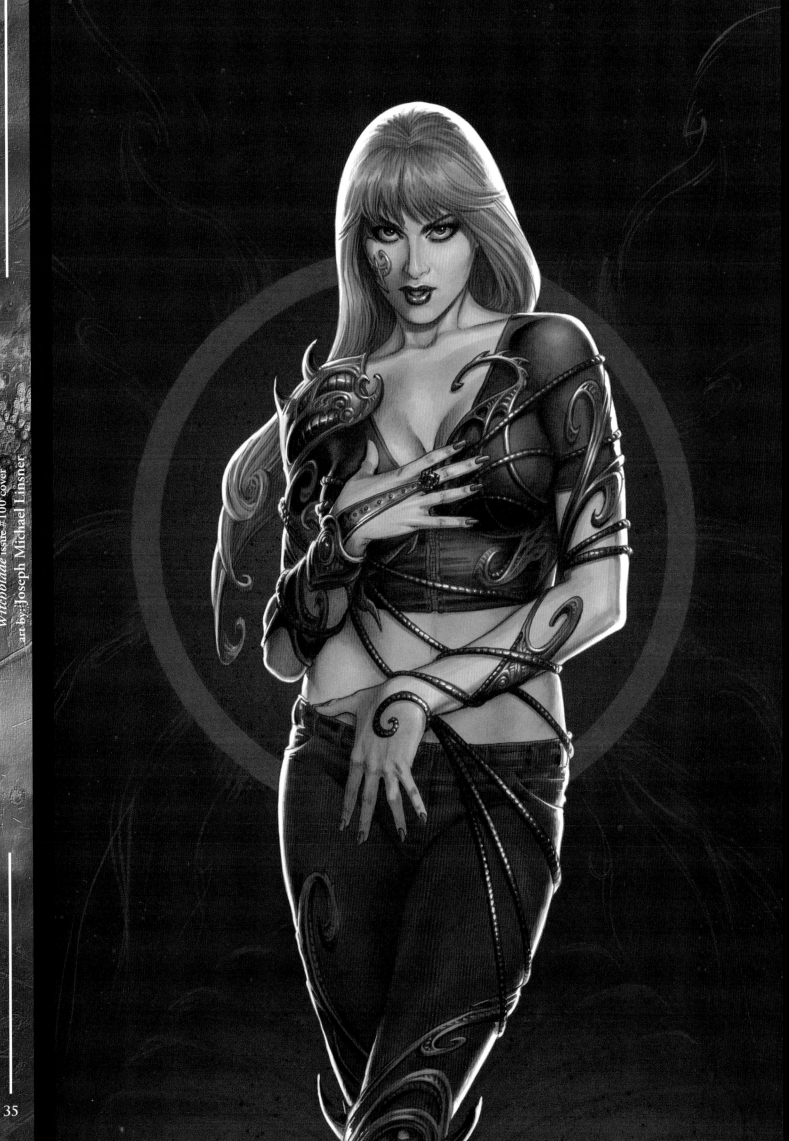

Witchblade issue #100 cover
art by: Joseph Michael Linsner

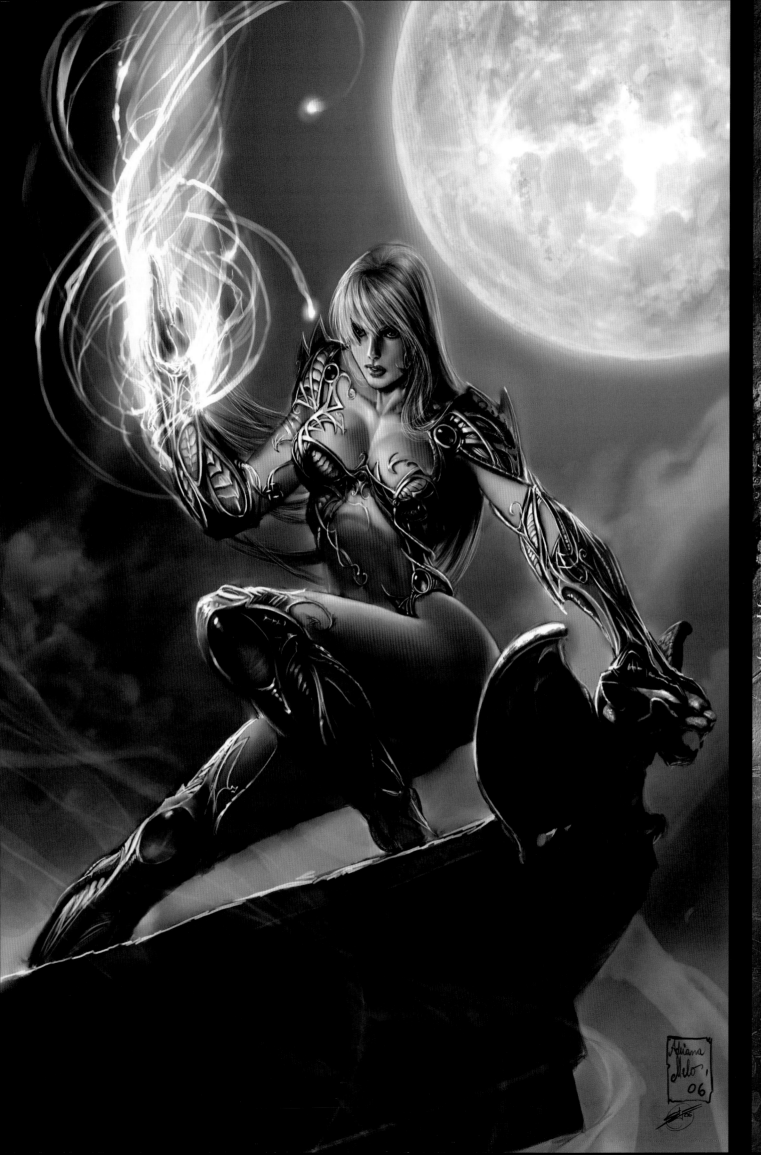

Witchblade issue #104 cover
art by: Adriana Melo and Stjepan Sejic

Witchblade issue #106 variant cover
art by: Adriana Melo

DANI

Witchblade issue #106 cover
art by: Chris Bachalo and Tim Townsend

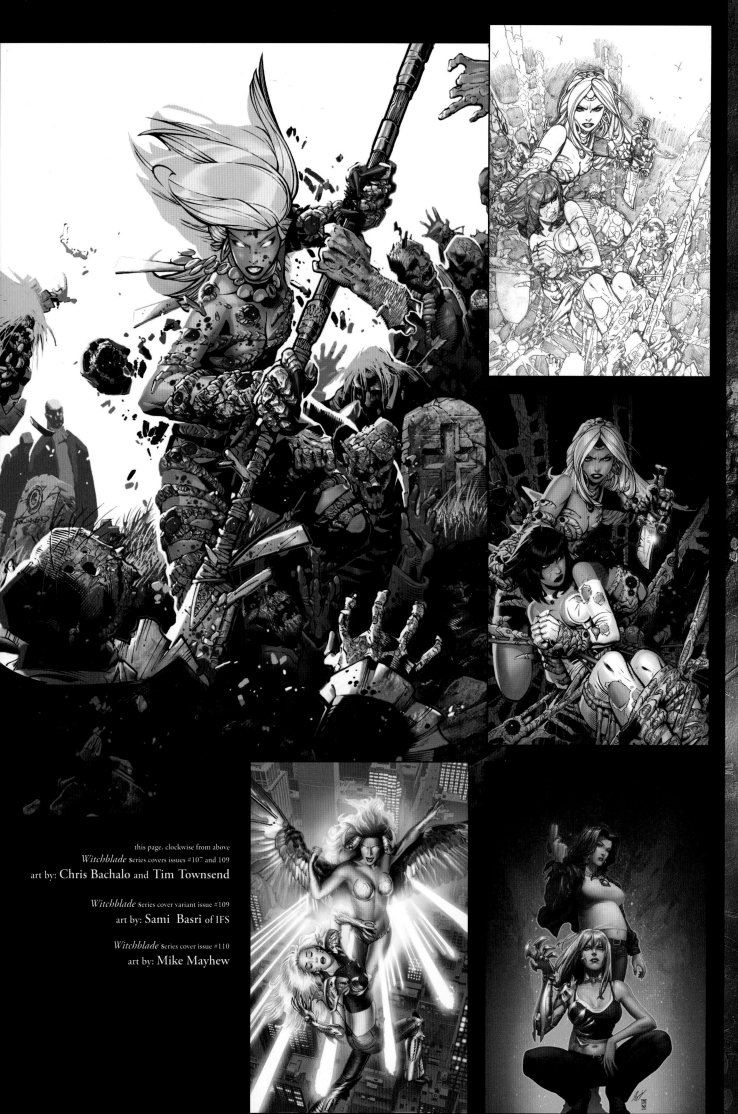

this page, clockwise from above
Witchblade series covers issues #107 and 109
art by: **Chris Bachalo** and **Tim Townsend**

Witchblade series cover variant issue #109
art by: **Sami Basri** of IFS

Witchblade series cover issue #110
art by: **Mike Mayhew**

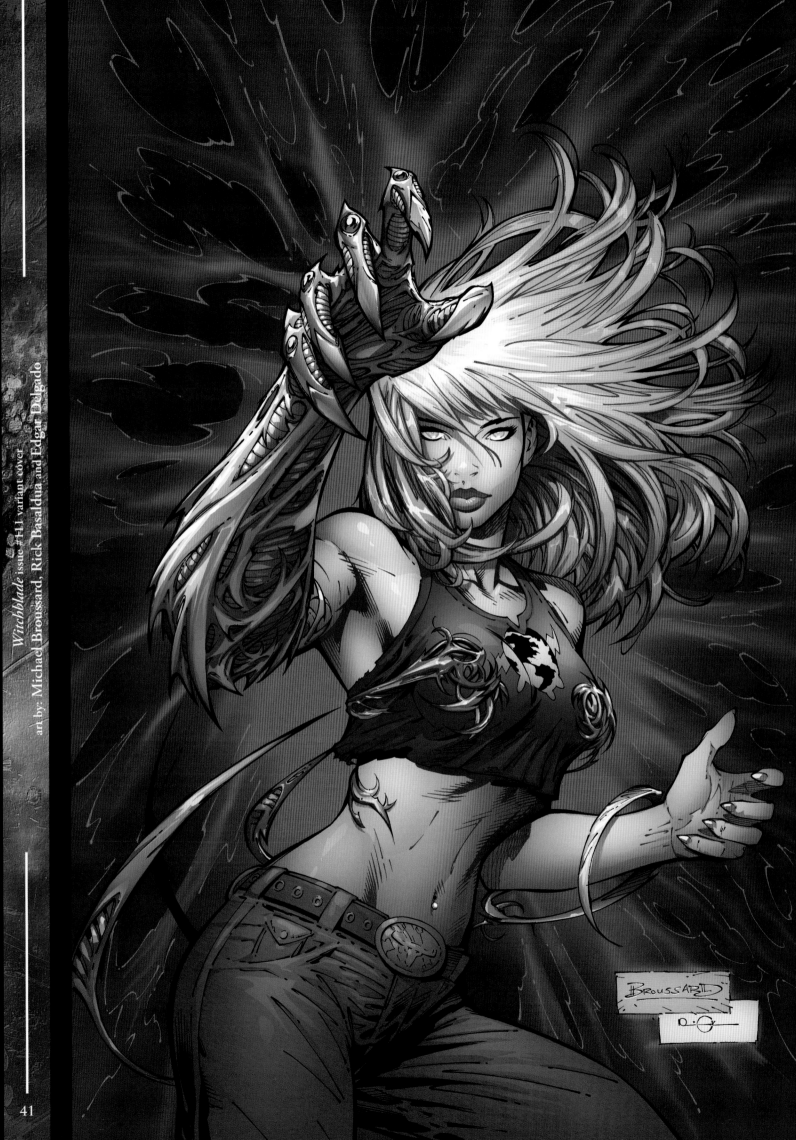

Witchblade issue #111 variant cover

art by: Michael Broussard, Rick Basaldua and Edgar Delgado

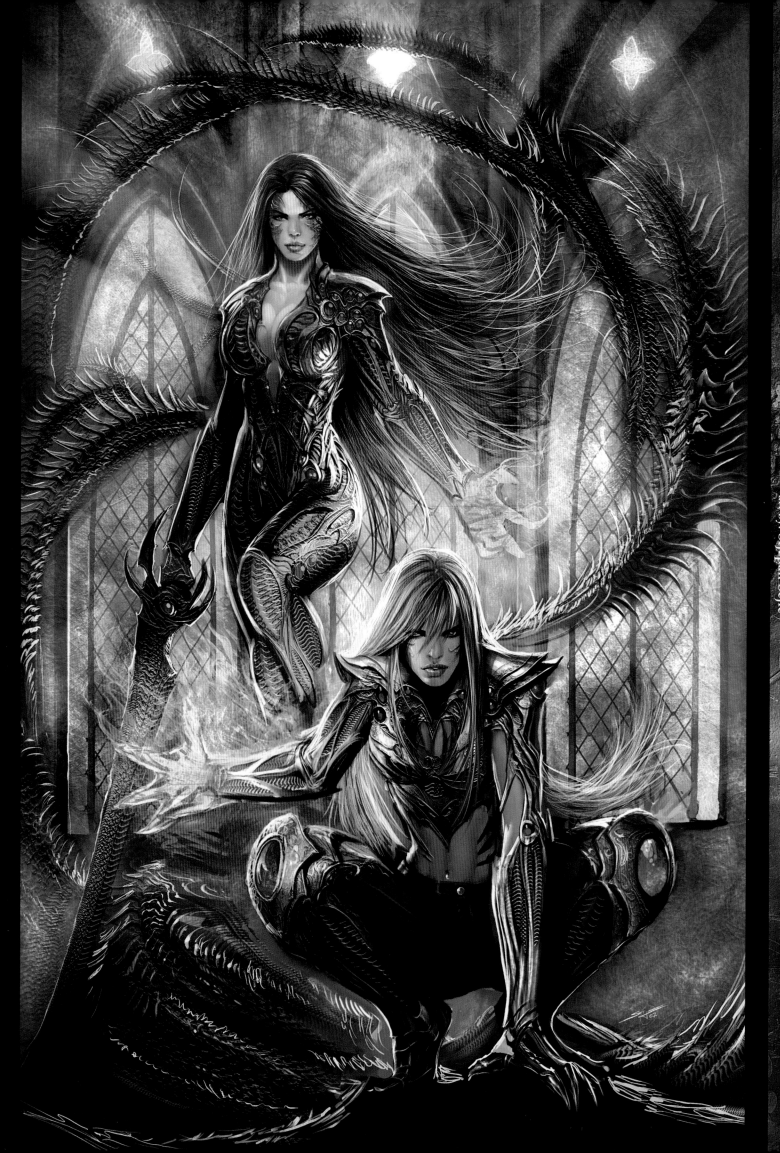

Witchblade issue #116 cover
art by: Stjepan Sejic

Witchblade issue #117 cover
art by: Luke Ross

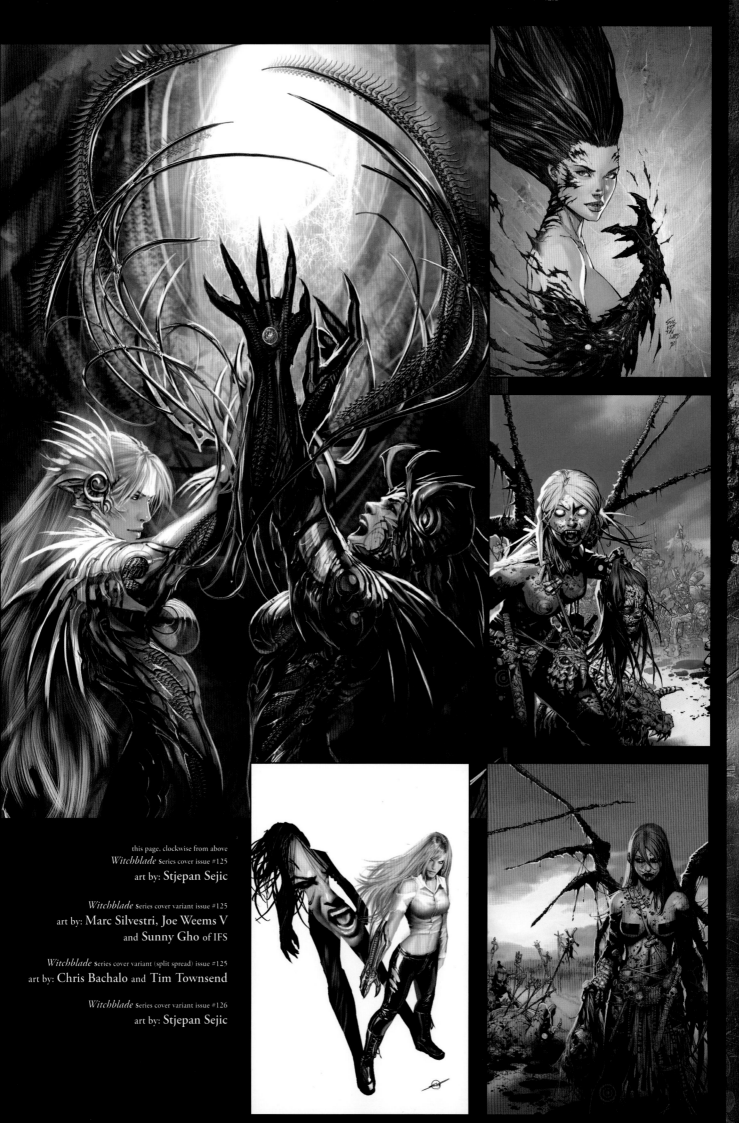

this page, clockwise from above
Witchblade series cover issue #125
art by: Stjepan Sejic

Witchblade series cover variant issue #125
art by: Marc Silvestri, Joe Weems V
and Sunny Gho of IFS

Witchblade series cover variant (split spread) issue #125
art by: Chris Bachalo and Tim Townsend

Witchblade series cover variant issue #126
art by: Stjepan Sejic

Witchblade issue #127 cover
art by: Stjepan Sejic

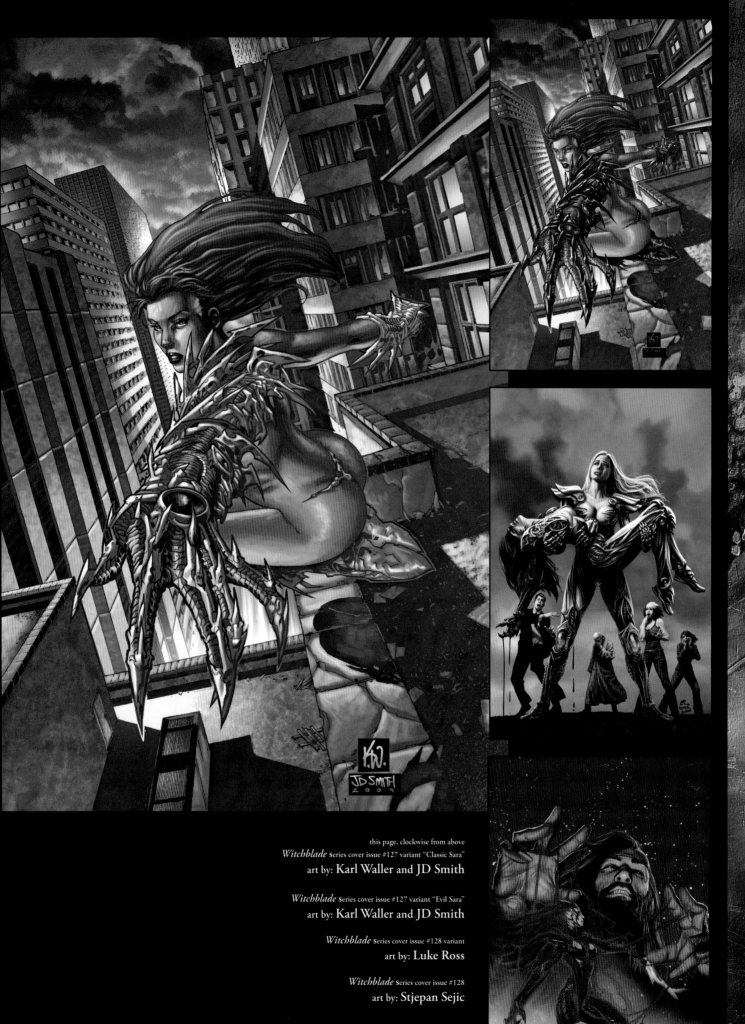

this page, clockwise from above
Witchblade series cover issue #127 variant "Classic Sara"
art by: Karl Waller and JD Smith

Witchblade series cover issue #127 variant "Evil Sara"
art by: Karl Waller and JD Smith

Witchblade series cover issue #128 variant
art by: Luke Ross

Witchblade series cover issue #128
art by: Stjepan Sejic

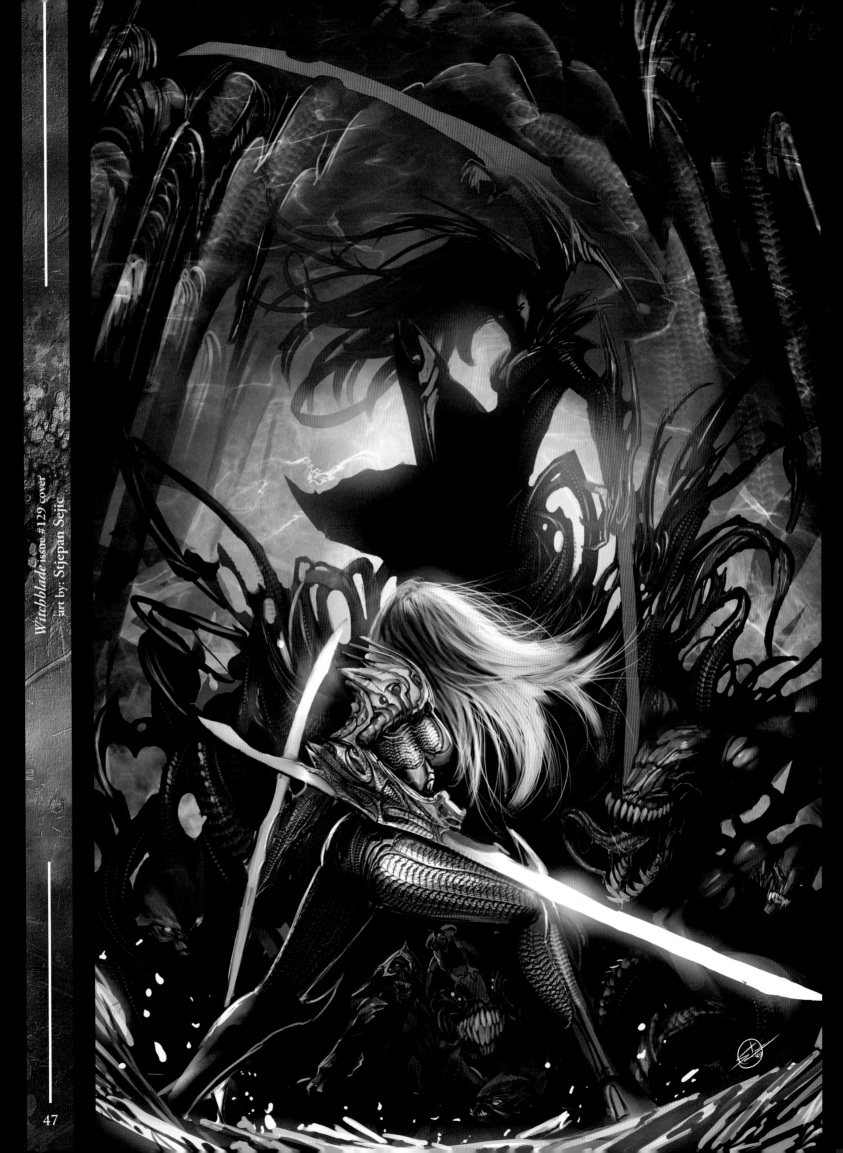

Witchblade issue #129 cover
art by: Stjepan Sejic

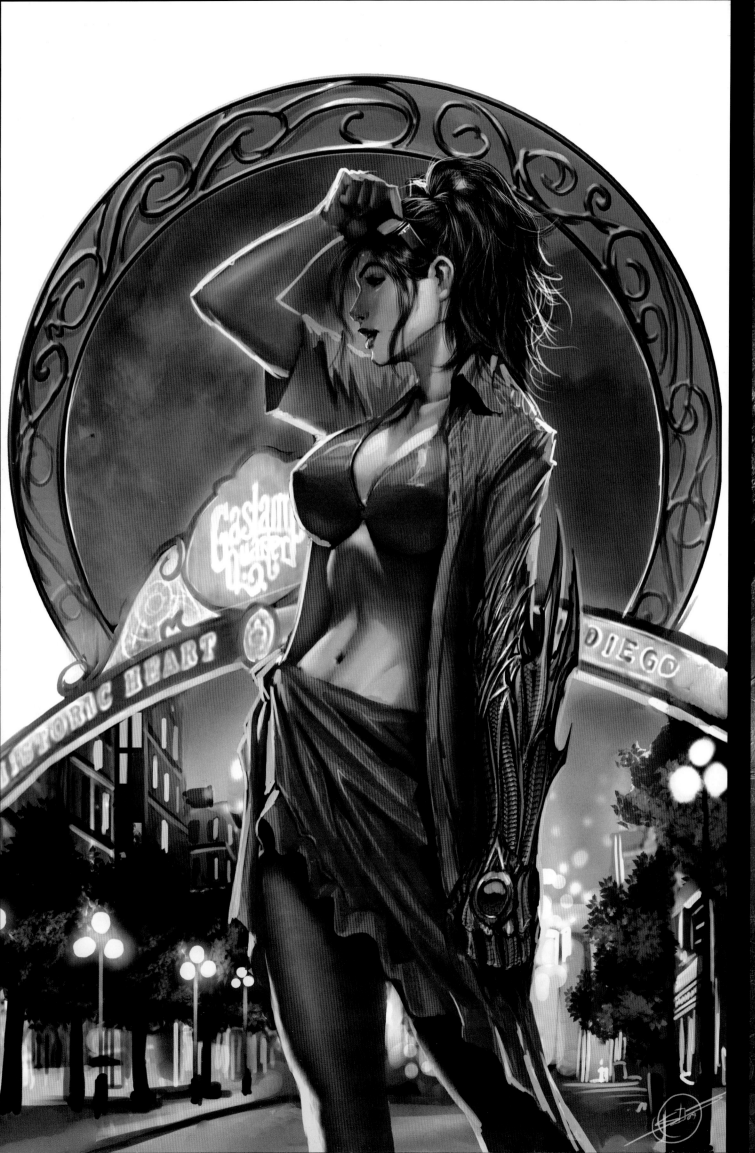

WitchBlade issue #128 San Diego Comic-Con 2009 variant cover
art by: Stjepan Sejic

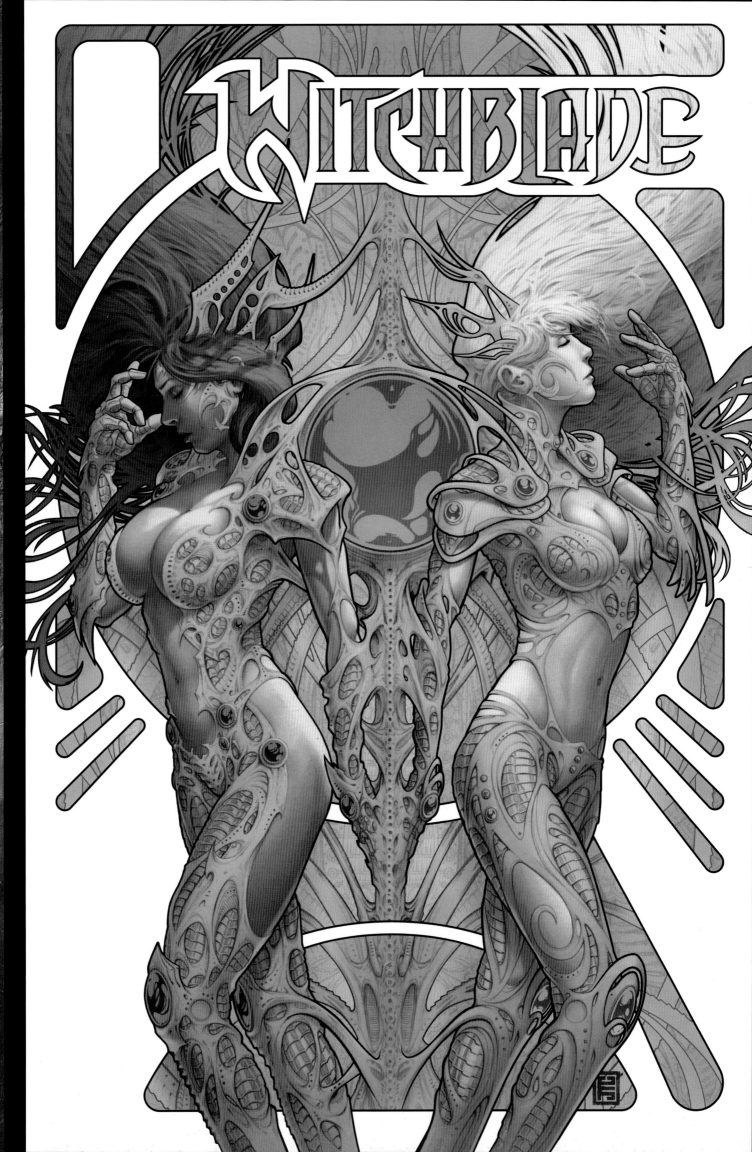

Witchblade issue #129 variant cover
art by: John Tyler Christopher

{WITCHBLADE: TAKERU}
Selected Works

Witchblade: Takeru series art from Poster #1
art by: **Kazasa Sumita**

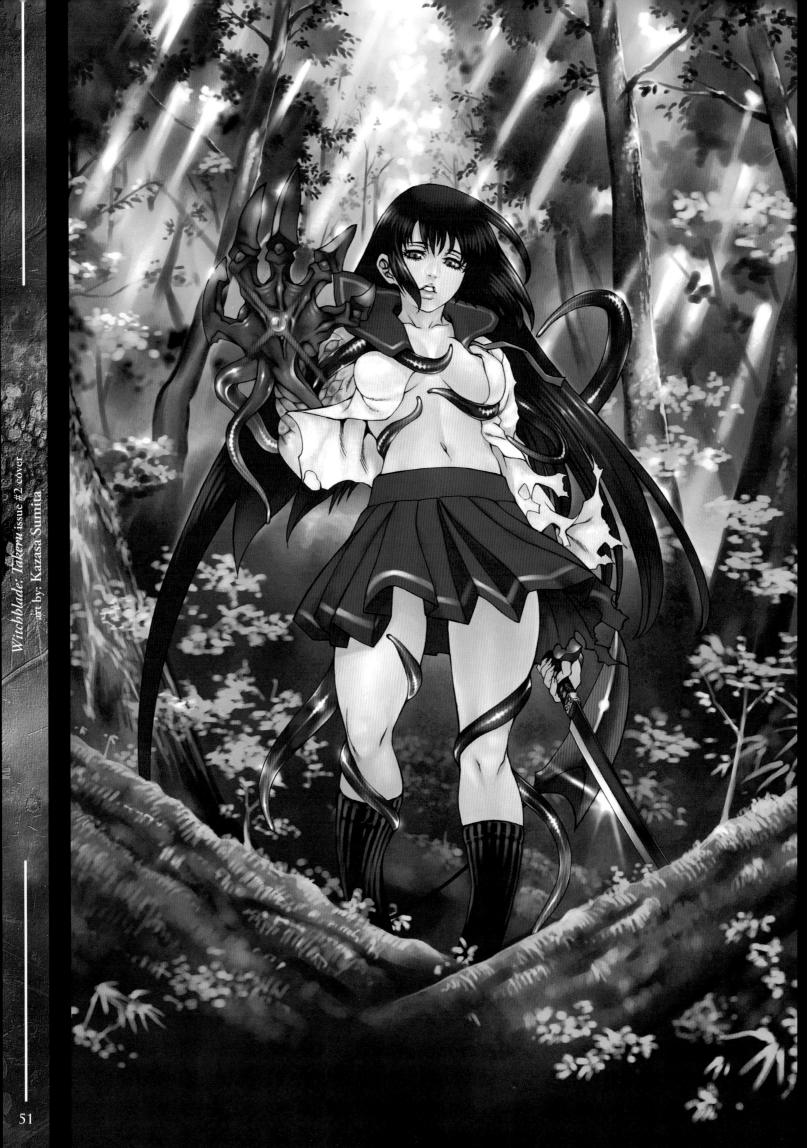

Witchblade: Takeru issue #2 cover
art by: Kazasa Sumita

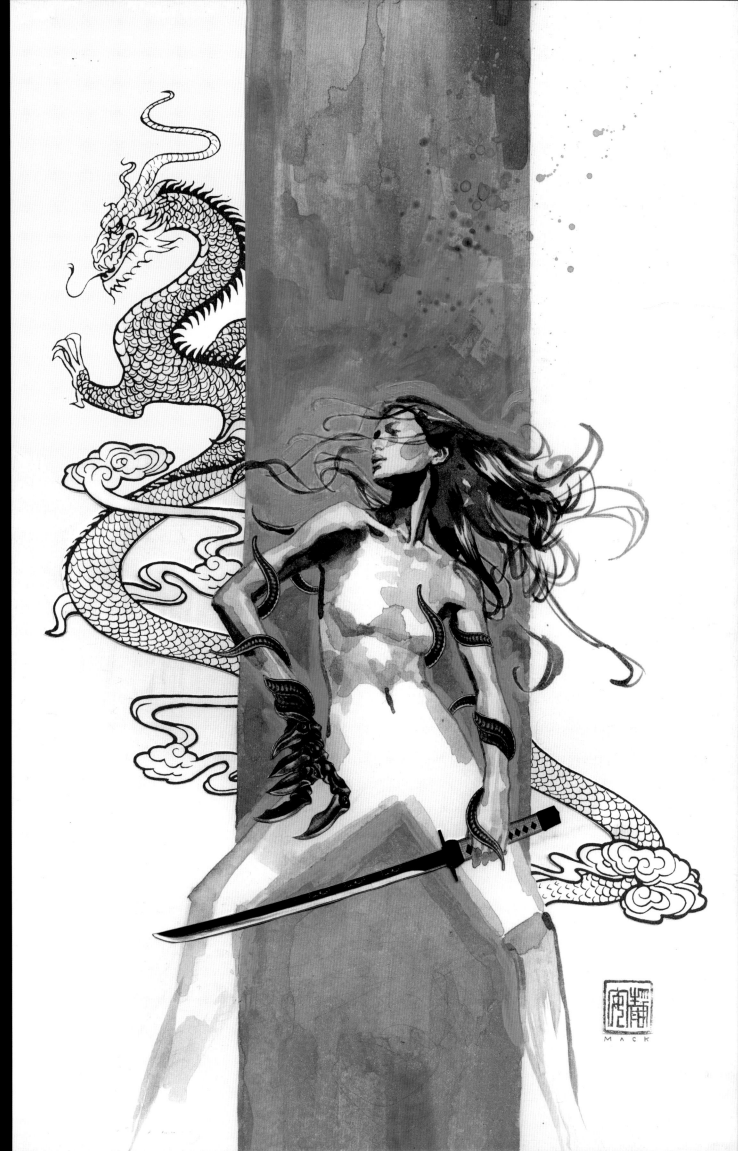

Witchblade: Takeru issue #7 cover
art by: David Mack

{WITCHBLADE ANIME}
DVD set art and Selected Works

Witchblade Anime promotional art
art by: Gonzo

Witchblade: Takeru issue #1 variant cover of Anime weilder "Masane"
art by: Marc Silvestri and Steve Firchow

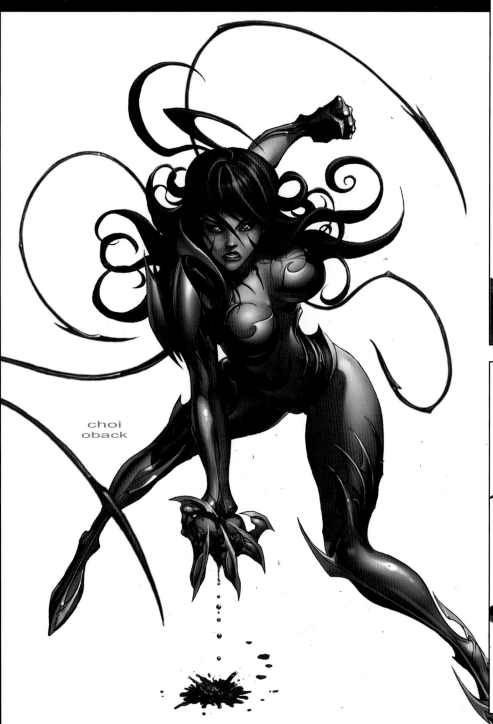

choi
oback

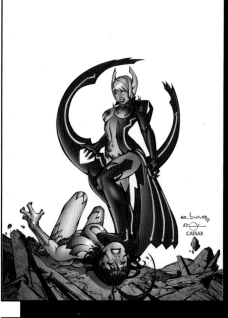

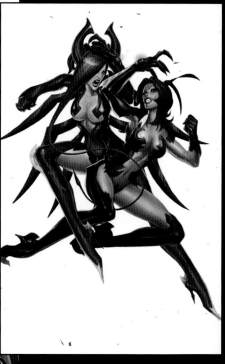

this page, clockwise from above

Witchblade Anime DVD Series box art

Volume 1 art by: **Mike Choi** and **Sonia Oback**

Volume 2 art by: **Eric Basaldua**, **Rick Basaldua**
and **Ceaser Rodriguez**

Volume 3 art by: **Keu Cha**

Volume 4 art by: **Stjepan Sejic**

Volume 5 art by: **Dale Keown**

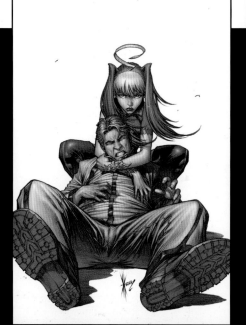

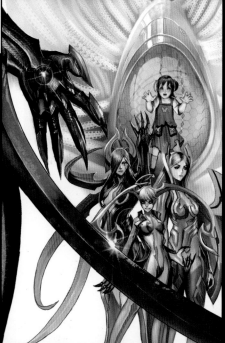

Witchblade Anime DVD volume 6 box art

art by: Marc Silvestri, Joe Weems V and Frank D'Armata

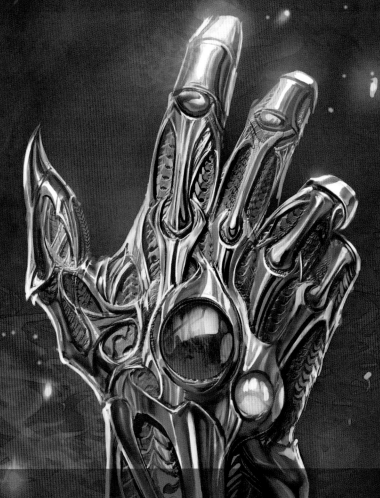

{WITCHBLADE}
Trade paperback covers • Selected Works

Witchblade volume 1 trade paperback cover
art by: Stjepan Sejic

Witchblade volume I "Origins" trade paperback reprint cover
art by: Michael Turner, D-Tron and JD Smith with design by Peter Steigerwald

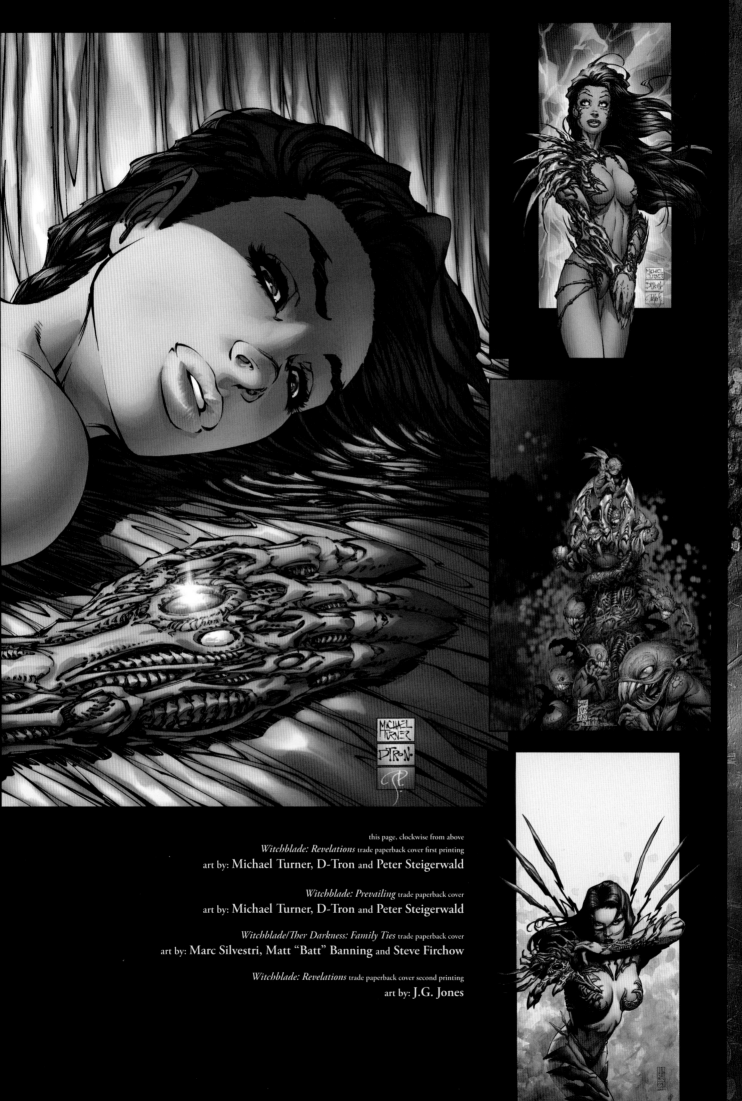

this page, clockwise from above

Witchblade: Revelations trade paperback cover first printing
art by: Michael Turner, D-Tron and Peter Steigerwald

Witchblade: Prevailing trade paperback cover
art by: Michael Turner, D-Tron and Peter Steigerwald

Witchblade/The Darkness: Family Ties trade paperback cover
art by: Marc Silvestri, Matt "Batt" Banning and Steve Firchow

Witchblade: Revelations trade paperback cover second printing
art by: J.G. Jones

Witchblade: Distinctions trade paperback cover.
art by: Randy Green, D-Tron and Steve Firchow

Witchblade volume #1-6 trade paperback covers
art by: Stjepan Šejić

Witchblade volume #7 trade paperback cover
art by: Stjepan Sejic

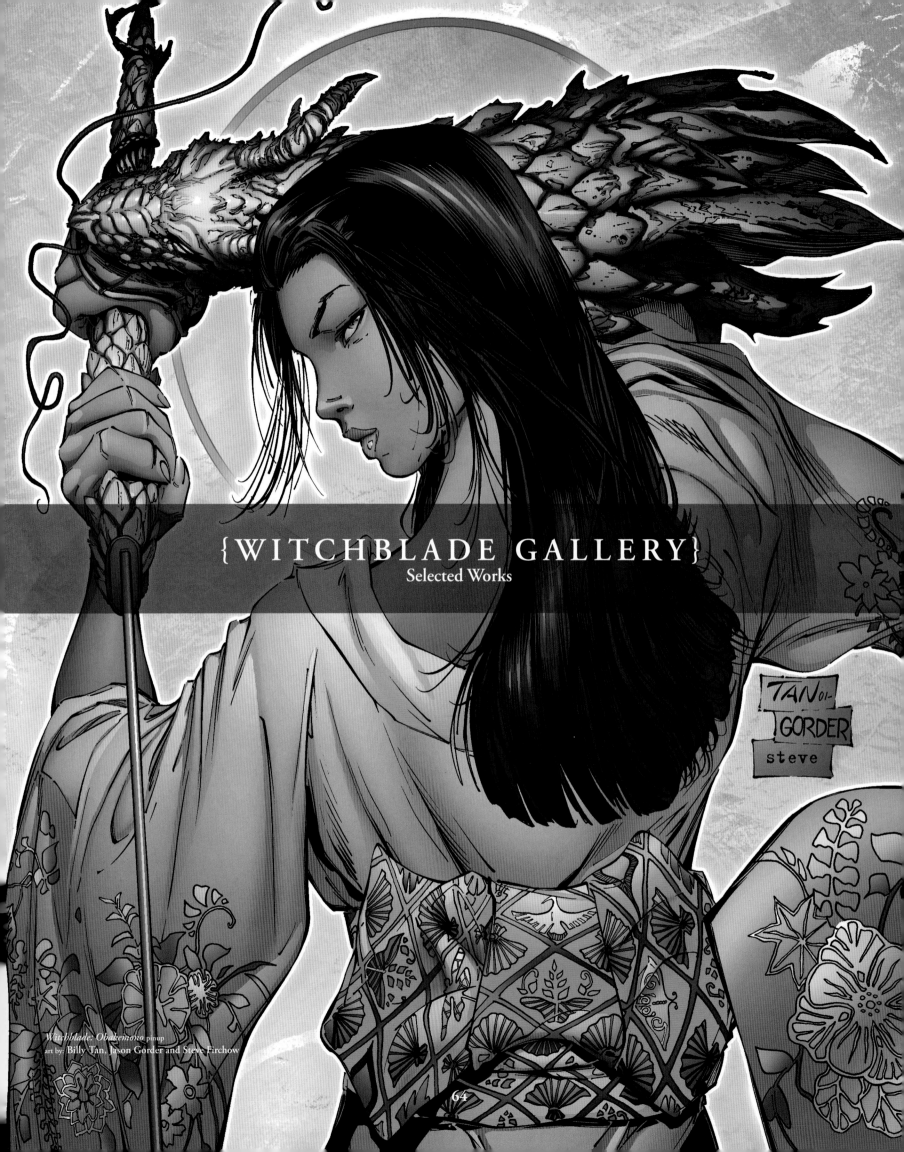

{WITCHBLADE GALLERY}
Selected Works

Witchblade: Obakemono pinup
art by: Billy Tan, Jason Gorder and Steve Firchow

Witchblade Lingerie pinup
art by: Michael Turner, D-Tron and JD Smith

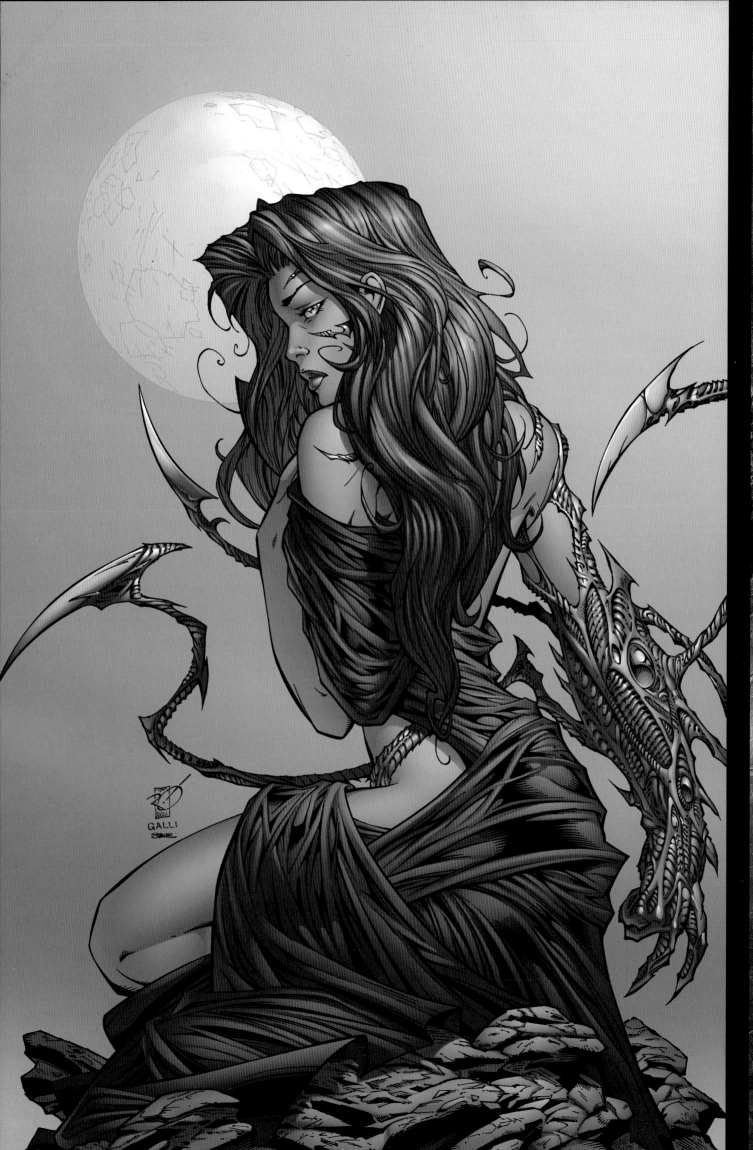

Witchblade pinup
art by: Romano Molenaar, Marco Galli and Steve Firchow

Witchblade pinup
art by: Andy Park, D-Tron and Dan Panosian

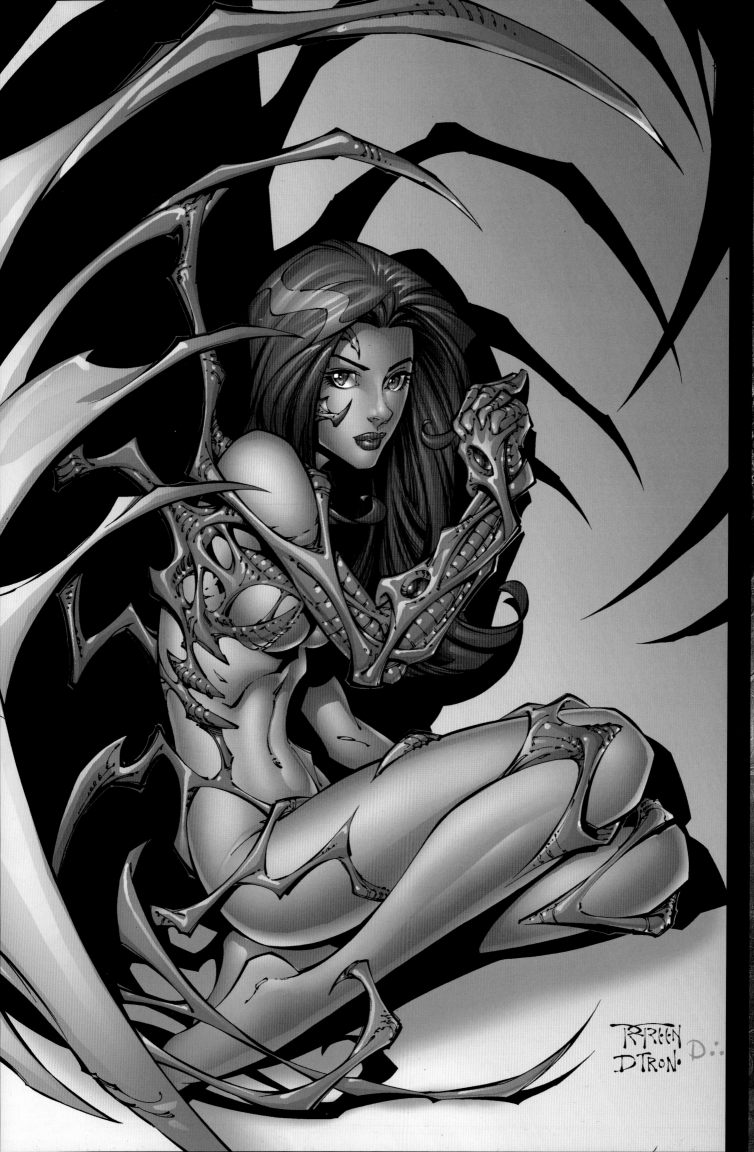

Witchblade pinup
art by: Randy Green, D-Tron and Dan Panosian

Tales of the Witchblade issue #6 cover
art by: Randy Green, Jon Sibal and Matt Nelson

est.talent
Sotelo

Tales of the Witchblade issue #2·cover

art by: David Finch; Matt "Batt" Banning and JD Smith

Witchblade: Bearers of the Battle variant cover
art by: Eric Basaldua and Steve Firchow

Witchblade pinup

art by: David Nakayama and Christina Strain

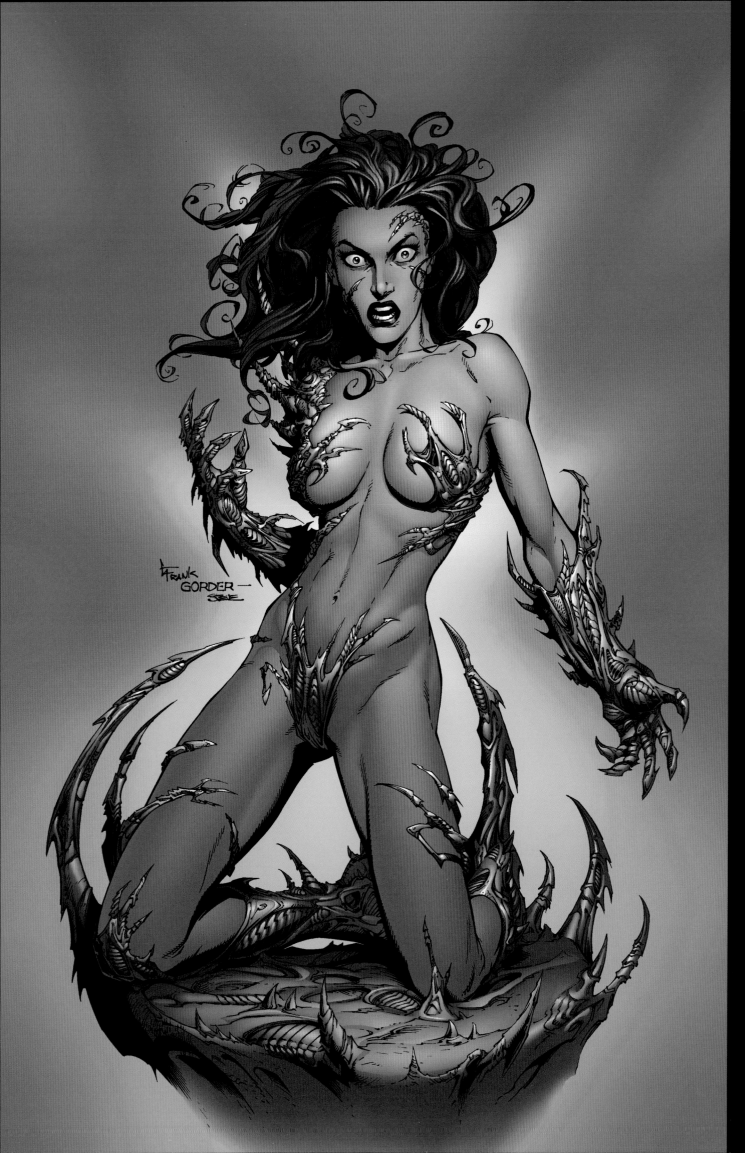

Witchblade pinup
art by: Gary Frank, Jason Gorder and Steve Firchow

Witchblade pinup
art by: Brandon Peterson

Witchblade Wizard: The Comics Magazine, cover
art by: Marc Silvestri, Joe Weems V and Steve Firchow

Witchblade: Disciples of the Blade trading card image
art by: Francis Manapul, Matt "Batt" Banning and Beth Sotelo

"Witchblade"
art by: Svetlin Velinov • www.velinov.com

"Witchblade"
art by: Michal Ivan

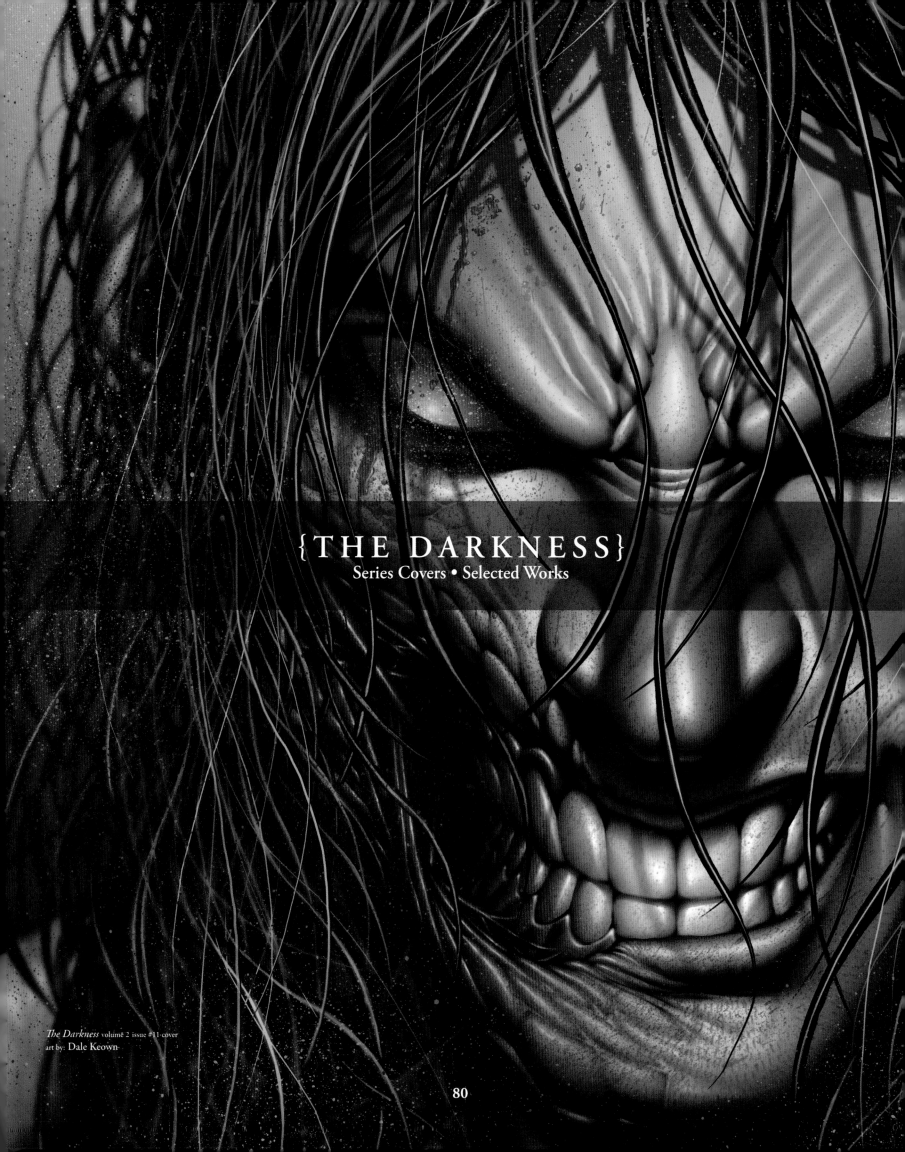

{THE DARKNESS}
Series Covers • Selected Works

The Darkness volume 2 issue #11 cover
art by: Dale Keown

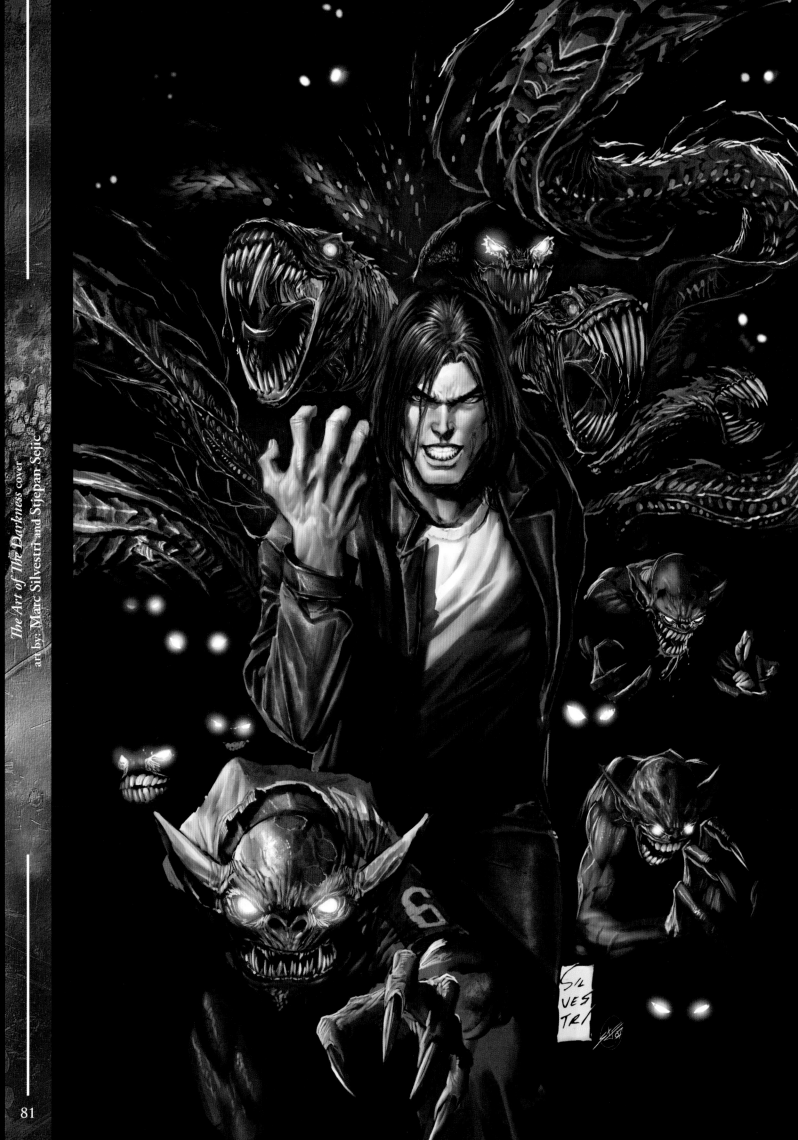

The Darkness Wizard: The Comics Magazine, cover

art by: Marc Silvestri

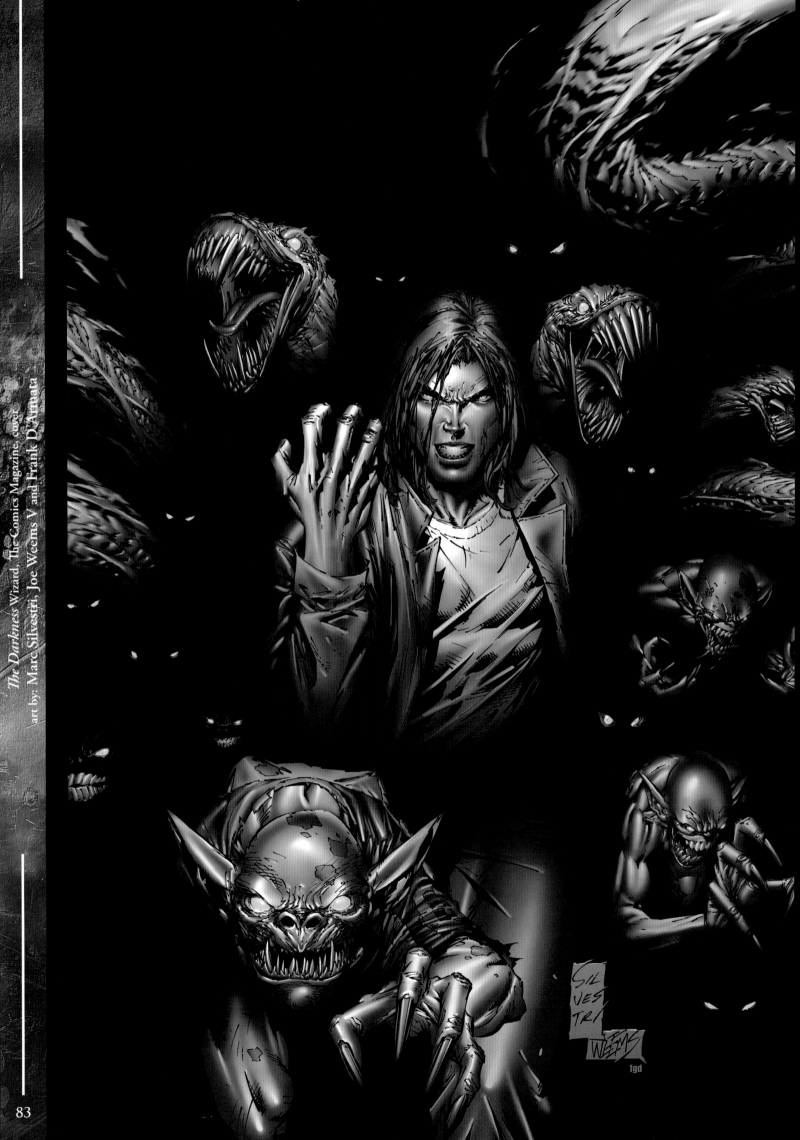

The Darkness Wizard, The Comics Magazine, cover
art by: Marc Silvestri, Joe Weems V and Frank D'Armata

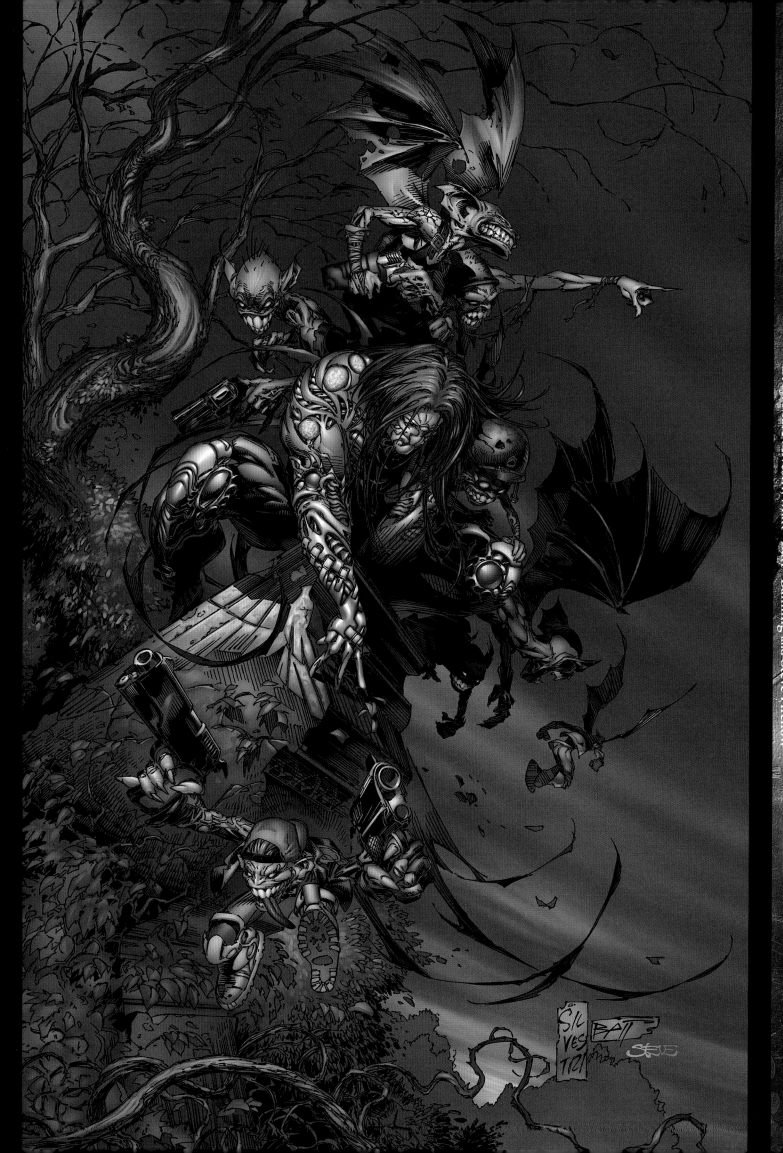

The Darkness volume 1 issue #1/2 cover
art by: Marc Silvestri, Matt "Batt" Banning and Steve Firchow

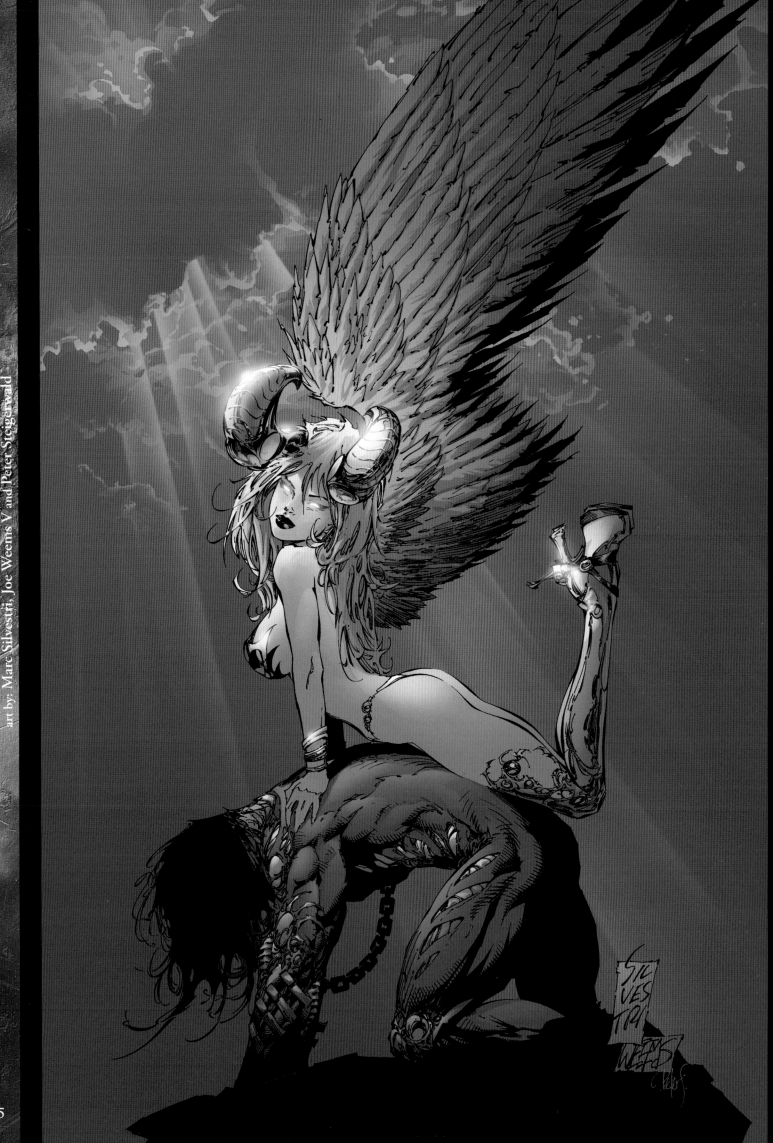

The Darkness volume 1 issue #1/2 reprint cover
art by: Marc Silvestri, Joe Weems V and Peter Steigerwald

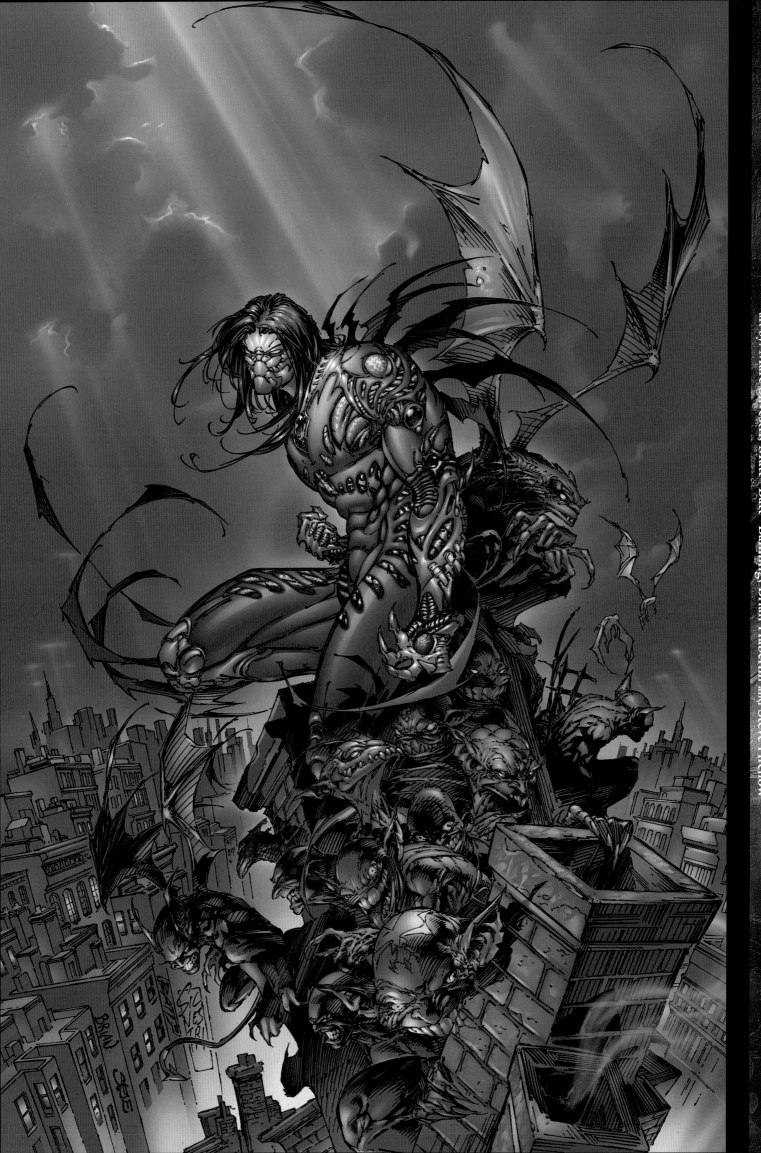

The Darkness volume 1 issue #1 cover]
art by: Marc Silvestri, Matt "Batt" Banning, Brian Haberlin and Steve Firchow

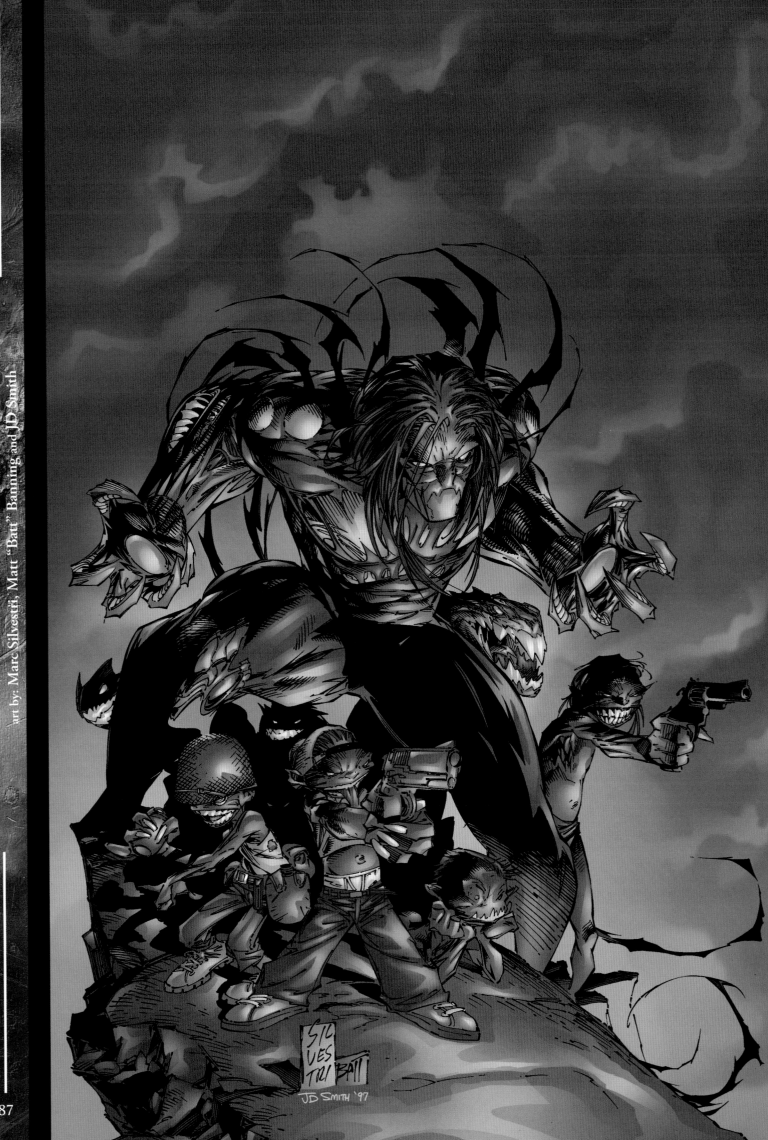

The Darkness volume 1 issue #11 cover #1 of 11

art by: Marc Silvestri, Matt "Batt" Banning and JD Smith

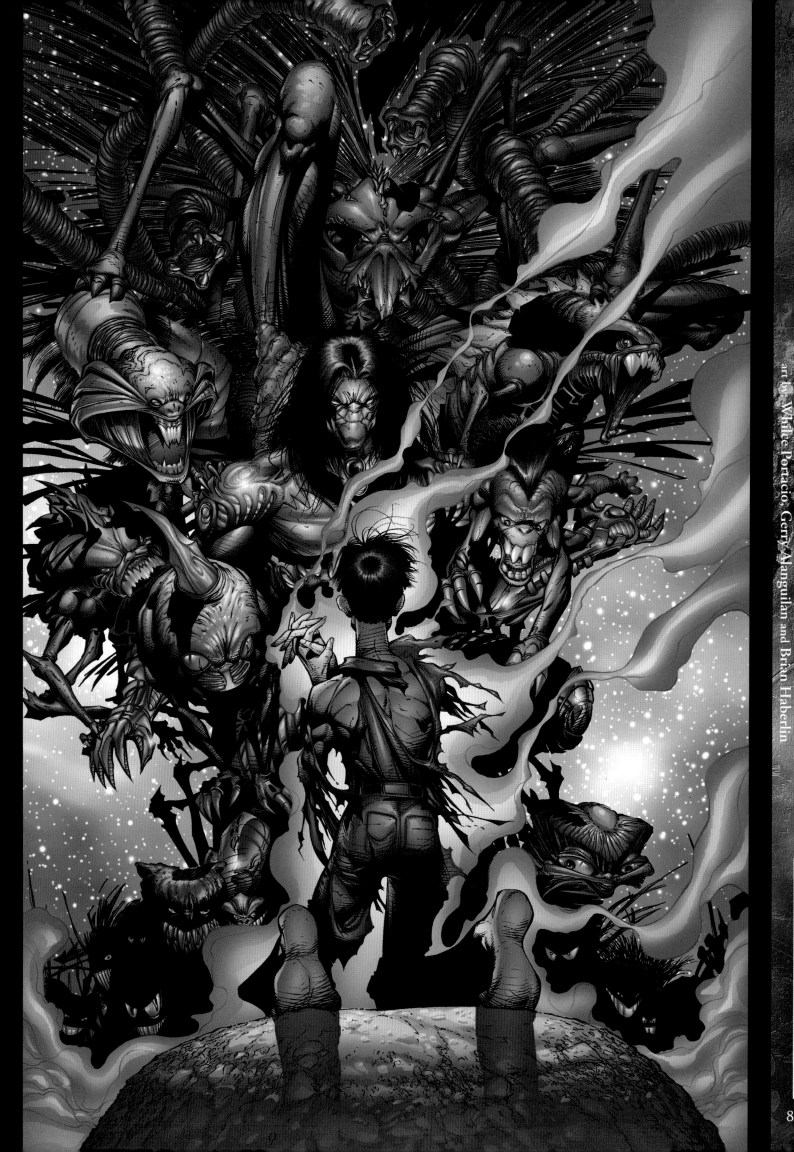

The Darkness volume 3 issue #11 cover #6 of 11
art by: Whilce Portacio, Gerry Alanguilan and Brian Haberlin

The Darkness volume 1 issue 11 cover #10 of 11

art by: Michael Turner, Joe Weems V and JD Smith

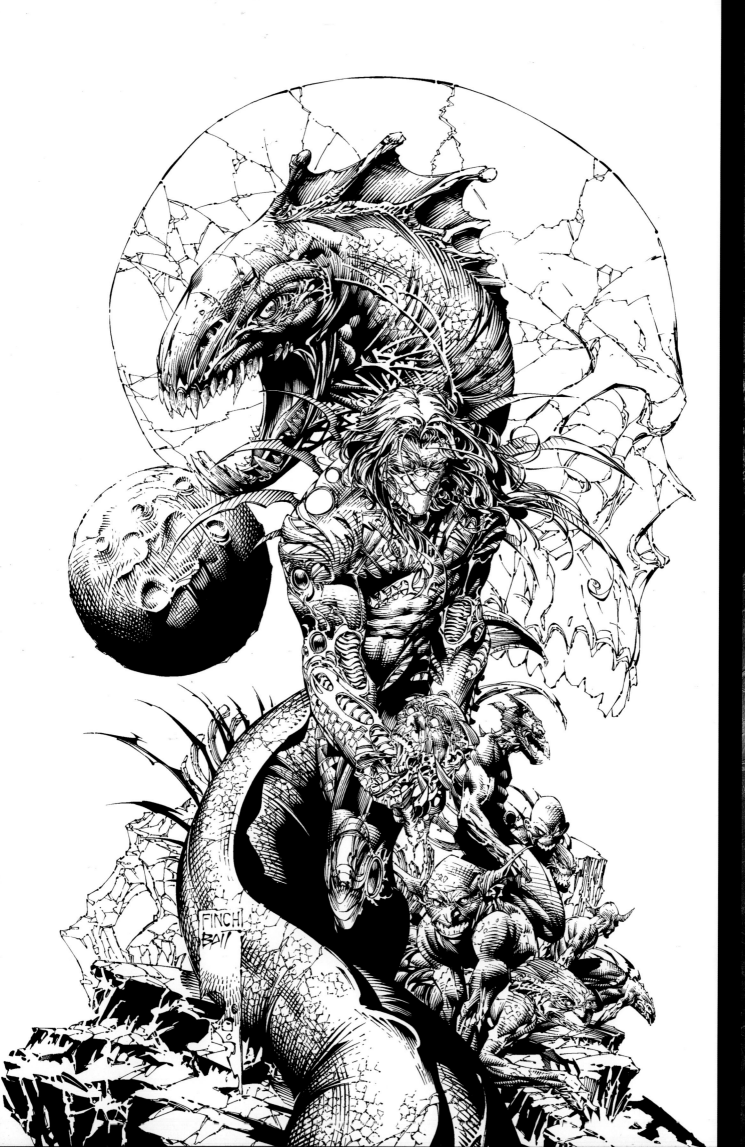

The Darkness volume 1 issue #11 cover #11 of 11 inks
art by: David Finch and Matt "Batt" Banning

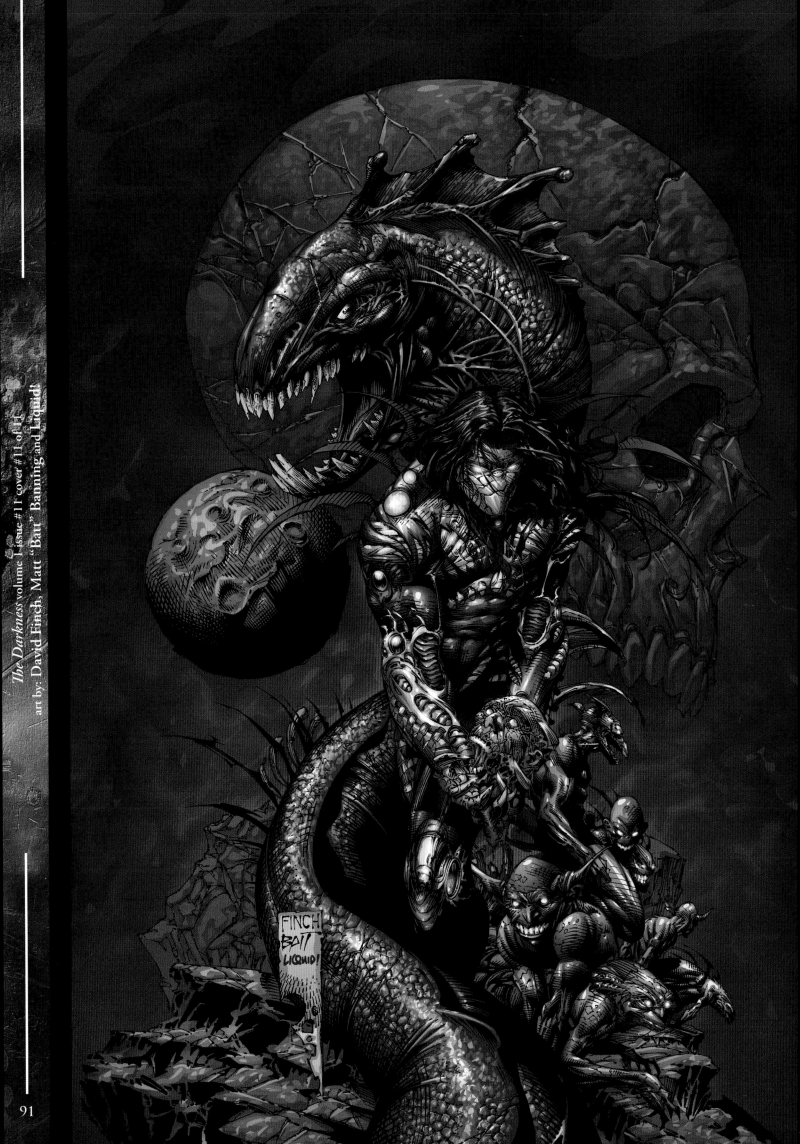

The Darkness volume 1 issue #11 cover #11 of 11
art by: David Finch, Matt "Batt" Banning and Liquid!

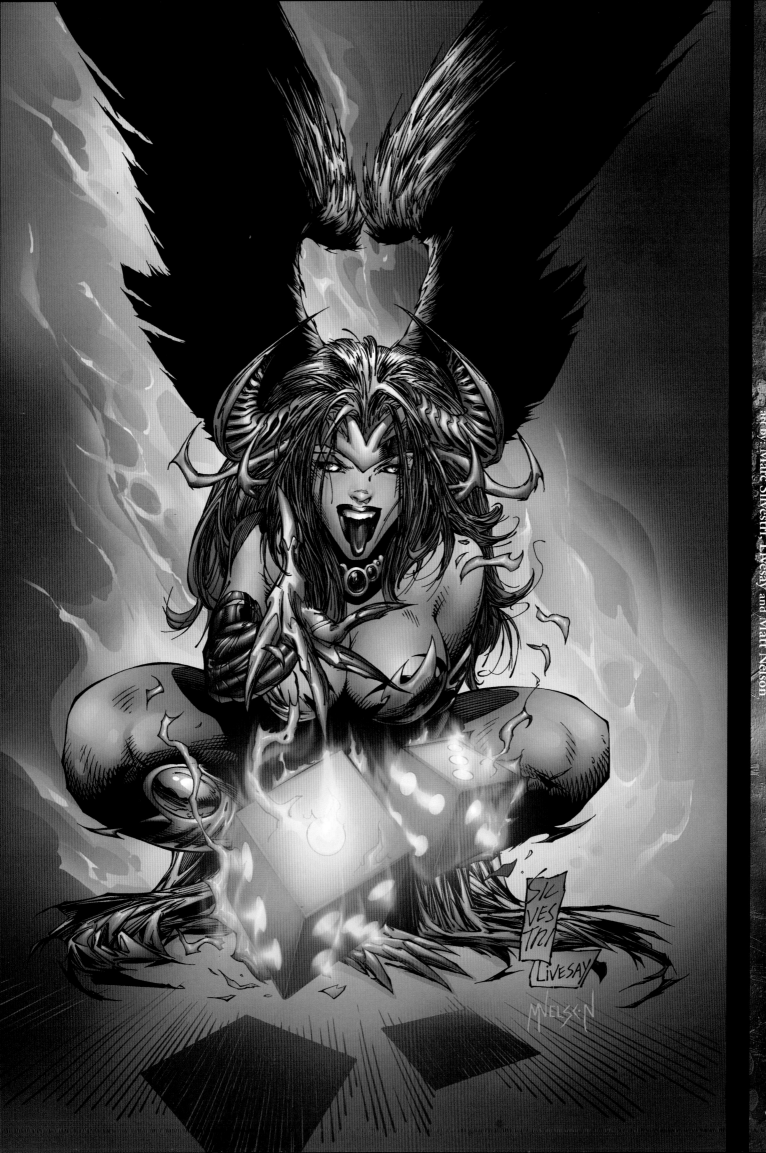

The Darkness volume 1 issue #25 variant cover
art by: Marc Silvestri, Livesay and Matt Nelson

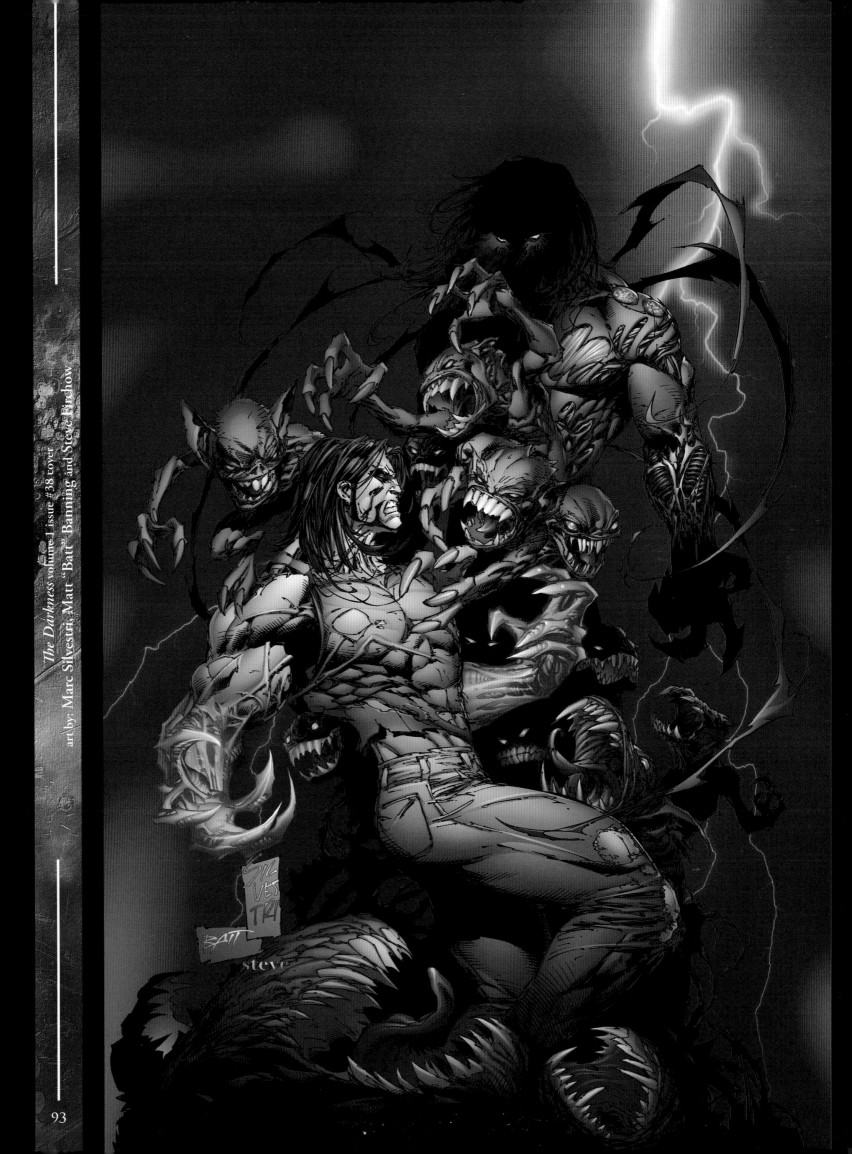

The Darkness volume 1 issue #38 cover
art by: Marc Silvestri, Matt "Batt" Banning and Steve Firchow

the Darkness volume 2 issues #1, 2, 3, 5, 6 and 10 covers
art by: Dale Keown

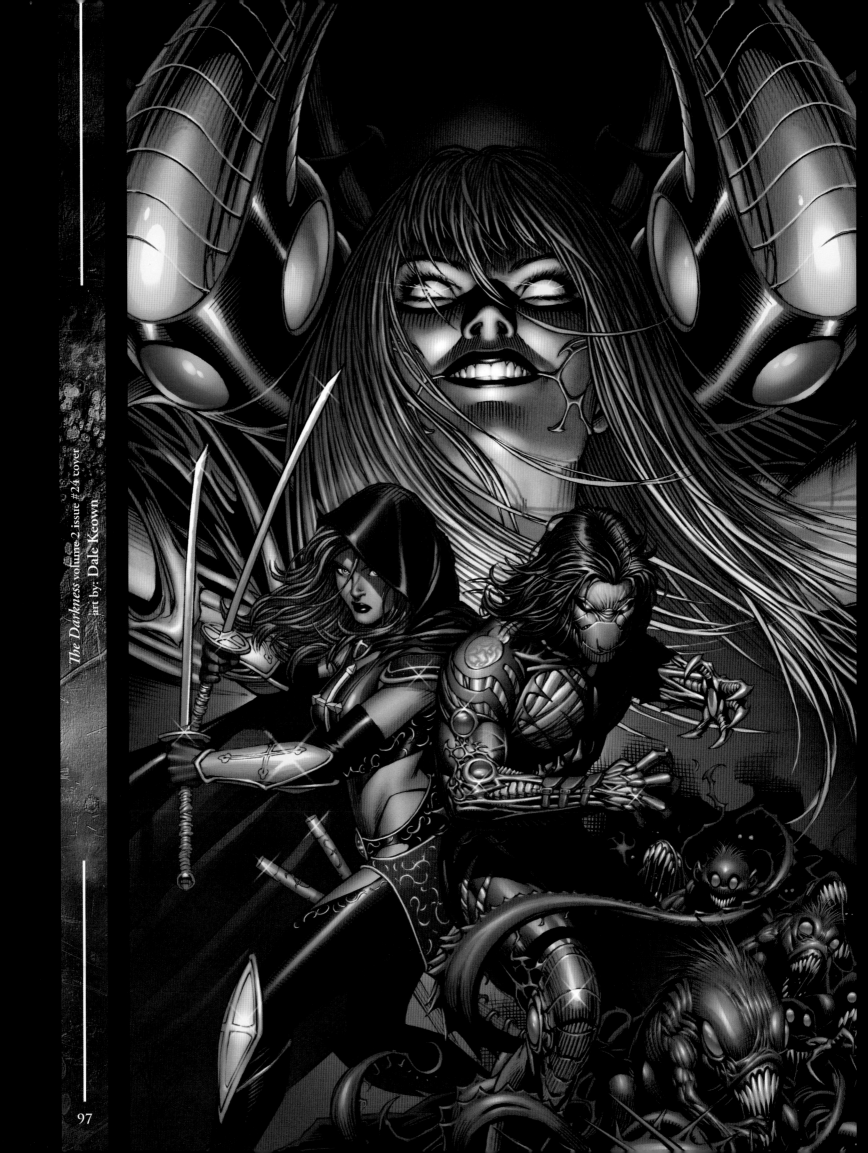

The Darkness volume 2 issue #24 cover
art by: Dale Keown

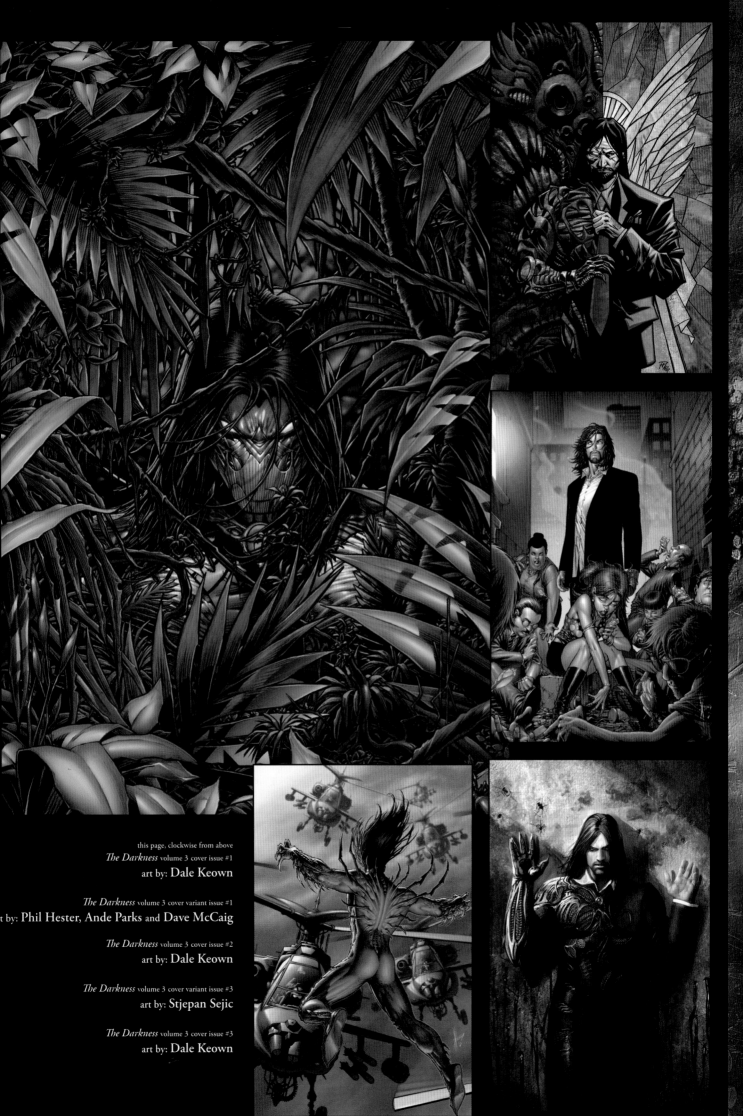

this page, clockwise from above
The Darkness volume 3 cover issue #1
art by: Dale Keown

The Darkness volume 3 cover variant issue #1
art by: Phil Hester, Ande Parks and Dave McCaig

The Darkness volume 3 cover issue #2
art by: Dale Keown

The Darkness volume 3 cover variant issue #3
art by: Stjepan Sejic

The Darkness volume 3 cover issue #3
art by: Dale Keown

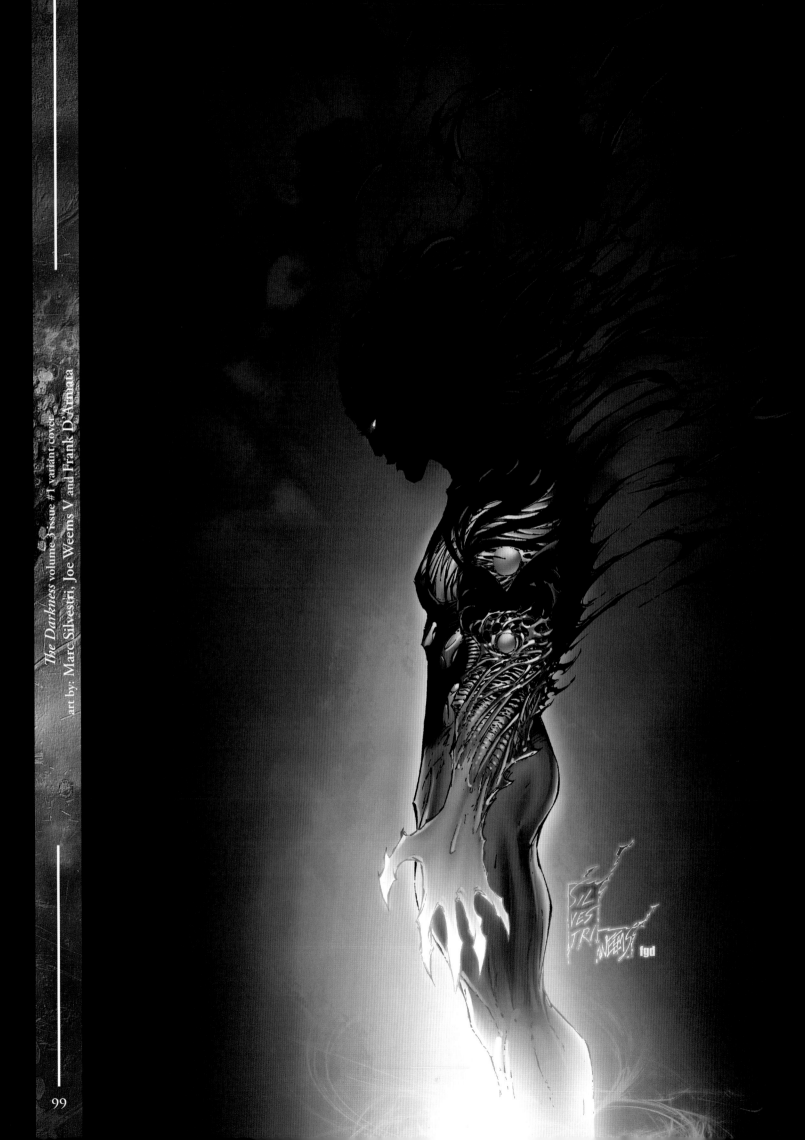

The Darkness volume 3 issue #1 variant cover
art by: Marc Silvestri; Joe Weems V and Frank D'Armata

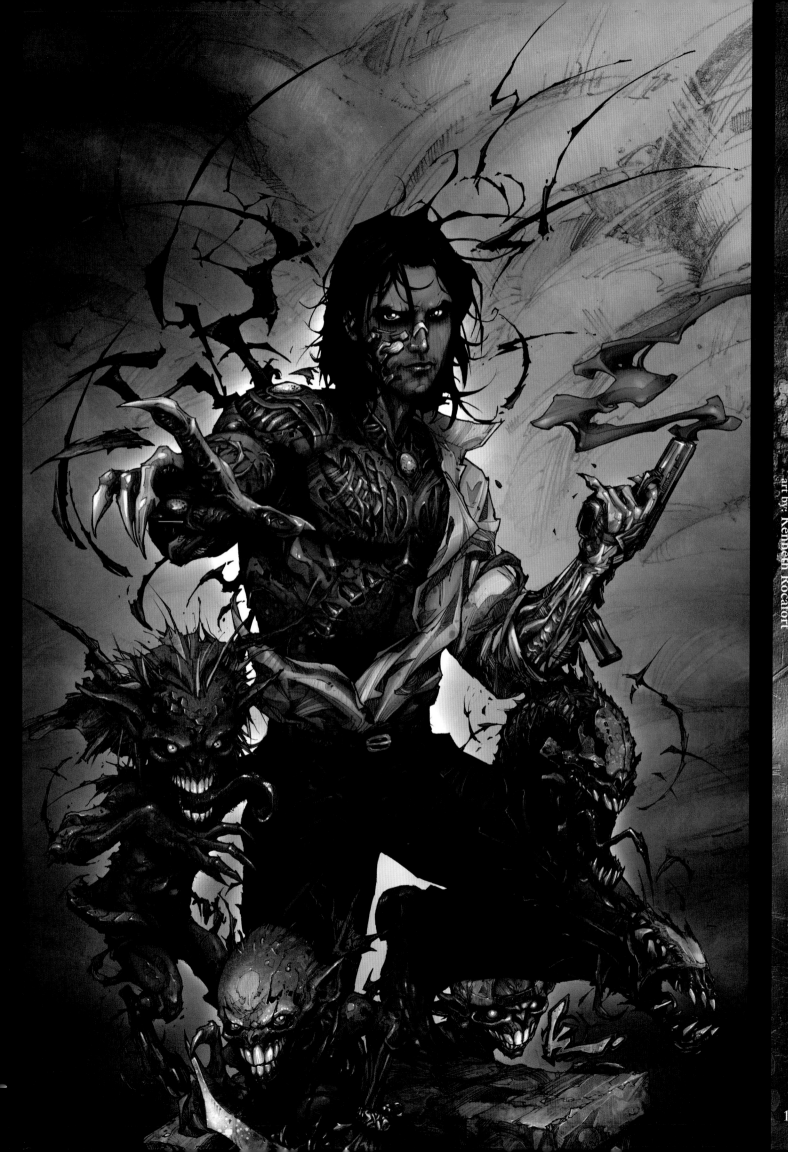

The Darkness volume 3 issue #4 variant cover
art by: Kenneth Rocafort

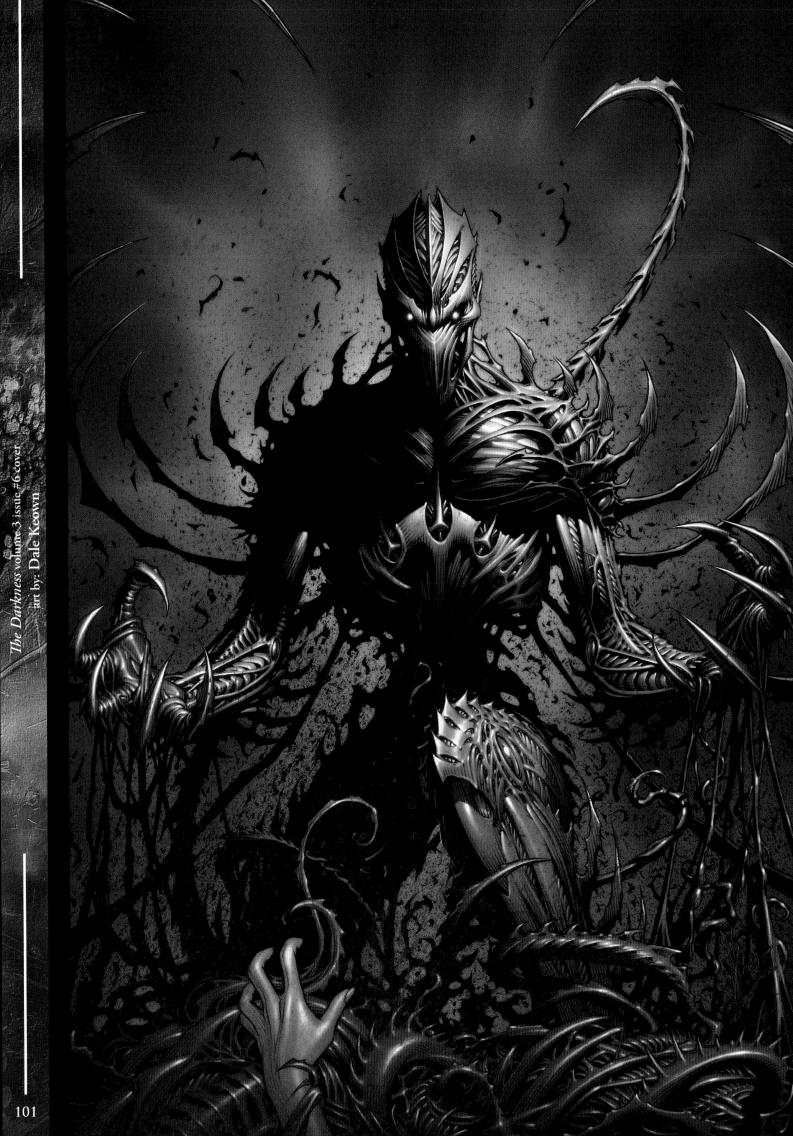

The Darkness volume 3 issue #6 cover

art by: Dale Keown

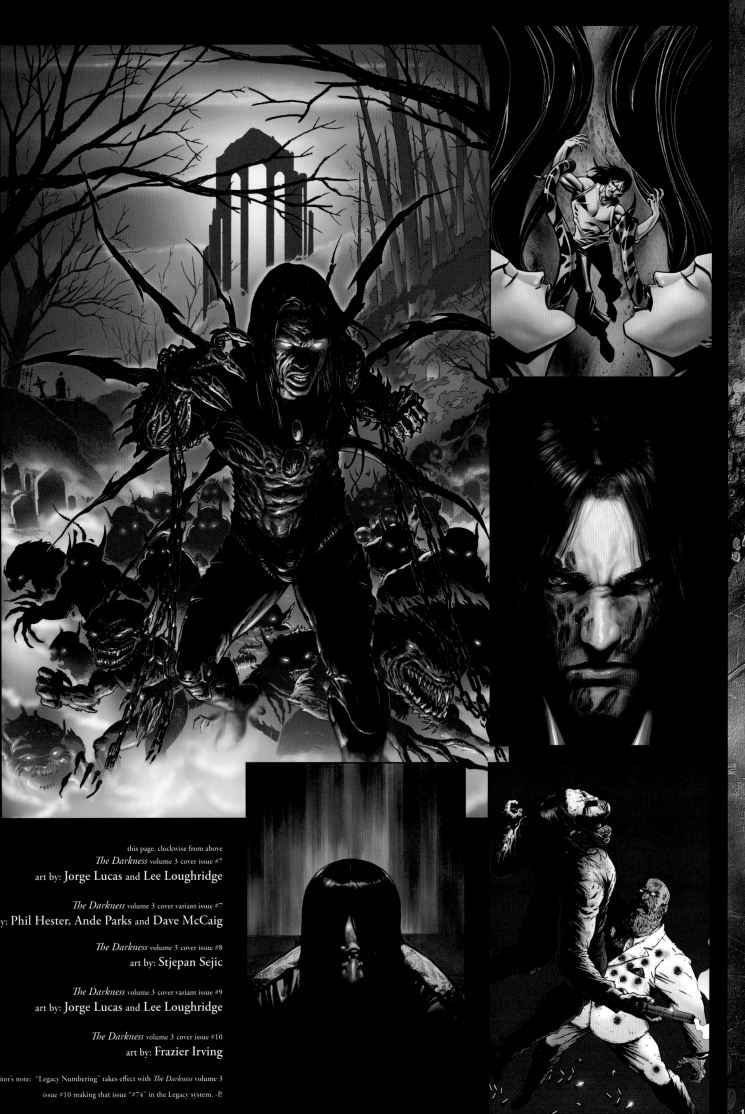

this page, clockwise from above

The Darkness volume 3 cover issue #7
art by: **Jorge Lucas** and **Lee Loughridge**

The Darkness volume 3 cover variant issue #7
y: **Phil Hester**, **Ande Parks** and **Dave McCaig**

The Darkness volume 3 cover issue #8
art by: **Stjepan Sejic**

The Darkness volume 3 cover variant issue #9
art by: **Jorge Lucas** and **Lee Loughridge**

The Darkness volume 3 cover issue #10
art by: **Frazier Irving**

itor's note: "Legacy Numbering" takes effect with *The Darkness* volume 3
issue #10 making that issue "#74" in the Legacy system. -P.

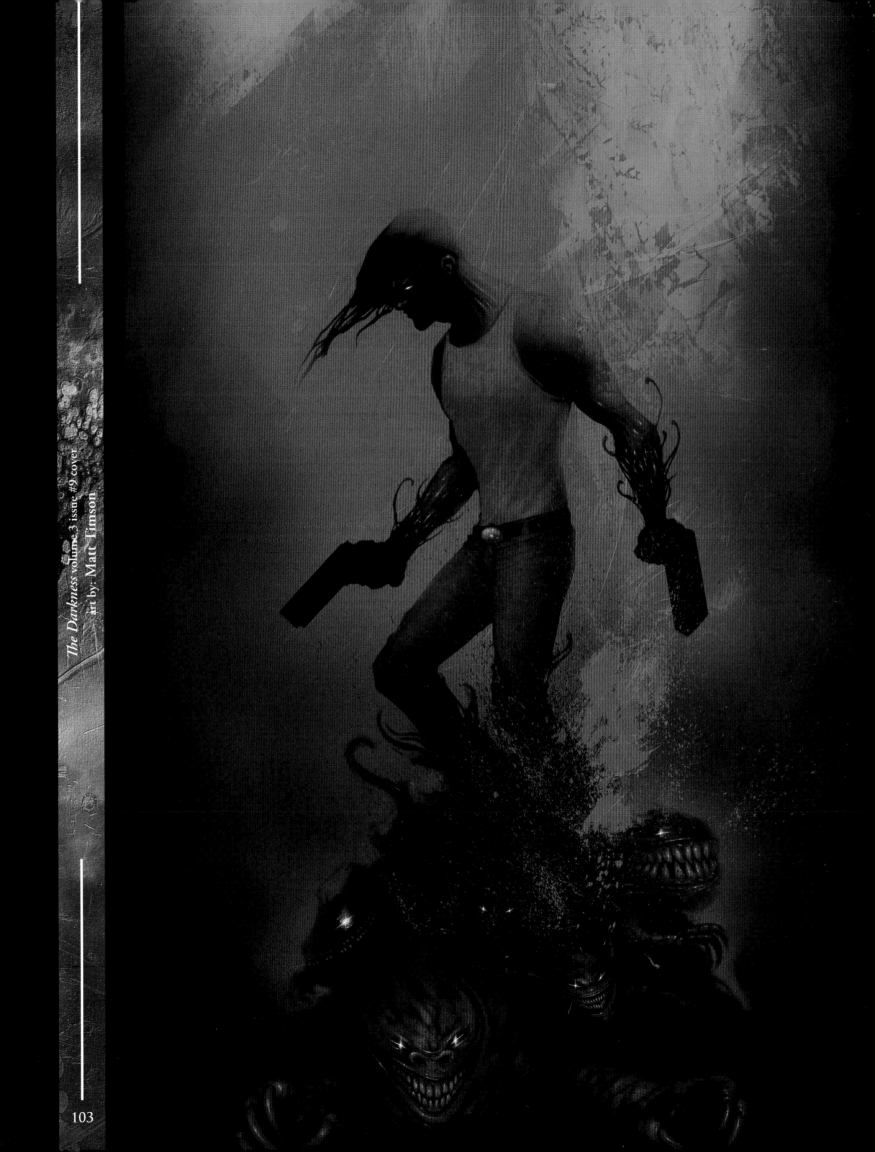

The Darkness volume 3 issue #9 cover
art by: Matt Timson

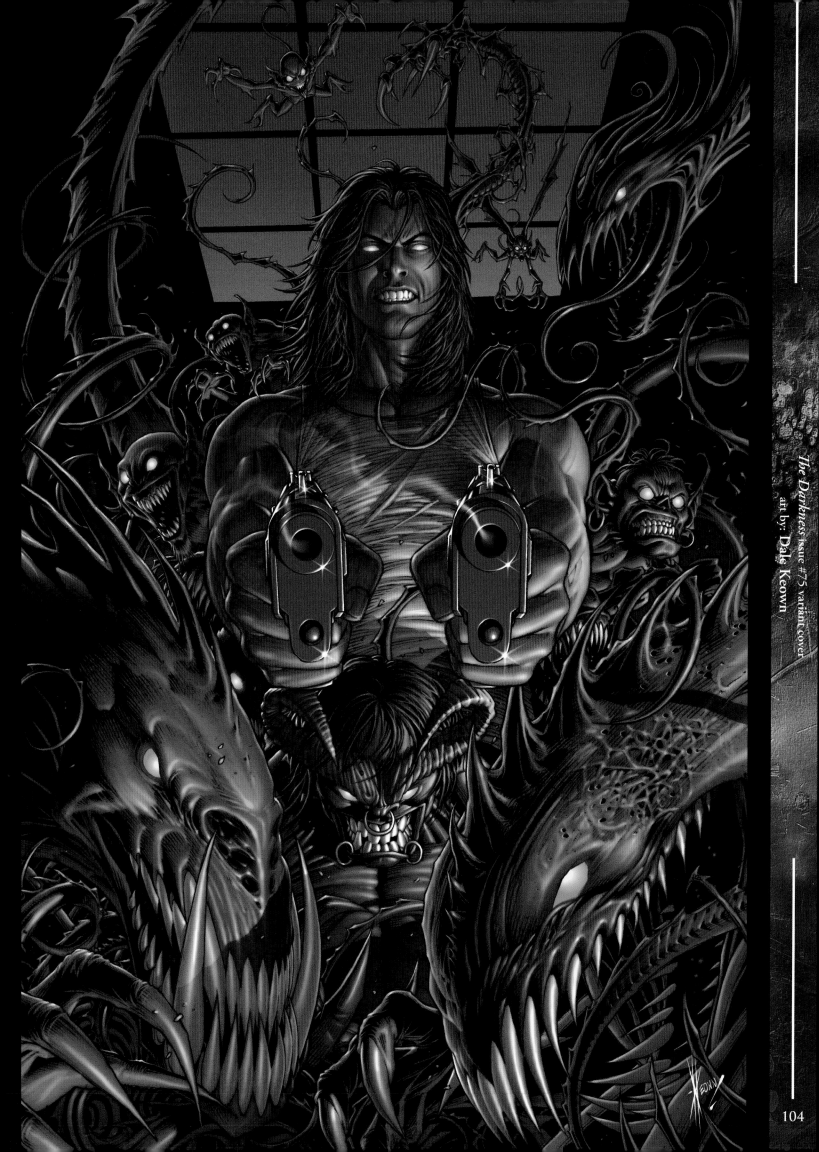

The Darkness issue #75 variant cover
art by: Dale Keown

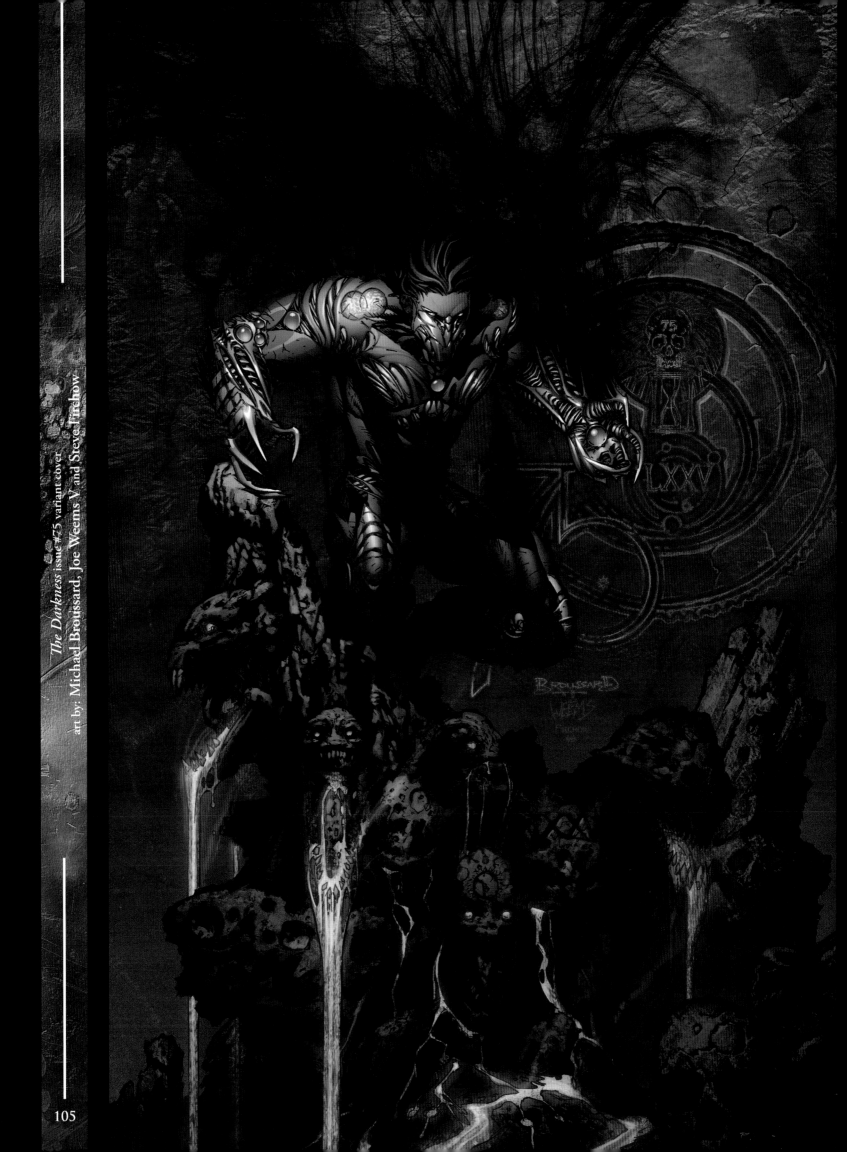

The Darkness issue #75 variant cover

art by: Michael Broussard, Joe Weems V and Steve Firchow

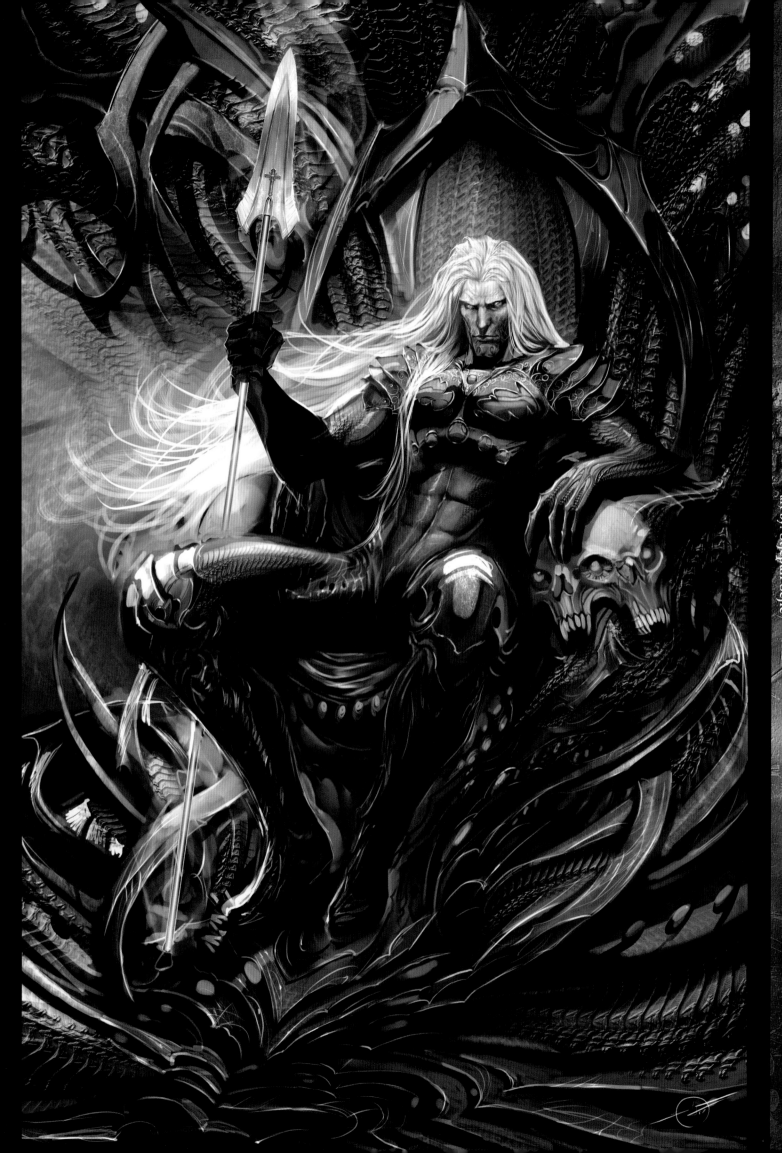

The Darkness issue #75 variant cover
art by: Stjepan Sejic

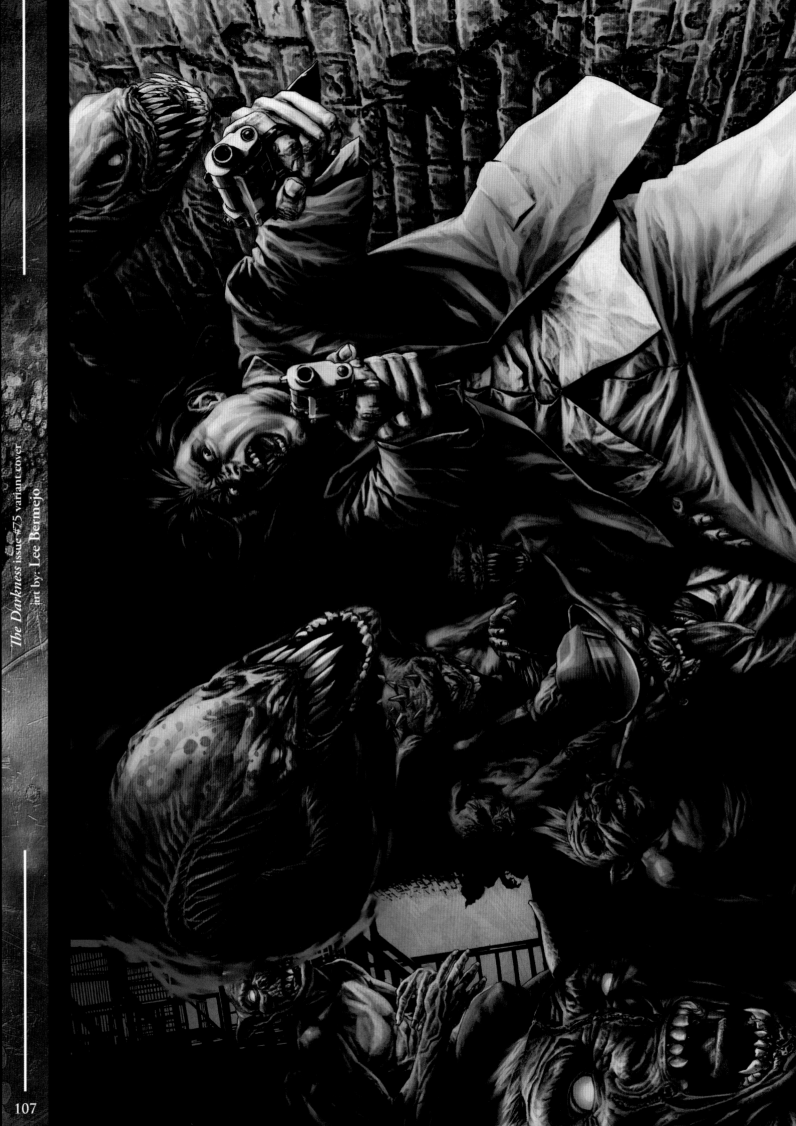

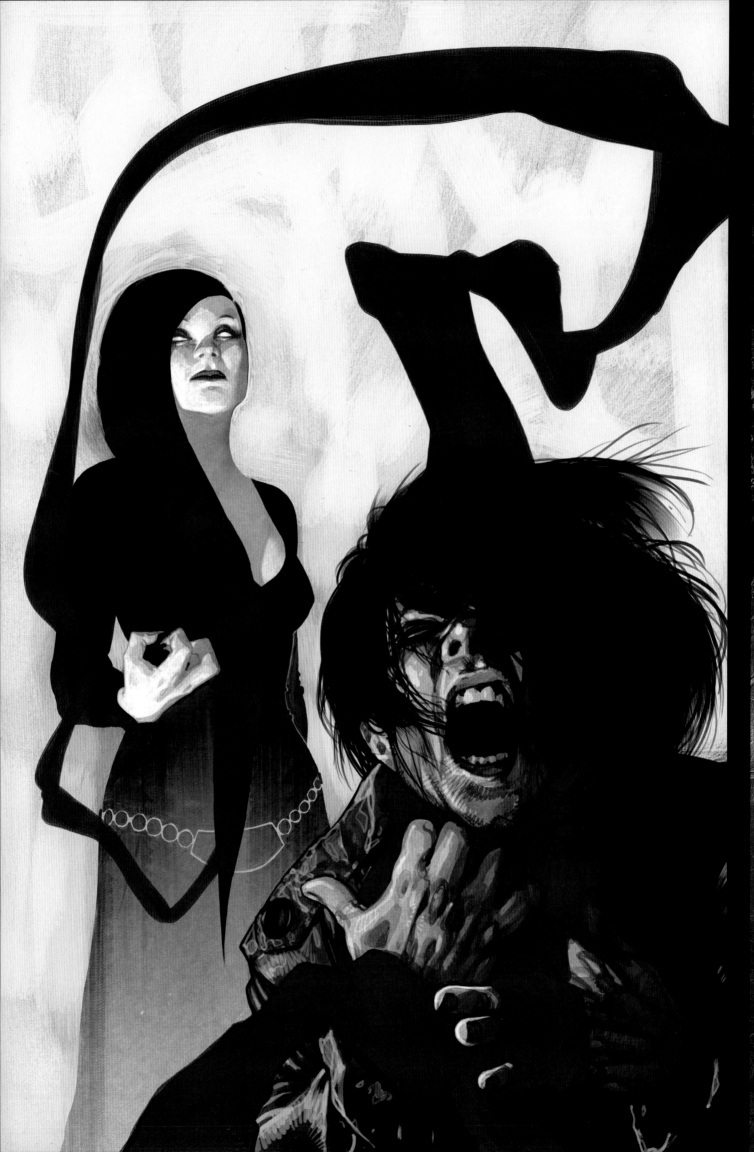

The Darkness issue #76 cover
art by: Frazier Irving

The Darkness issue #76 variant cover
art by: Josh Medors and JD Smith

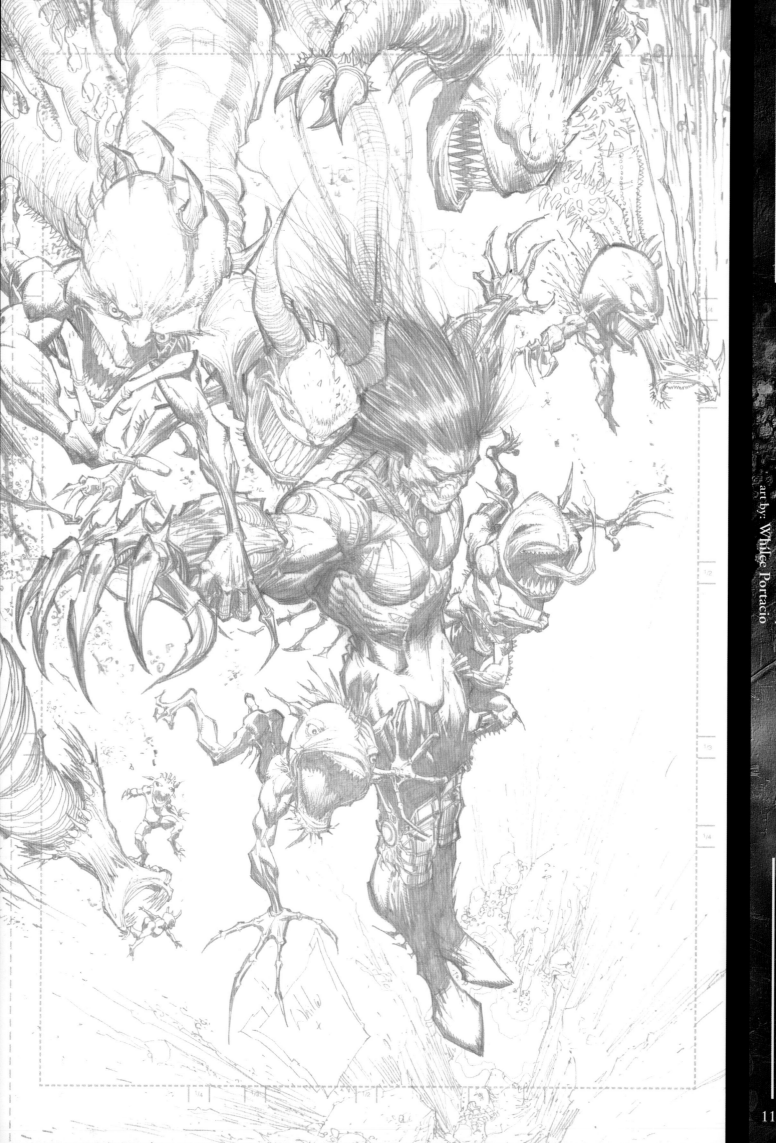

The Darkness issue #79 cover pencils
art by: Whilce Portacio

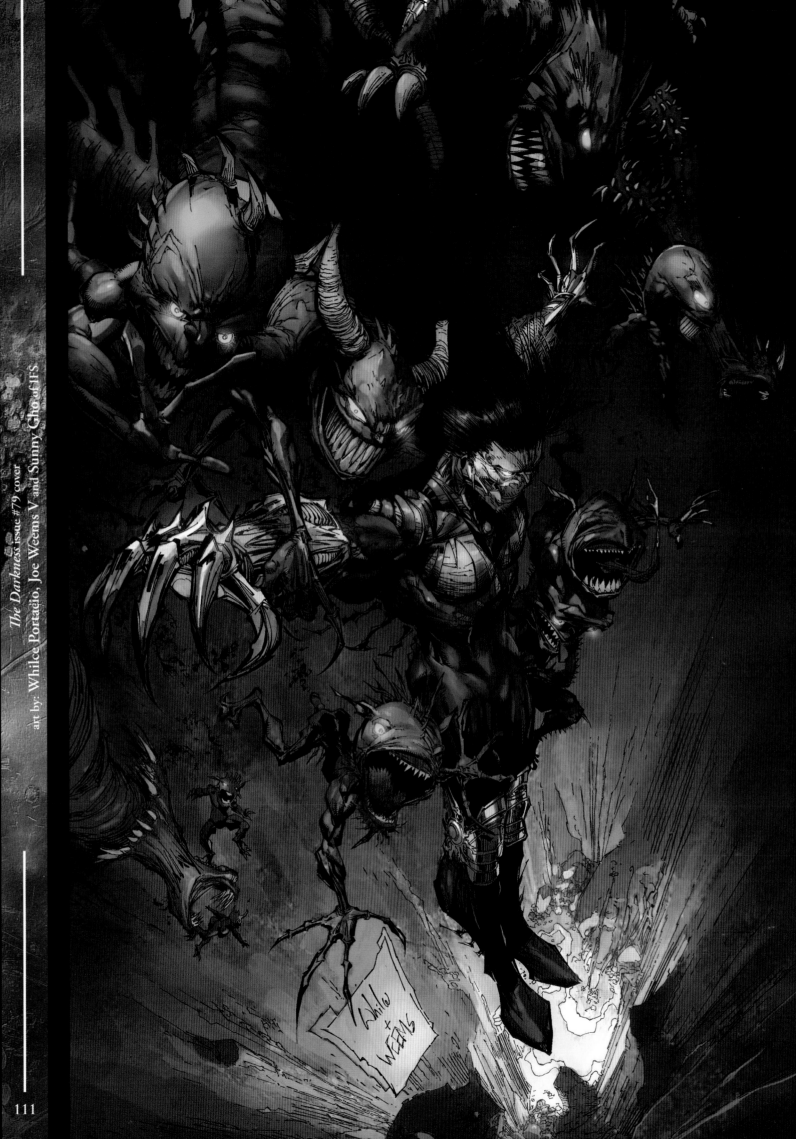

The Darkness issue #79 cover
art by: Whilce Portacio, Joe Weems V and Sunny Gho of IFS

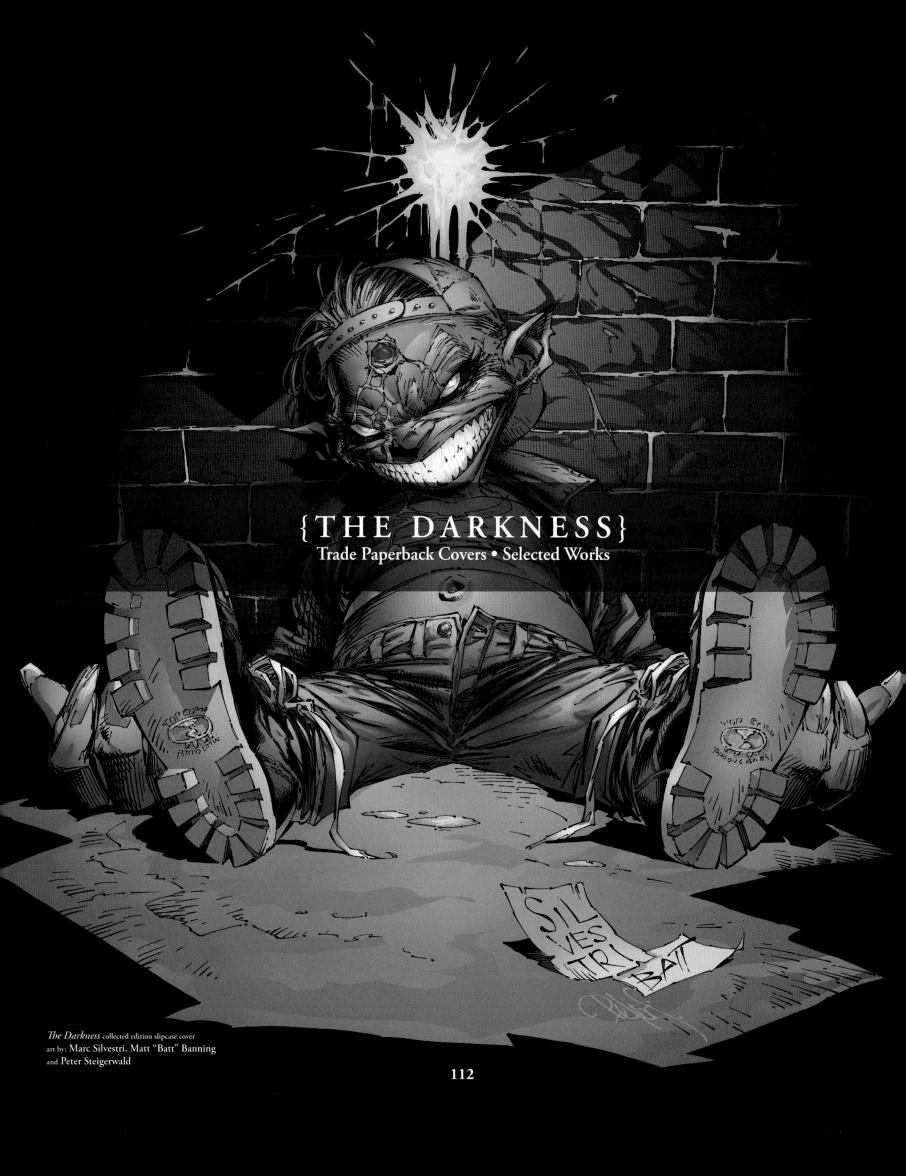

{THE DARKNESS}
Trade Paperback Covers • Selected Works

The Darkness collected edition slipcase cover
art by: Marc Silvestri, Matt "Batt" Banning
and Peter Steigerwald

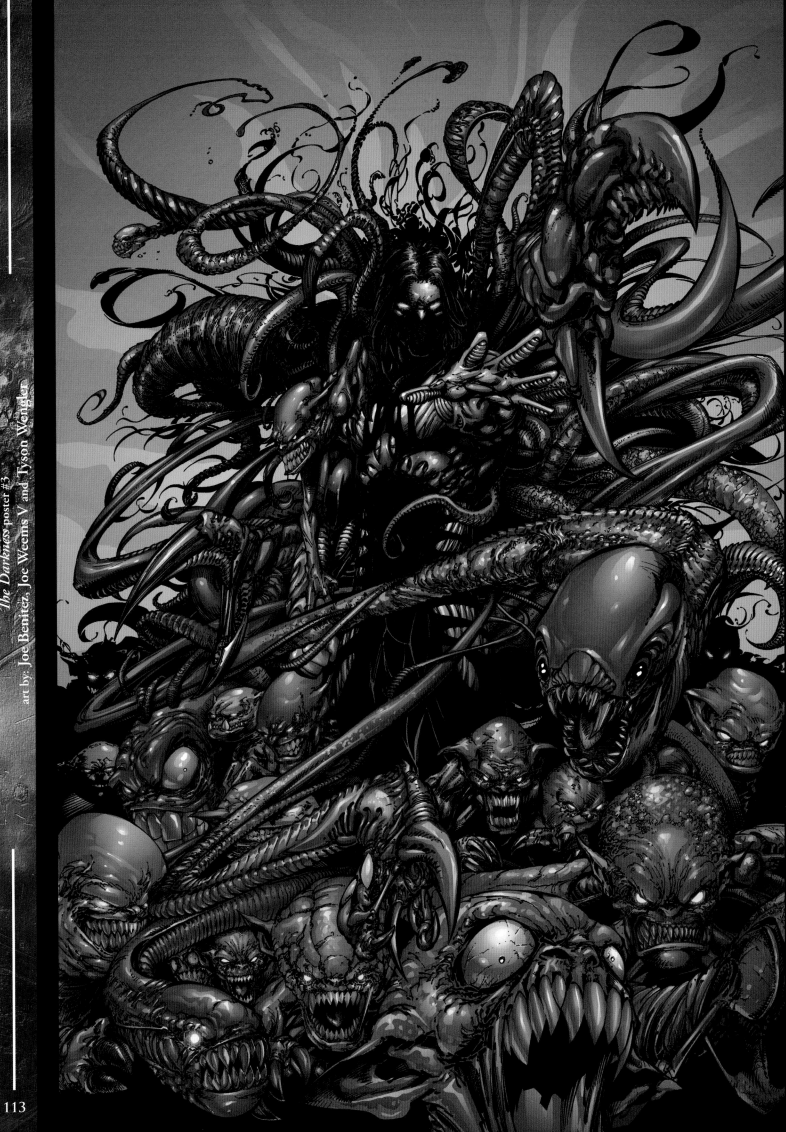

The Darkness poster #3

art by: Joe Benitez, Joe Weems V and Tyson Wengler

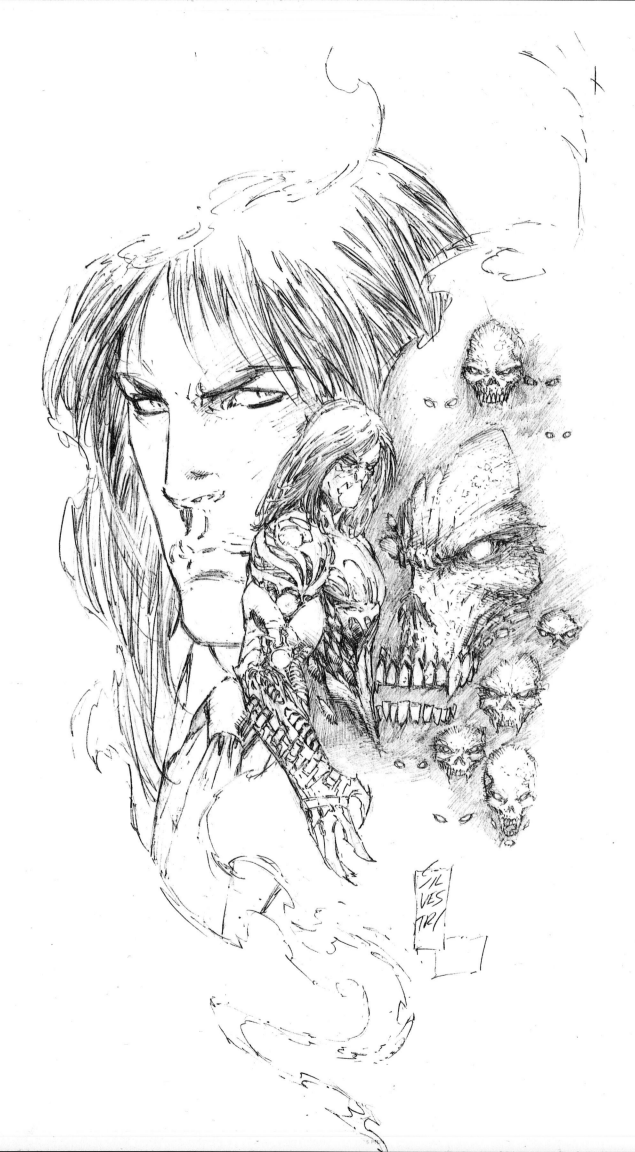

The Darkness: Coming of Age trade paperback cover
art by: Marc Silvestri, Matt "Batt" Banning and Steve Firehow

The Darkness: Heart of Darkness trade paperback cover
art by: Marc Silvestri, Matt "Batt" Banning and Steve Firchow

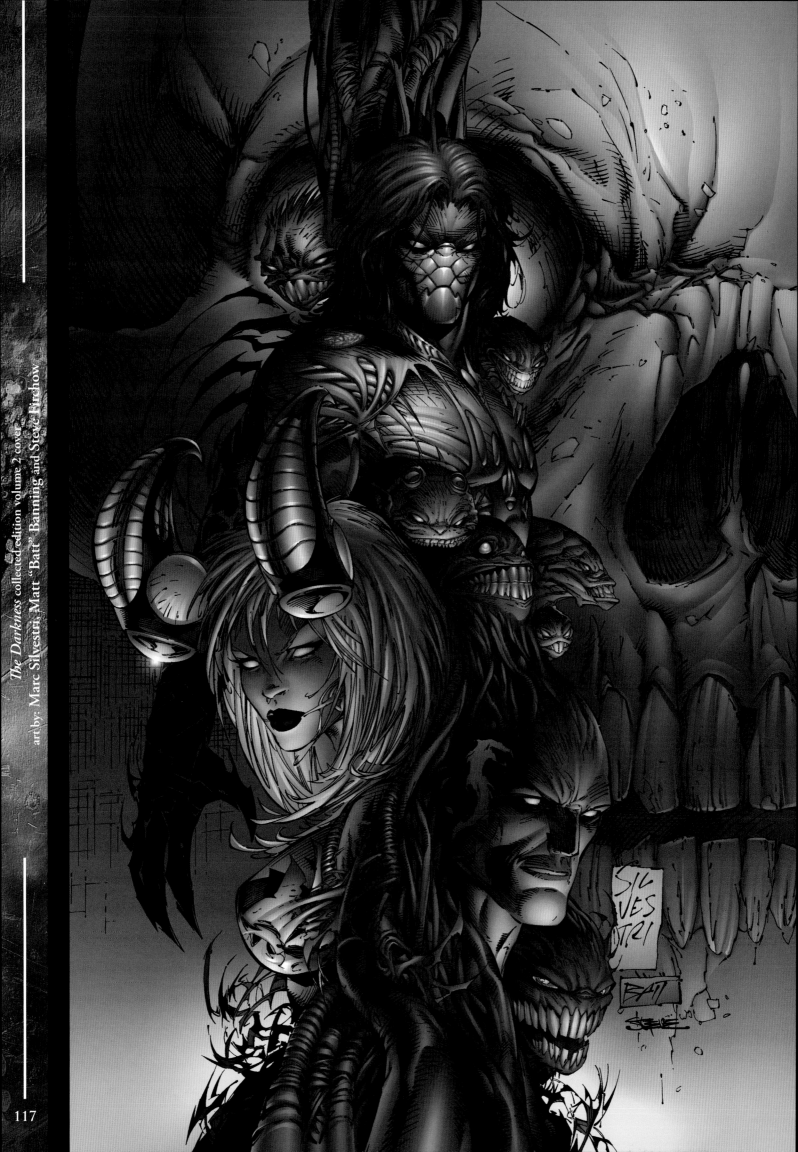

The Darkness collected edition volume 2 cover
art by: Marc Silvestri, Matt "Batt" Banning and Steve Firchow

The Darkness: Accursed volume 2 trade paperback cover pencils
art by: Michael Broussard

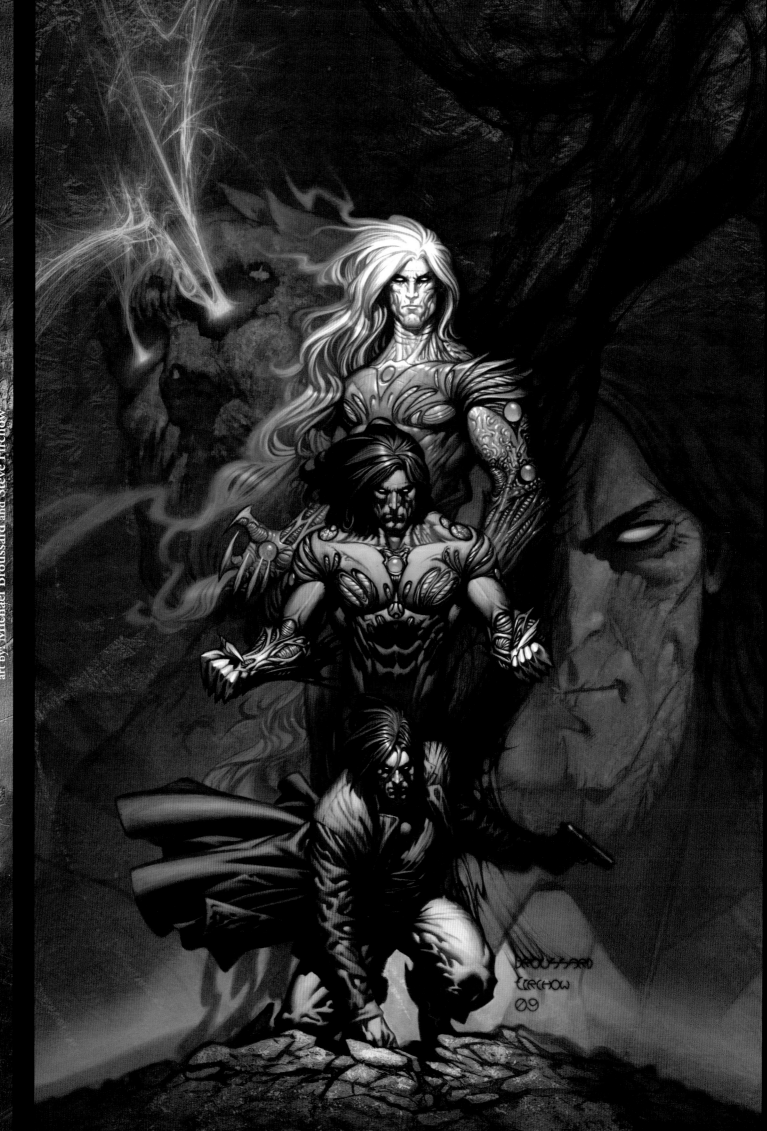

The Darkness: Accursed volume 2 trade paperback cover
art by: Michael Broussard and Steve Firchow

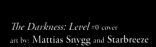

{THE DARKNESS: LEVELS}
Limited Series Covers • Selected Works

The Darkness: Level #0 cover
art by: Mattias Snygg and Starbreeze

122

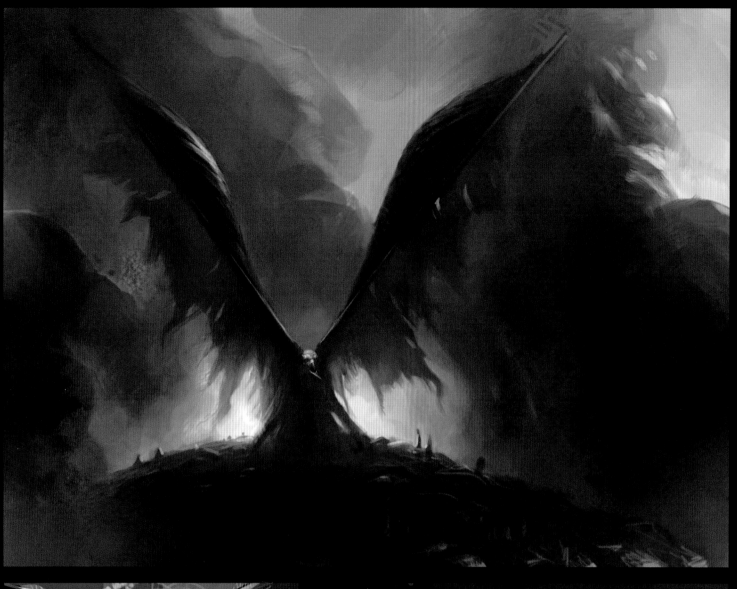

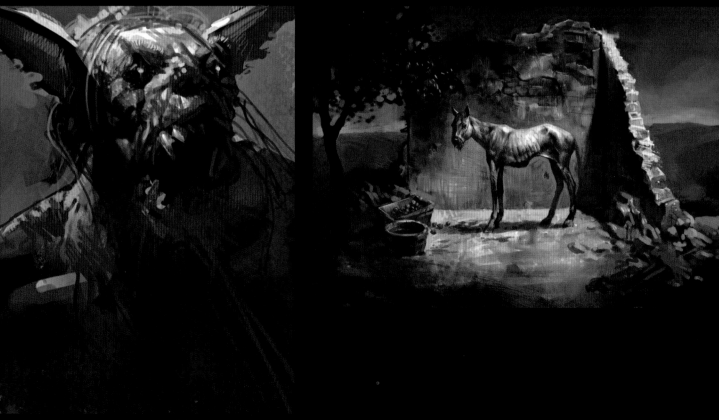

{THE DARKNESS GALLERY}
Selected Works

"The Darkness"
art by: Stjepan Sejic

132

The Darkness issue #80 cover B
art by: Michal Ivan

Tales of the The Darkness issue #1/2 reprint cover
art by: Marc Silvestri, Joe Weems V and Peter Steigerwald

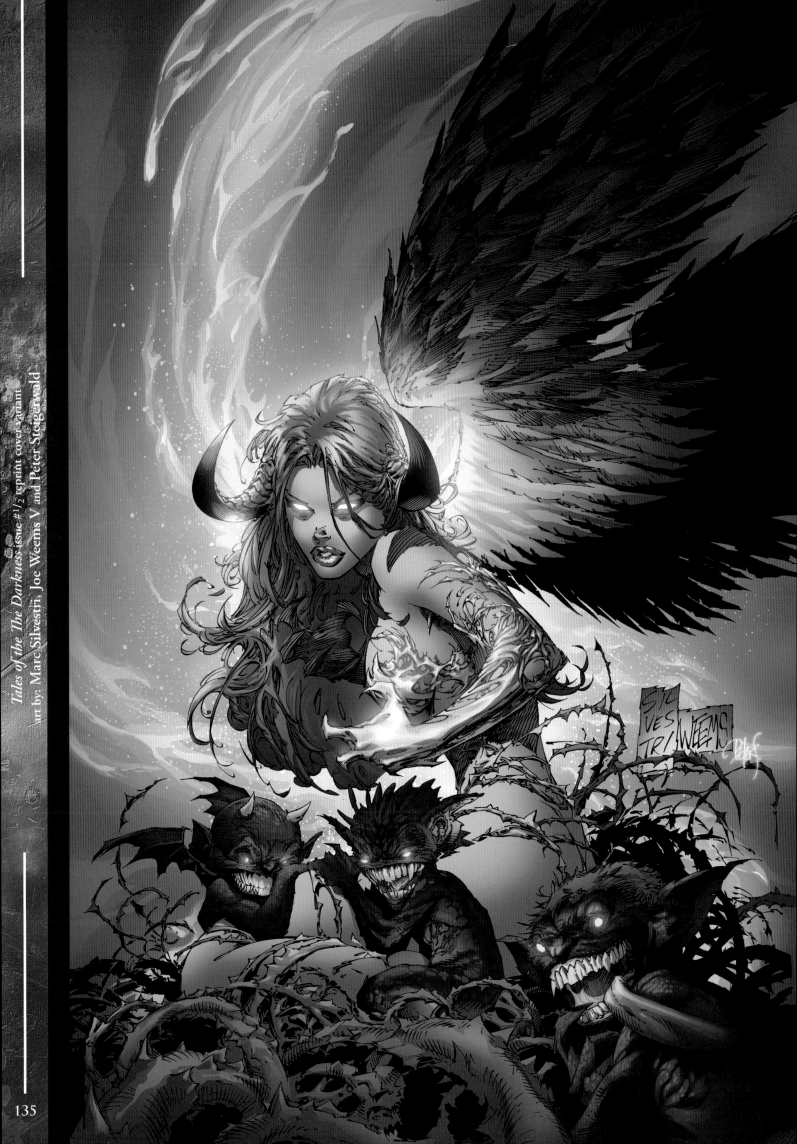

Tales of the The Darkness issue #1/2 reprint cover variant
art by: Marc Silvestri, Joe Weems V and Peter Steigerwald

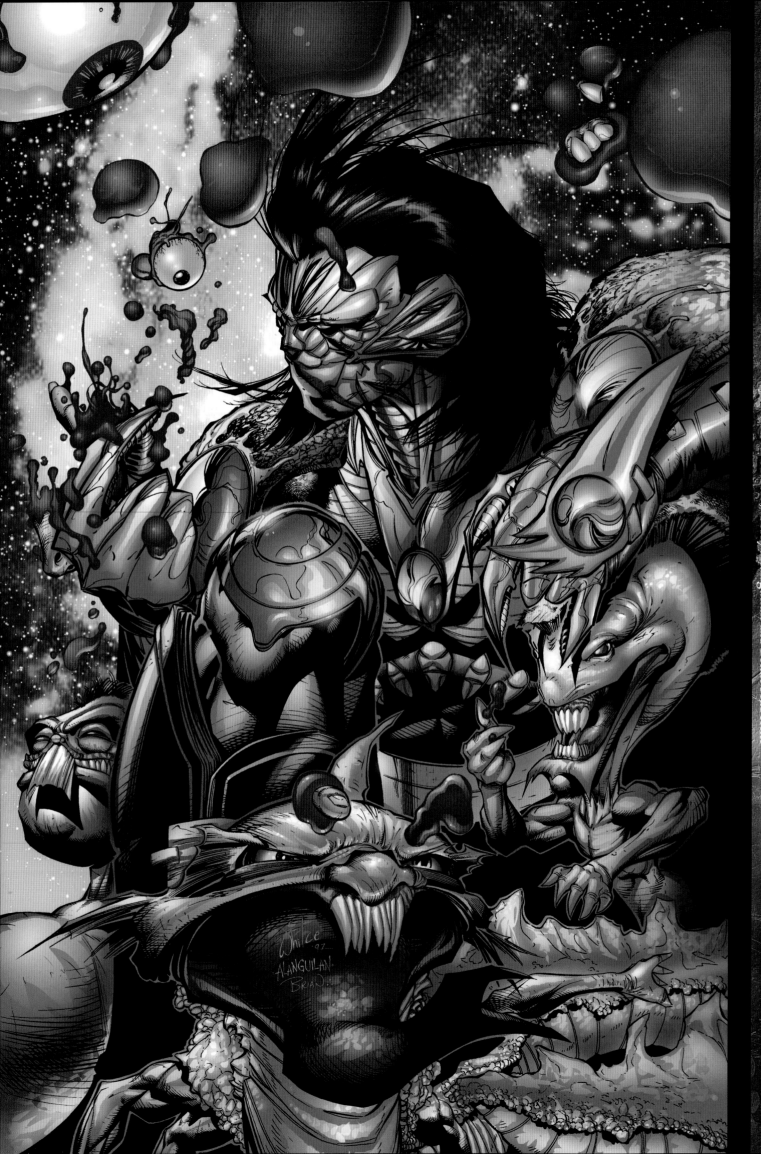

Tales of the Darkness issue #1 cover
art by: Whilce Portacio, Gerry Alanguilan and Brian Haberlin

The Darkness: Lodbrok's Hand Issue #1 Cover B
art by: Michael Avon Oeming and Val Staples

The Darkness: Lodbroks Hand issue #1 cover A
art by: Massimo Carnevale

The Darkness: Black Sails issue #1 cover B
art by: Keu Cha

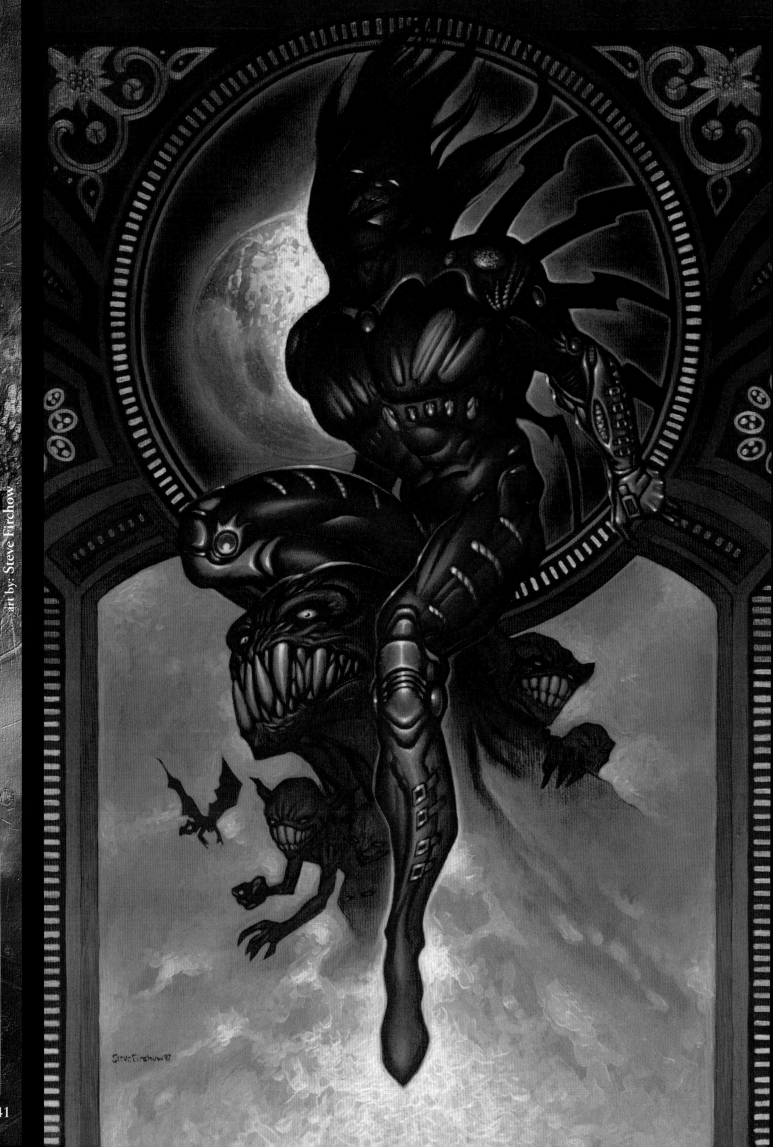

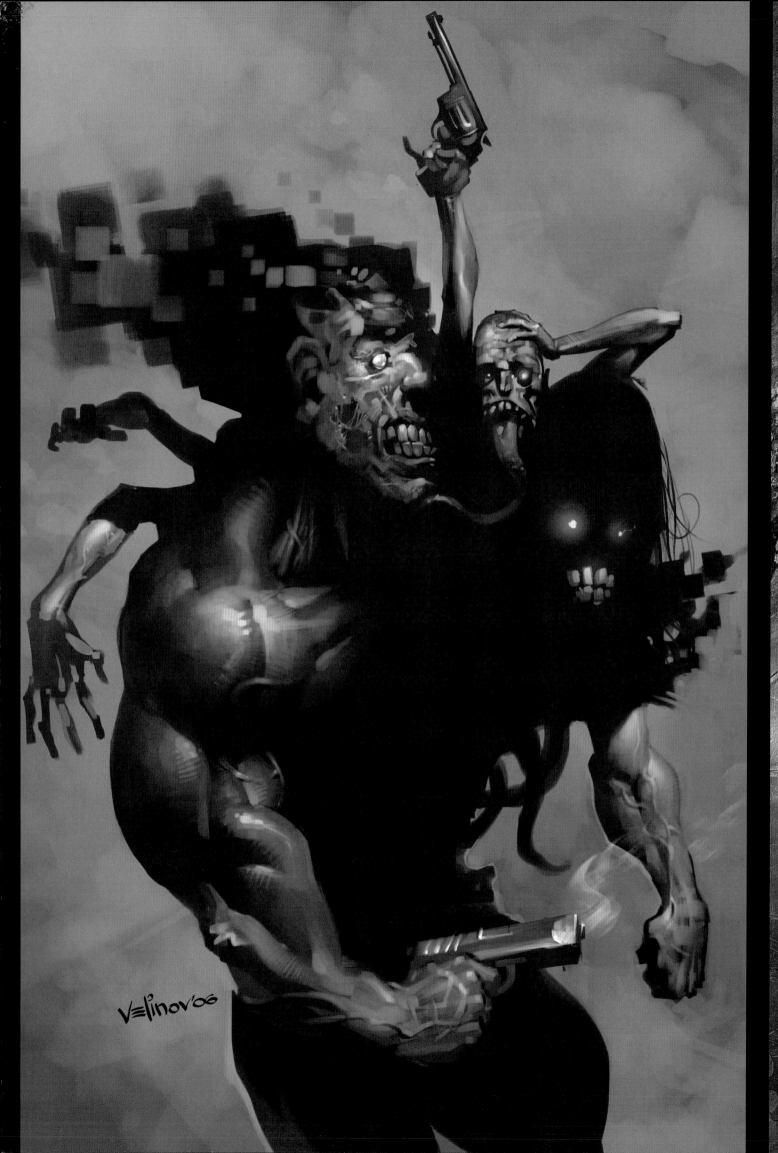

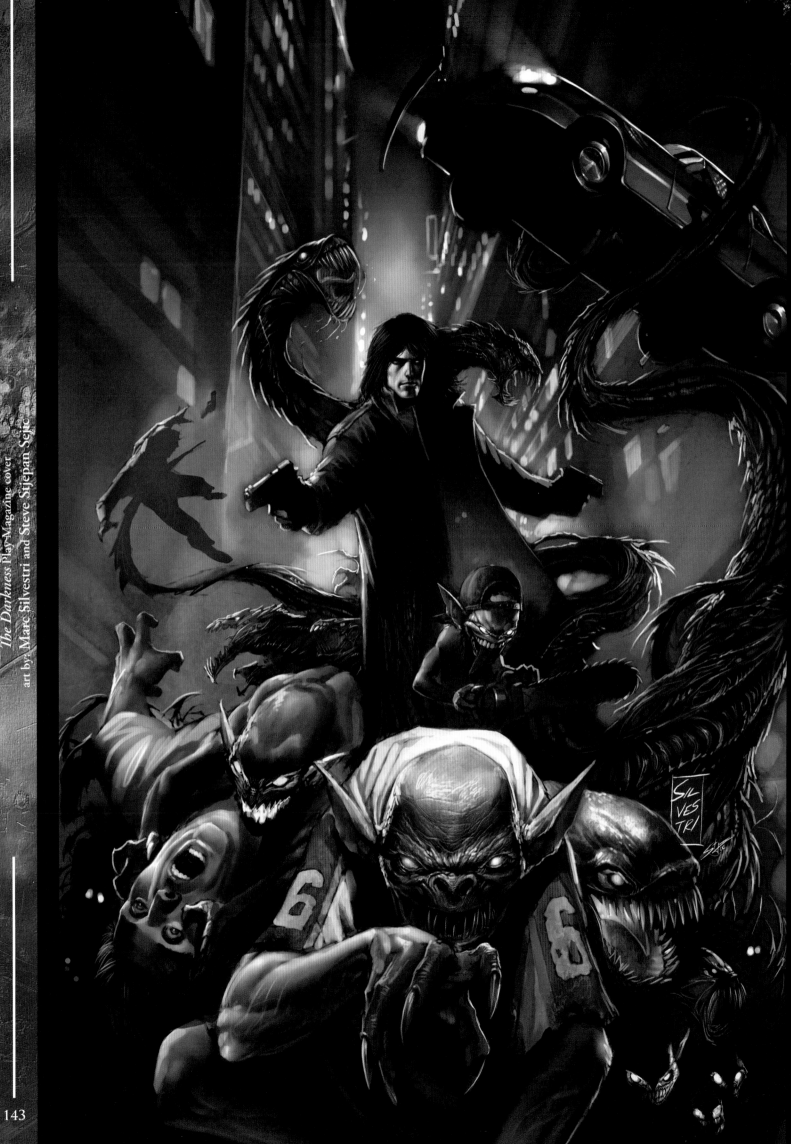

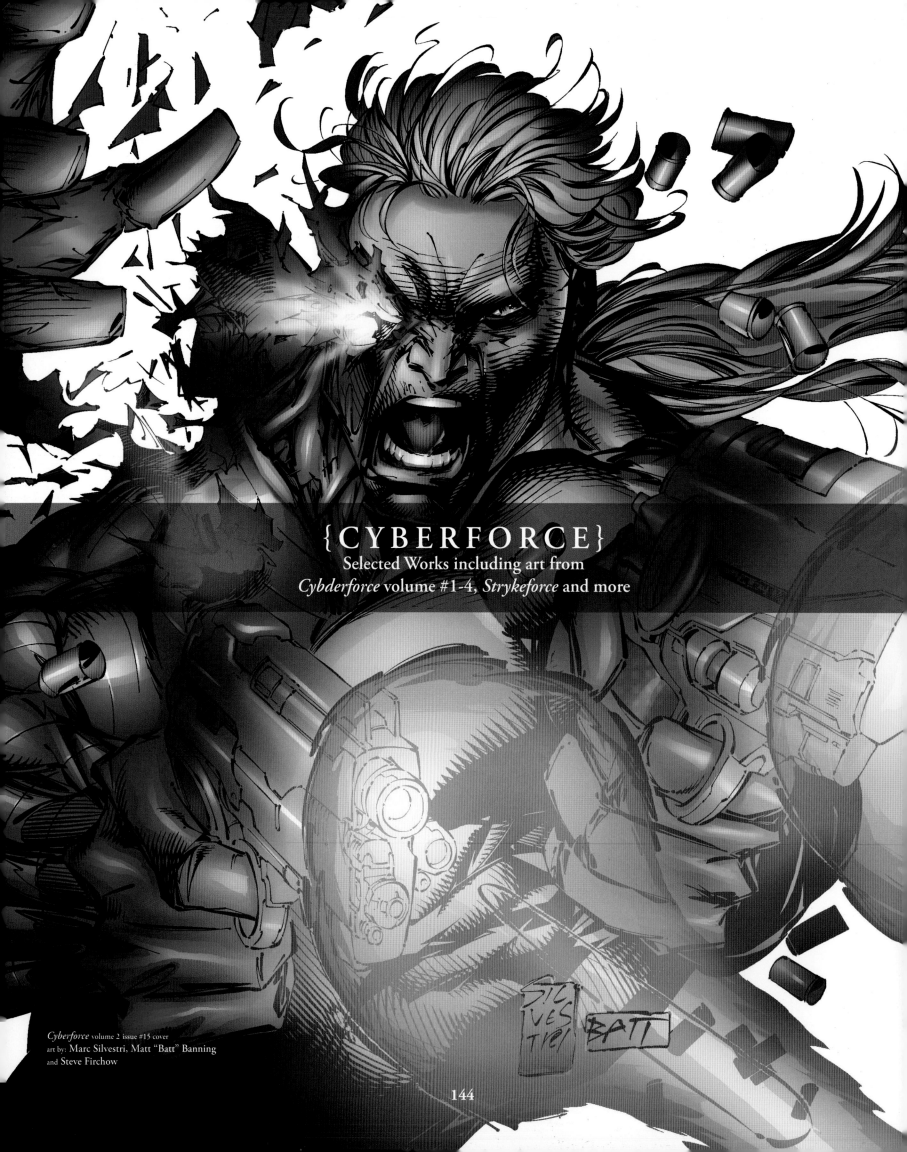

{CYBERFORCE}
Selected Works including art from
Cybderforce volume #1-4, *Strykeforce* and more

Cyberforce volume 2 issue #15 cover
art by: Marc Silvestri, Matt "Batt" Banning
and Steve Firchow

144

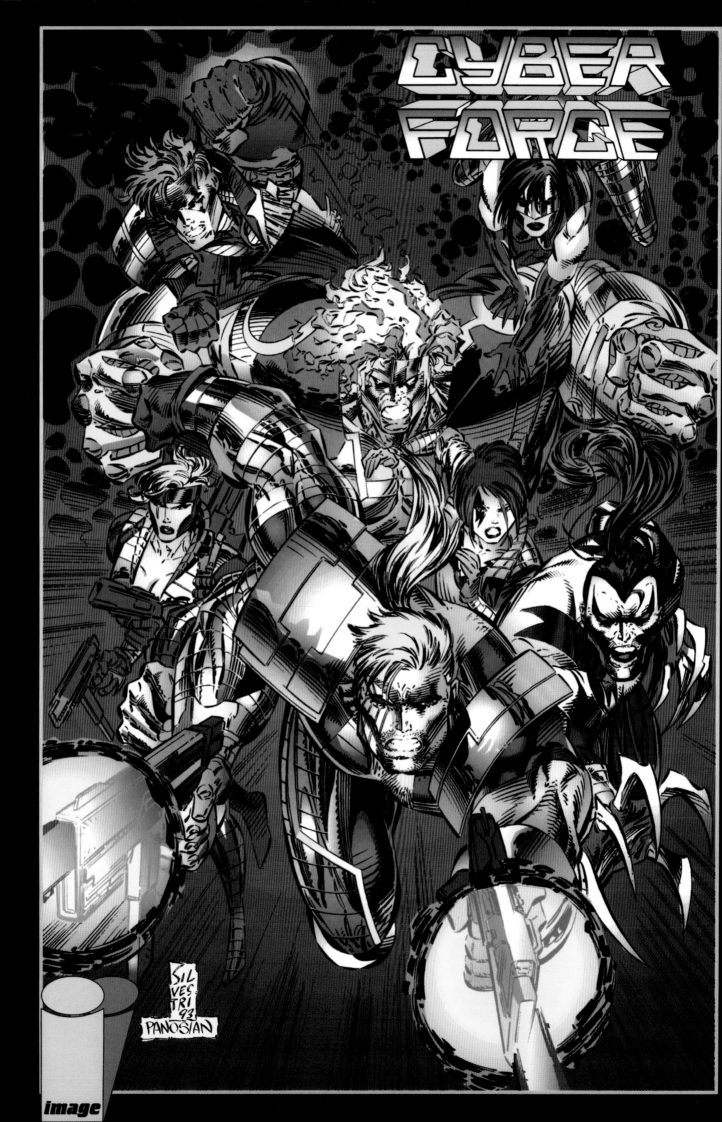

CYBER FORCE

Cyberforce volume-1 Poster 1992
art by: Marc Silvestri and Dan Panosian

SILVESTRI 93 PANOSIAN

image

STRYKER ™ © MARC SILVESTRI 1992

HEATWAVE ™ © MARC SILVESTRI 1992

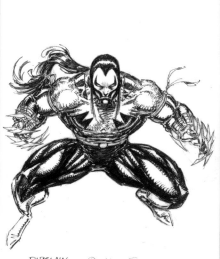

RIPCLAW ™ © MARC SILVESTRI 1992

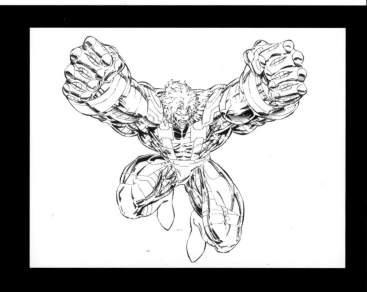

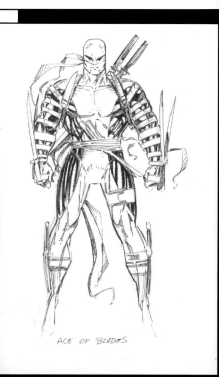

ACE OF BLADES

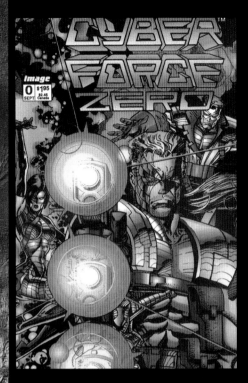

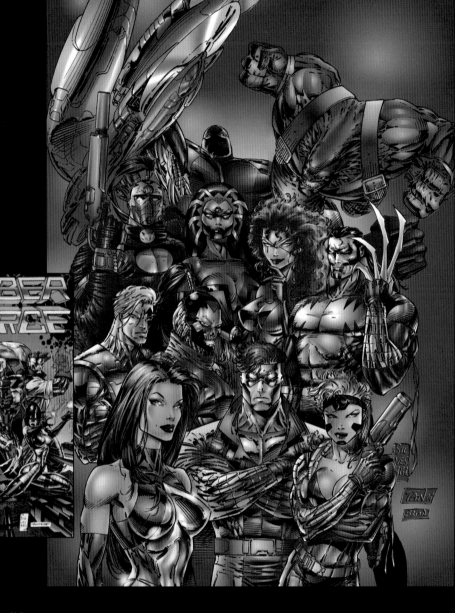

Cyberforce

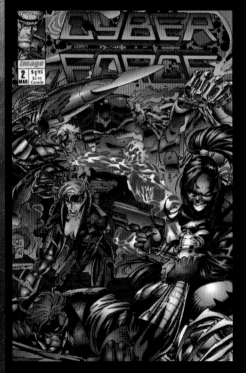

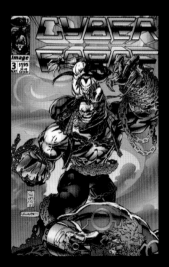

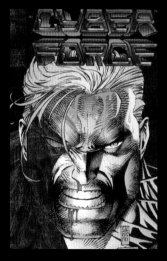

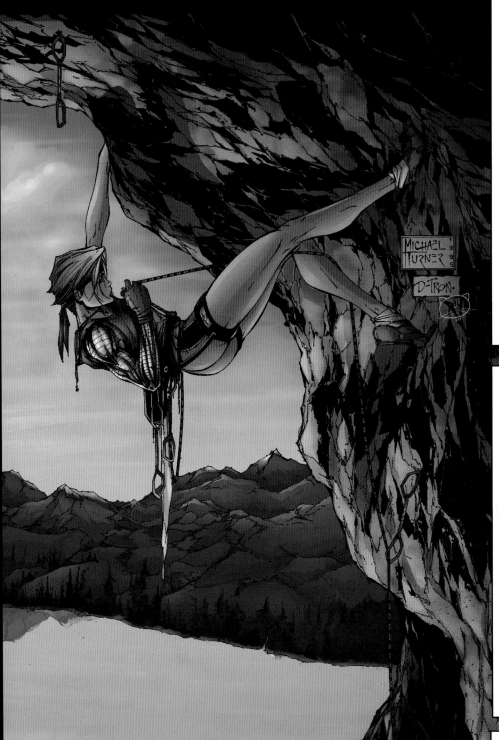

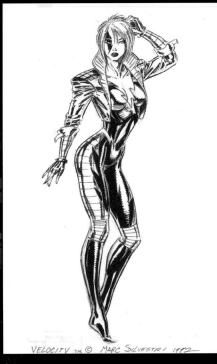

VELOCITY ™ © MARC SILVESTRI 1992

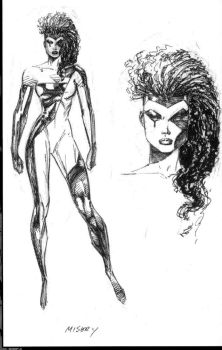

MISERY

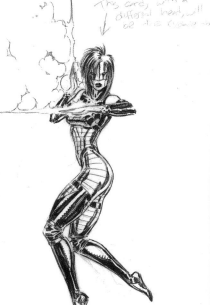

This card, with a different head, will be the Cyblade

CYBLADE ™ © MARC SILVESTRI 1992

this page, clockwise from above
Ballistic Action "Ballistic"
art by: Michael Turner, D-Tron and Catherine Burch

Cyberforce volume 1 concept designs
art by: Marc Silvestri

Cyberforce volume 2 "Assault with a Deadly Woman" trade paperback cover inks
art by: Marc Silvestri and Matt "Batt" Banning

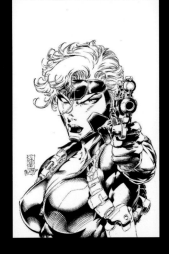

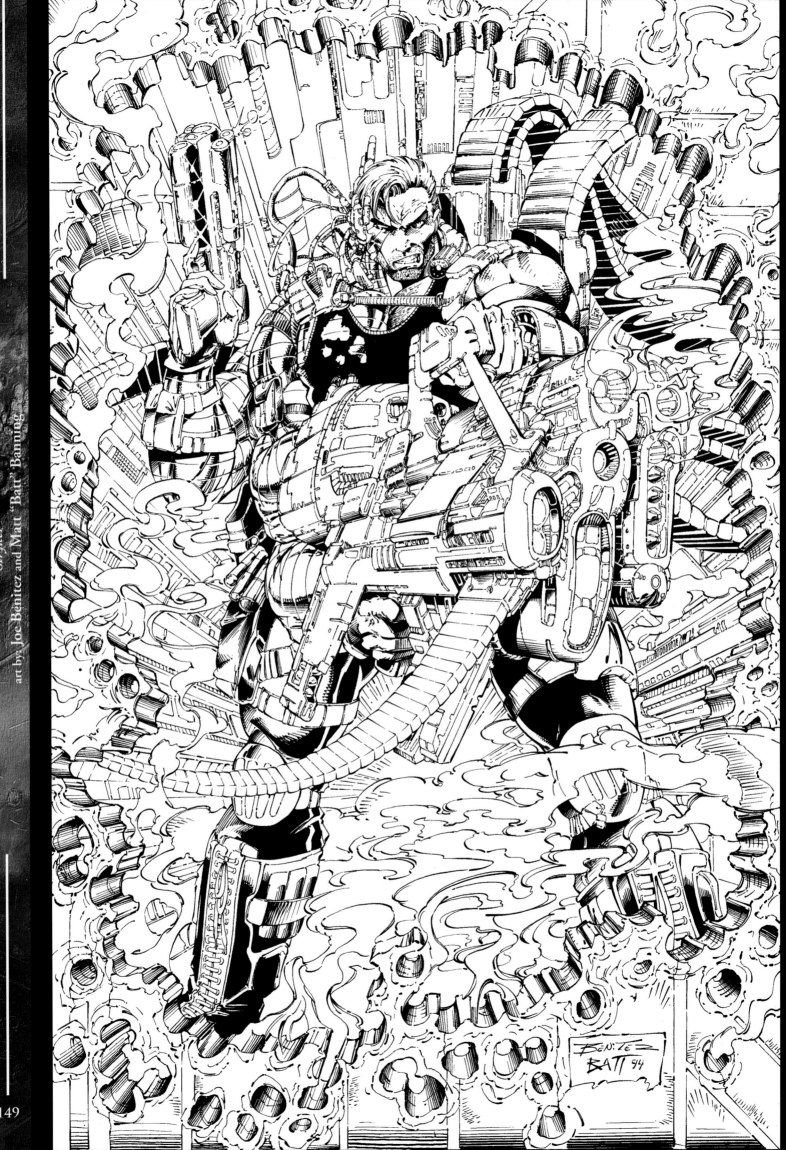

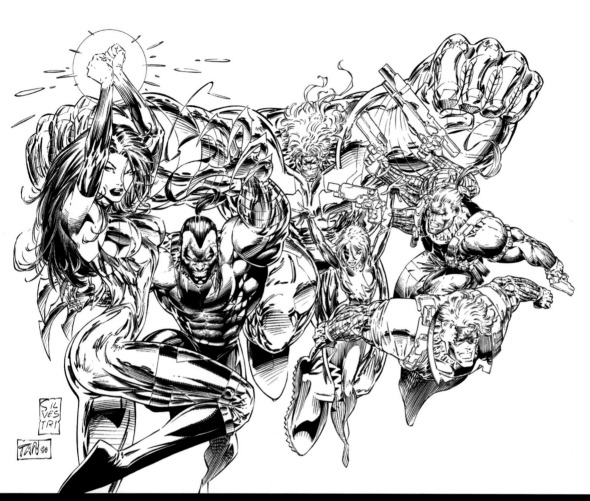

Cyberforce volume 2, Wizard Magazine issue #45
art by Marc Silvestri, Billy Tan and Tyson Wengler

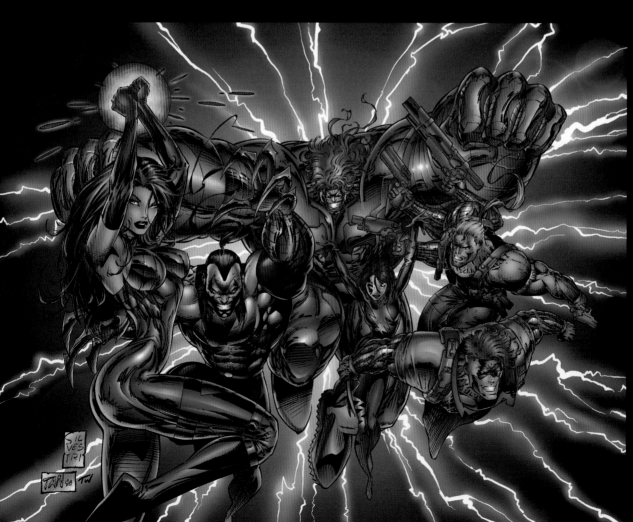

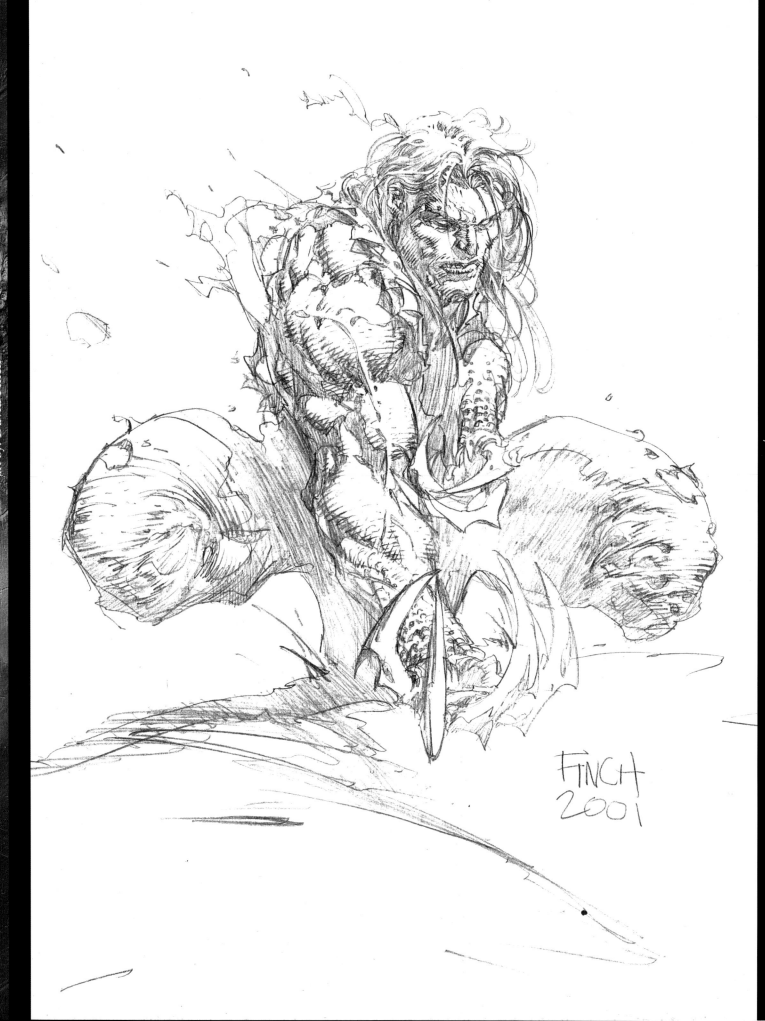

Cyberforce volume 2 issue #12
art by Marc Silvestri, Matt "Batt" Banning, and Steve Firchow

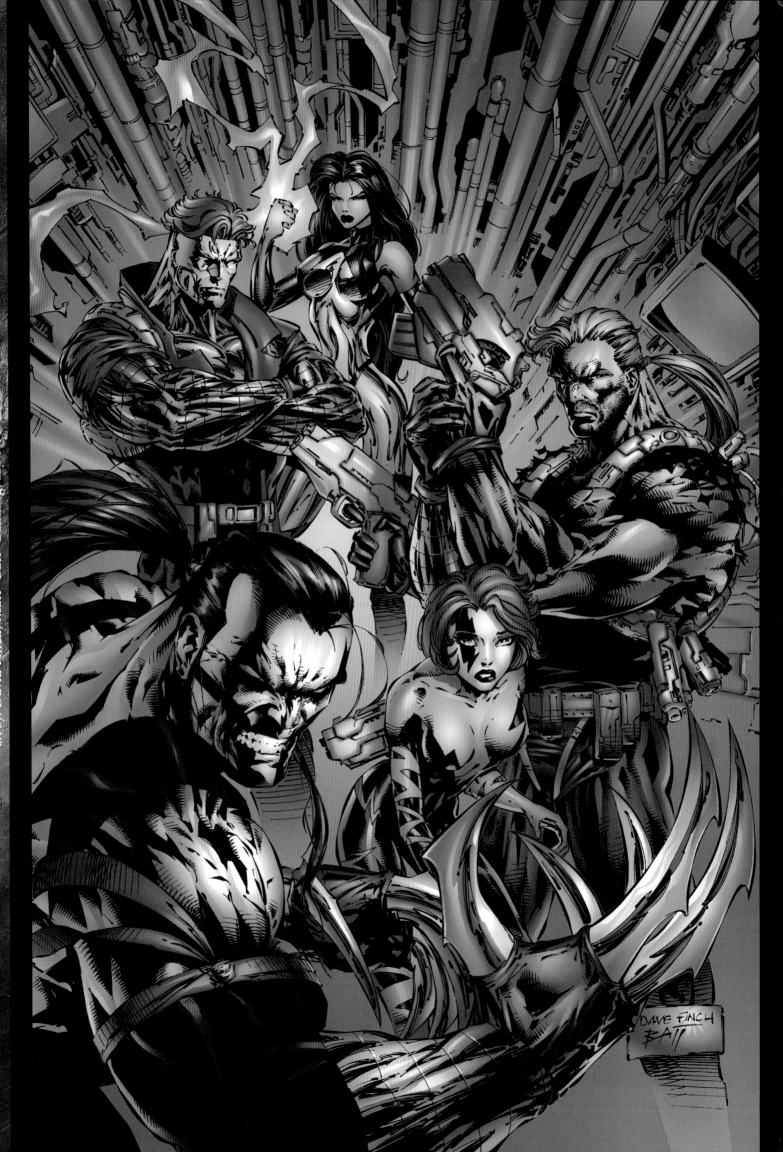

Cyberforce volume 2 issue #16

art by: David Finch, Matt "Batt" Banning, and Steve Firchow

153

Cyberforce volume 2 issue #17 cover pencils
art by: David Finch

DAVE FINCH

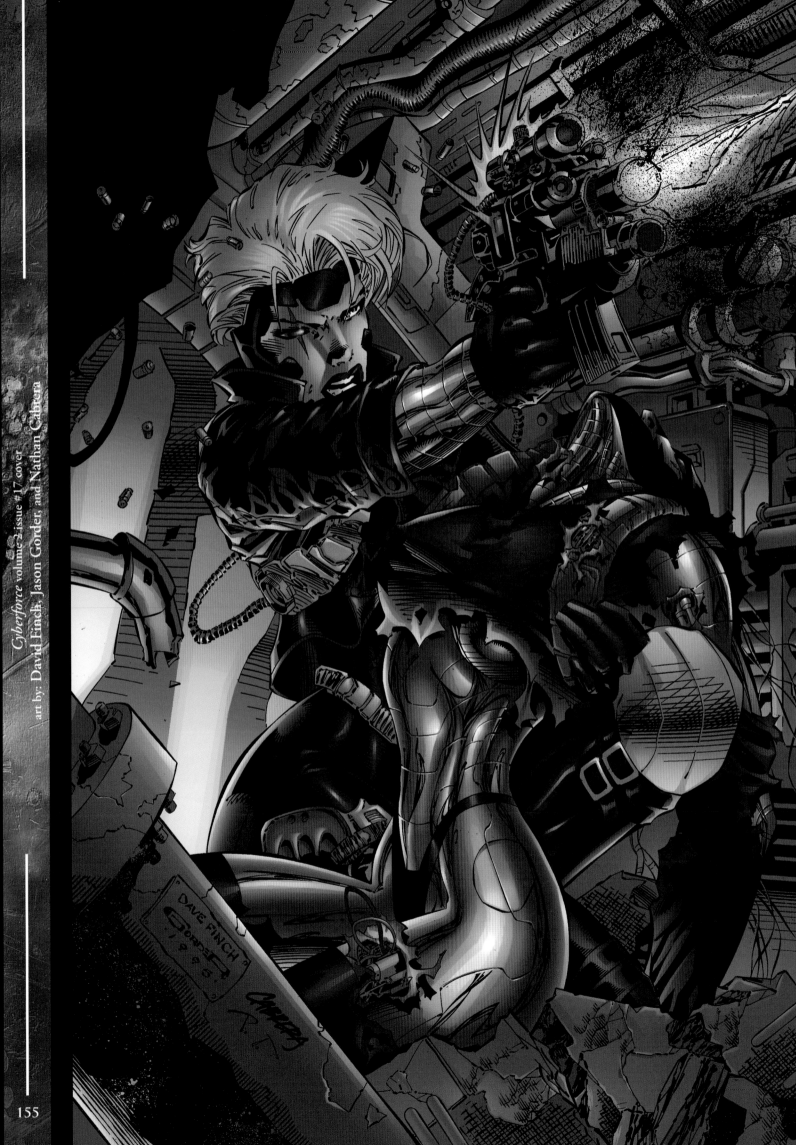

Cyberforce volume 2 issue #17 cover

art by: David Finch, Jason Gorder, and Nathan Cabrera

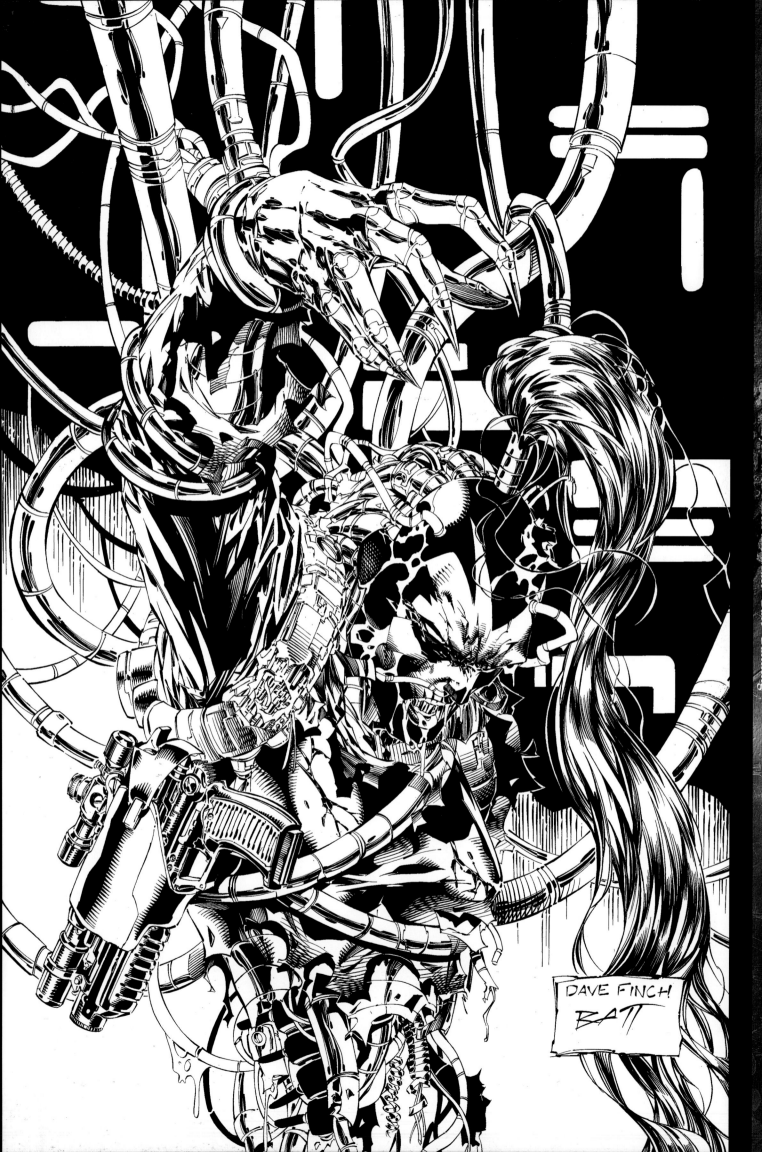

Cyberforce volume 2 issue #18 cover inks
art by: David Finch and Matt "Batt" Banning

DAVE FINCH
BATT

Cyberforce volume 2 issue #18 cover

art by: David Finch, Matt "Batt" Banning, and Steve Firchow

Cyberforce volume 3 issue #1 cover variant
art by: Marc Silvestri

Cyberforce volume 3 issue #1 cover variant

art by: Marc Silvestri, Joe Weems V, and Dream Engine

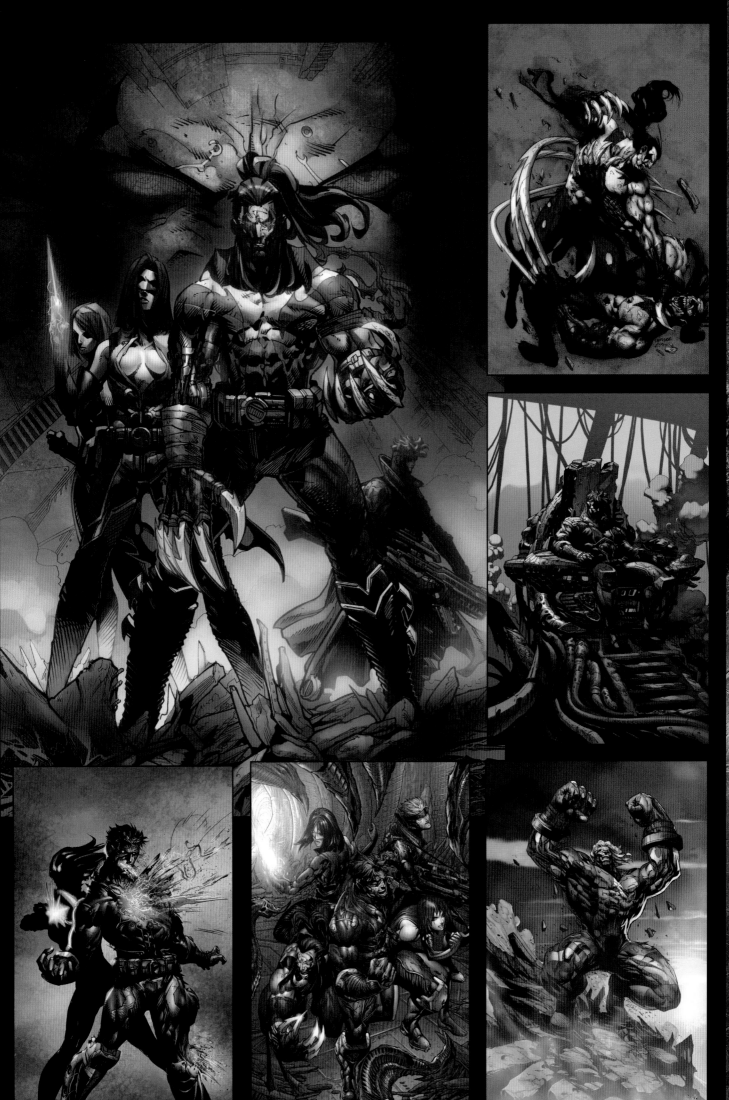

Cyberforce volume 3 issue #1-6 covers
art by: Pat Lee, Erik Sander and Dream Engine

Cyberforce volume 3 issue #2 cover B
art by: Marc Silvestri, Joe Weems V and Steve Firchow

Ballistic issue #3 cover
art by Michael Turner, D-Tron and Tyson Wengler

"Stryker:"

art by Tyler Kirkham and Frank D'Armata

FGD

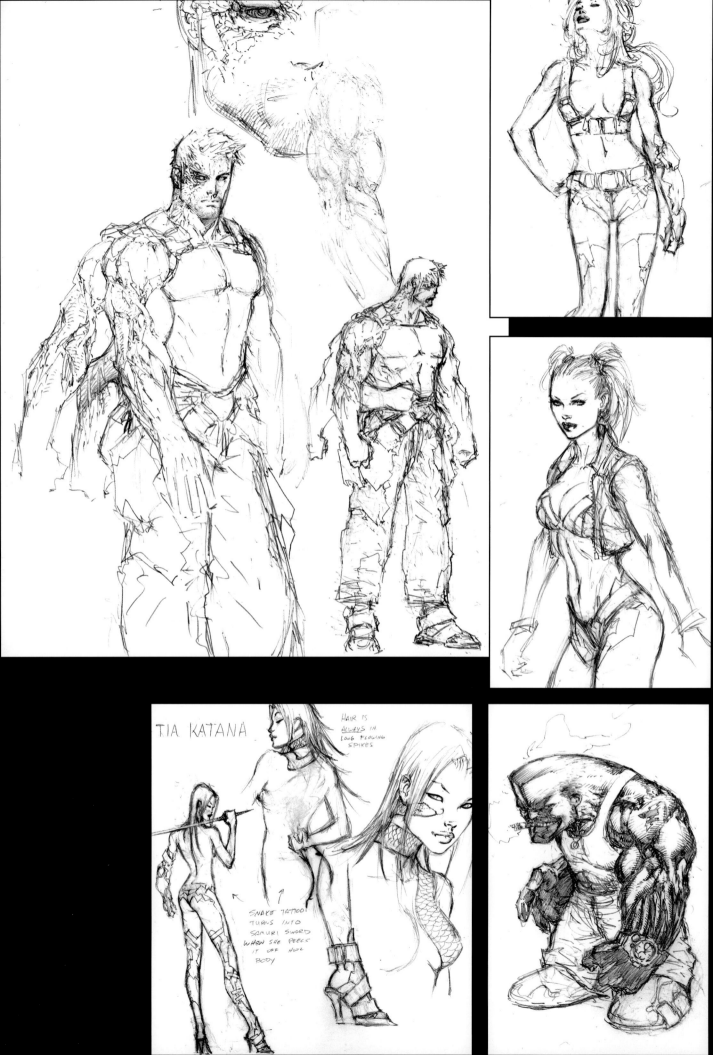

TIA KATANA

HAIR IS ALWAYS IN LONG FLOWING SPIKES

SNAKE TATTOO TURNS INTO SAMURI SWORD WHEN SHE PEELS IT OFF HER BODY

MIDNIGHT LILY

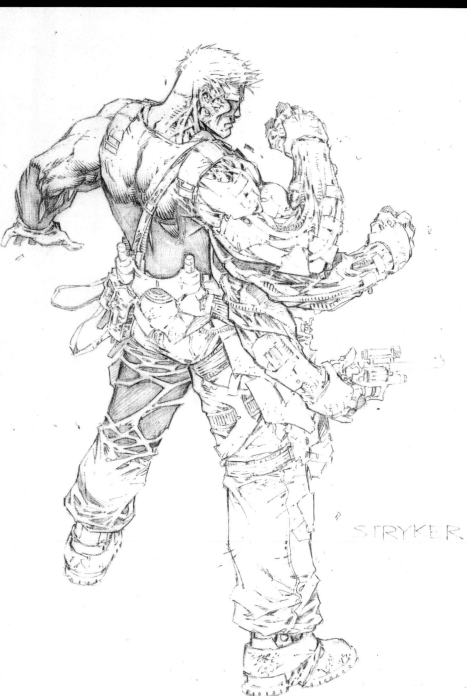

STRYKER

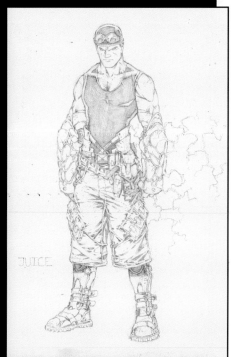

JUICE

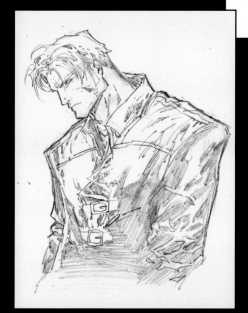

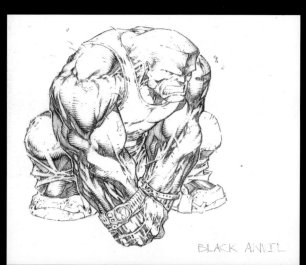

BLACK ANVIL

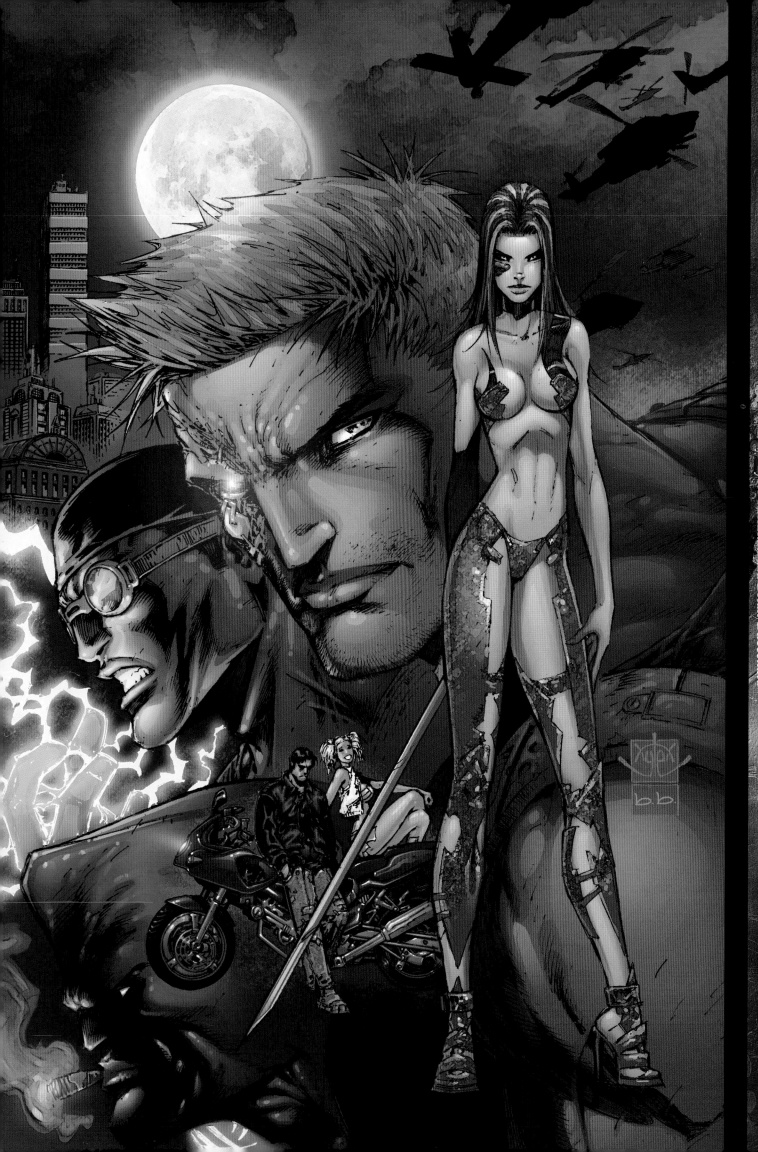

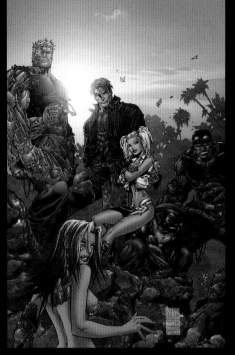

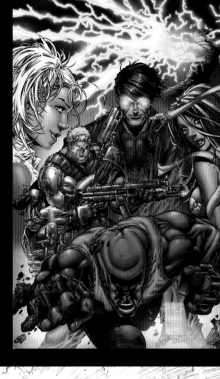

thsi page, clockwise from right
Strykeforce issue #1, 5 and 2-3 covers
art by: Tyler Kirkham, Marlo Alquiza
and Brian Buccellato

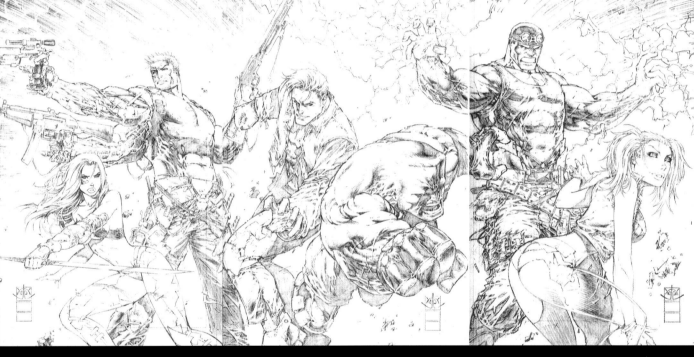

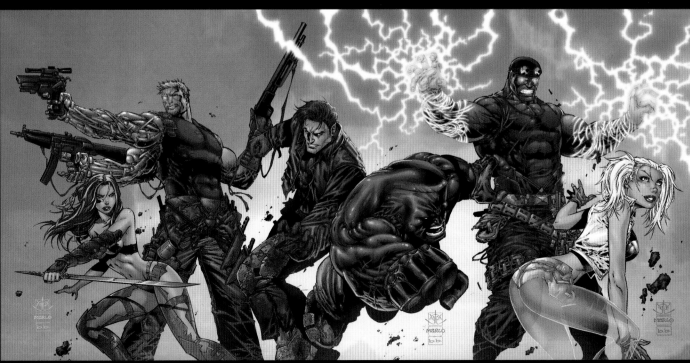

Cyberforce volume 4 promotional art lineart
art by: Kenneth Rocafort

Cyberforce volume 4 promotional art
art by: Kenneth Rocafort

{APHRODITE IX}
Series Covers • Selected Works

Aphrodite IX issue #2 cover
art by: David Finch, Joe Weems V
and Steve Firchow

170

Aphrodite IX issue #0 cover
art by: David Finch, Joe Weems V and Liquid!

ZOOM 90%

INITIALIZE SEQUENCE

BIO ROID

TACT

FINCH
WEEMS
LIQUID!

451/00

SYSTEM FAILURE

Aphrodite IX issue #1 cover inks
art by: David Finch and Joe Weems V

Aphrodite IX issue #1 cover

art by: David Finch, Joe Weems V and Steve Firchow

FINCH
WEEMS
STEVE

Aphrodite IX issue #1 cover variant C
art by: Marc Silvestri, Joe Weems V and Steve Firchow

Aphrodite IX issue #1 variant cover D
art by: Joe Benitez, Joe Victor Llamas and Dan Kemp

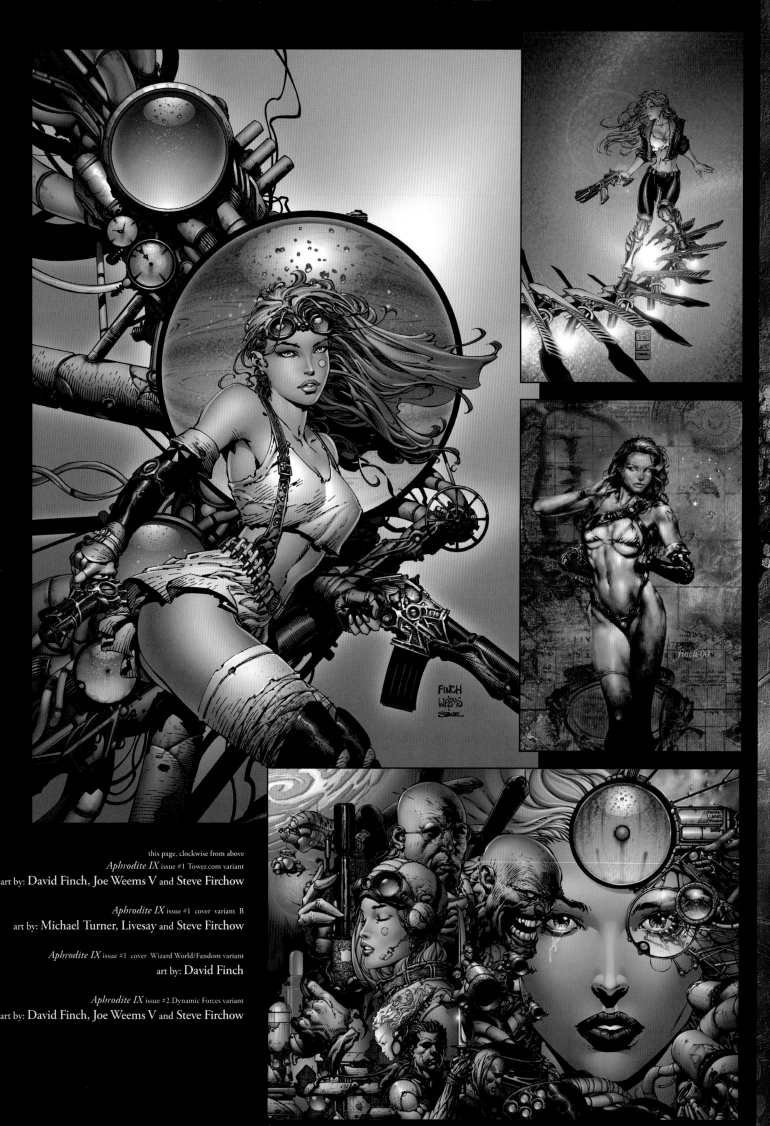

this page, clockwise from above

Aphrodite IX issue #1 Tower.com variant

art by: David Finch, Joe Weems V and Steve Firchow

Aphrodite IX issue #1 cover variant B

art by: Michael Turner, Livesay and Steve Firchow

Aphrodite IX issue #1 cover Wizard World/Fandom variant

art by: David Finch

Aphrodite IX issue #2 Dynamic Forces variant

art by: David Finch, Joe Weems V and Steve Firchow

Aphrodite IX issue #3 cover
art by: David Finch, Victor Llamas and Steve Firchow

FINCH
2001
·LLAMAS·
STEVE

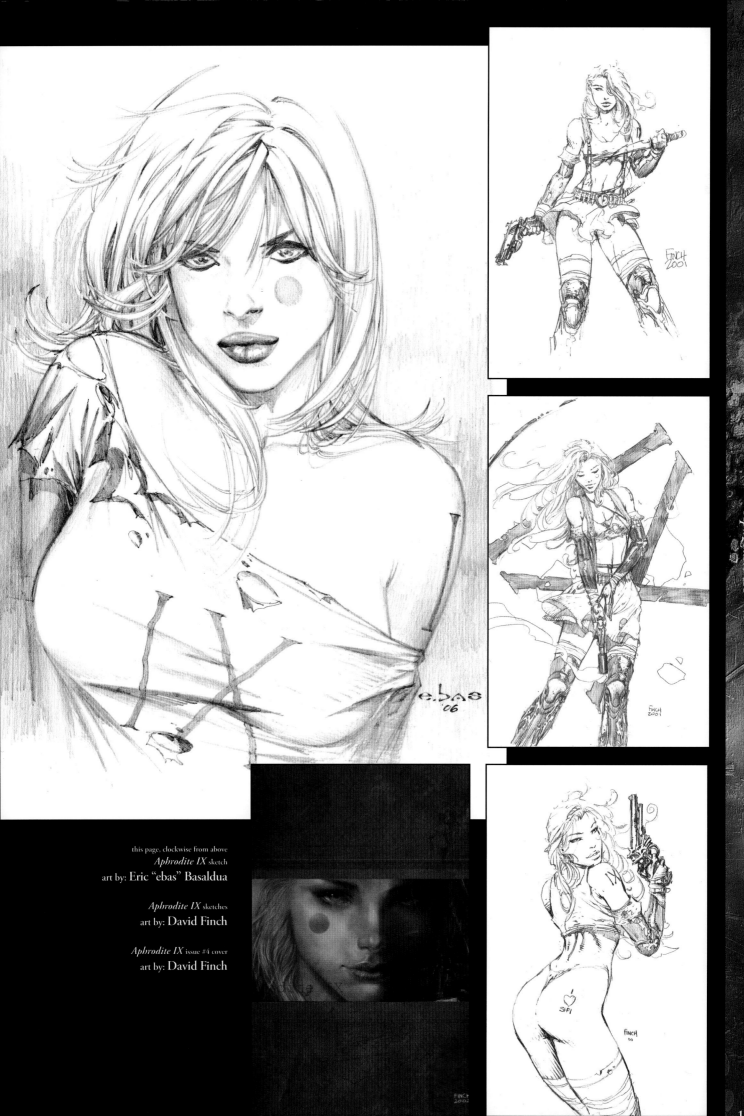

this page, clockwise from above
Aphrodite IX sketch
art by: Eric "ebas" Basaldua

Aphrodite IX sketches
art by: David Finch

Aphrodite IX issue #4 cover
art by: David Finch

trevor
2003
steve

{THE MAGDALENA}
Series Covers • Selected Works

"The Magdalena" from *Free Comic Book Day 2007*
art by: Stjepan Sejic

The Magdalena volume 1 issue #1 cover variant

art by: Joe Benitez, Joe Weems V and Peter Steigerwald

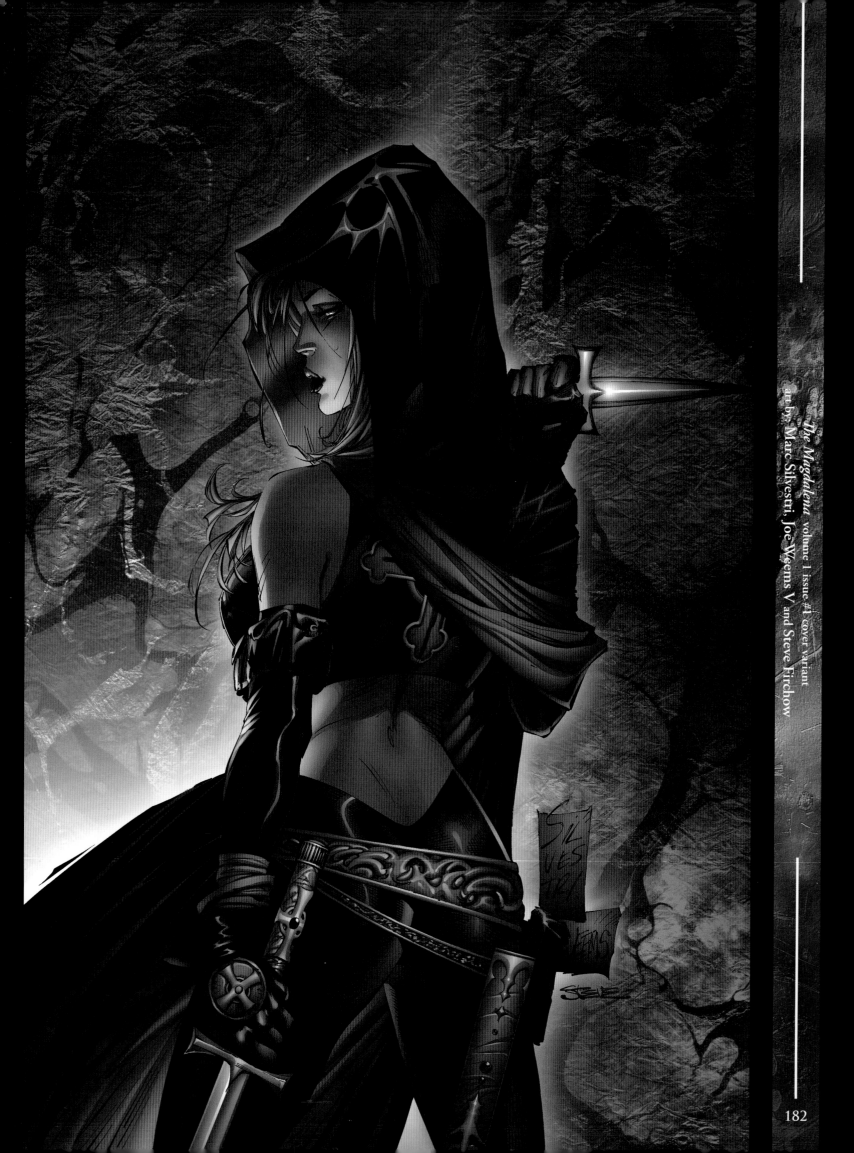

The Magdalena volume 1 issue #1 cover variant art by Marc Silvestri, Joe Weems V and Steve Firchow

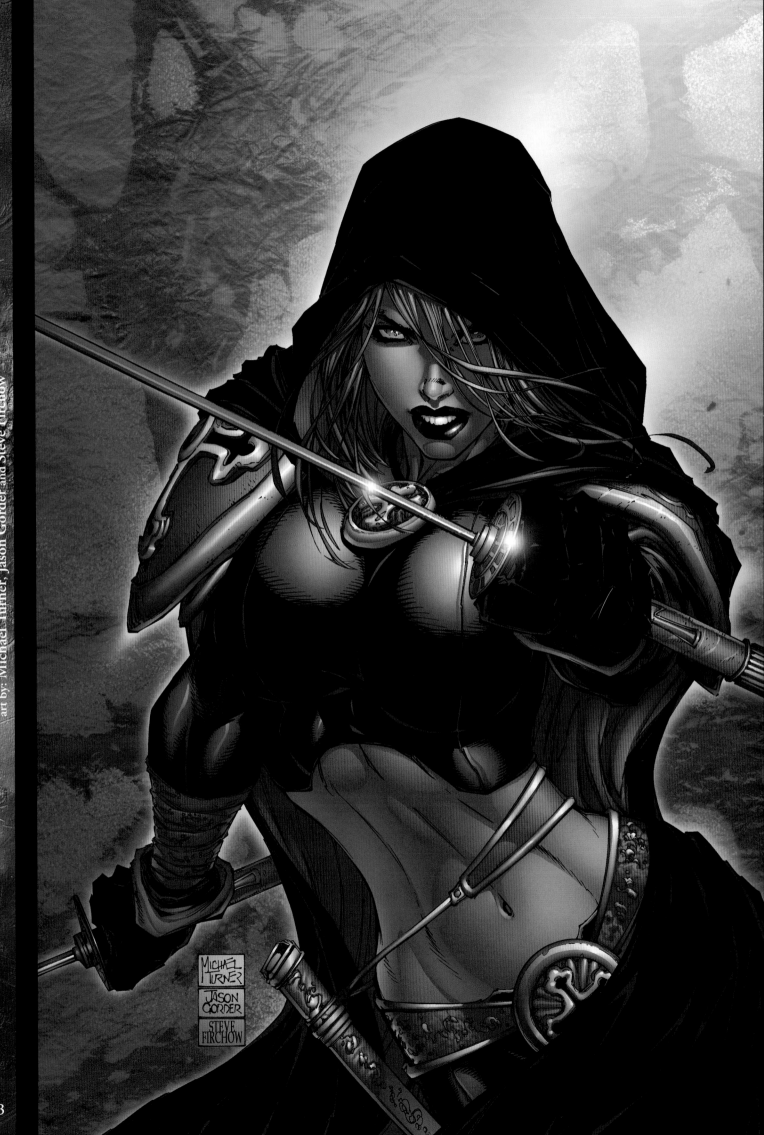

The Magdalena volume 1 issue #1 cover variant
art by: Michael Turner, Jason Gorder and Steve Firchow

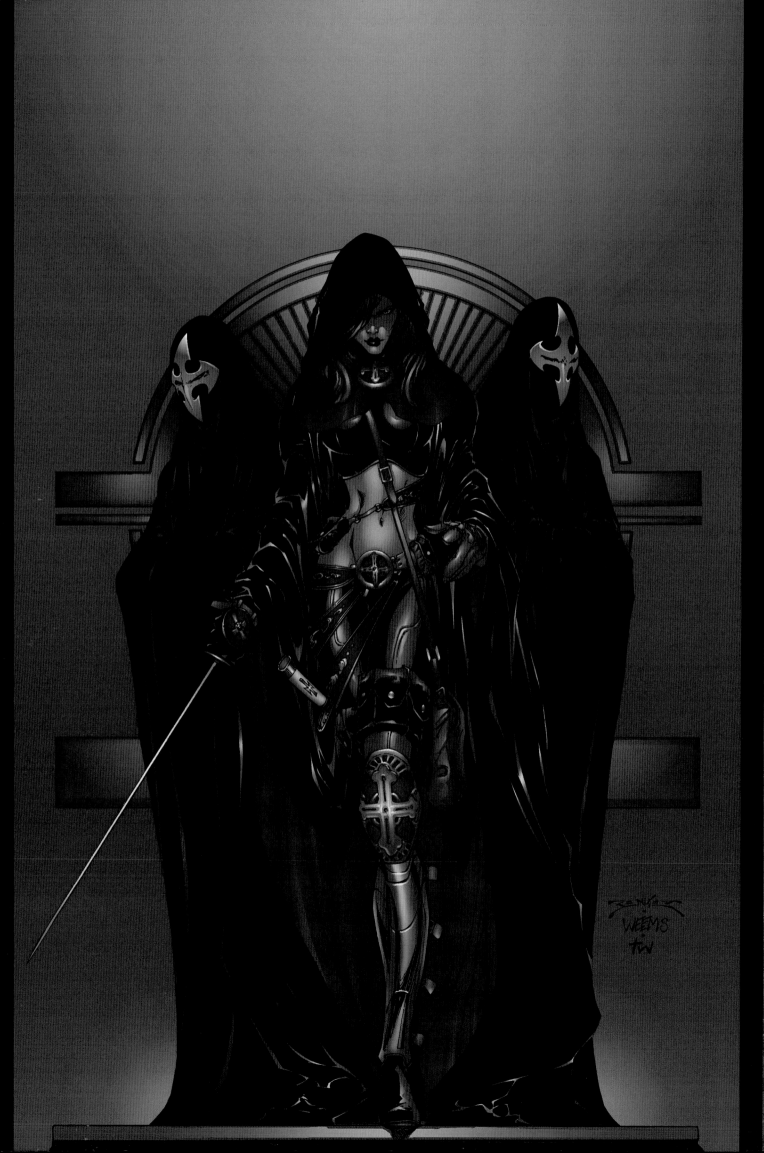

The Magdalena volume 1 issue #3 cover
art by Joe Benitez, Joe Weems V and Tyson Wengler

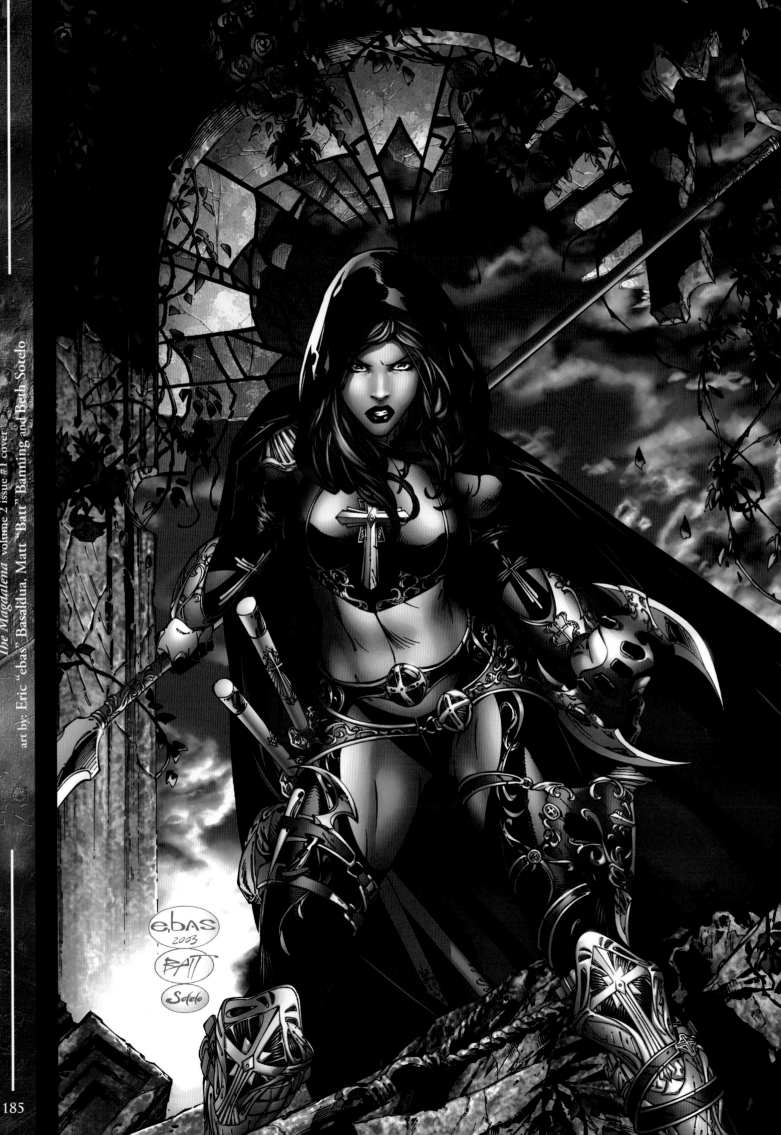

The Magdalena volume 2 issue #1 cover variant
art by: Jim Silke

The Magdalena volume 2 issue #1 cover variant
art by: Joseph Michael Linsner

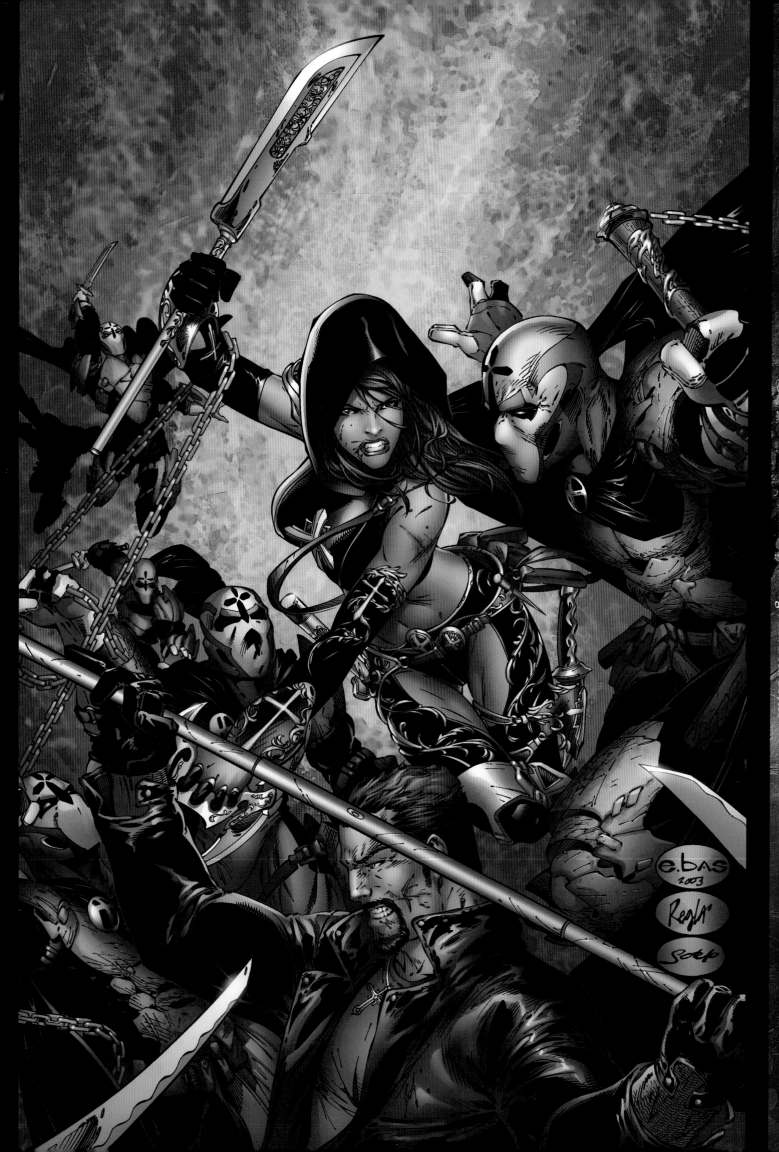

The Magdalena volume 2 issue #2 cover
art by: Eric "ebas" Basaldua, Sal Regla and Beth Sotelo

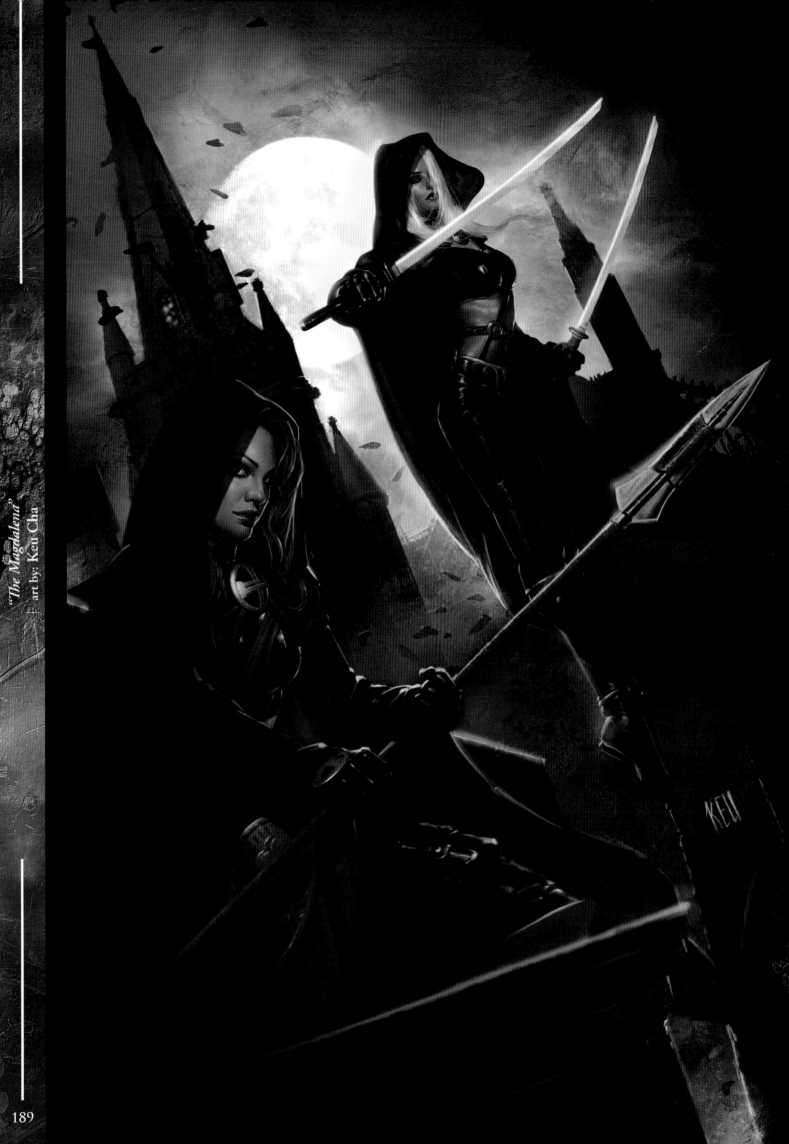

"The Magdalena"
art by: Keu Cha

{ H U N T E R - K I L L E R }
Series Covers • Selected Works

Hunter-Killer issue #12 variant cover
art by: Kenneth Rocafort

Hunter-Killer issue #0 cover
art by: Marc Silvestri, Joe Weems V and Steve Firchow

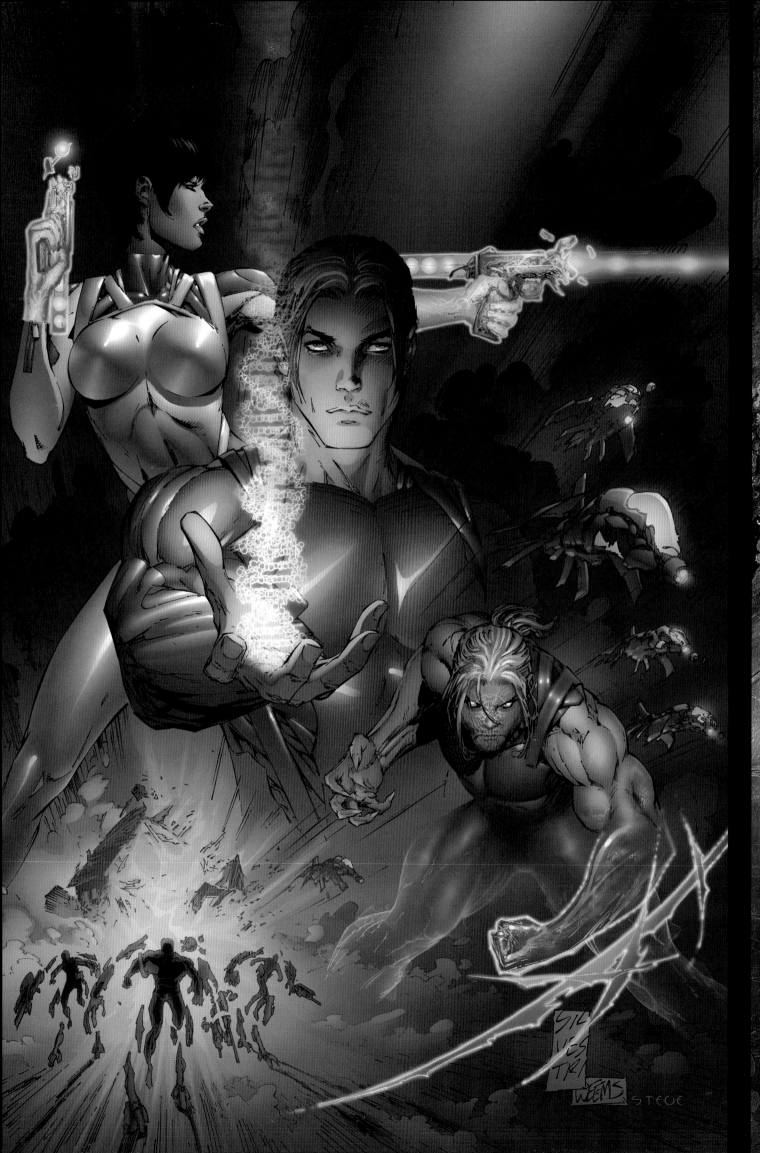

Hunter-Killer issue #1 cover variant C
art by: J. Scott Campbell and Steve Firchow

Hunter-Killer issue #1 cover variant B
art by: Trevor Hairsine and Steve Firchow

194

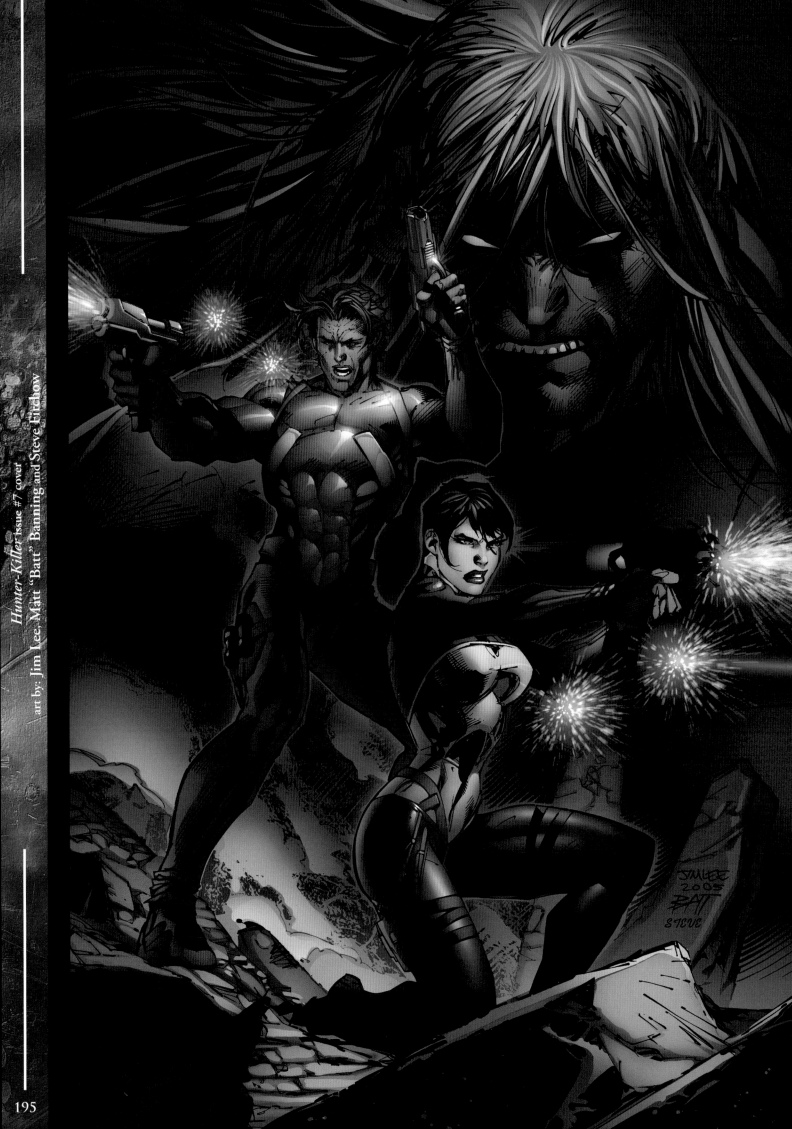

Hunter-Killer issue #7 cover
art by: Jim Lee, Matt "Batt" Banning and Steve Firchow

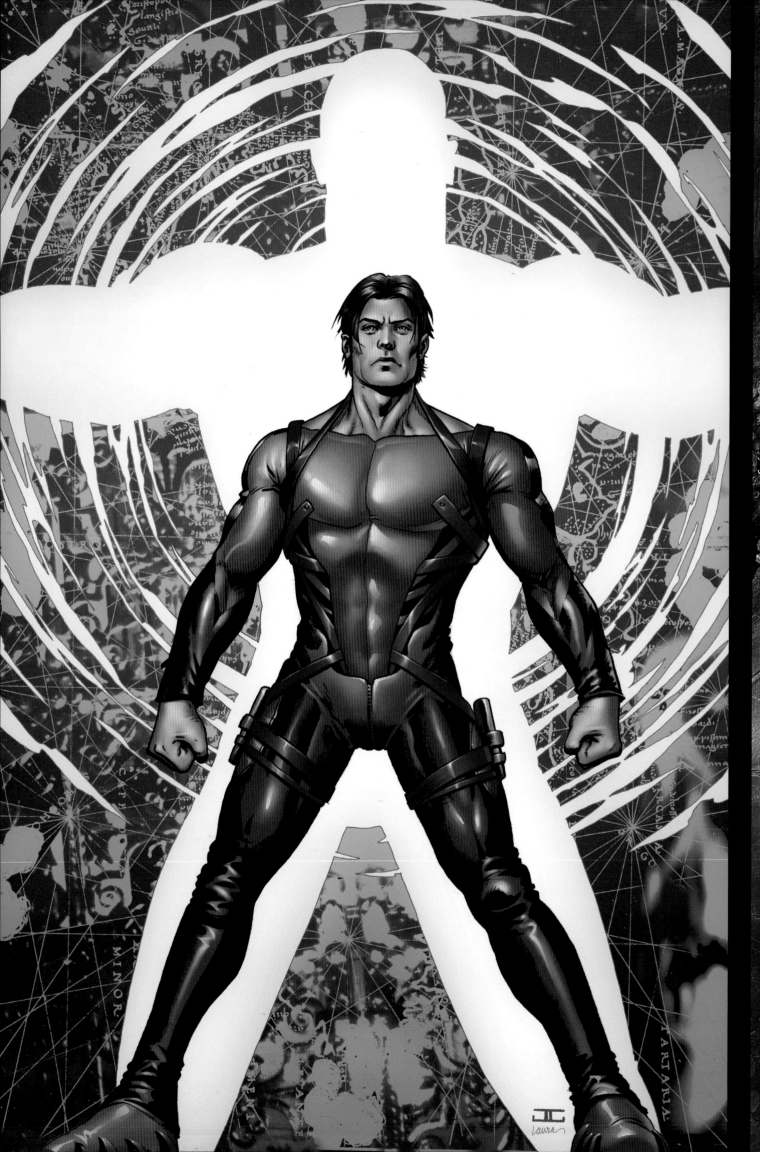

Hunter-Killer issue #8 cover
art by: John Cassaday and Laura Martin

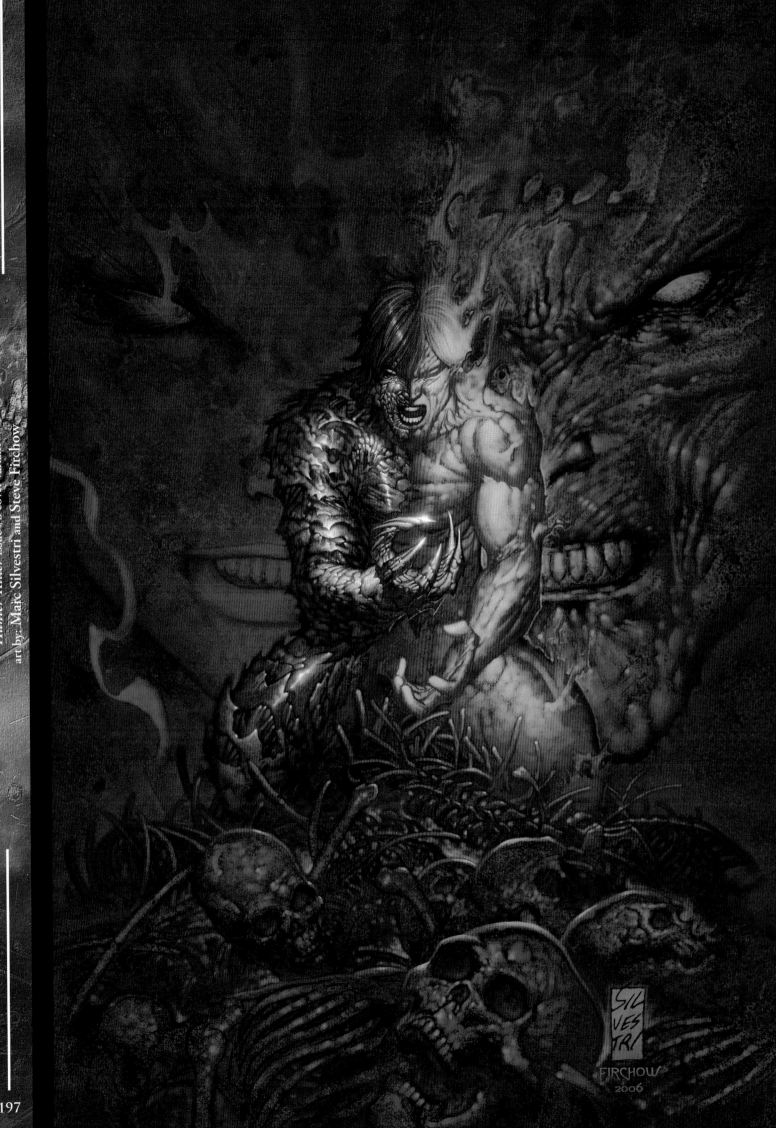

Hunter-Killer issue #8 cover variant
art by: Marc Silvestri and Steve Firchow

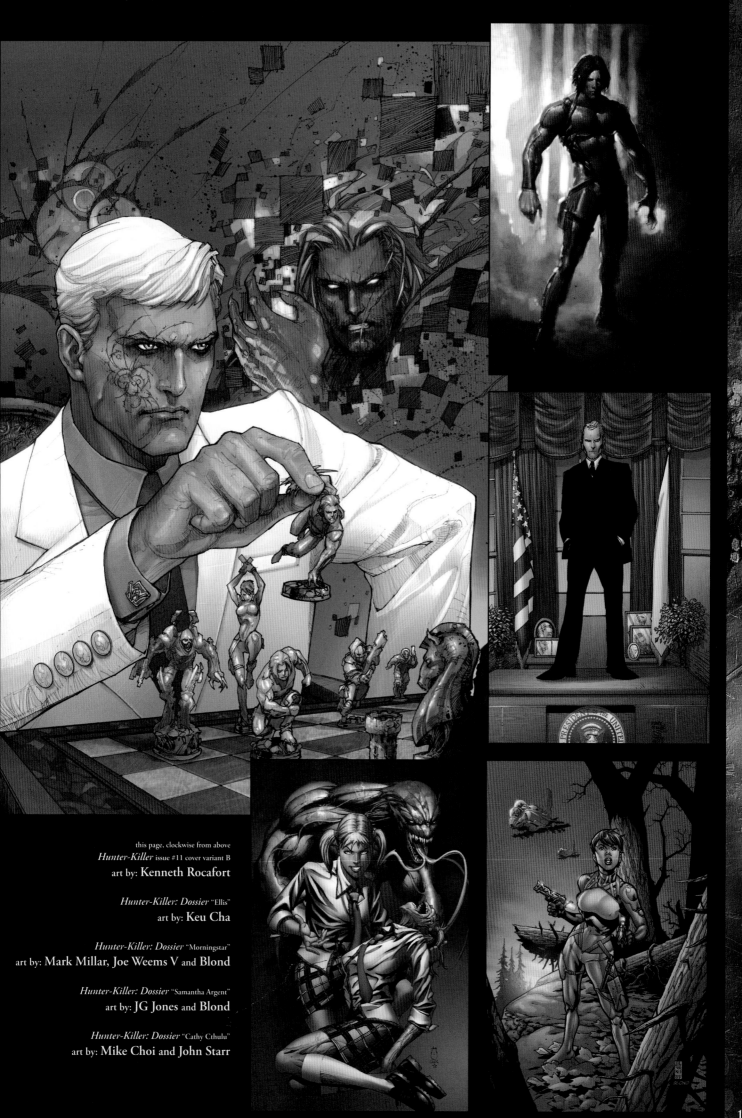

this page, clockwise from above
Hunter-Killer issue #11 cover variant B
art by: **Kenneth Rocafort**

Hunter-Killer: Dossier "Ellis"
art by: **Keu Cha**

Hunter-Killer: Dossier "Morningstar"
art by: **Mark Millar, Joe Weems V and Blond**

Hunter-Killer: Dossier "Samantha Argent"
art by: **JG Jones and Blond**

Hunter-Killer: Dossier "Cathy Cthulu"
art by: **Mike Choi and John Starr**

Hunter-Killer issue #12 cover
art by: Marc Silvestri and Frank D'Armata

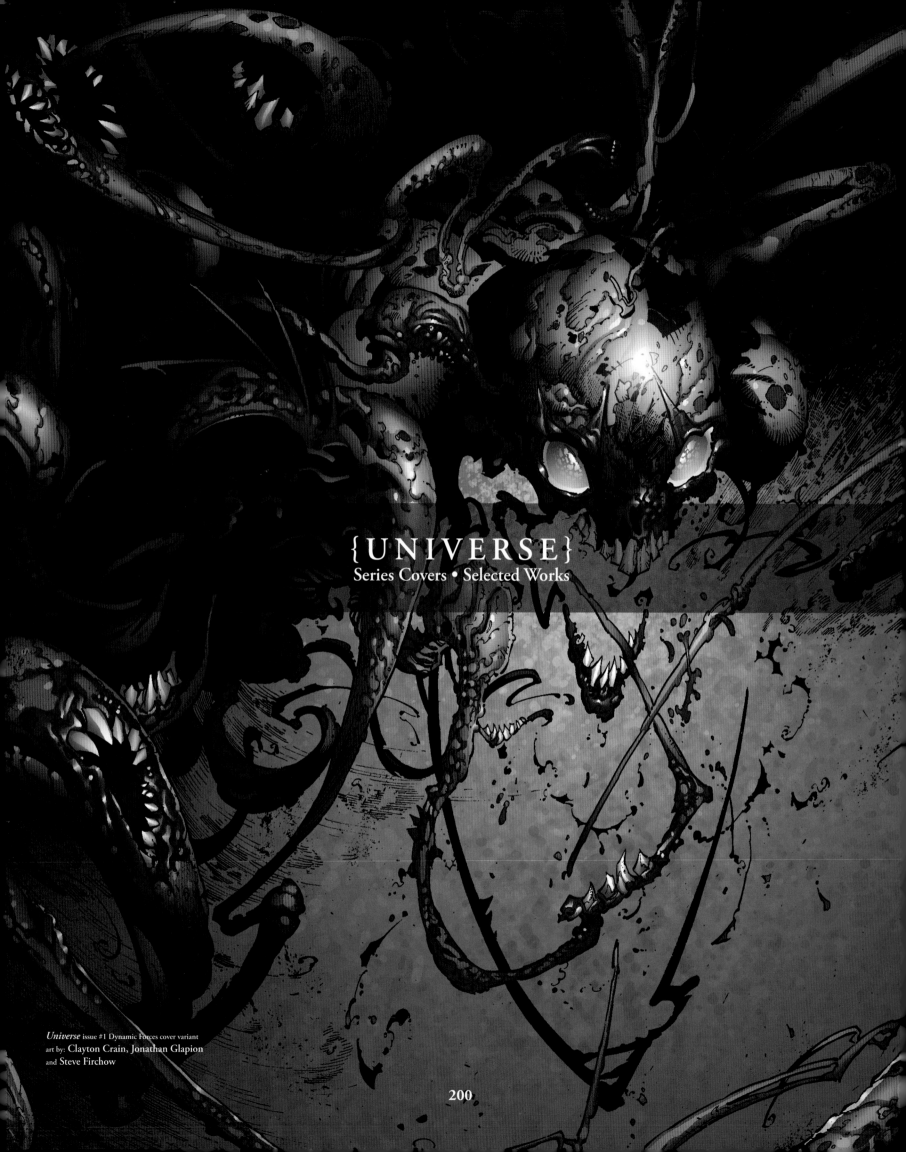

{ U N I V E R S E }
Series Covers • Selected Works

Universe issue #1 Dynamic Forces cover variant
art by: Clayton Crain, Jonathan Glapion
and Steve Firchow

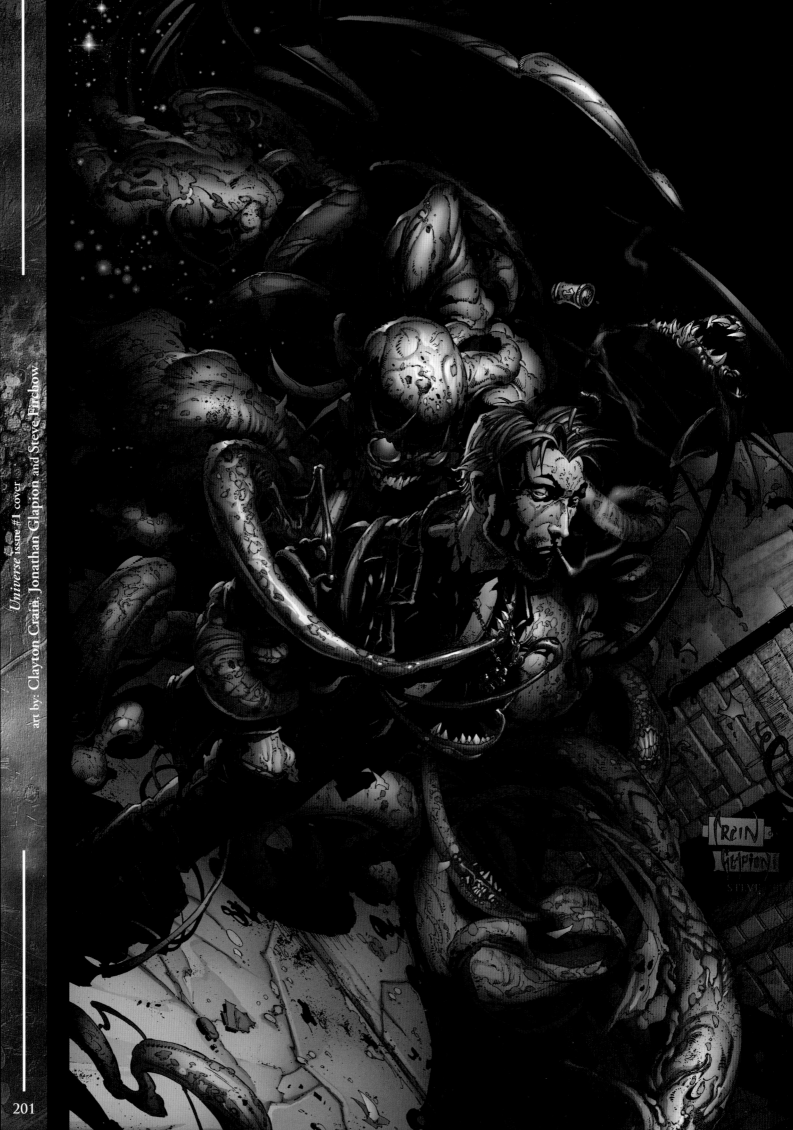

Universe issue #1 cover

art by: Clayton Crain, Jonathan Glapion and Steve Firchow

Universe issue #1 cover variant A pencils
art by: David Finch

FINCH
2001

LAYOUT

202

Universe issue #1 cover variant A
art by: David Finch

Universe issue #1 cover variant B
art by Marc Silvestri, Billy Tan and Steve Firchow

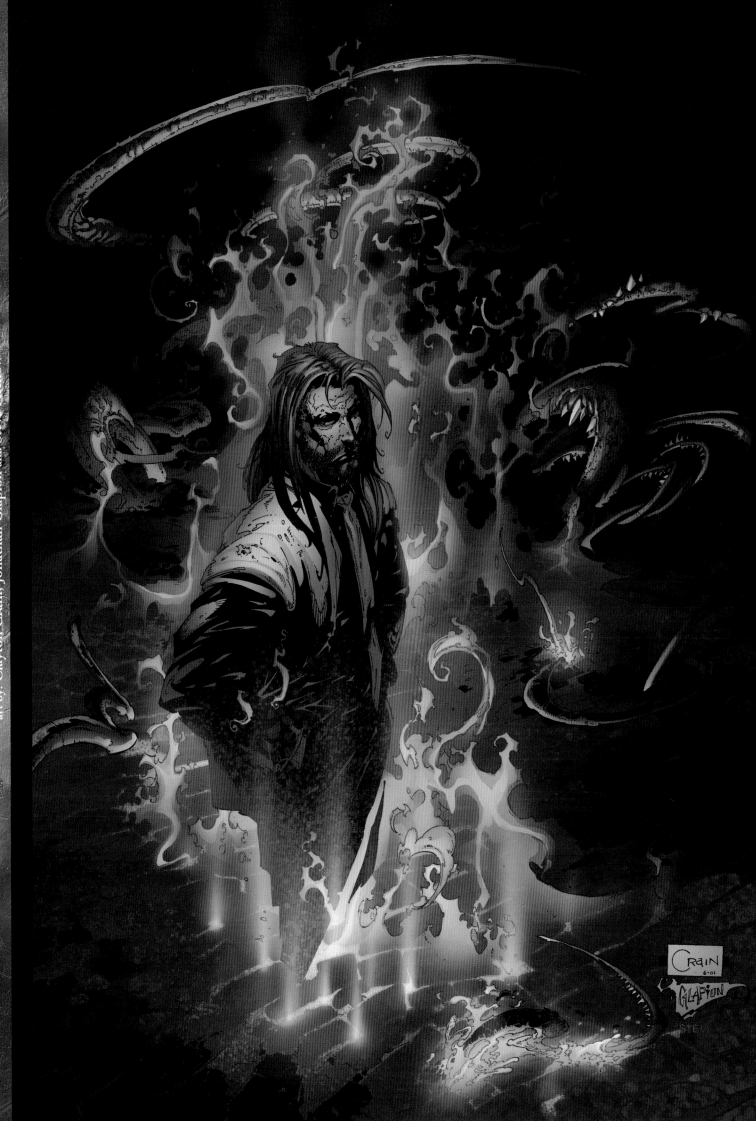

Universe issue #3 cover

art by: Clayton Crain, Jonathan Glapion and Steve Firchow

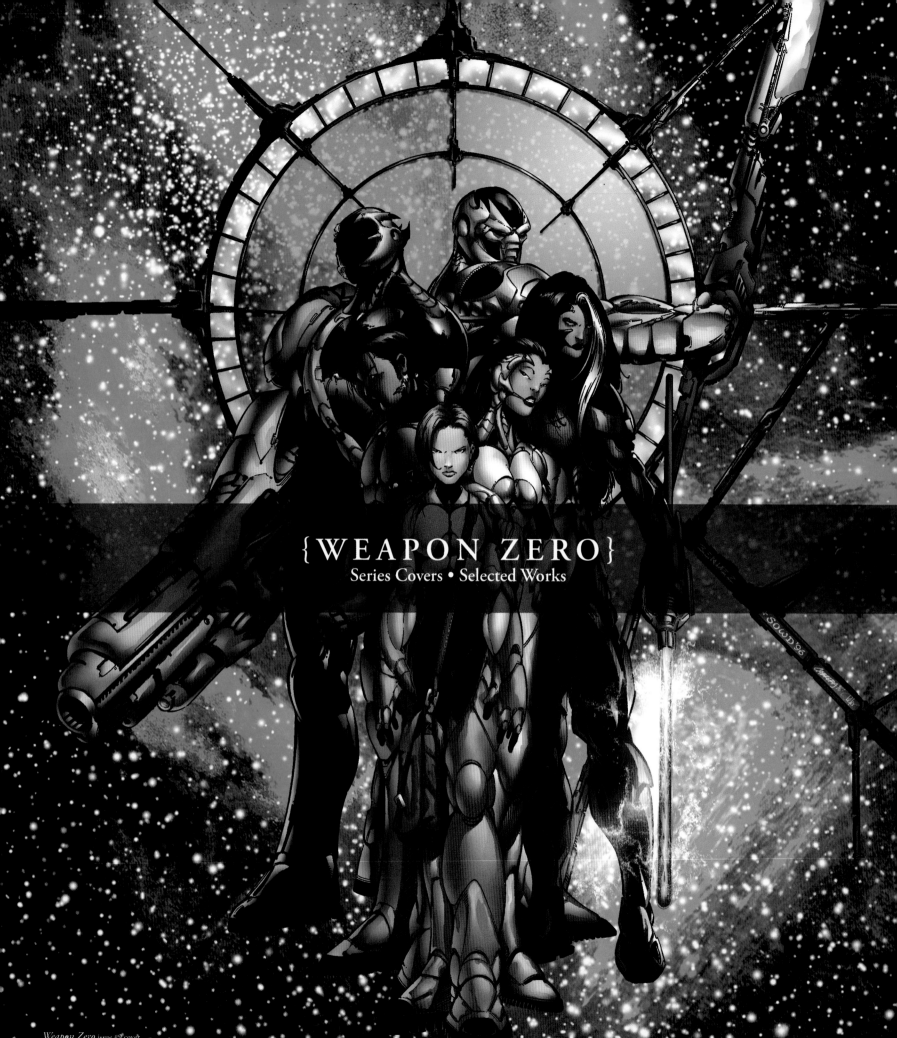

{WEAPON ZERO}
Series Covers • Selected Works

Weapon Zero issue #9 cover
art by: Joe Benitez, Aaron Sowd
and Nathan Cabrera

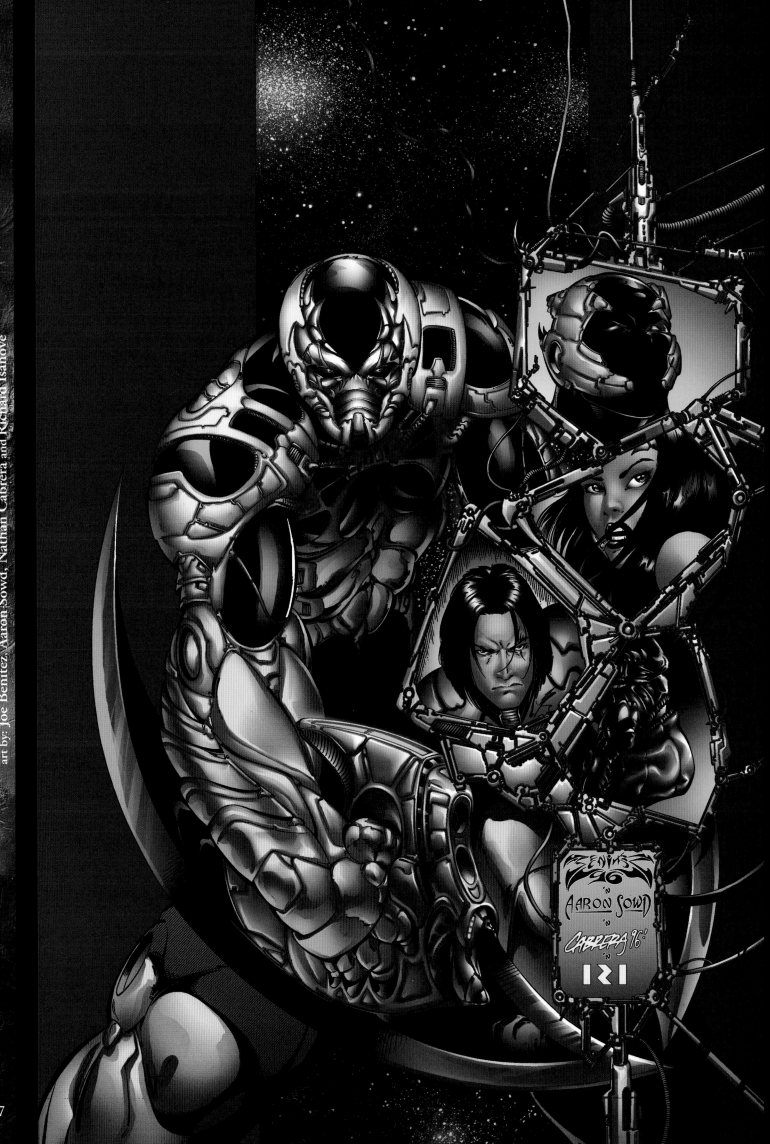

Weapon Zero issue #7 cover

art by: Joe Benitez, Aaron Sowd, Nathan Cabrera and Richard Isanove

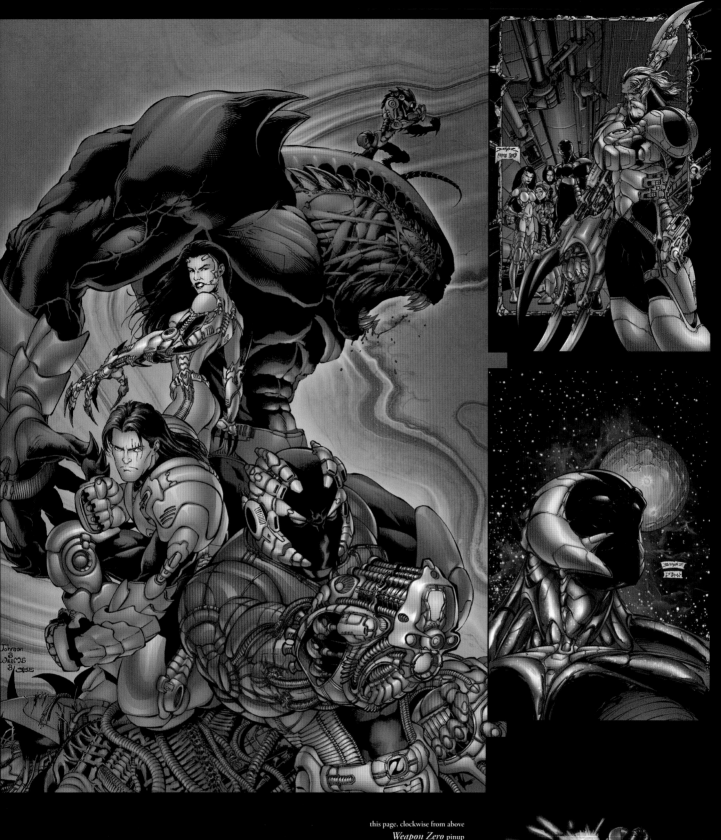

this page, clockwise from above
Weapon Zero pinup
art by: **Drew Johnson, Joe Weems V** and **Steve Firchow**

Weapon Zero issue #8 cover
art by: **Joe Benitez, Aaron Sowd** and **Dean White**

Weapon Zero issue #11 cover
art by: **Joe Benitez, D-Tron** and **Dean White**

Weapon Zero issue #13 cover
art by: **Joe Benitez, Joe Weems V** and **Dean White**

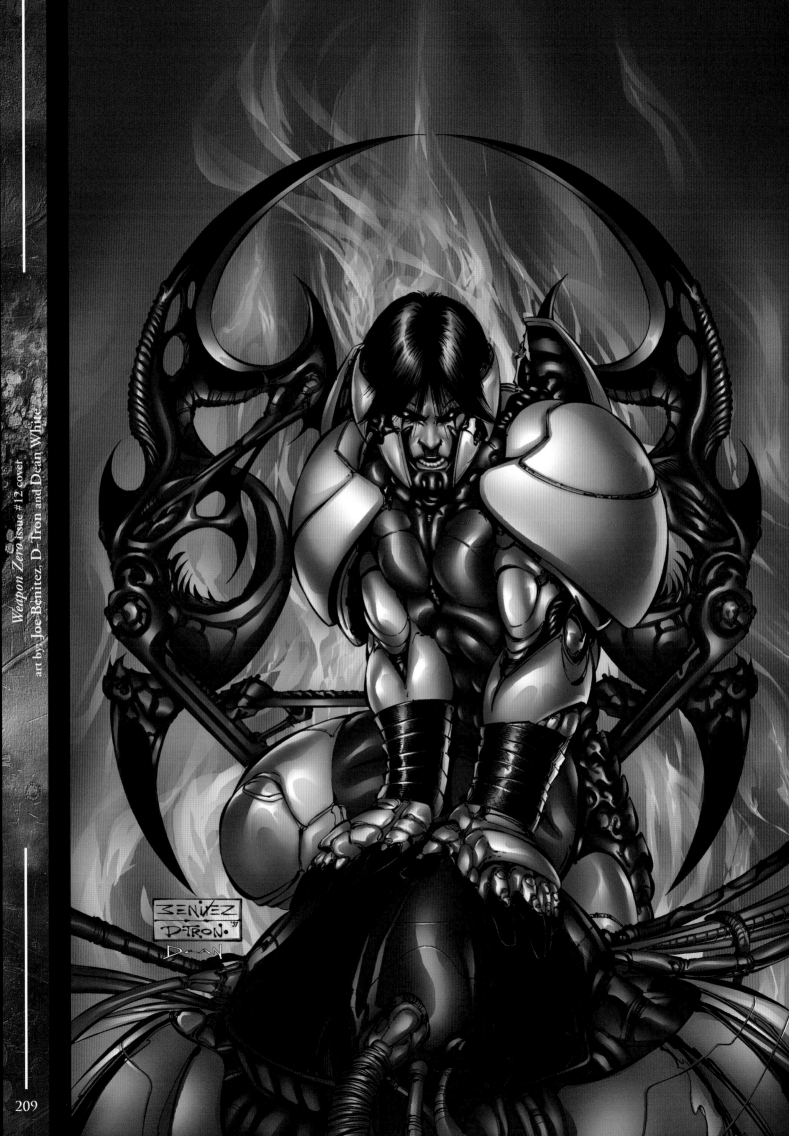

Weapon Zero issue #12 cover
art by Joe Benitez, D-Tron and Dean White

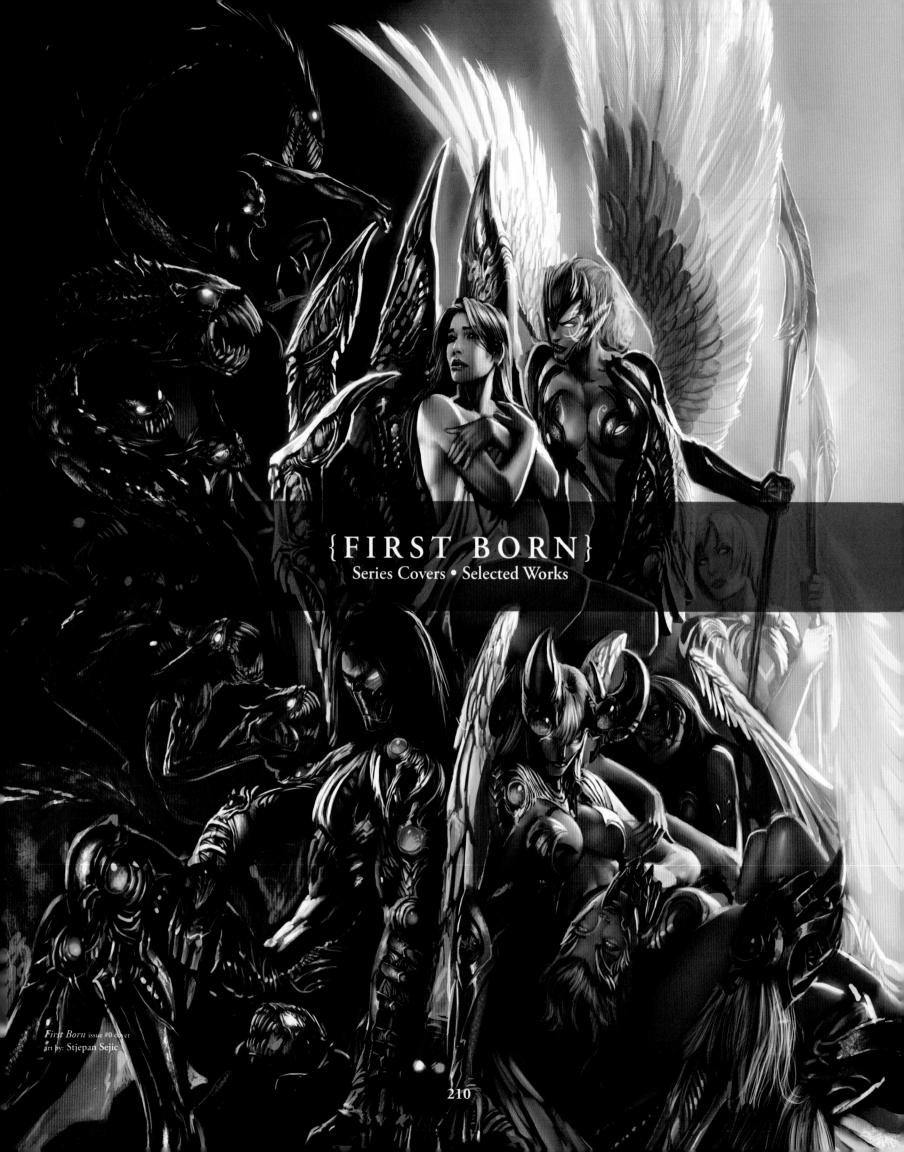

{ F I R S T B O R N }
Series Covers • Selected Works

First Born issue #0 cover
art by: Stjepan Sejic

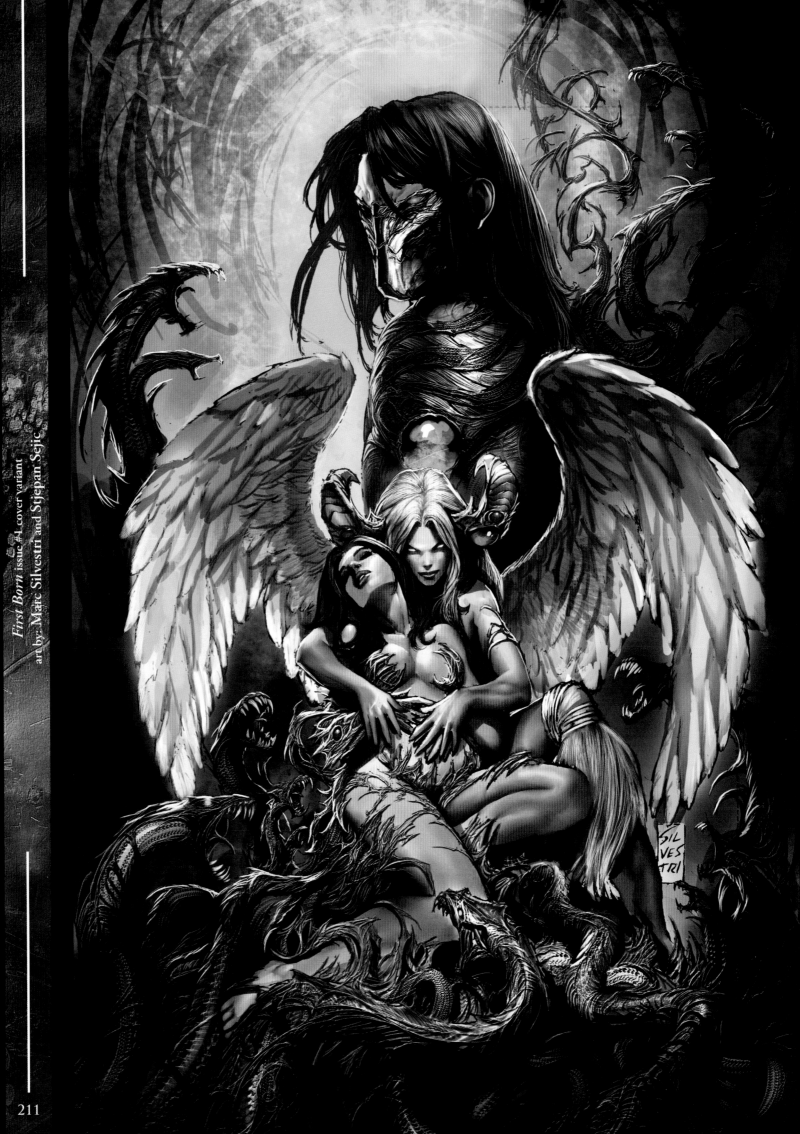

First Born issue #2 cover variant A
art by: Dale Keown

First Born issue #2 cover Variant B
art by: Stjepan Sejic

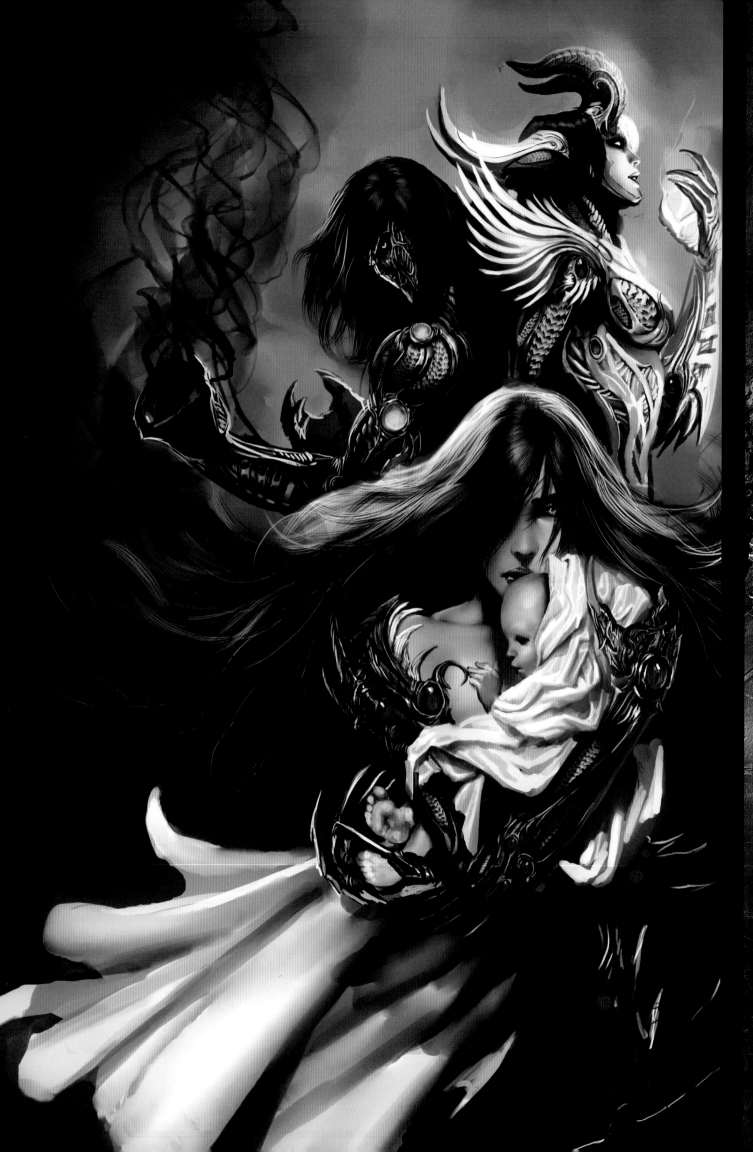

First Born issue #3 cover variant
art by: Stjepan Sejic

"The Angelus"
art by: Stjepan Sejic

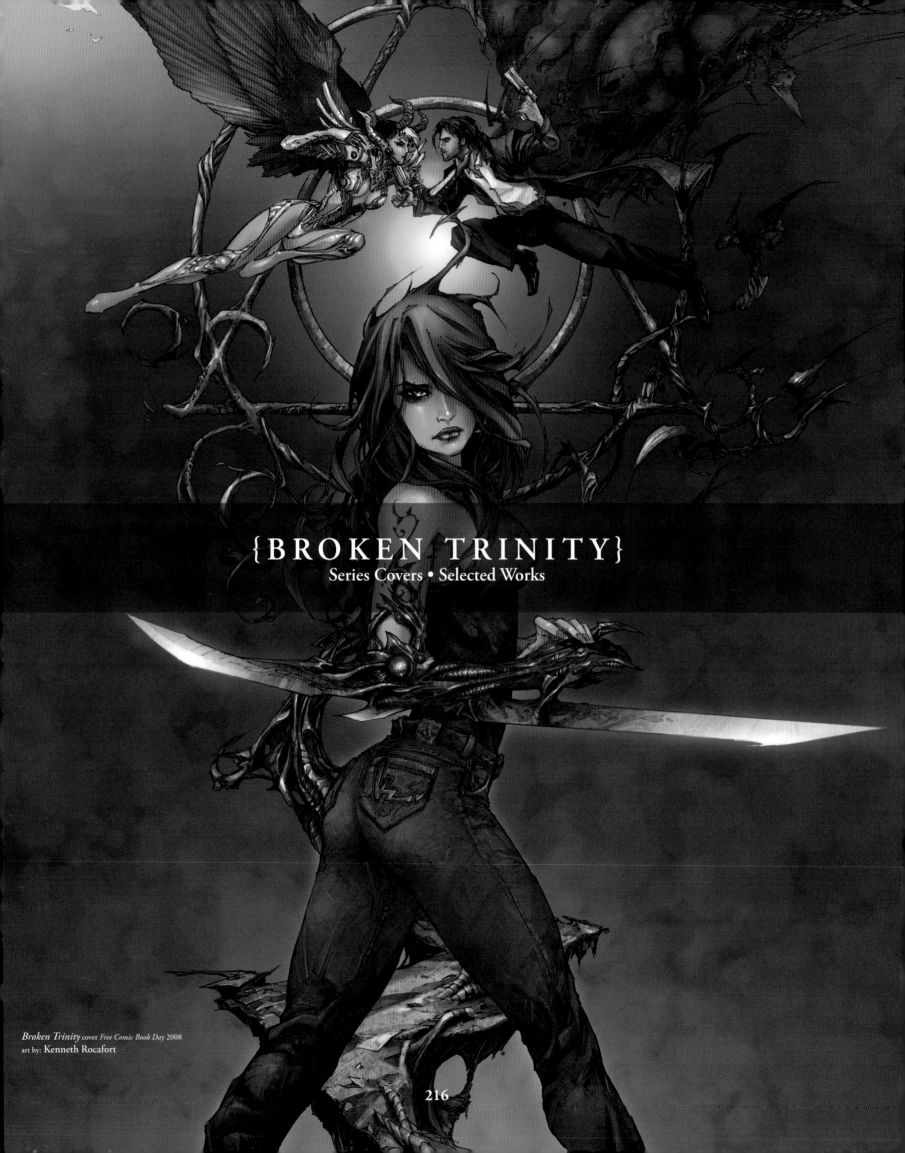

{BROKEN TRINITY}
Series Covers • Selected Works

Broken Trinity covet *Free Comic Book Day 2008*
art by: Kenneth Rocafort

216

Broken Trinity issue #2 cover variant

art by: Marc Silvestri, Joe Weems V and Frank D'Armata

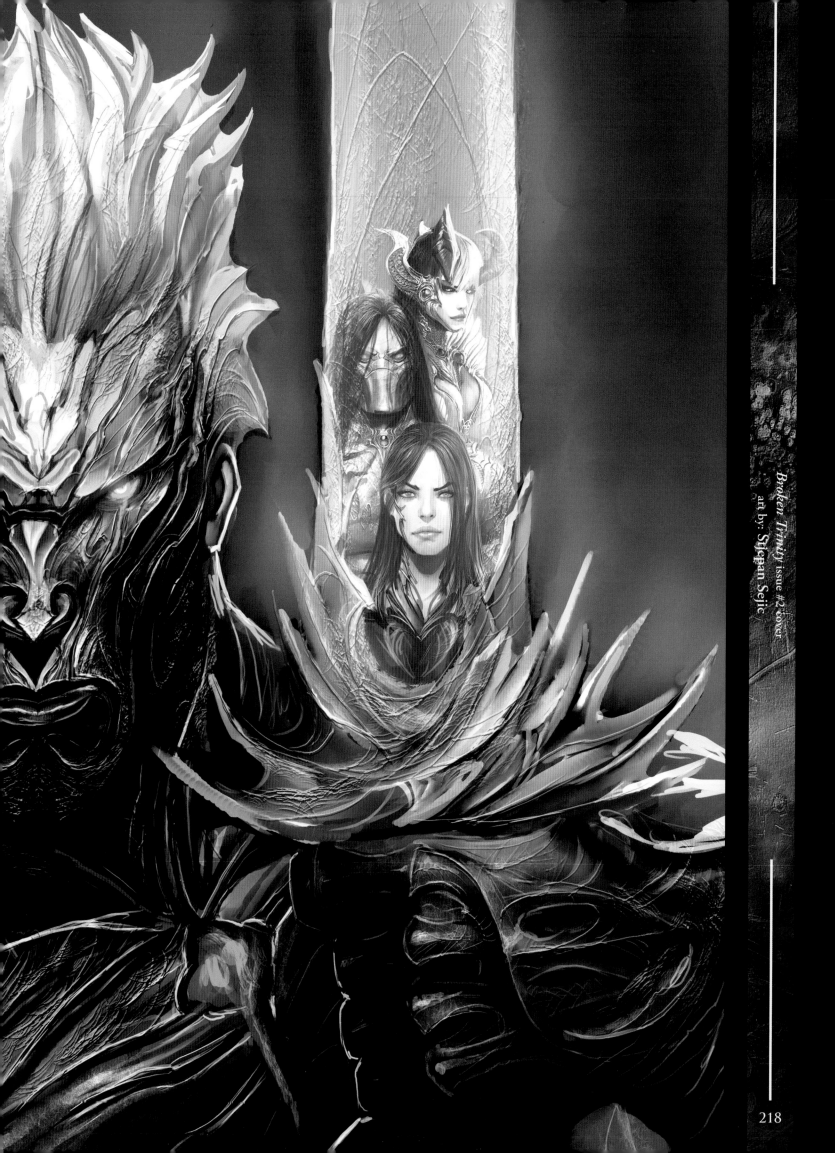

Broken Trinity issue #2 cover
art by: Stjepan Sejic

Broken Trinity issue #3 wraparound cover
art by: Stjepan Sejic

Broken Trinity issue #1-3 cover variant(s)
art by: Dale Keown

Broken Trinity: The Darkness/Angelus/Witchblade issue #1 tie-in cover B variants
art by: Jeffrey Spokes

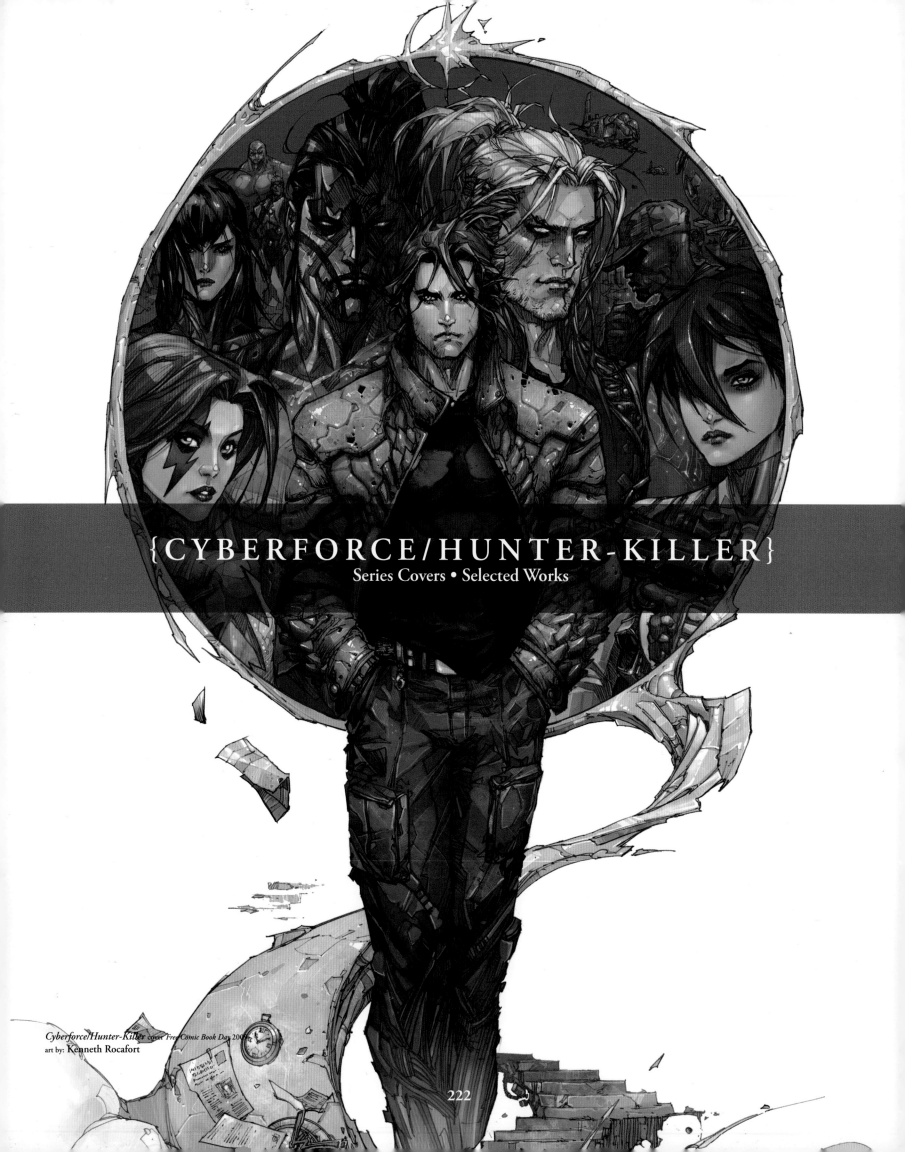

{CYBERFORCE/HUNTER-KILLER}
Series Covers • Selected Works

Cyberforce/Hunter-Killer cover Free Comic Book Day 2009
art by: Kenneth Rocafort

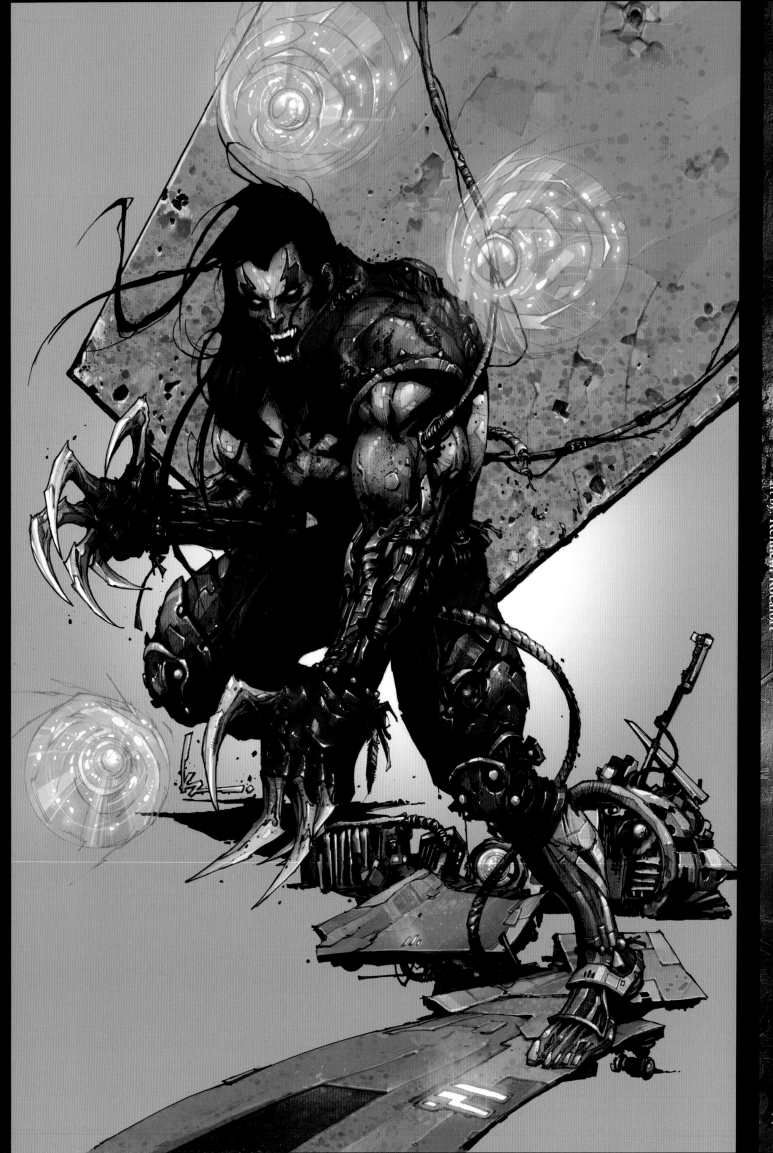

Cyberforce/Hunter-Killer issue #2 cover
art by: Kenneth Rocafort

Cyberforce/Hunter-Killer issue #2 cover variant
art by: Stjepan Sejic

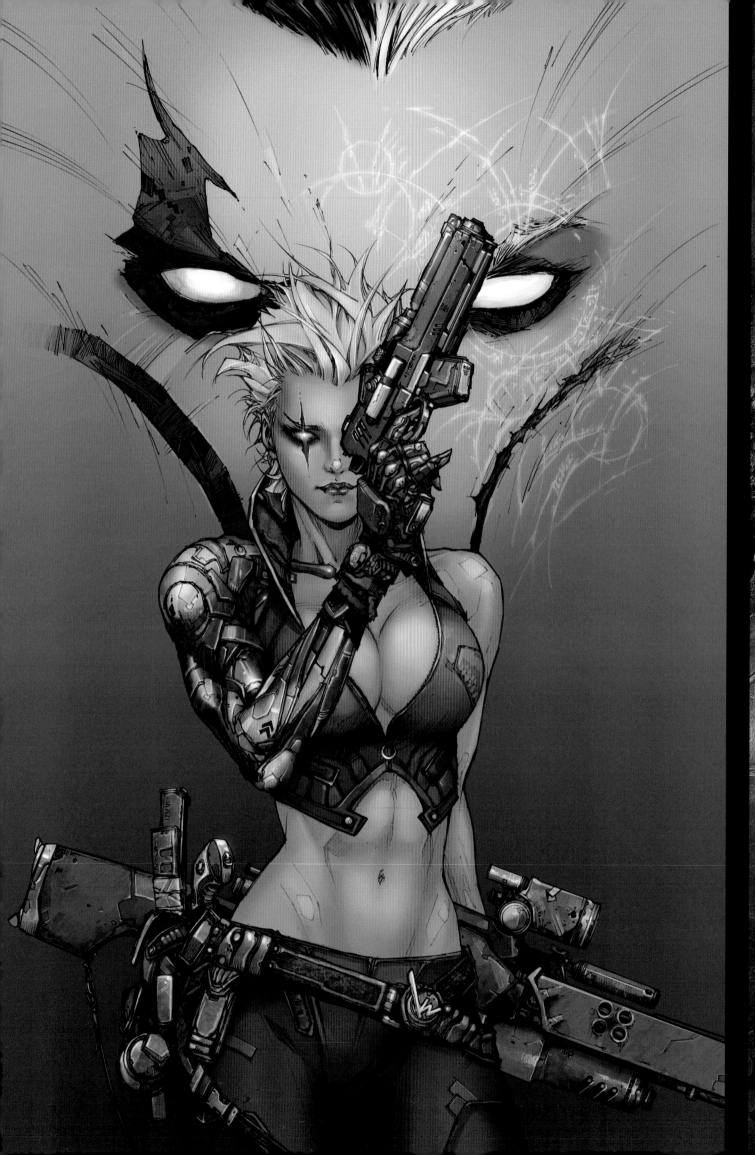

Cyberforce/Hunter-Killer issue #3 cover
art by: Kenneth Rocafort

Cyberforce/Hunter-Killer Issue #3 cover variant pencils
art by: Whilce Portacio

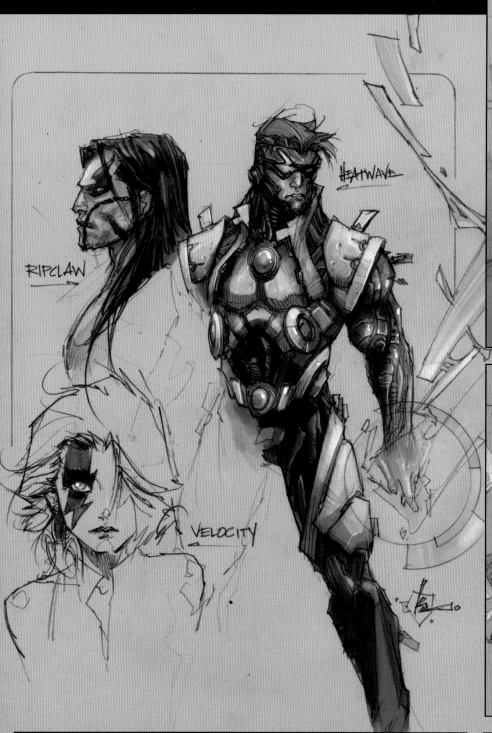

RIPCLAW

HEATWAVE

VELOCITY

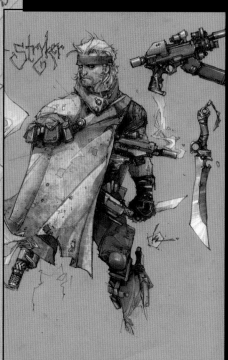

Stryker

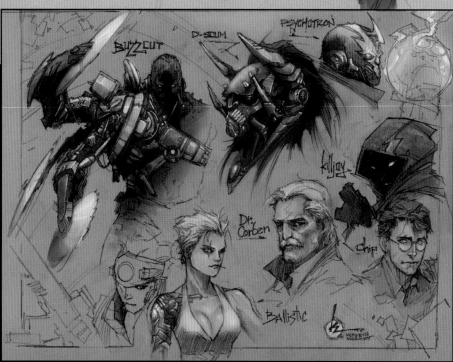

BUZZCUT

D-SCUM

PSYCHOTRON

Killjoy

Dr. Corben

chip

Ballistic

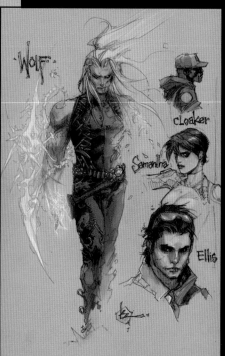

WOLF

cLoaker

Samantha

Ellis

Cyberforce/Hunter-Killer concept designs
art by: Kenneth Rocafort

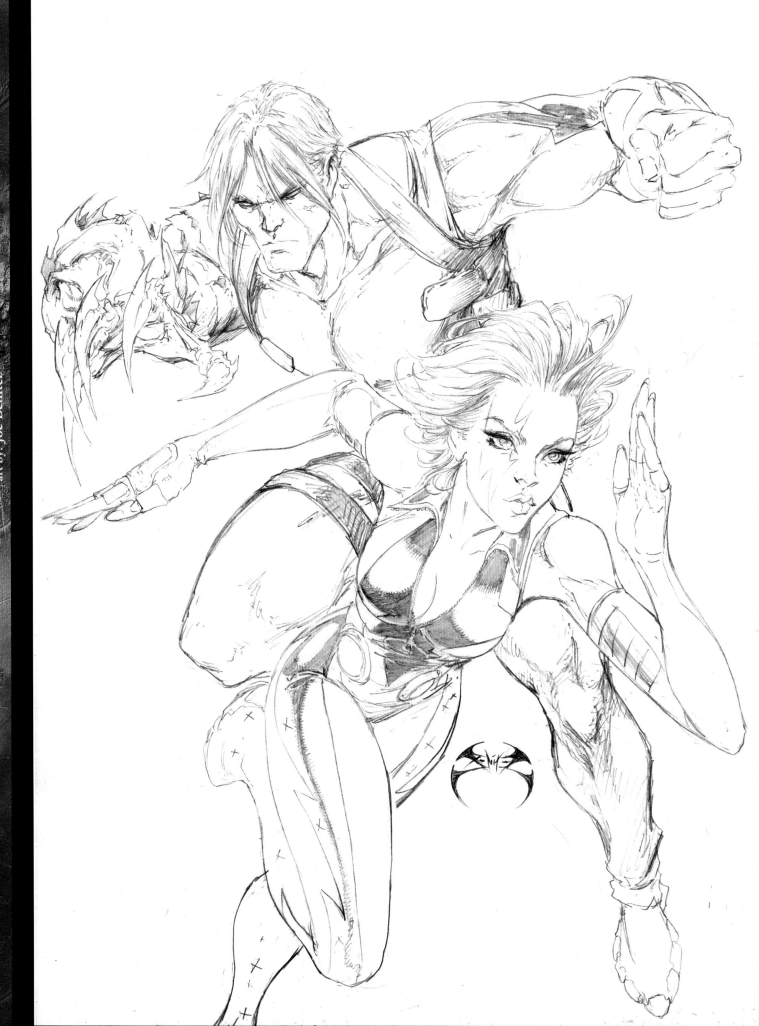

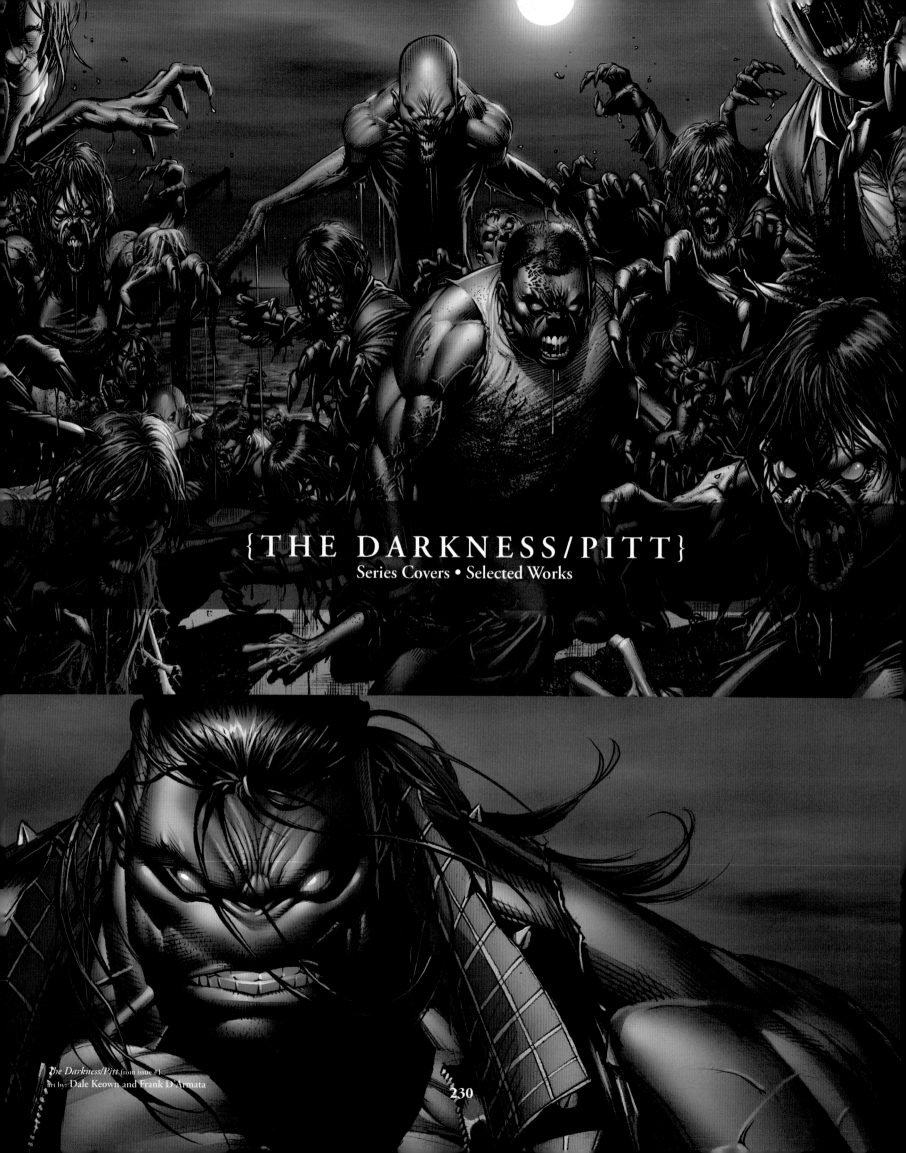

{THE DARKNESS/PITT}
Series Covers • Selected Works

The Darkness/Pitt from issue #1
art by: Dale Keown and Frank D'Armata

230

The Darkness/Pitt issue #1 cover A
art by: Dale Keown

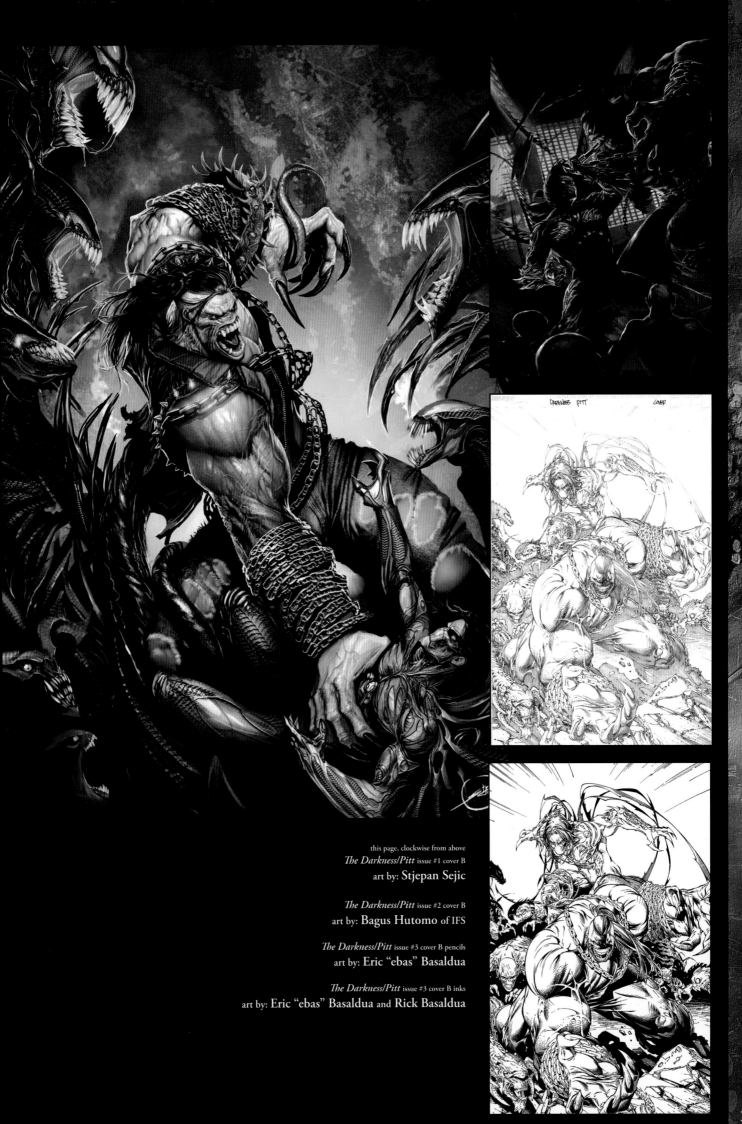

this page, clockwise from above
The Darkness/Pitt issue #1 cover B
art by: **Stjepan Sejic**

The Darkness/Pitt issue #2 cover B
art by: **Bagus Hutomo** of IFS

The Darkness/Pitt issue #3 cover B pencils
art by: **Eric "ebas" Basaldua**

The Darkness/Pitt issue #3 cover B inks
art by: **Eric "ebas" Basaldua** and **Rick Basaldua**

{GALLERY}
Posters • Covers • Selected Works

Top Cow Jam Poster 2003
art by: Marc Silvestri, Eric "ebas" Basaldua, Francis Manapul,
Matt "Batt" Banning and Steve Firchow

234

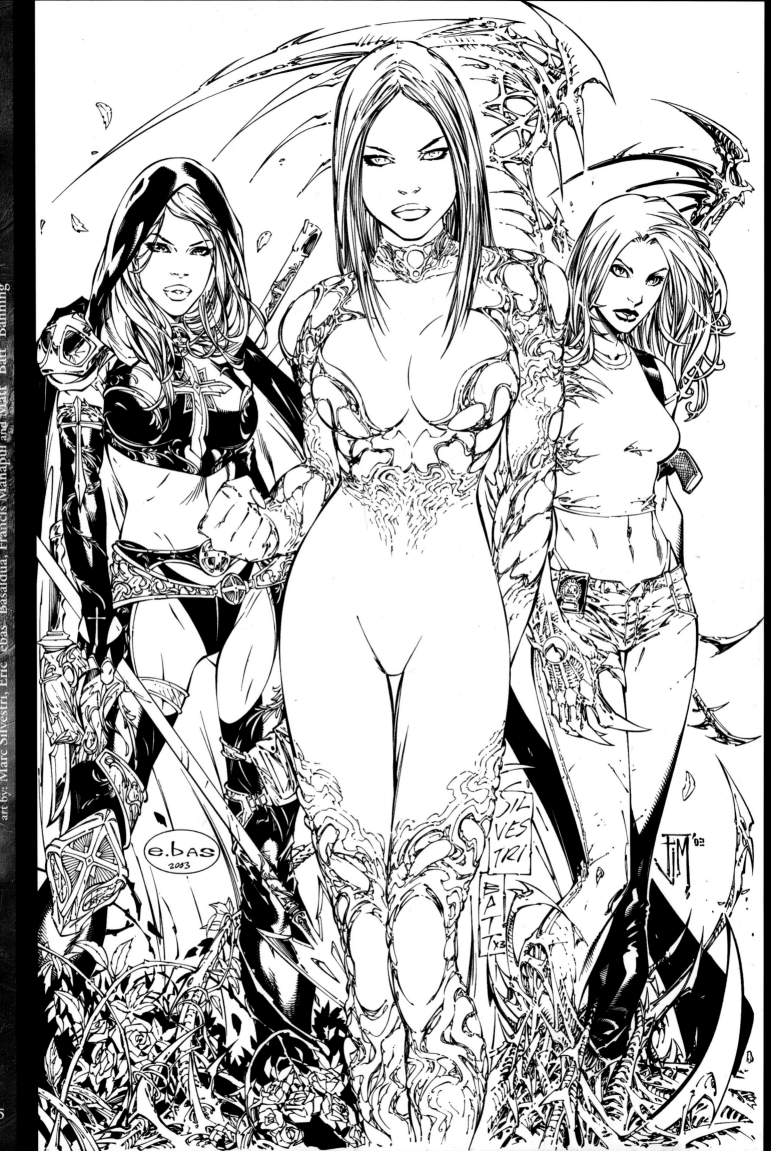

Top Cow Jam Poster 2003 inks

art by: Marc Silvestri, Eric "ebas" Basaldua, Francis Manapul and Matt "Batt" Banning

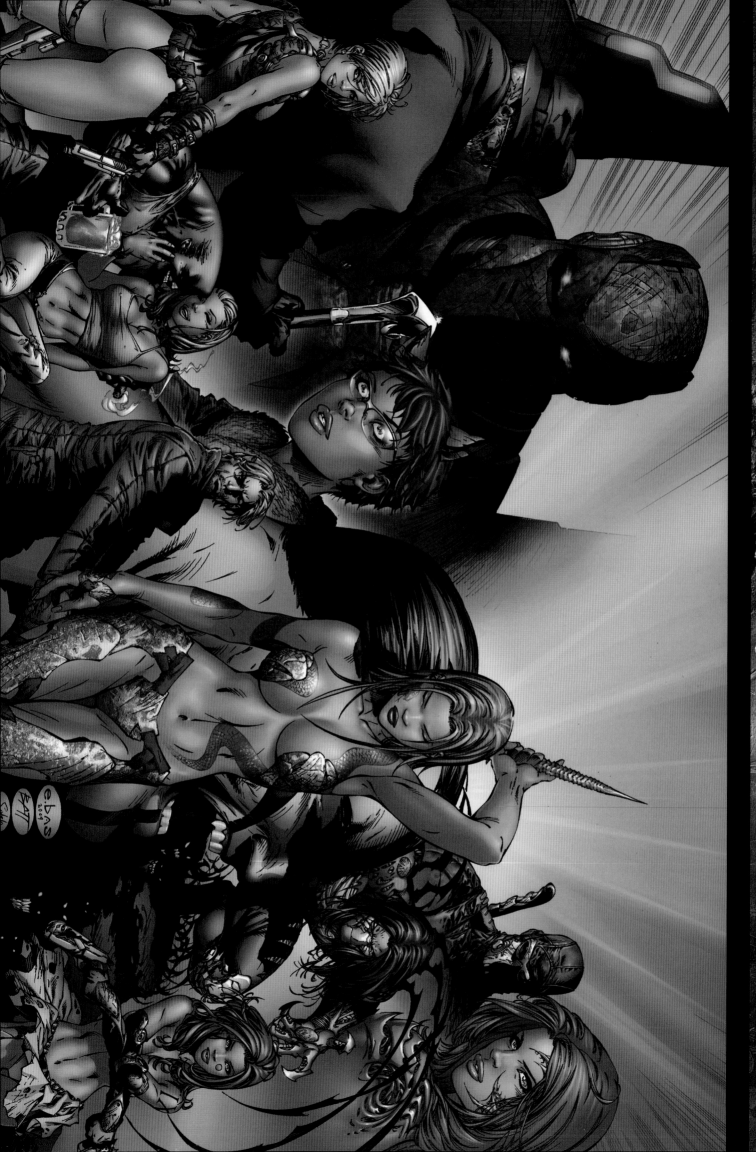

Top Cow Sketchbook cover 2004
art by: Eric "eBas" Basaldua, Matt "Batt" Banning and Beth Sotelo

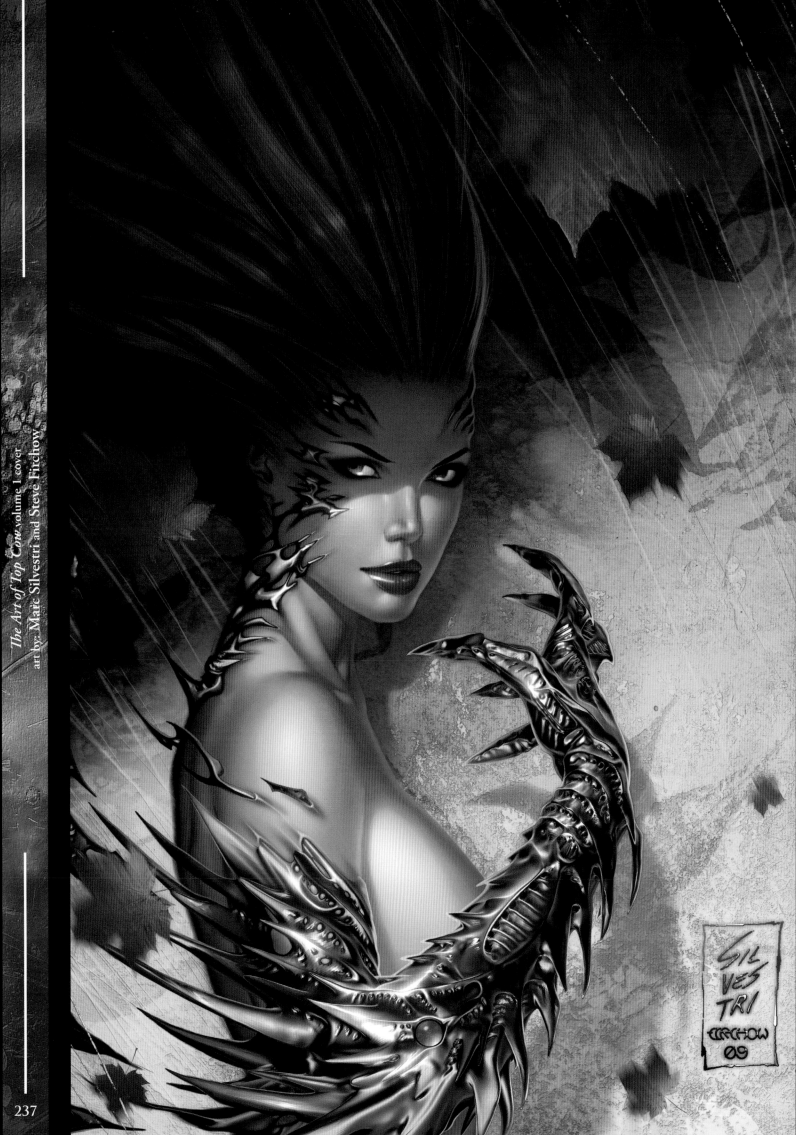

The Art of Top Cow volume 1 cover
art by: Marc Silvestri and Steve Firchow

{ THE AGENCY }
Series Covers • Selected Works

The Agency issue #1 cover
art by: Kyle Hotz and Matt Nelson

238

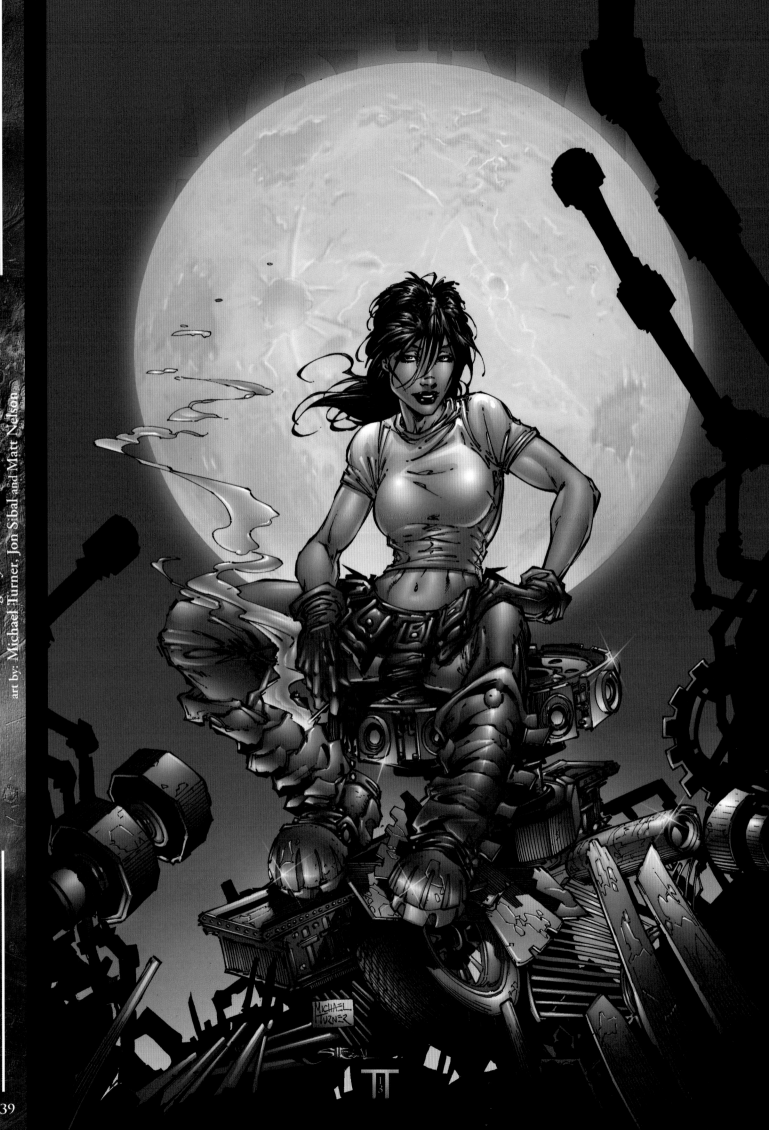

The Agency issue #1 cover variant
art by: Michael Turner, Jon Sibal and Matt Nelson

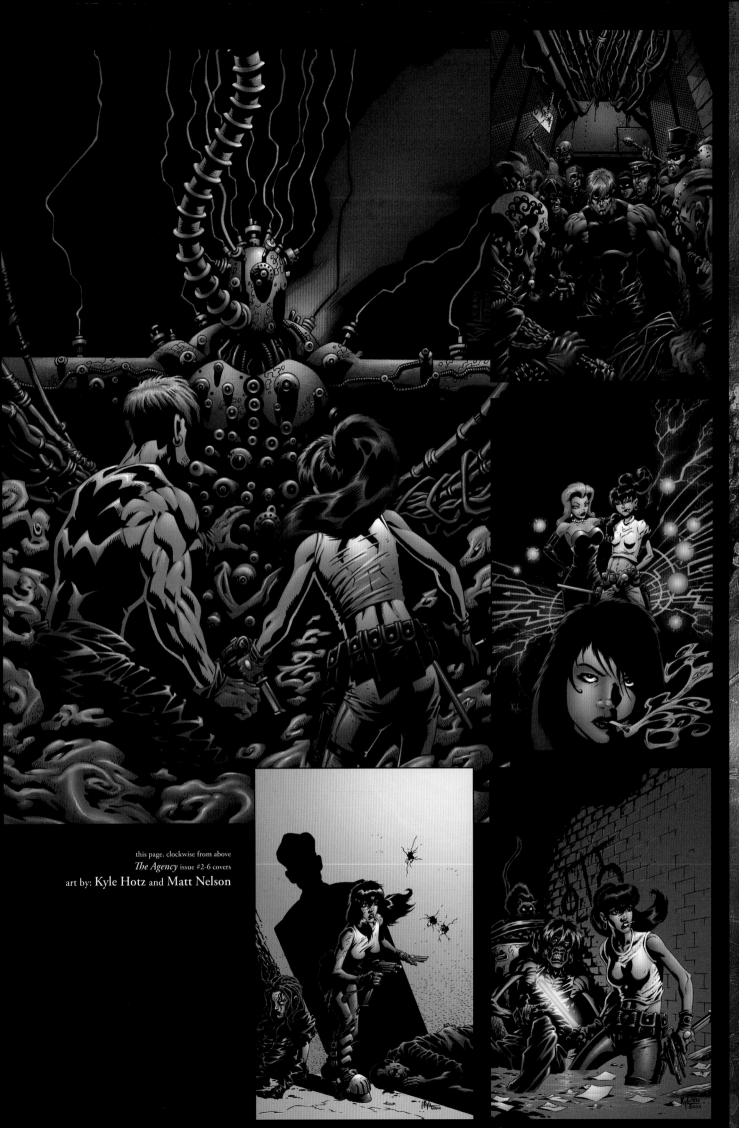

this page, clockwise from above
The Agency issue #2-6 covers
art by: Kyle Hotz and Matt Nelson

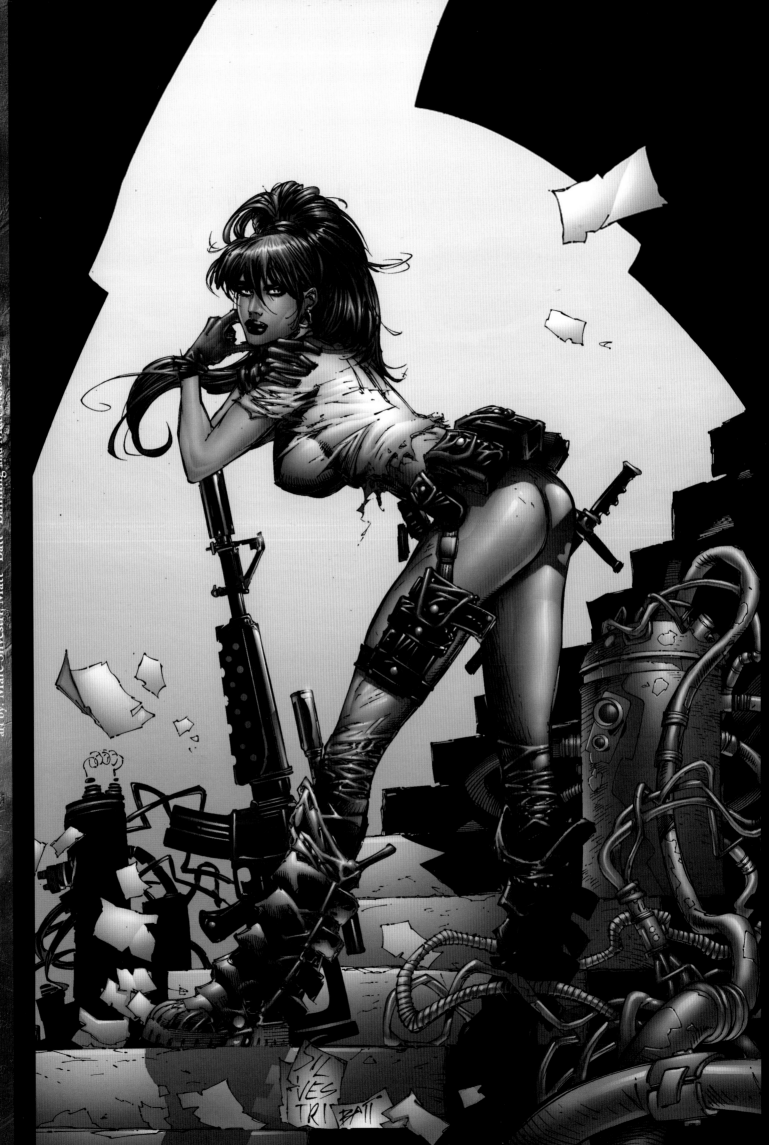

The Agency issue #1 cover variant

art by: Marc Silvestri; Matt "Batt" Banning and Matt Nelson

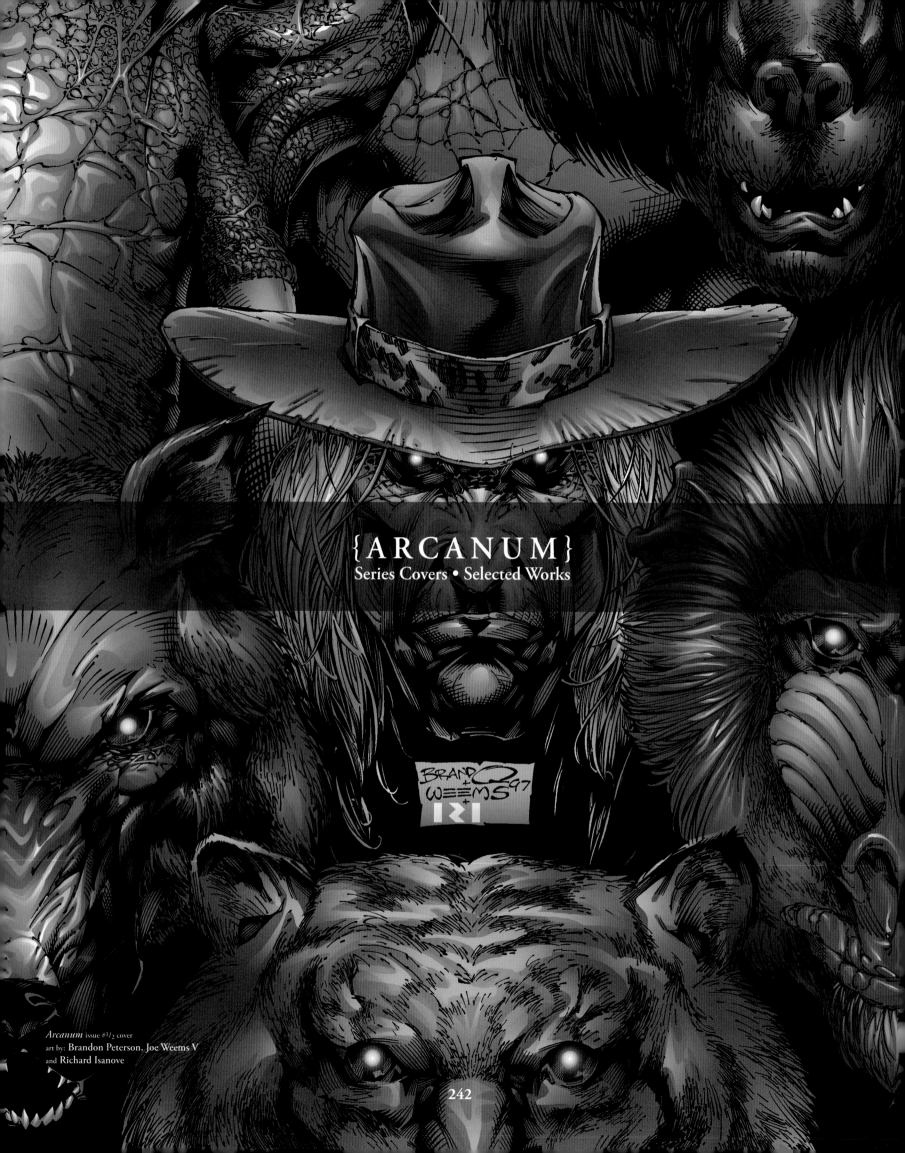

{ARCANUM}
Series Covers • Selected Works

Arcanum issue #1/2 cover
art by: Brandon Peterson, Joe Weems V
and Richard Isanove

242

Arcanum trade paperback cover
art by: Brandon Peterson, Matt "Batt" Banning and Steve Firchow

243

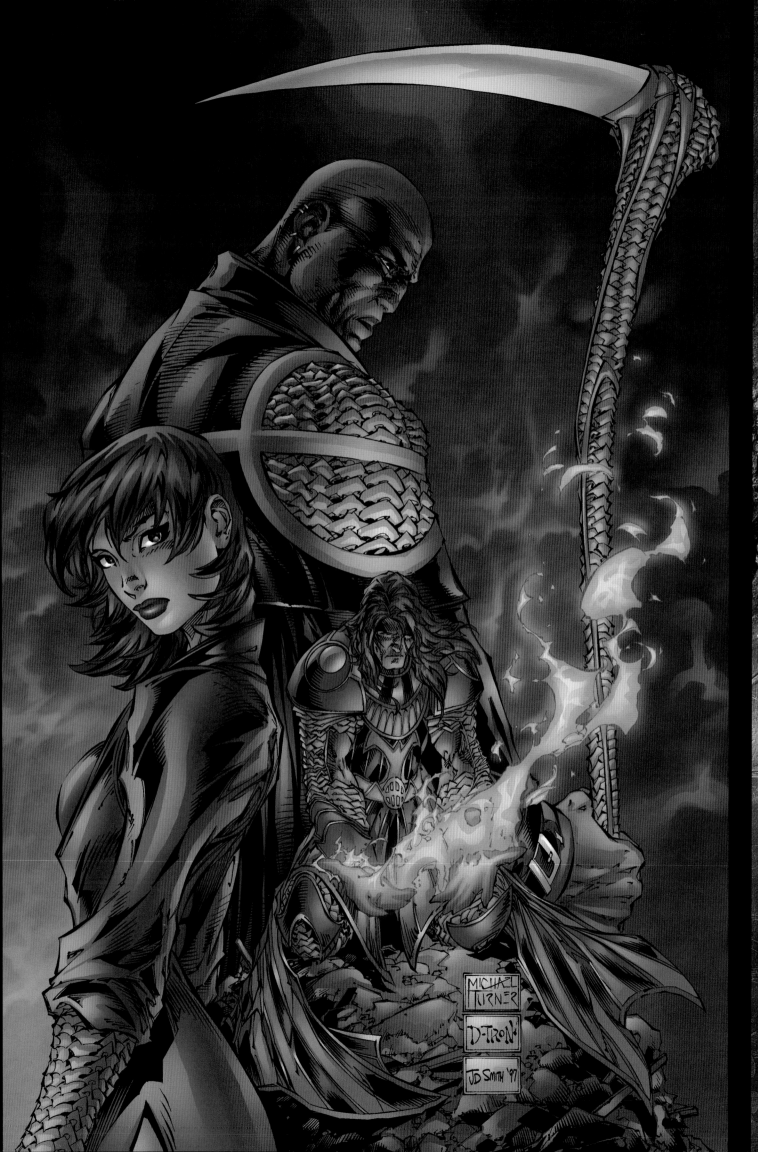

Arcanum issue #4 variant cover
art by: Michael Turner, D-Tron and JD Smith

MICHAEL
TURNER

D-TRON

JD SMITH '97

Arcanum issue #4 cover

art by: Brandon Peterson, Joe Weems V and Richard Isanove

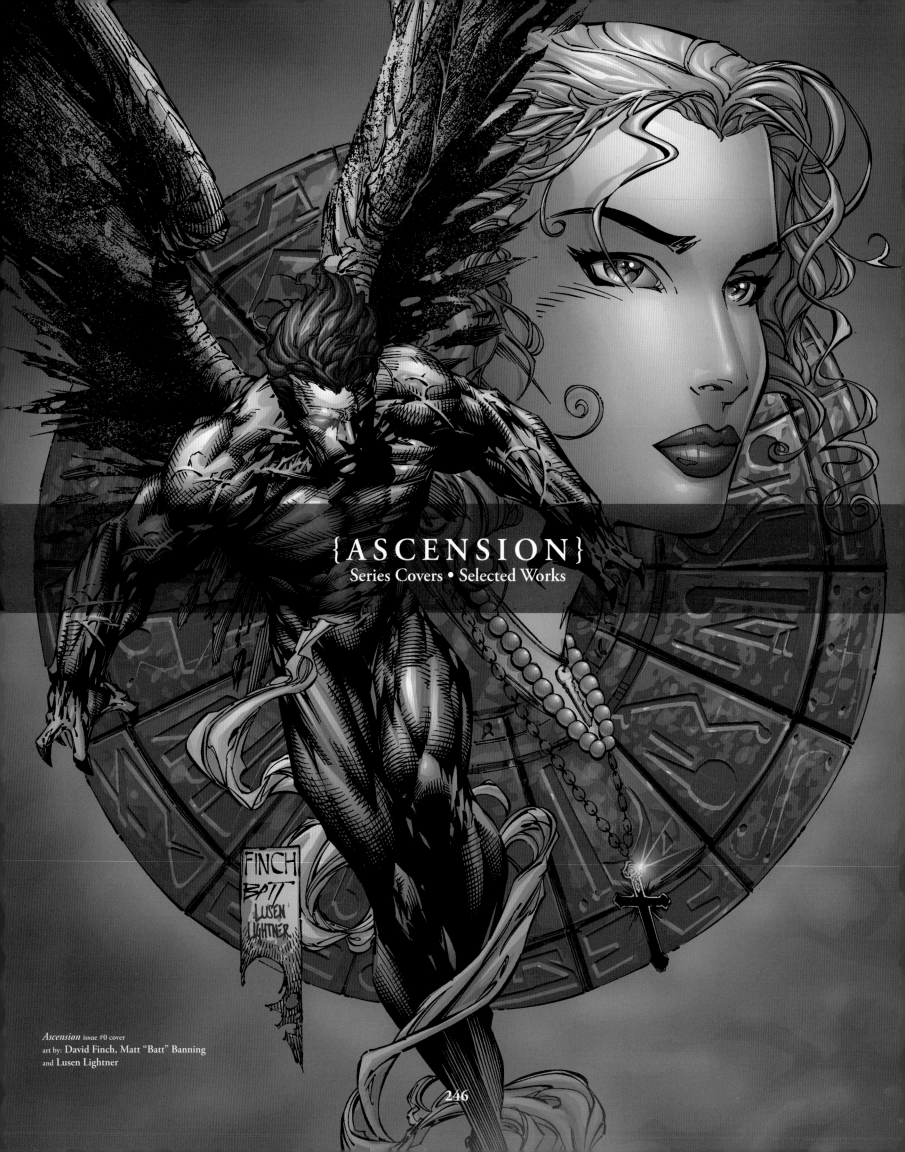

{ASCENSION}
Series Covers • Selected Works

Ascension issue #0 cover
art by: David Finch, Matt "Batt" Banning
and Lusen Lightner

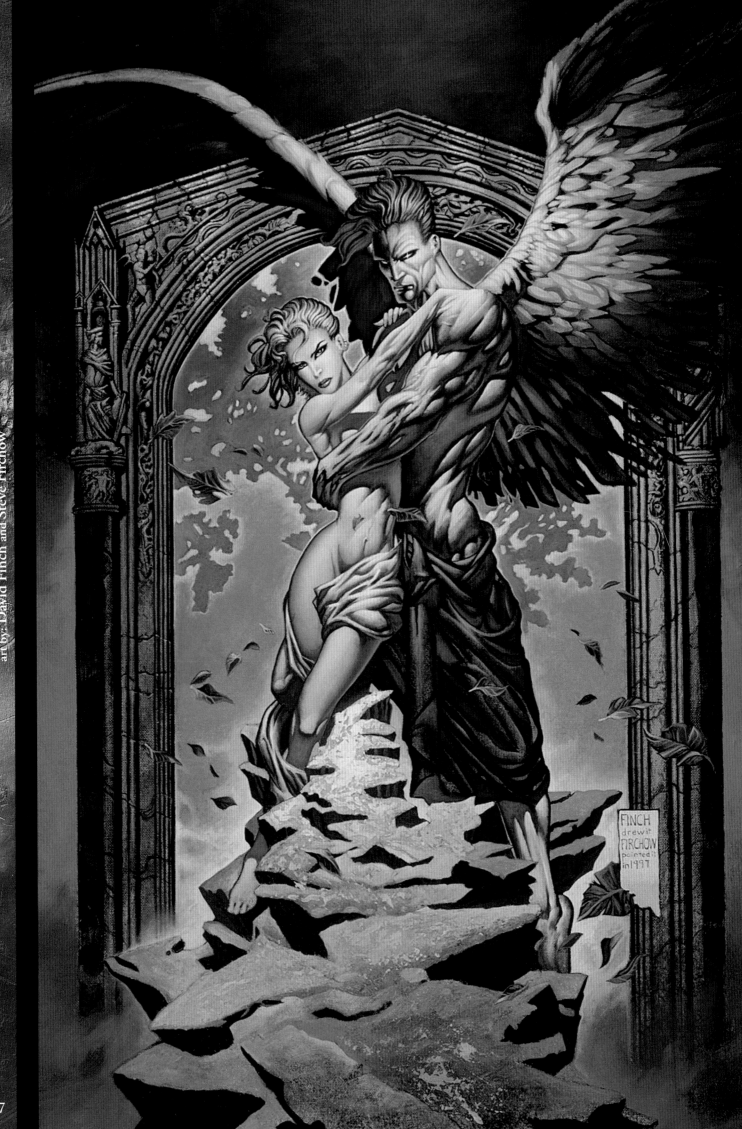

"Ascension"

art by: David Finch and Steve Firchow

FINCH
drew it
FIRCHOW
painted it
in 1997

Ascension issue #1 page 4 and 5 pencils
art by: David Finch

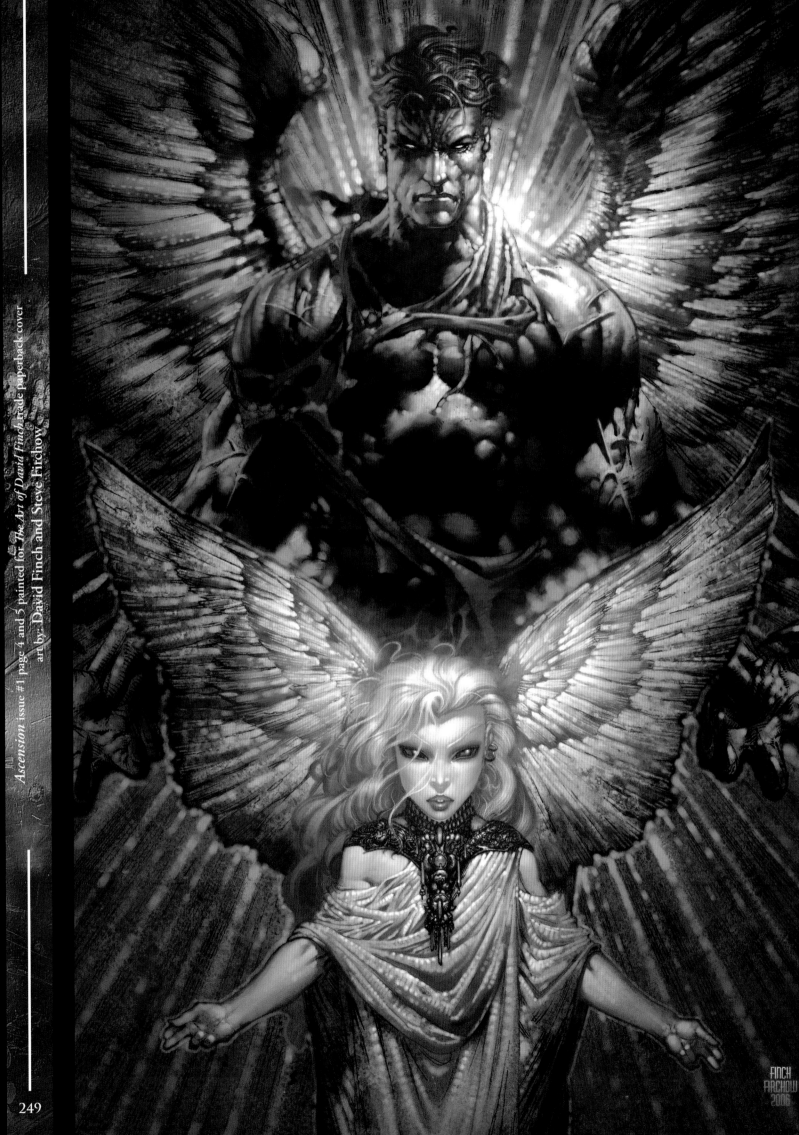

Ascension issue #1 page 4 and 5 painted for *The Art of David Finch* trade paperback cover
art by: David Finch and Steve Firchow

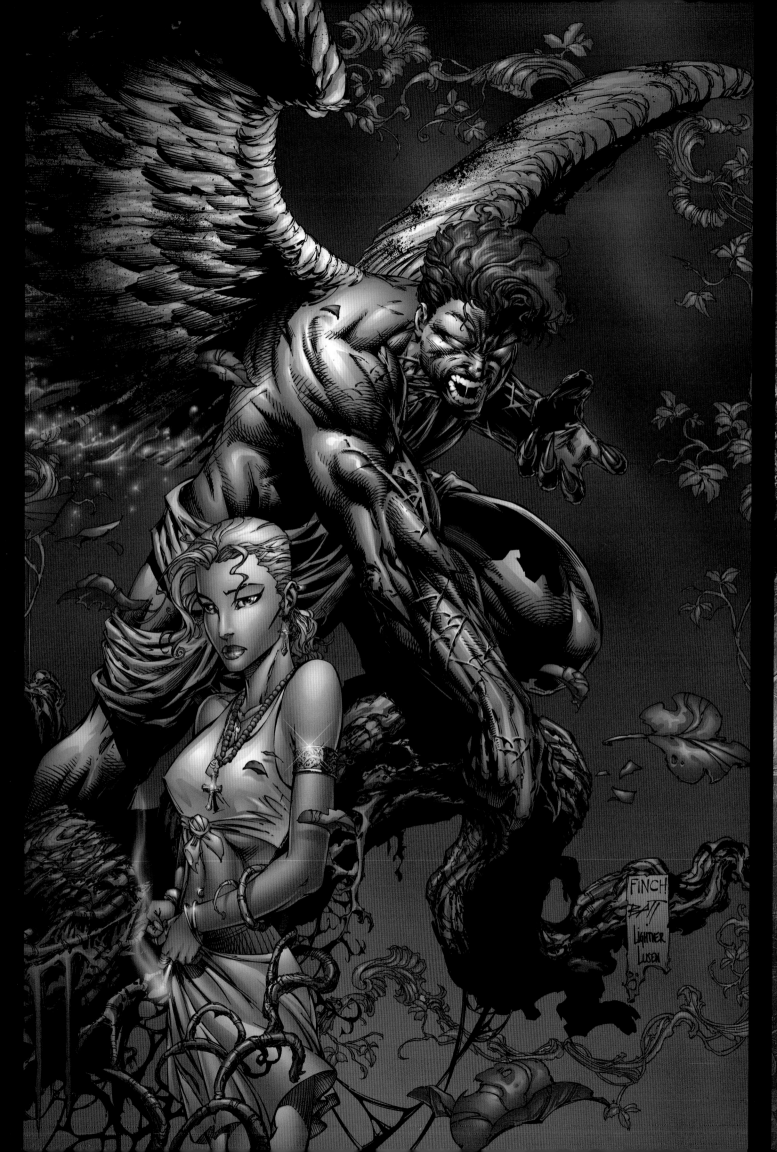

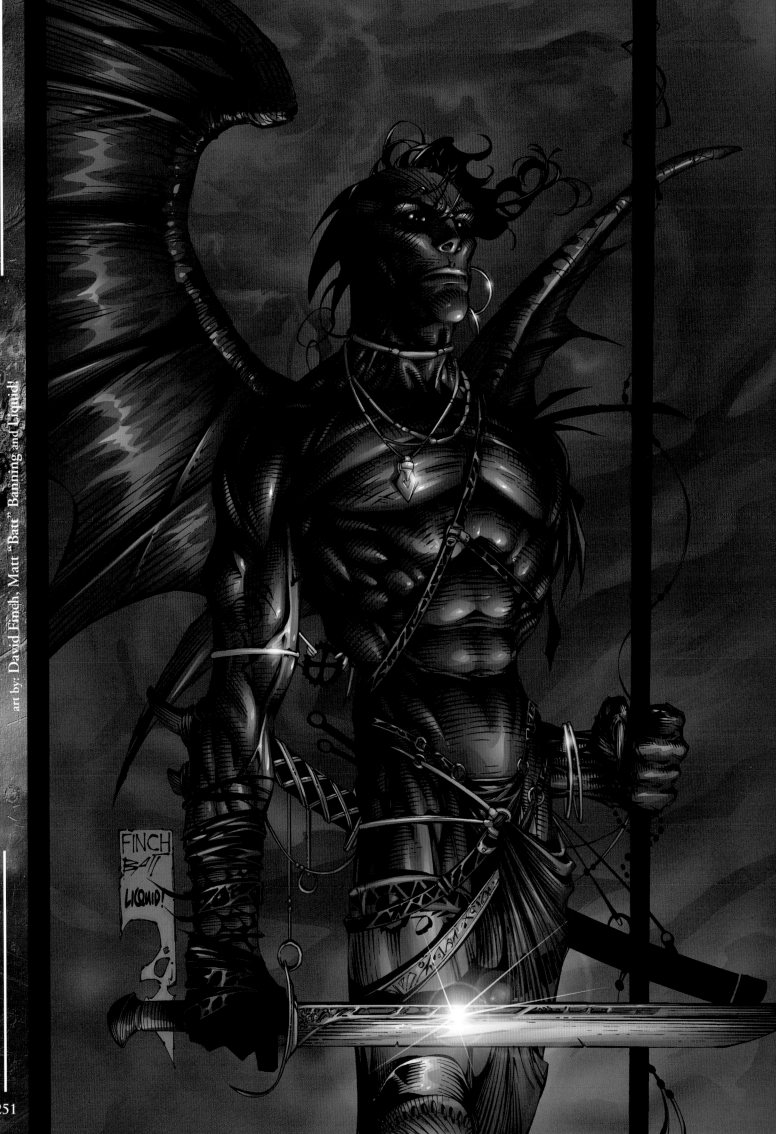

Ascension issue #2 cover

art by: David Finch, Matt "Batt" Banning and Liquid!

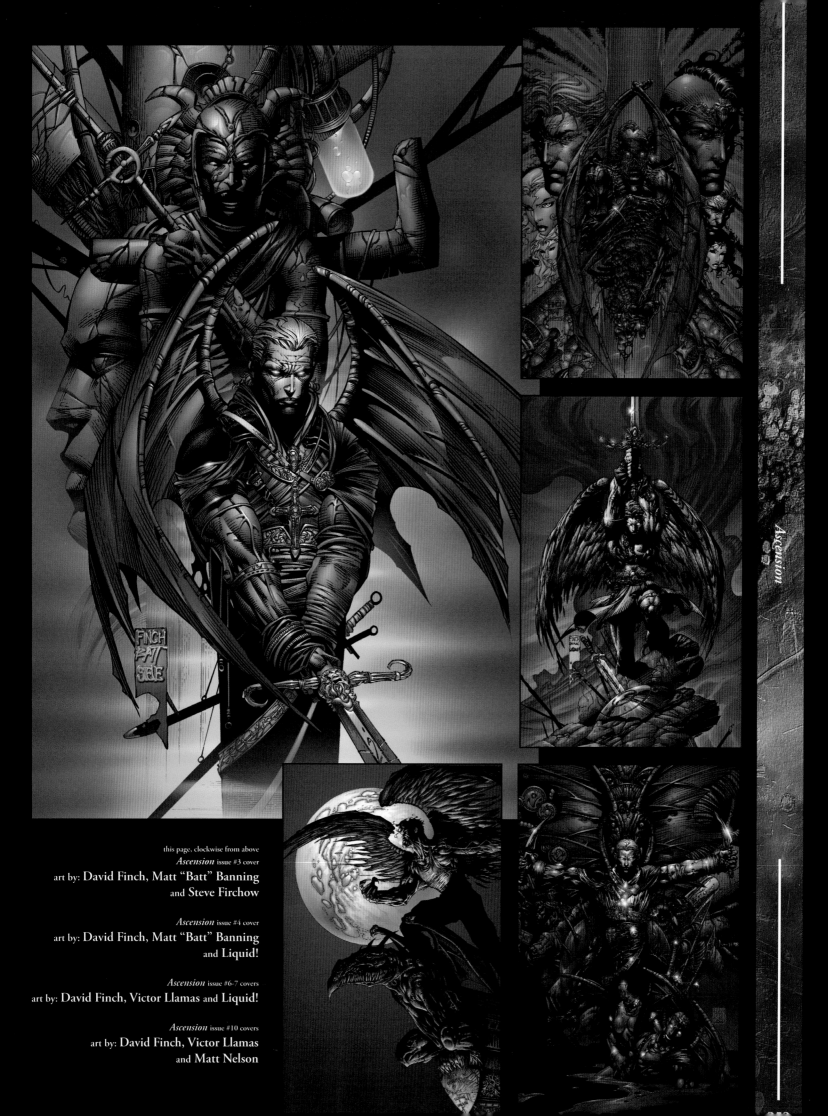

this page, clockwise from above
Ascension issue #3 cover
art by: David Finch, Matt "Batt" Banning
and Steve Firchow

Ascension issue #4 cover
art by: David Finch, Matt "Batt" Banning
and Liquid!

Ascension issue #6-7 covers
art by: David Finch, Victor Llamas and Liquid!

Ascension issue #10 covers
art by: David Finch, Victor Llamas
and Matt Nelson

Ascension issue #11 cover
art by: David Finch

FINCH
98-

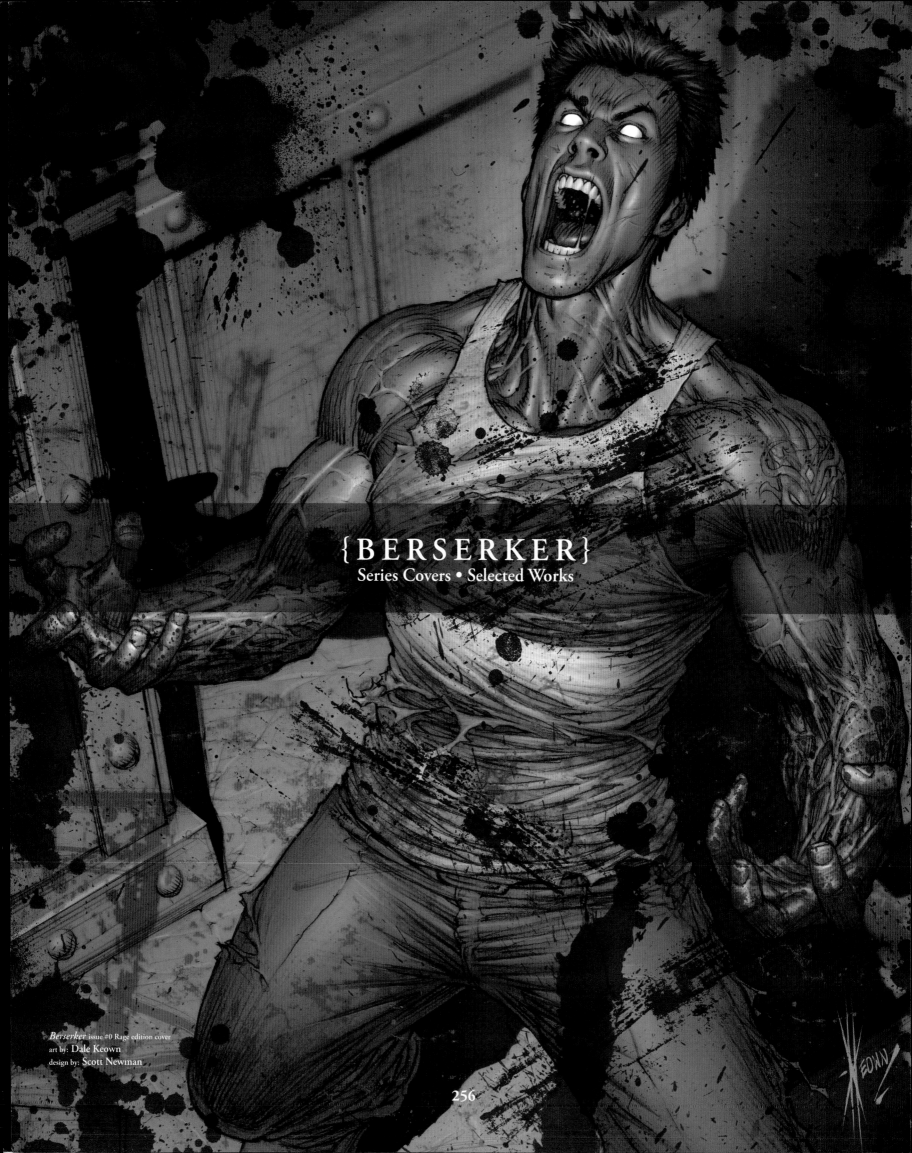

{ B E R S E R K E R }
Series Covers • Selected Works

Berserker issue #0 Rage edition cover
art by: Dale Keown
design by: Scott Newman

Berserker issue #0 cover
art by: Dale Keown

257

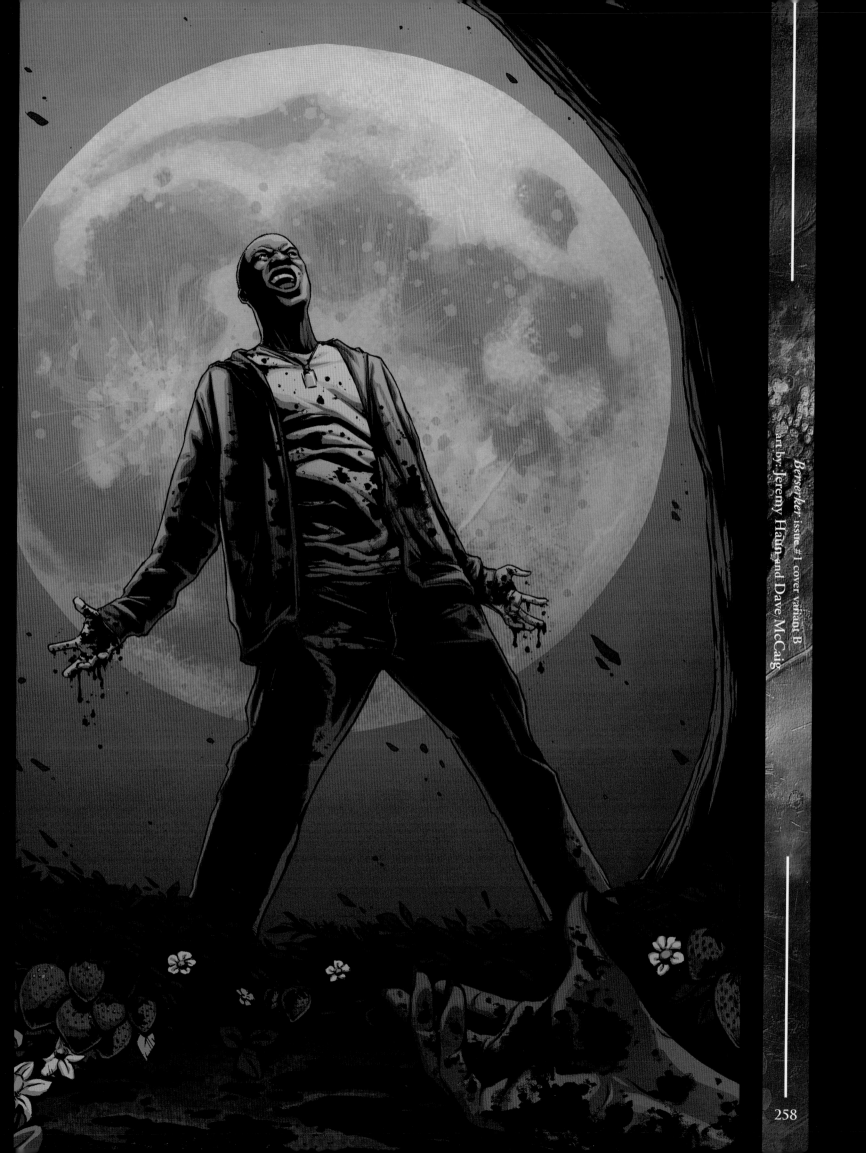

Berserker issue #1 cover variant B
art by: Jeremy Haun and Dave McCaig

Berserker issue #1 cover A
art by: Dale Keown

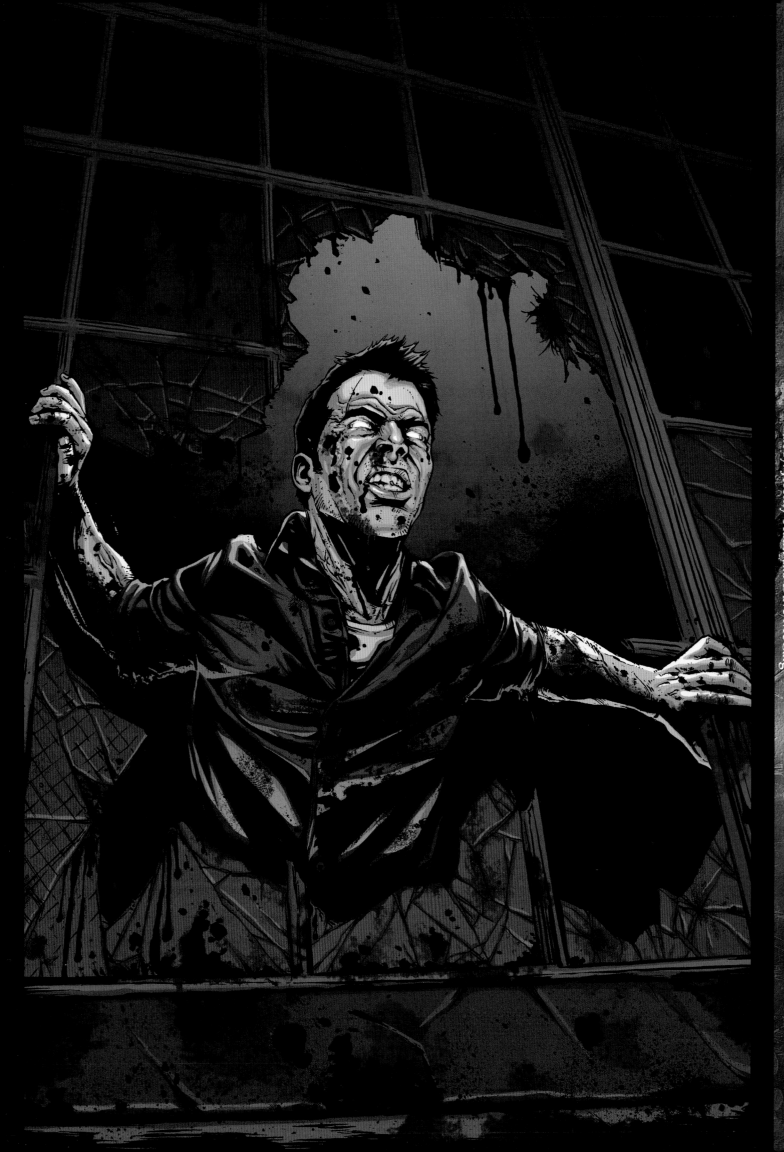

Berserker issue #2 cover variant B
art by: Jeremy Haun and Dave McCaig

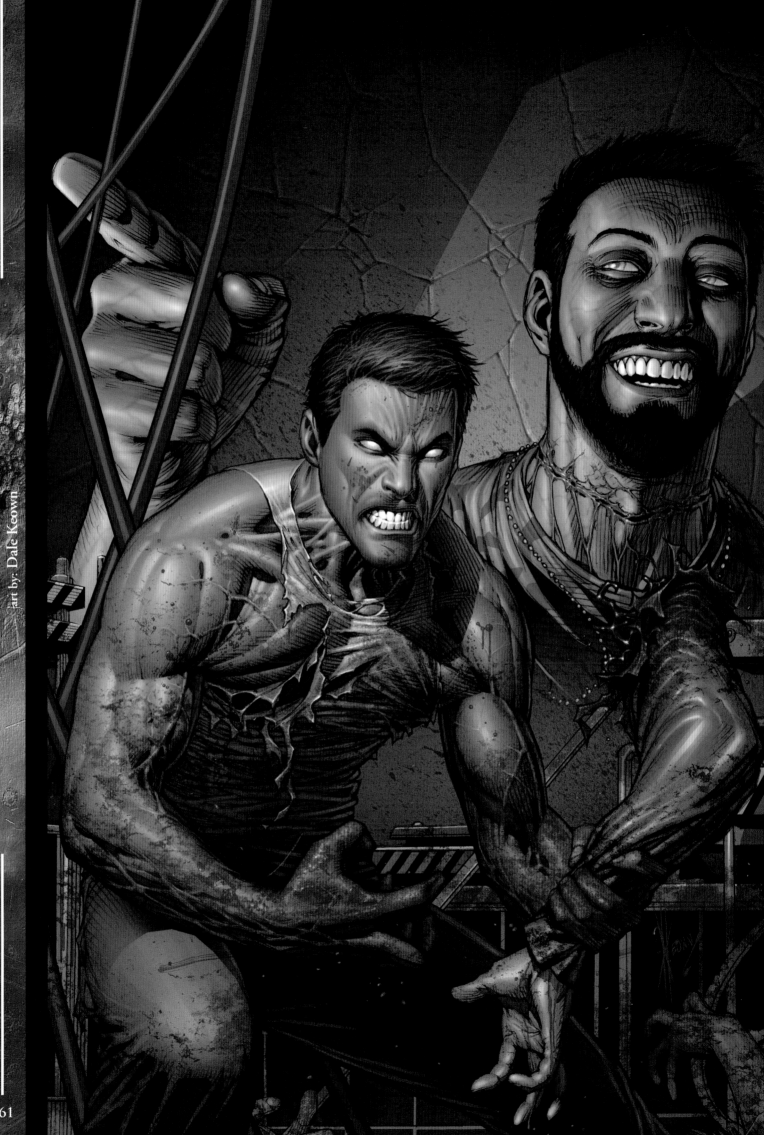

Berserker issue #2 cover A
art by: Dale Keown

Berserker issue #3 cover A
art by: Dale Keown

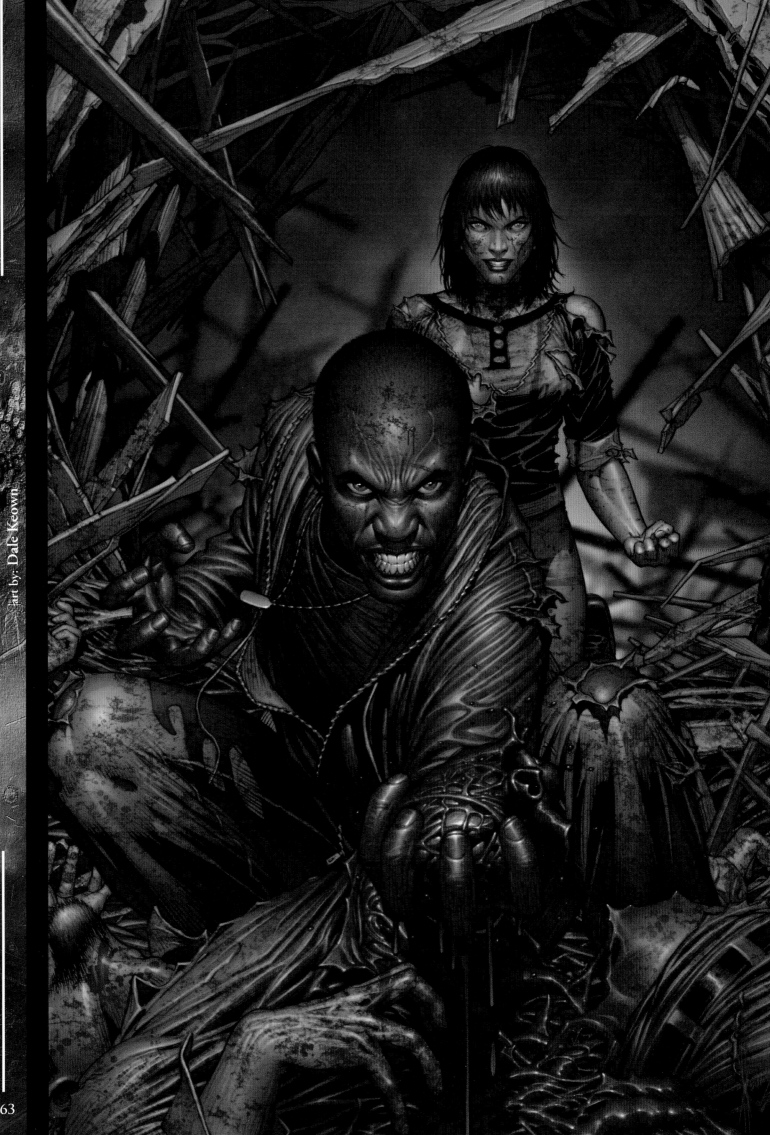

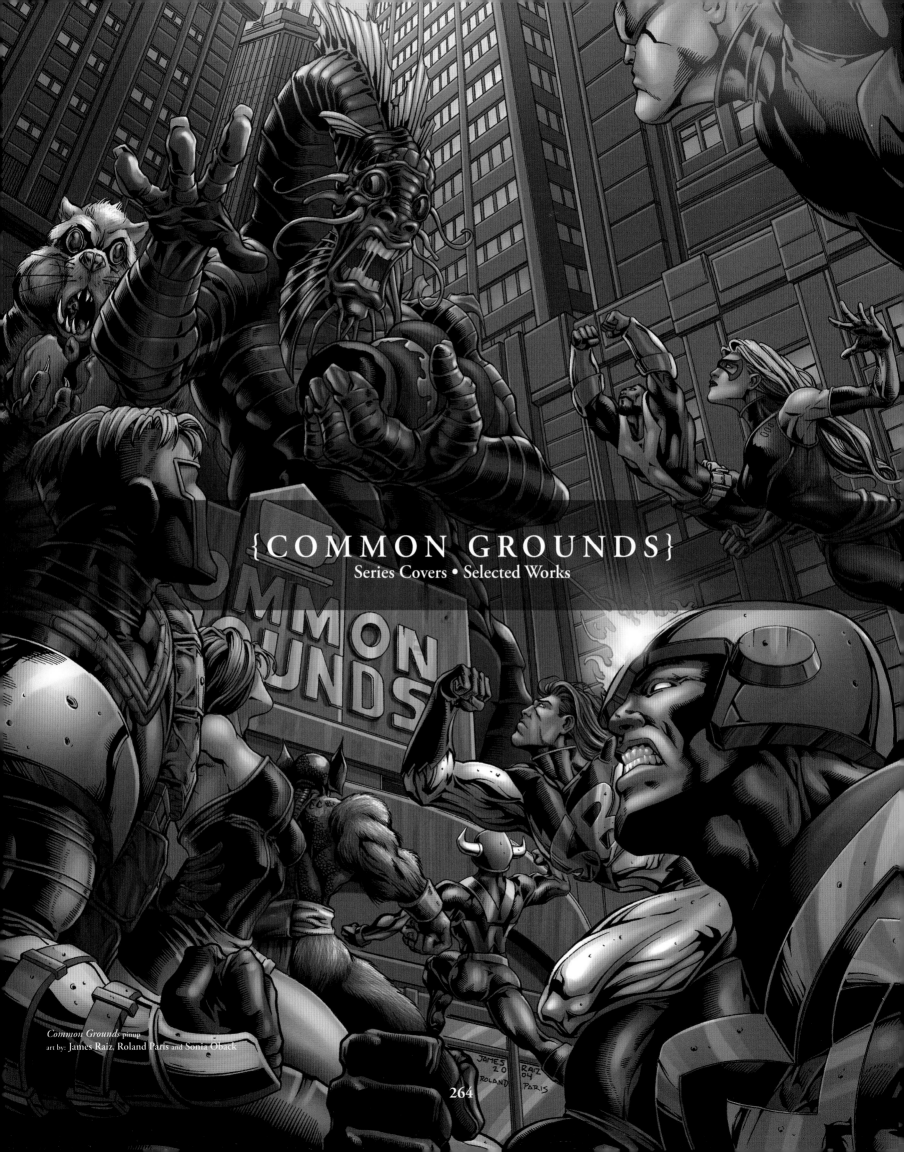

{COMMON GROUNDS}
Series Covers • Selected Works

Common Grounds pinup
art by: James Raiz, Roland Paris and Sonia Oback

264

Common Grounds issue #1 alternate cover
art by: J. Scott Campbell and Matt Milla

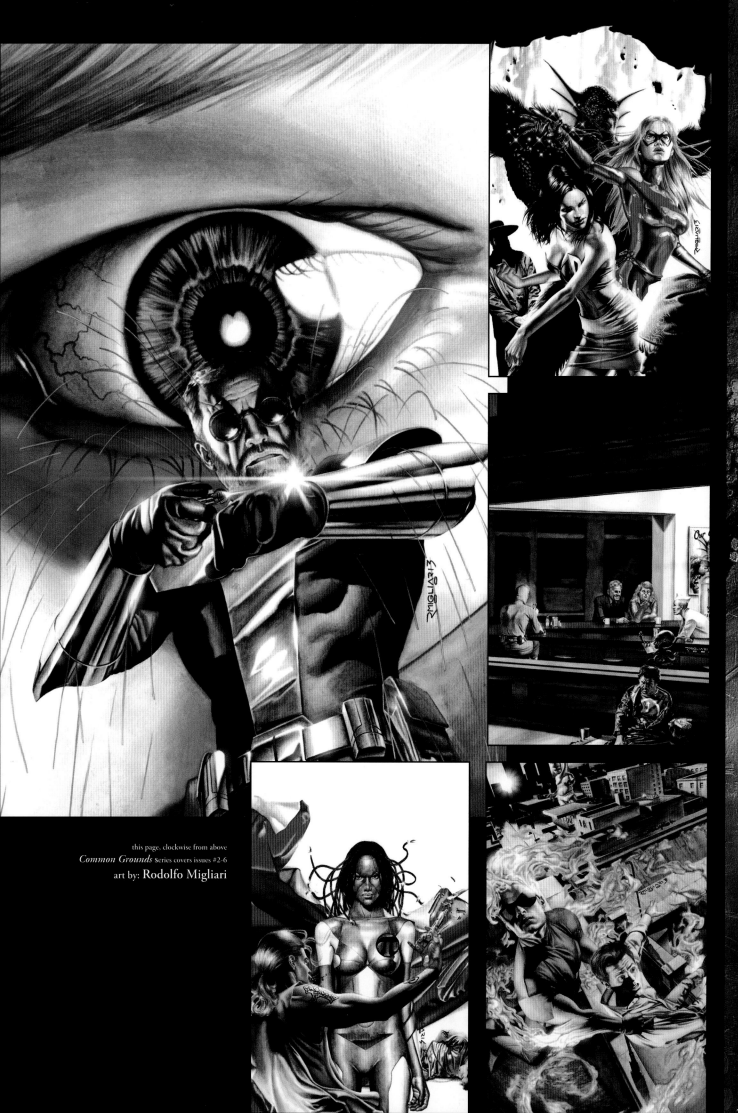

this page, clockwise from above
Common Grounds series covers issues #2-6
art by: Rodolfo Migliari

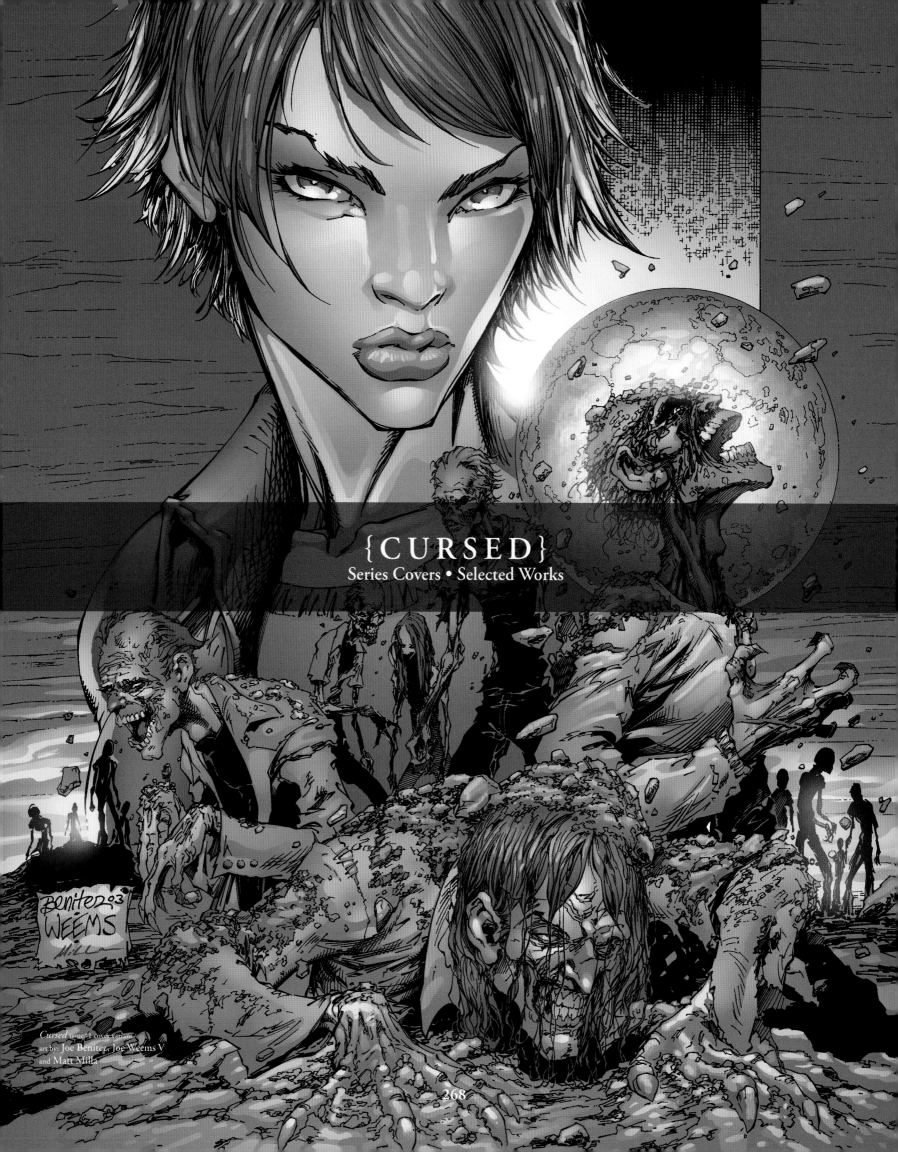

{CURSED}
Series Covers • Selected Works

Cursed issue 1 cover variant
art by: Joe Benitez, Joe Weems V
and Matt Milla

268

Cursed Issue #1 cover

art by: Romano Molenaar, Sal Regla and Brian Buccellato

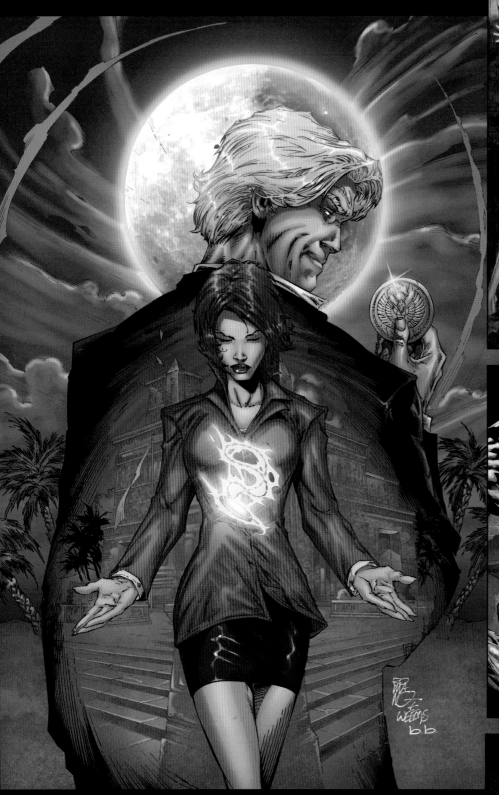

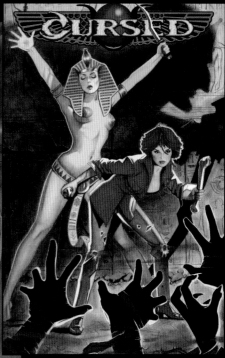

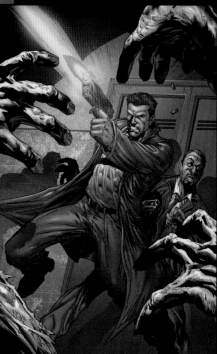

this page, clockwise from above
Cursed issue #2 cover
art by: Romano Molenaar, Joe Weems V and Brian Buccellato

Cursed issue #2 cover variant
art by: Jim Silke

Cursed issue #3-4 covers
art by: Romano Molenaar, Kevin Conrad and Brian Buccellato

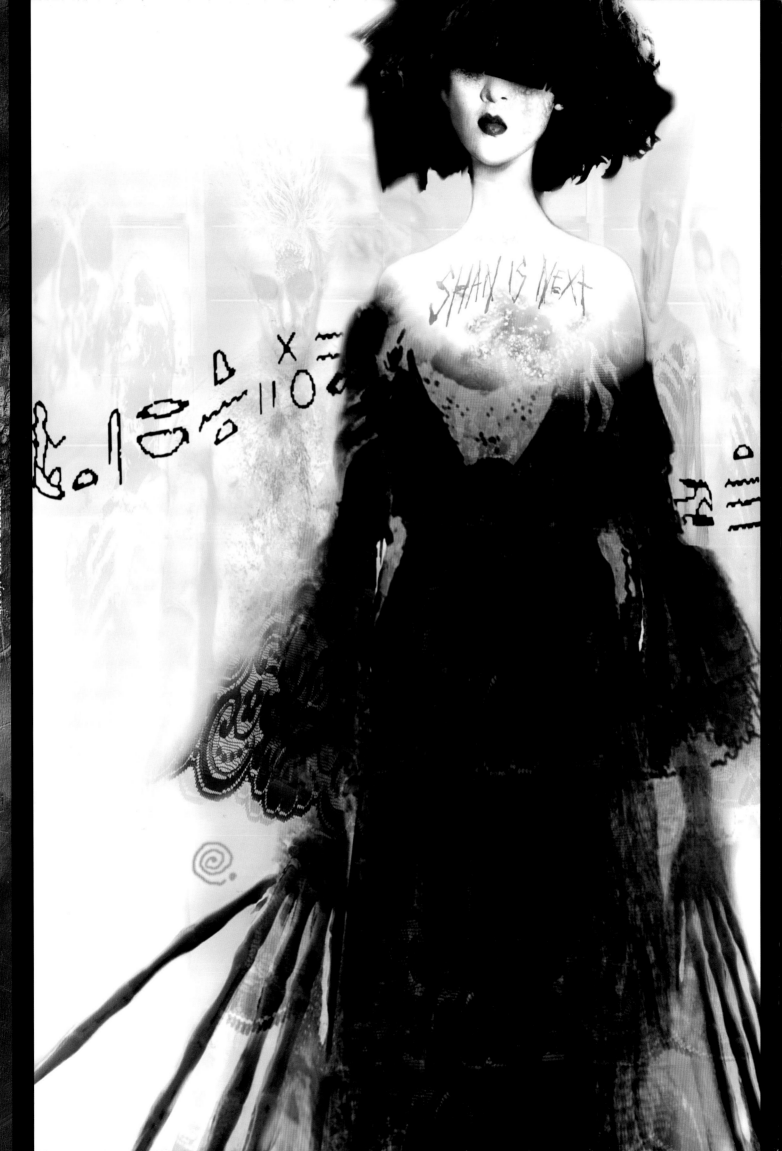

Cursed issue #3 cover variant
art by: Chris Bachalo

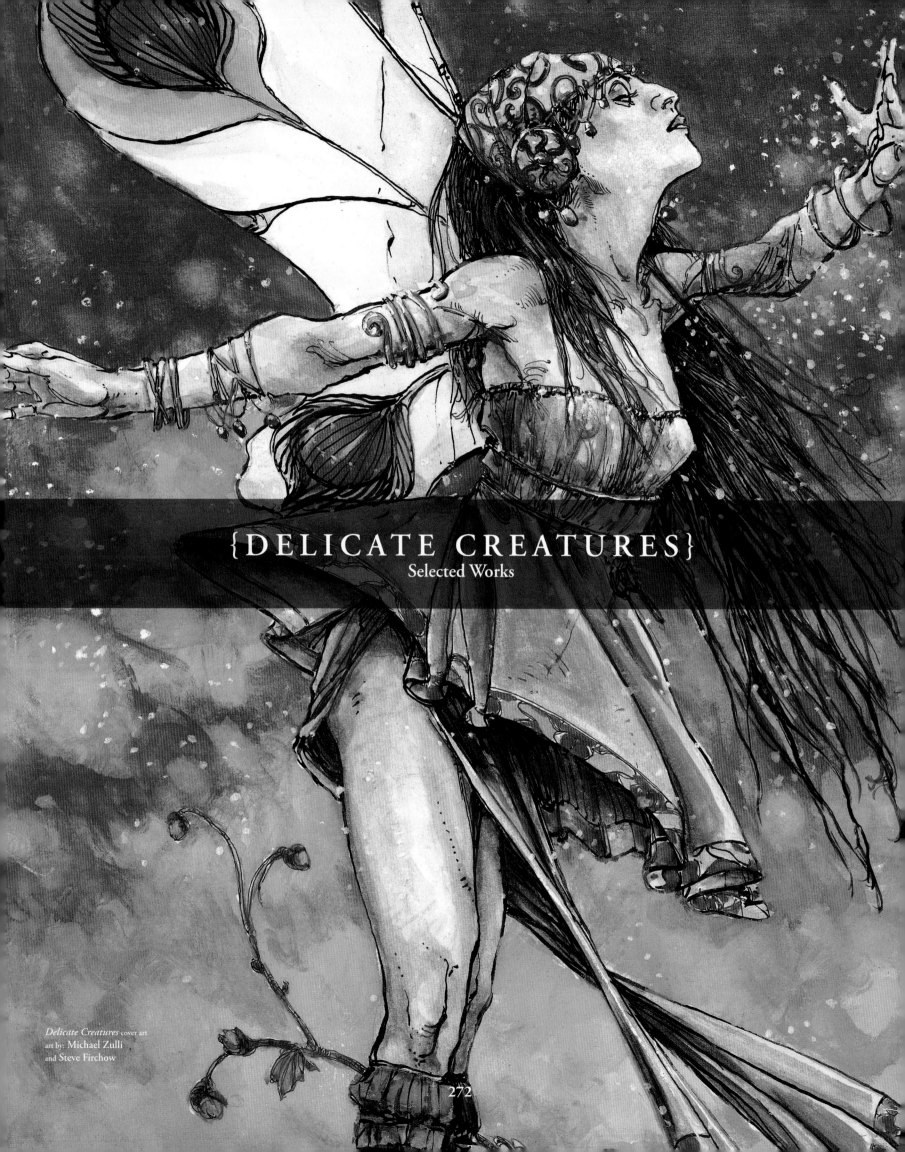

{DELICATE CREATURES}
Selected Works

Delicate Creatures cover art
art by: Michael Zulli
and Steve Firchow

Delicate Creatures page 2-3 spread
art by: Michael Zulli and Steve Firchow

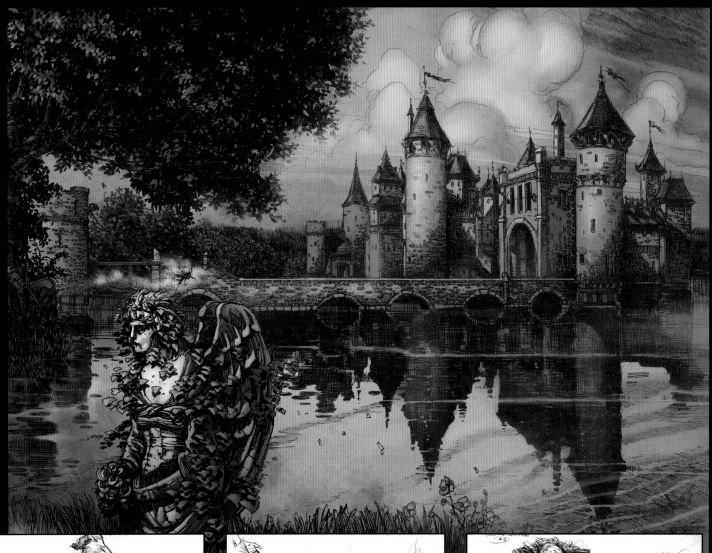

this page, clockwise from top
Delicate Creatures page 4-5 spread
art by: Michael Zulli and Steve Firchow

Delicate Creatures sketches
art by: Michael Zulli

Delicate Creatures page 38-39 spread
art by: Michael Zulli and Steve Firchow

DOWN⬇

{ D O W N }
Series Covers • Selected Works

Down trade paperback cover
art by: Tony Harris, Ray Snyder
and J.D. Mettler

276

Down issue #1 cover.
art by: Tony Harris

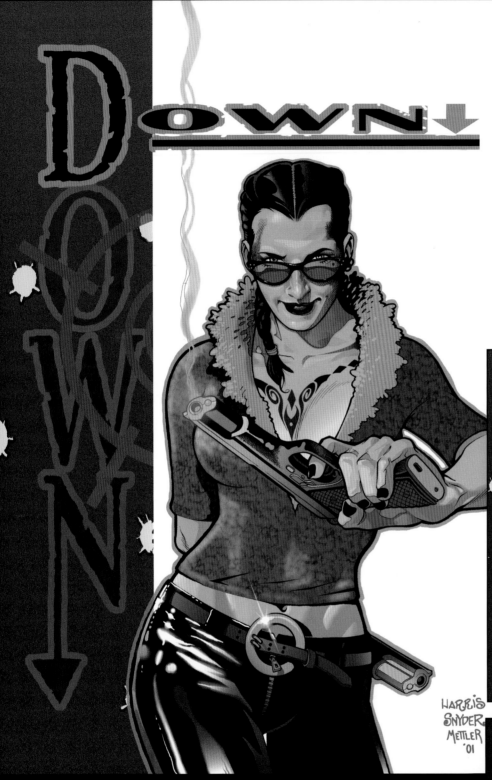

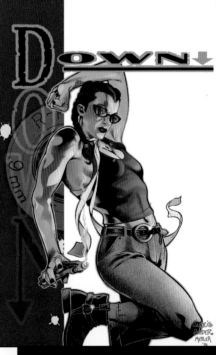

this page, clockwise from above
Down issues #2-3
art by: Tony Harris, Ray Snyder and J.D. Mettler

Down inventory cover
art by: Tony Harris, Ray Snyder and J.D. Mettler

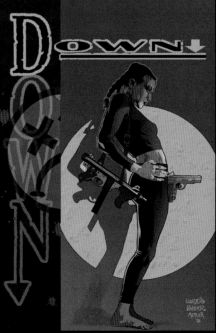

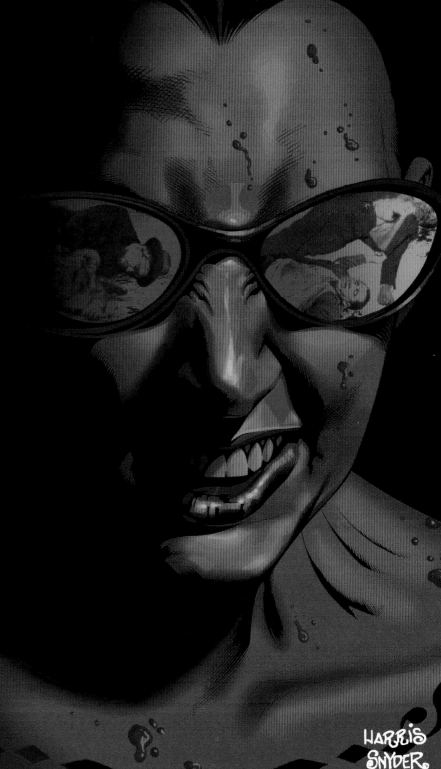

Down issue #4 cover

art by: Tony Harris, Ray Snyder and J.D. Mettler

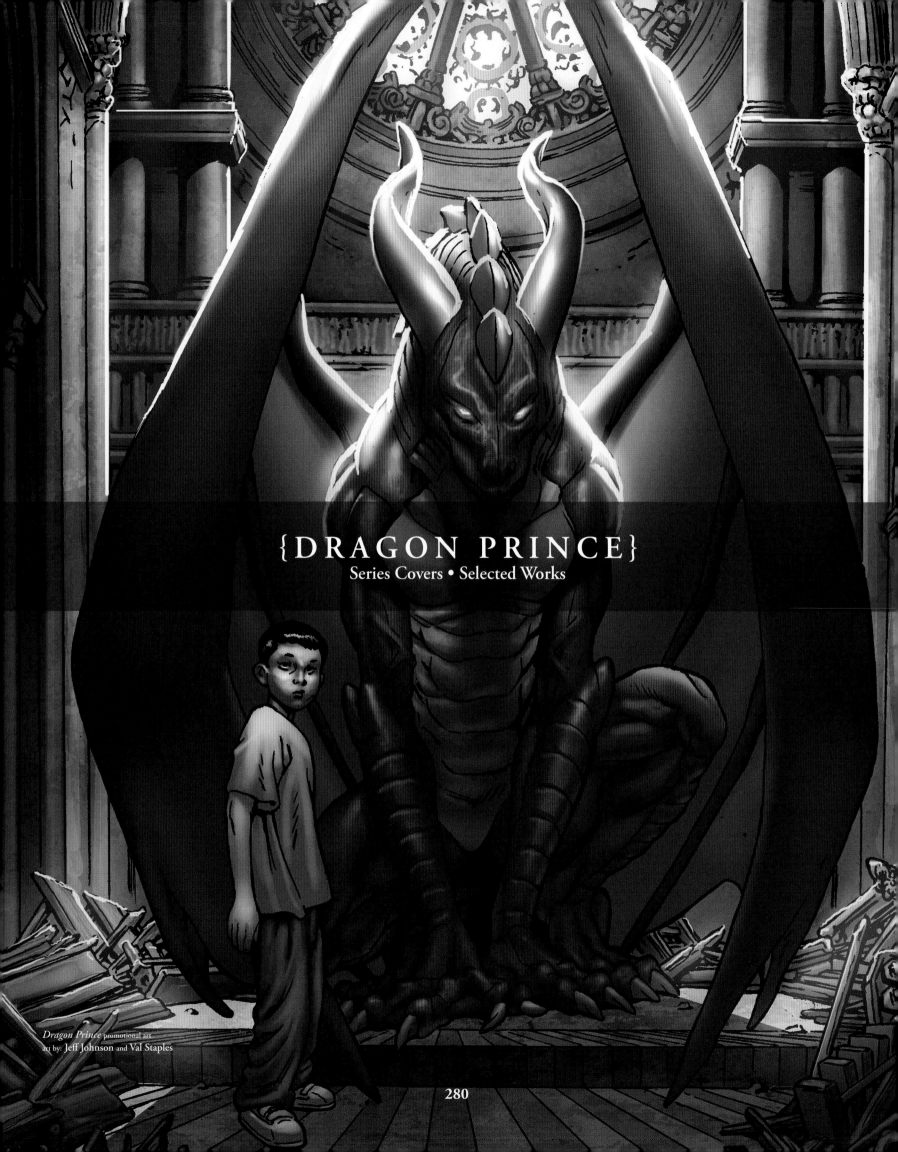

{DRAGON PRINCE}
Series Covers • Selected Works

Dragon Prince promotional art
art by: Jeff Johnson and Val Staples

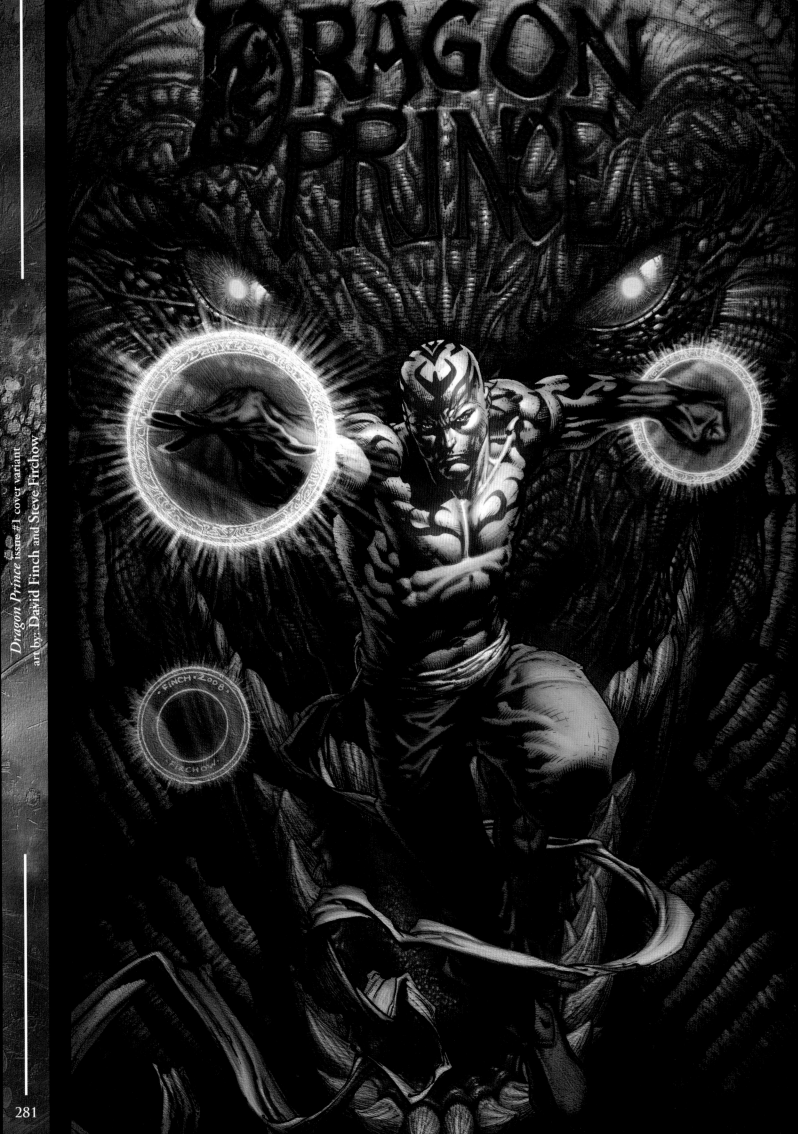

Dragon Prince issue #1 cover variant
art by: Stjepan Sejic

Dragon Prince issue #4 cover variant
art by: Ryan Sook

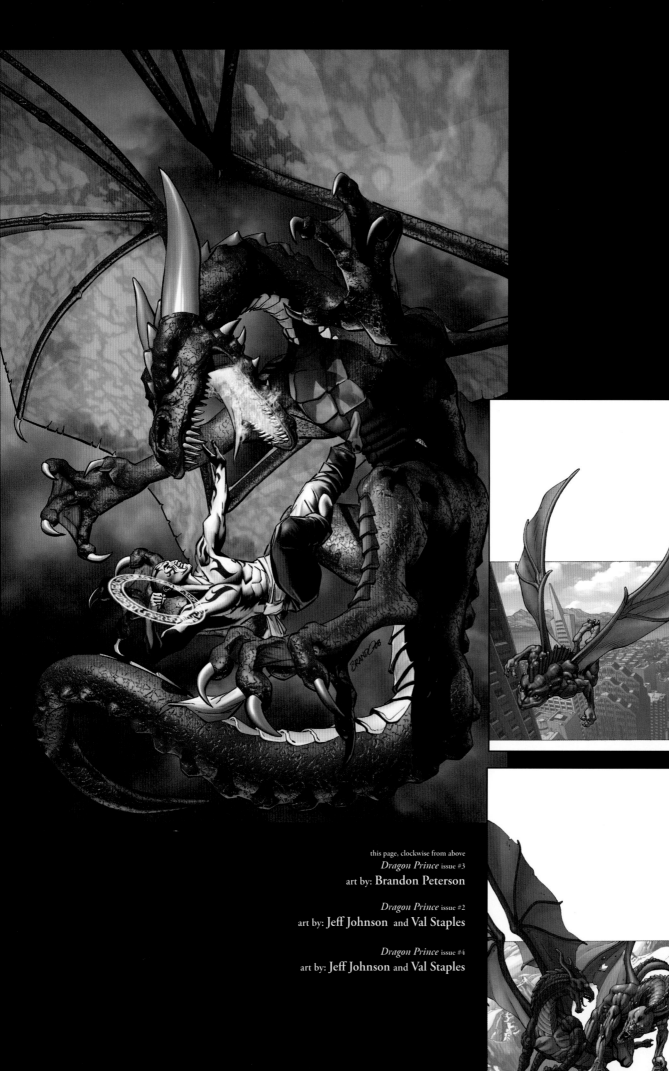

this page, clockwise from above
Dragon Prince issue #3
art by: Brandon Peterson

Dragon Prince issue #2
art by: Jeff Johnson and Val Staples

Dragon Prince issue #4
art by: Jeff Johnson and Val Staples

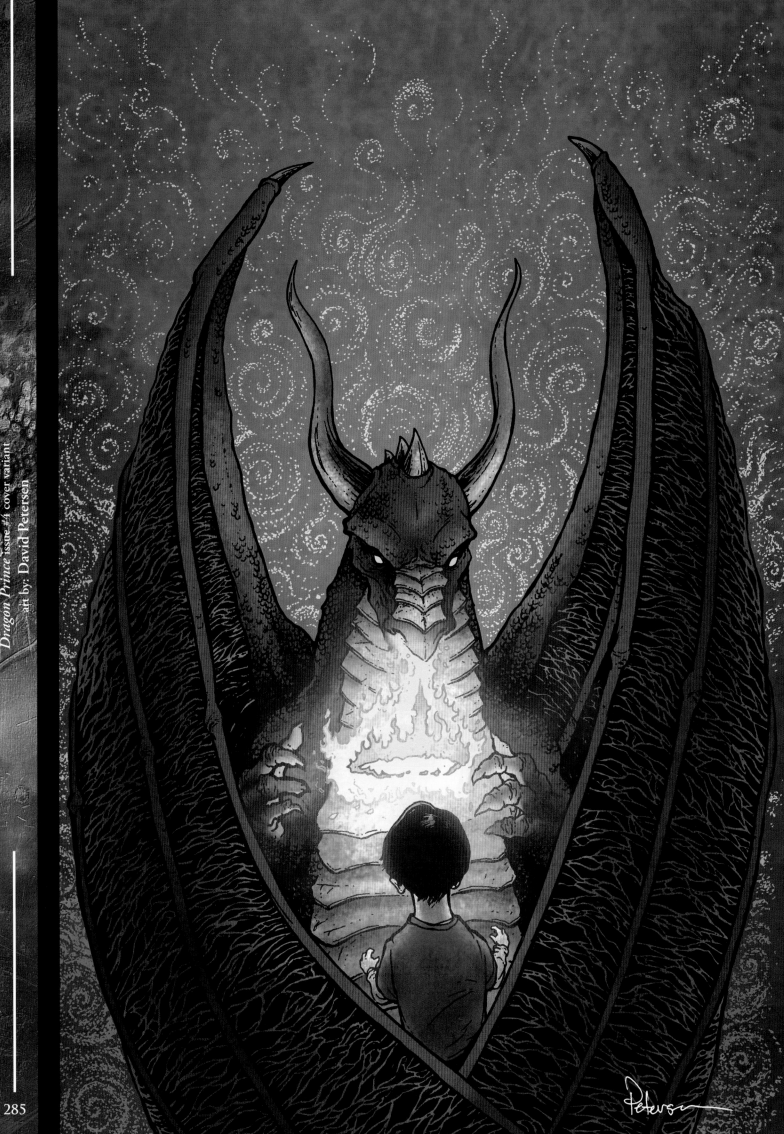

Dragon Prince issue #4 cover variant
art by: David Petersen

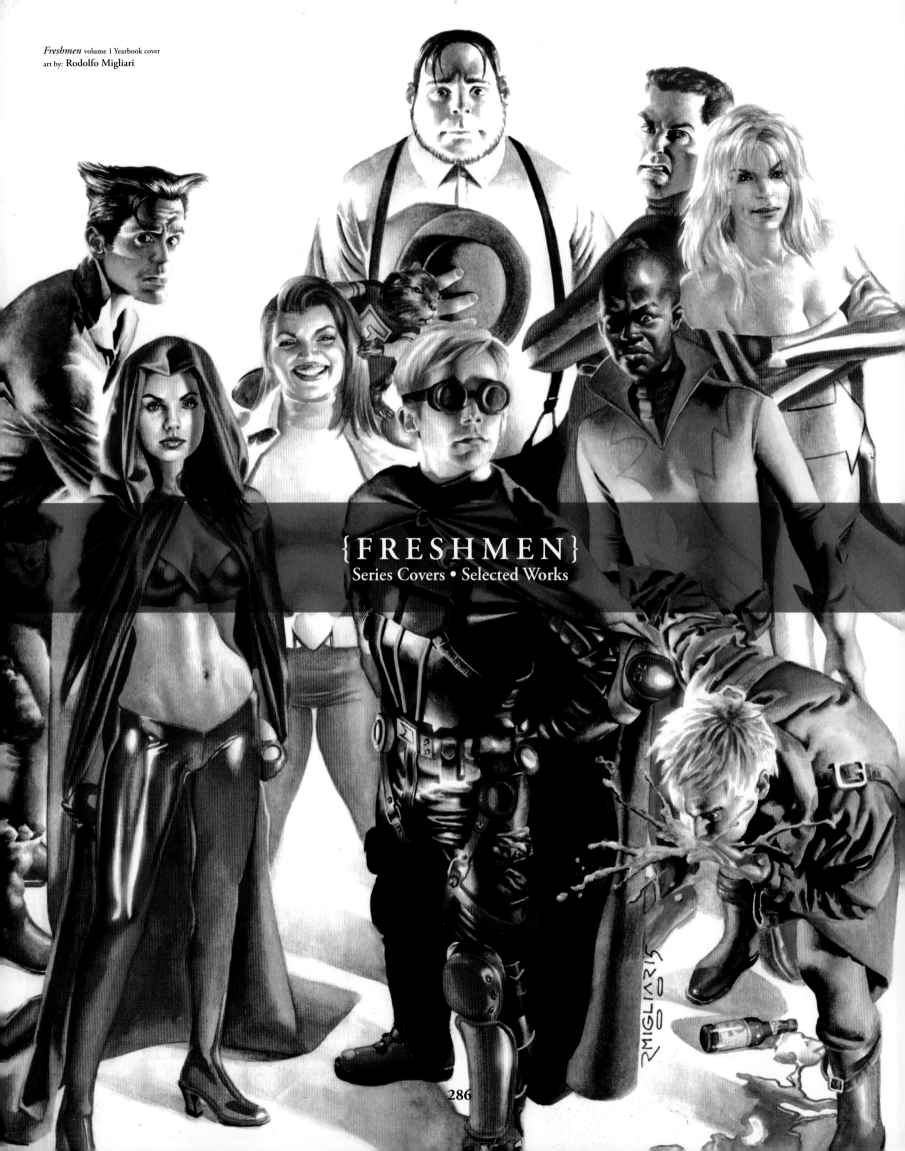

Freshmen volume 1 Yearbook cover
art by: Rodolfo Migliari

{ F R E S H M E N }
Series Covers • Selected Works

286

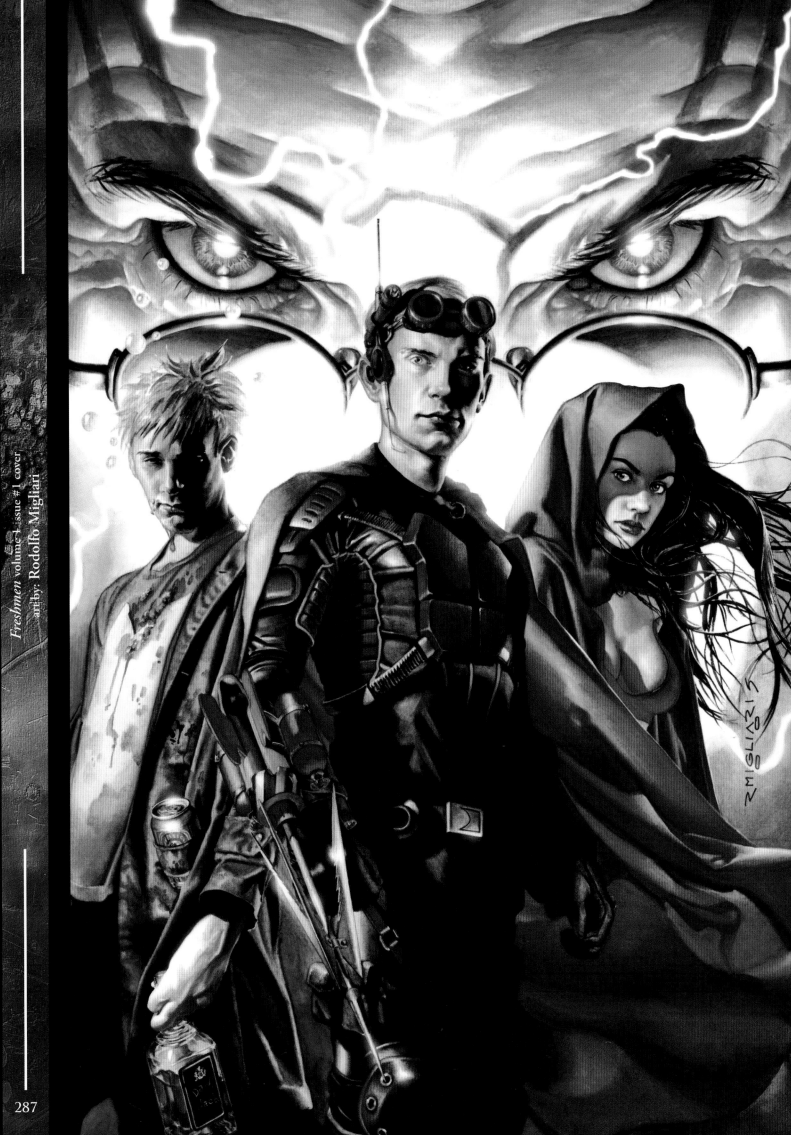

Freshmen volume 1 issue # 1 cover
art by: Rodolfo Migliari

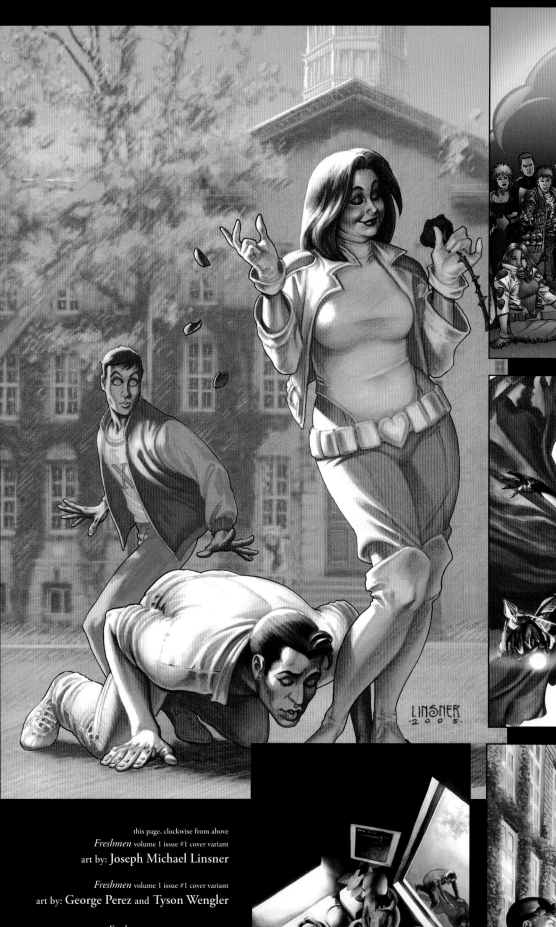

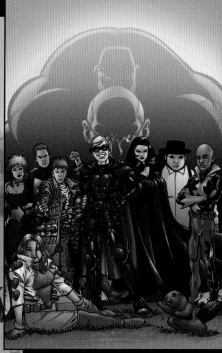

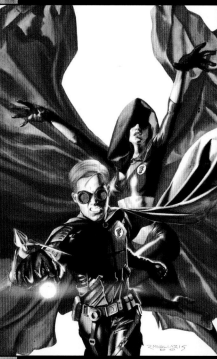

this page, clockwise from above
Freshmen volume 1 issue #1 cover variant
art by: Joseph Michael Linsner

Freshmen volume 1 issue #1 cover variant
art by: George Perez and Tyson Wengler

Freshmen volume 1 issue #2-4 covers
art by: Rodolfo Migliari

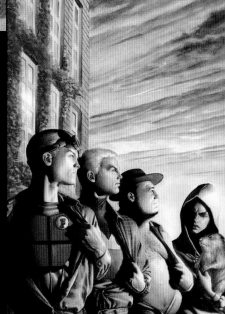

Freshmen volume 1 issue #5 cover
art by: Rodolfo Migliari

Freshmen volume 2 issue #1 cover
art by: Rodolfo Migliari

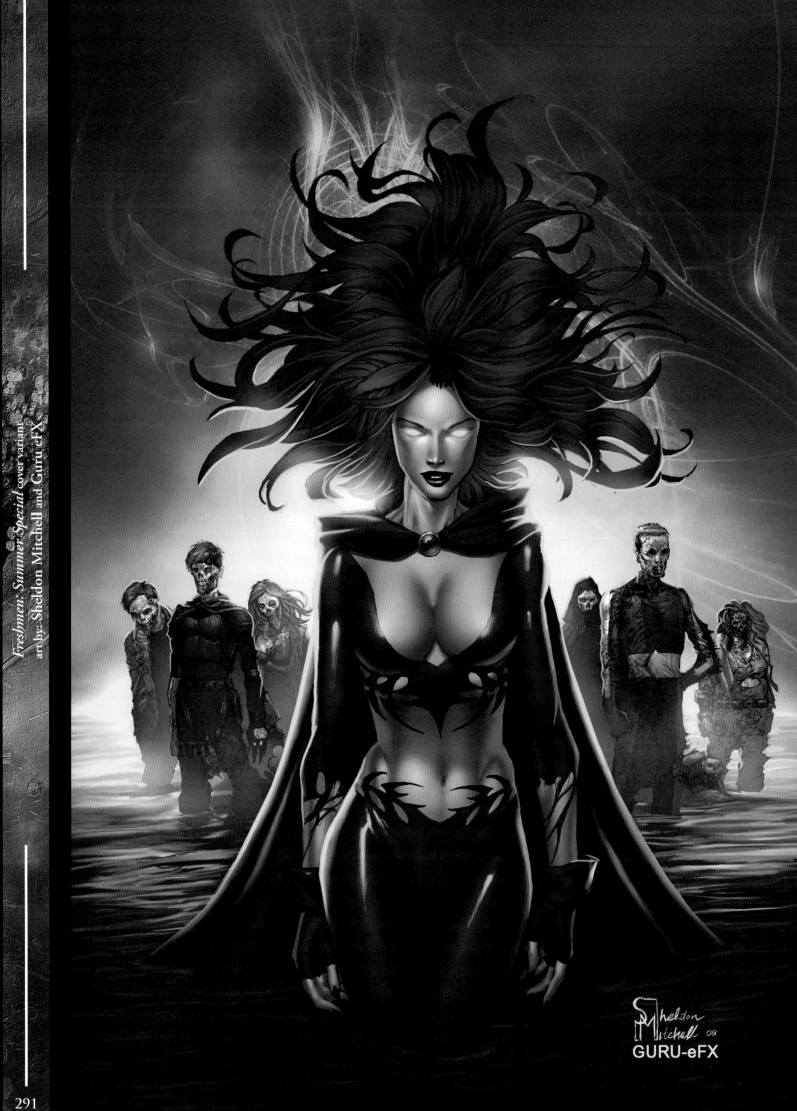

Sheldon
Mitchell 08
GURU-eFX

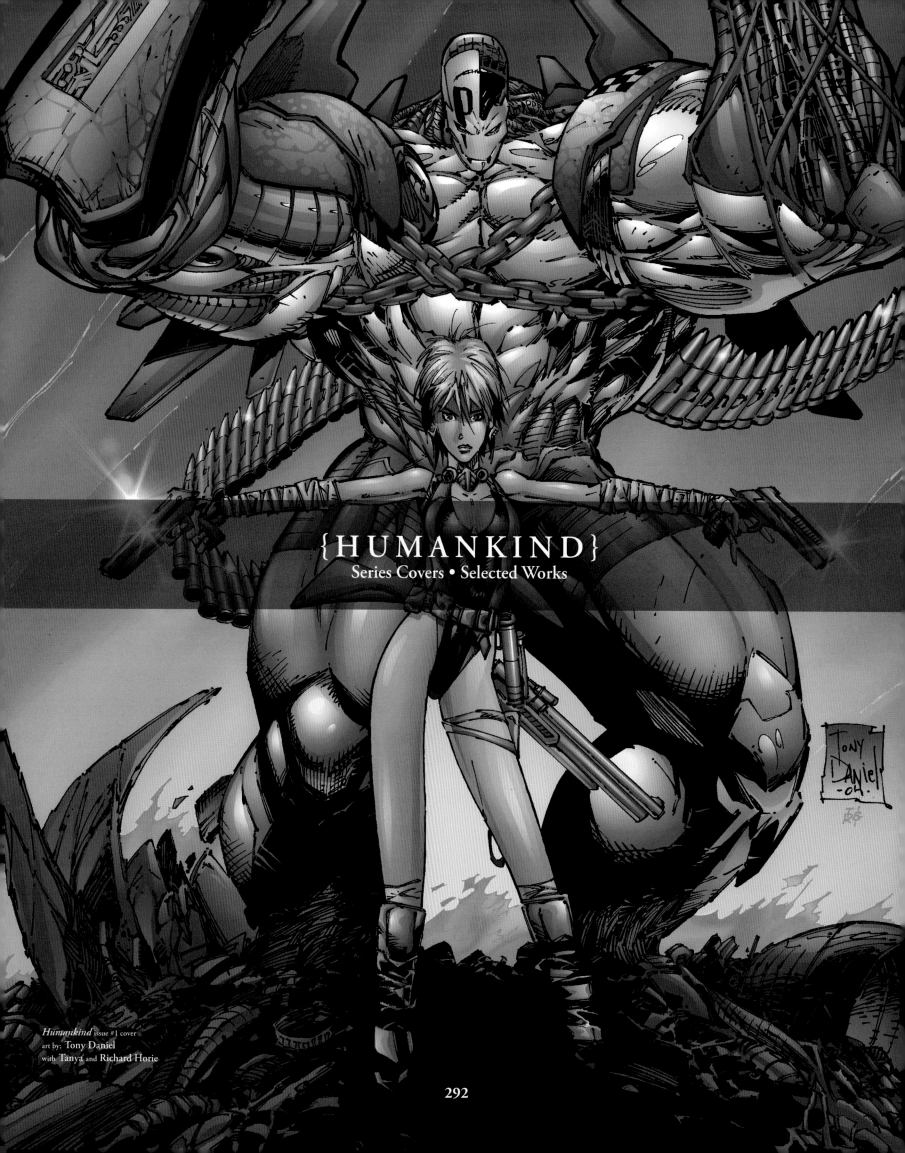

{HUMANKIND}
Series Covers • Selected Works

Humankind issue #1 cover
art by: Tony Daniel
with Tanya and Richard Horie

Humankind issue #1 cover variant

art by: Marc Silvestri, Joe Weems V and Steve Firchow

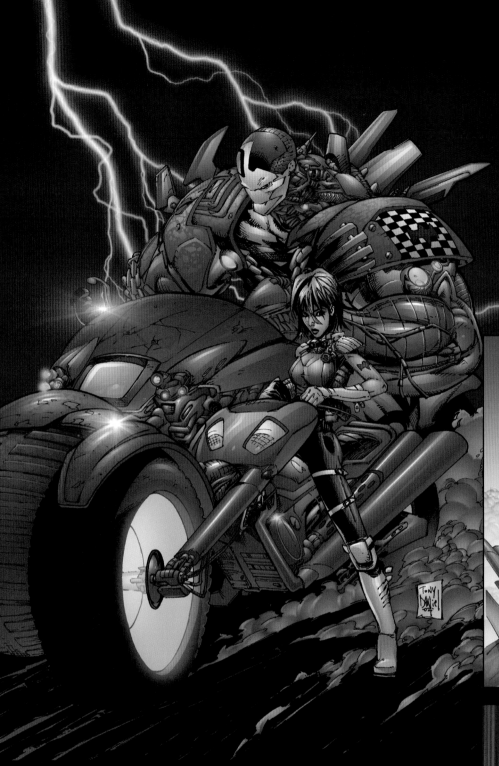

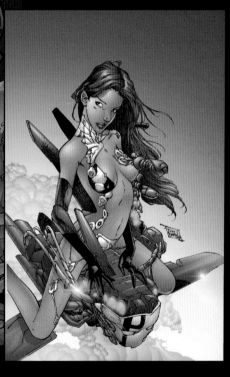

this page, clockwise from above
Humankind issue #2-4 covers
art by: Tony Daniel with Tanya and Richard Horie

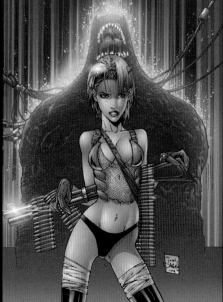

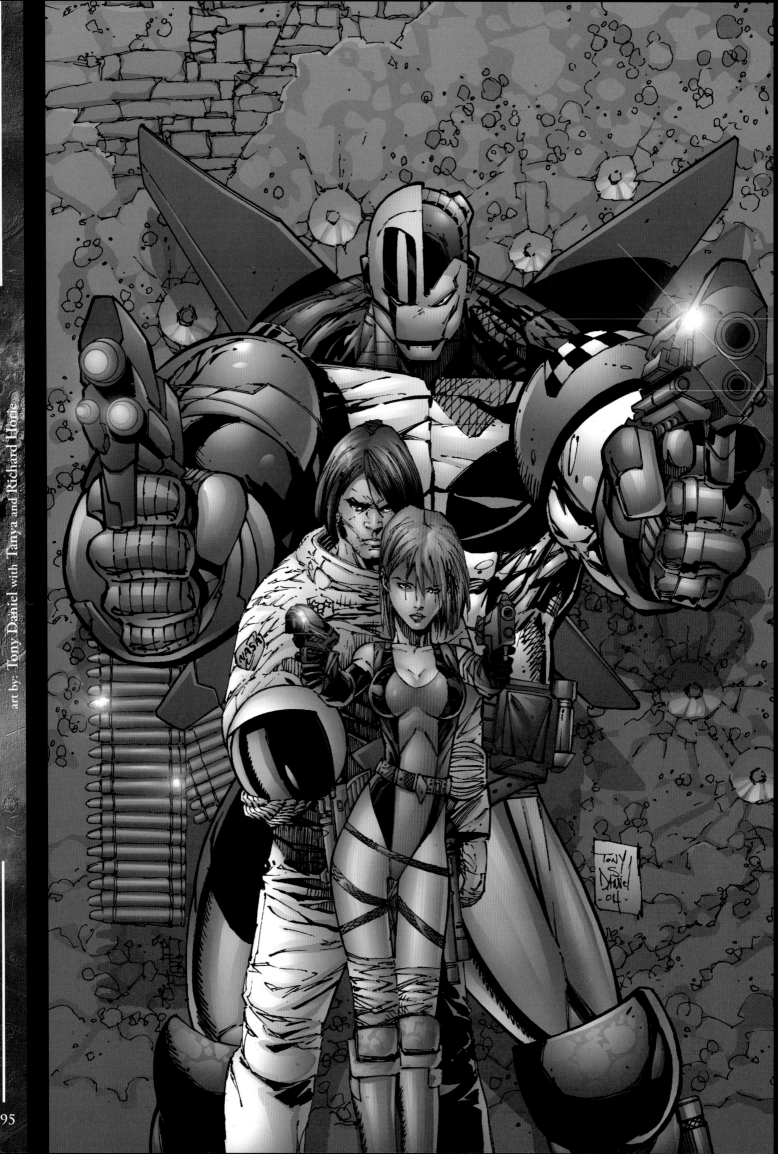

{IMPALER}
Volume 2 Series Covers • Selected Works

Impaler volume 1 trade paperback cover
art by: John Paul Leon

Impaler volume 2·issue #1 cover
art by: Matt Timson

297

clockwise from top/left: *Impaler* volume 2 issue #2-5 covers art by: Matt Timson

issue #1 cover variant art by: Sheldon Mitchell, Rick Basaldua and Steve Firchow

Impaler volume 2 issue #6 wraparound cover
art by: Matt Timson

299

{INFERNO: HELLBOUND}
Series Covers • Selected Works

Inferno: Hellbound issue #1 cover variant F
art by: Michael Turner, Jason Gorder
and Peter Steigerwald

300

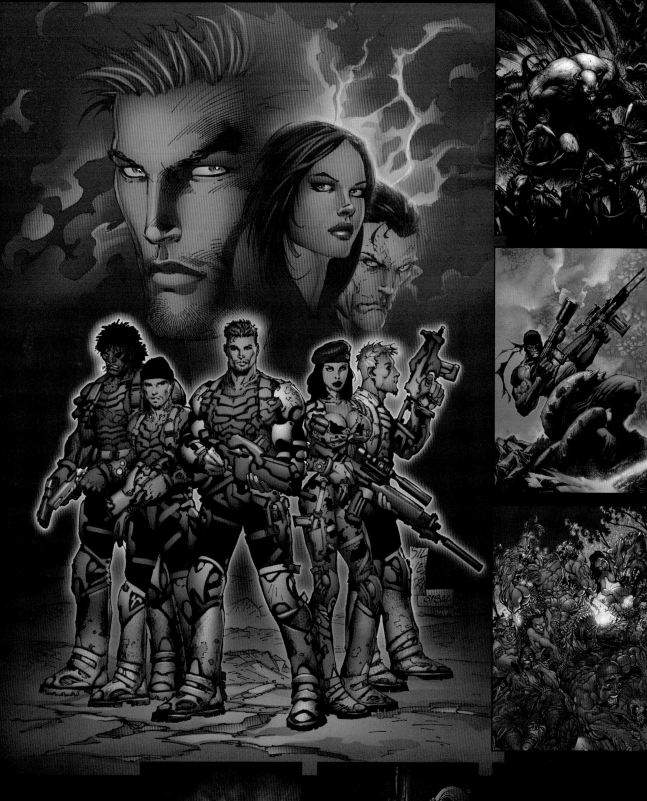

this page, clockwise from above
Inferno: Hellbound issue #2 cover
art by: Marc Silvestri, Jon Sibal
and Steve Firchow

Inferno: Hellbound issue #1 cover variant B
art by: Dale Keown
and Peter Steigerwald

Inferno: Hellbound issue #1 cover variant C
art by: Wayne Turner
and Steve Firchow

Inferno: Hellbound issue #1 cover variant D
art by: J. Scott Campbell
Eric "ebas" Basaldua
and Tyson Wengler

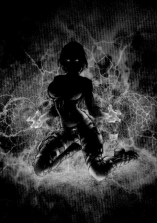

Inferno: Hellbound issue #2 cover variant
art by: Marc Silvestri
and Peter Steigerwald

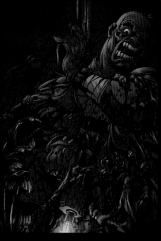

Inferno: Hellbound issue #1 cover variant G
art by: Joe Benitez,
Eric "ebas" Basaldua
and Tyson Wengler

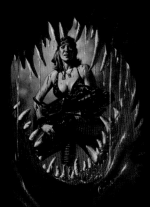

Inferno: Hellbound issue #1 cover variant E
art by: Joe Jusko

Inferno: Hellbound issue #3 cover

art by: Marc Silvestri, Matt "Batt" Banning and Steve Firchow

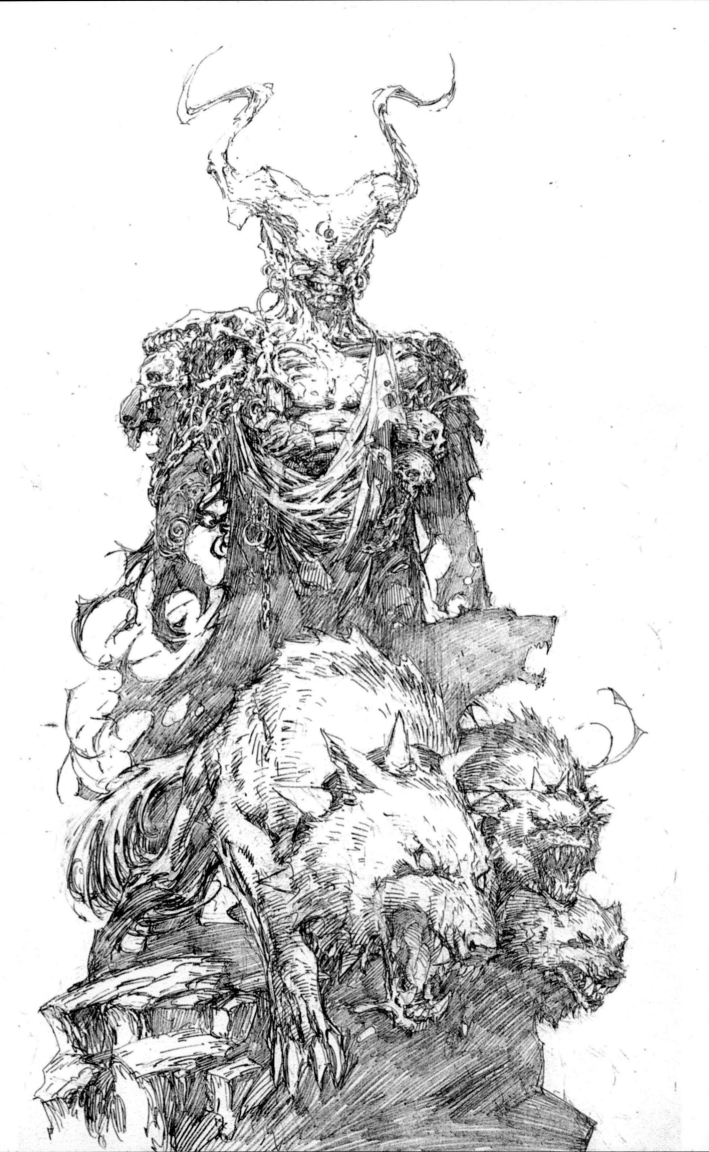

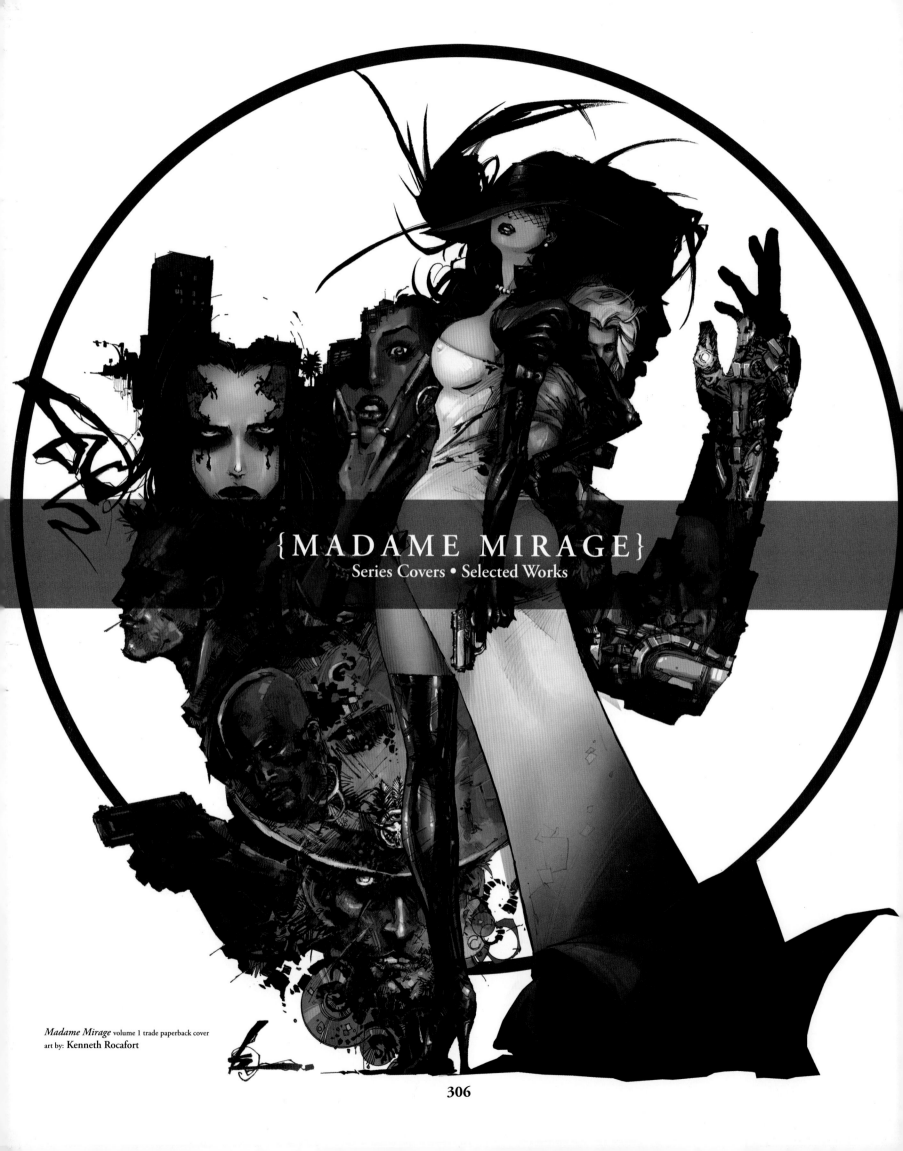

{MADAME MIRAGE}
Series Covers • Selected Works

Madame Mirage volume 1 trade paperback cover
art by: Kenneth Rocafort

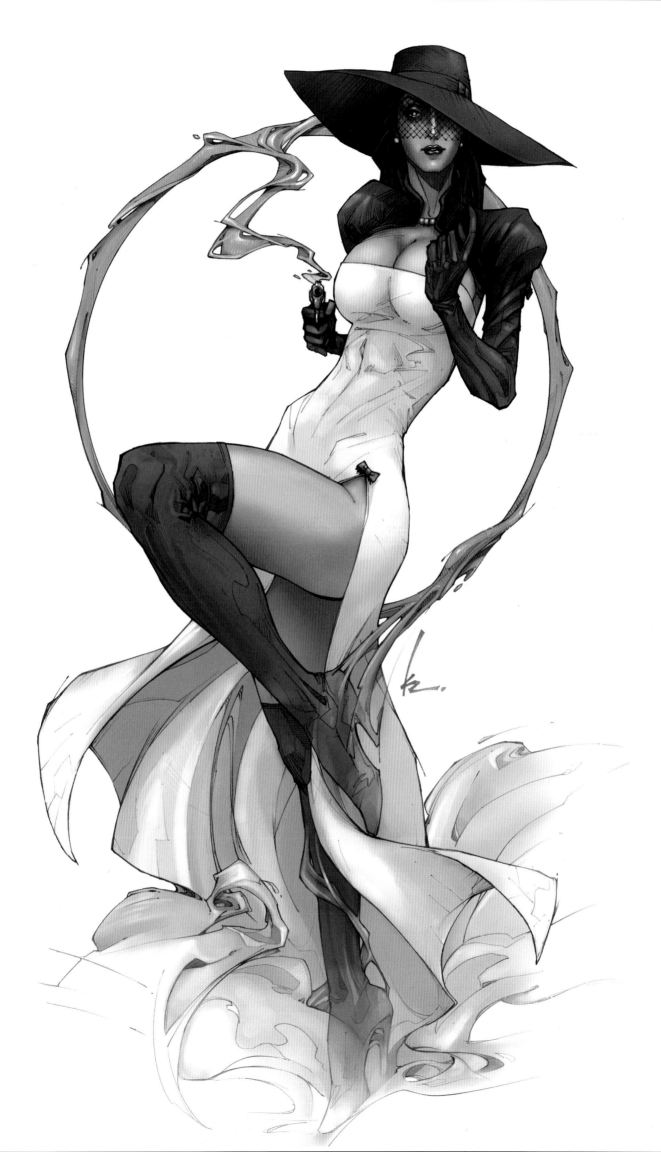

Madame Mirage volume 1 issue #1 cover variant
art by: Kenneth Rocafort

Madame Mirage volume 1 issue #1 cover variant
art by: Greg Horn

Greg Horn

Madame Mirage volume 1 issue #2 cover variant
art by: Kenneth Rocafort

Madame Mirage volume 1 issues #2-5 covers
art by: Kenneth Rocafort

Madame Mirage volume 1 issue #6 cover
art by: Kenneth Rocafort

AGGRESSIVE SOLUTIONS INTERNATIONAL

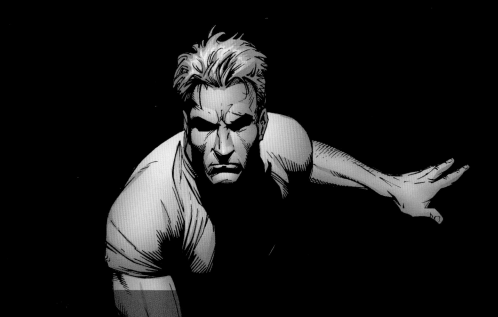

{MIDNIGHT NATION}
Series Covers • Selected Works

Midnight Nation issue #1 Dynamic Forces
European exclusive cover variant
art by: **Gary Frank, Jason Gorder**
and **Dan Kemp**

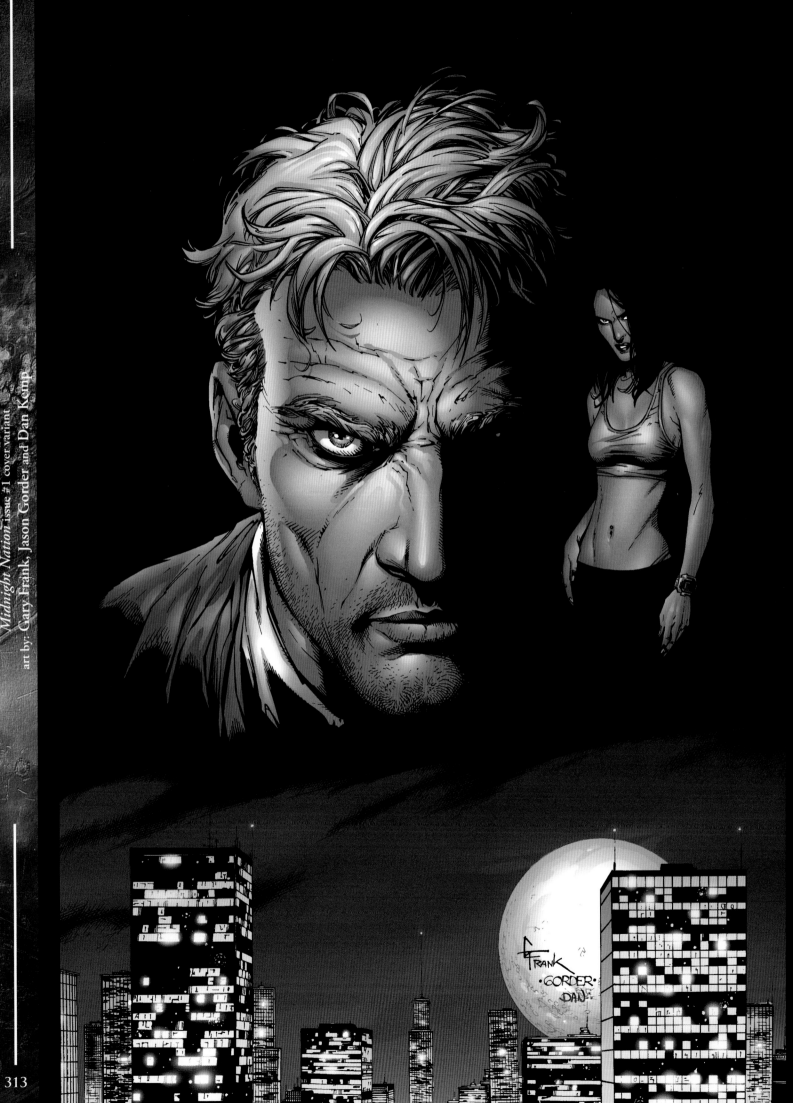

Midnight Nation issue #1 cover variant
art by: Gary Frank, Jason Gorder and Dan Kemp

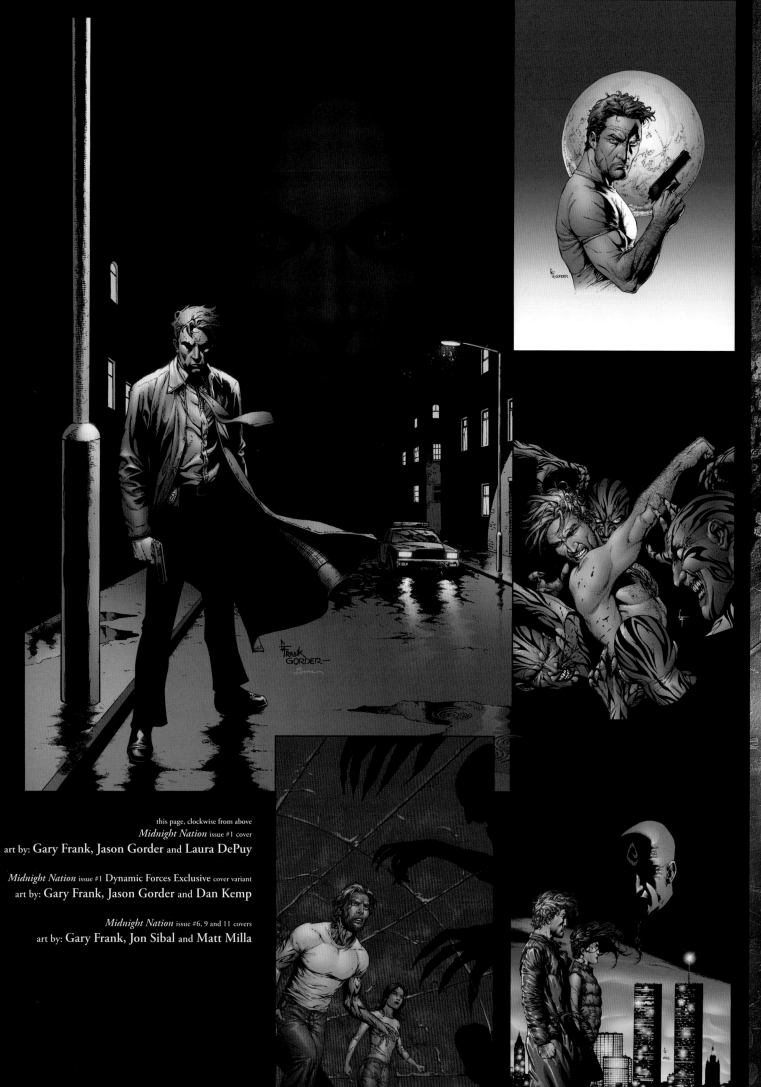

this page, clockwise from above
Midnight Nation issue #1 cover
art by: **Gary Frank, Jason Gorder** and **Laura DePuy**

Midnight Nation issue #1 Dynamic Forces Exclusive cover variant
art by: **Gary Frank, Jason Gorder** and **Dan Kemp**

Midnight Nation issue #6, 9 and 11 covers
art by: **Gary Frank, Jon Sibal** and **Matt Milla**

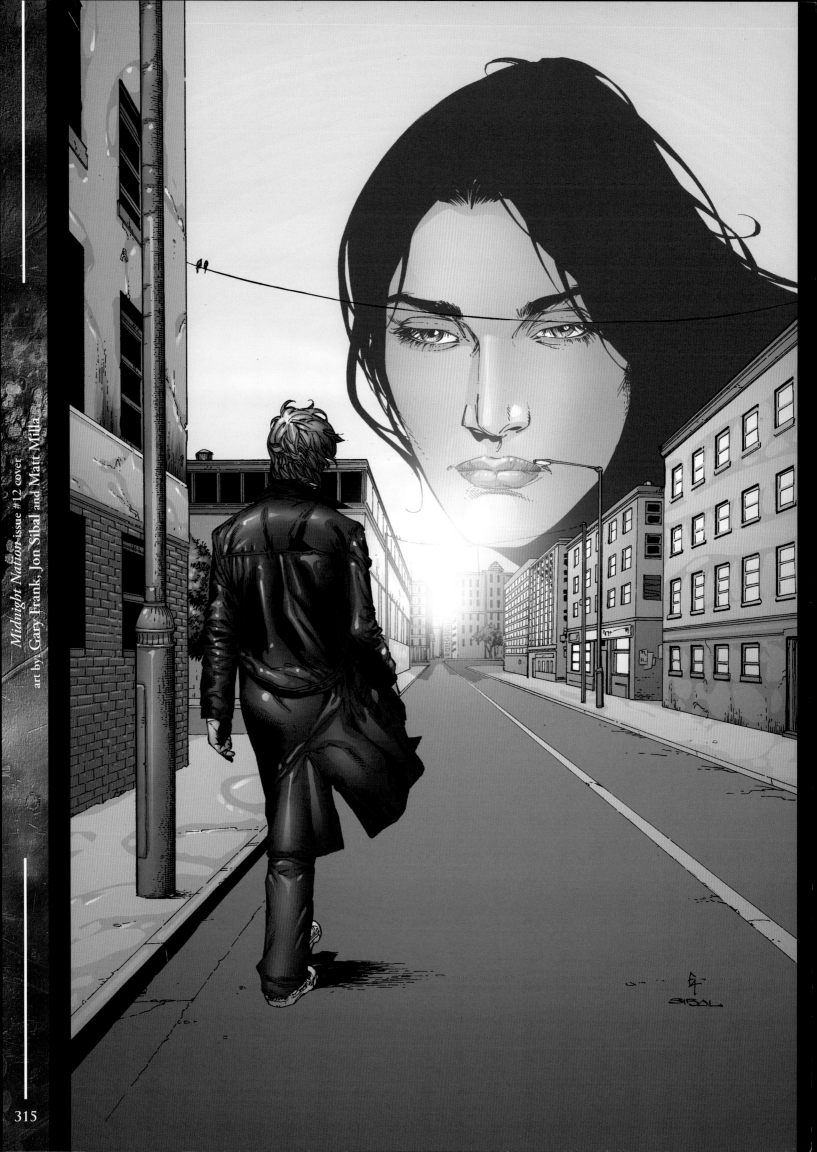

Midnight Nation issue #12 cover
art by: Gary Frank, Jon Sibal and Matt Milla

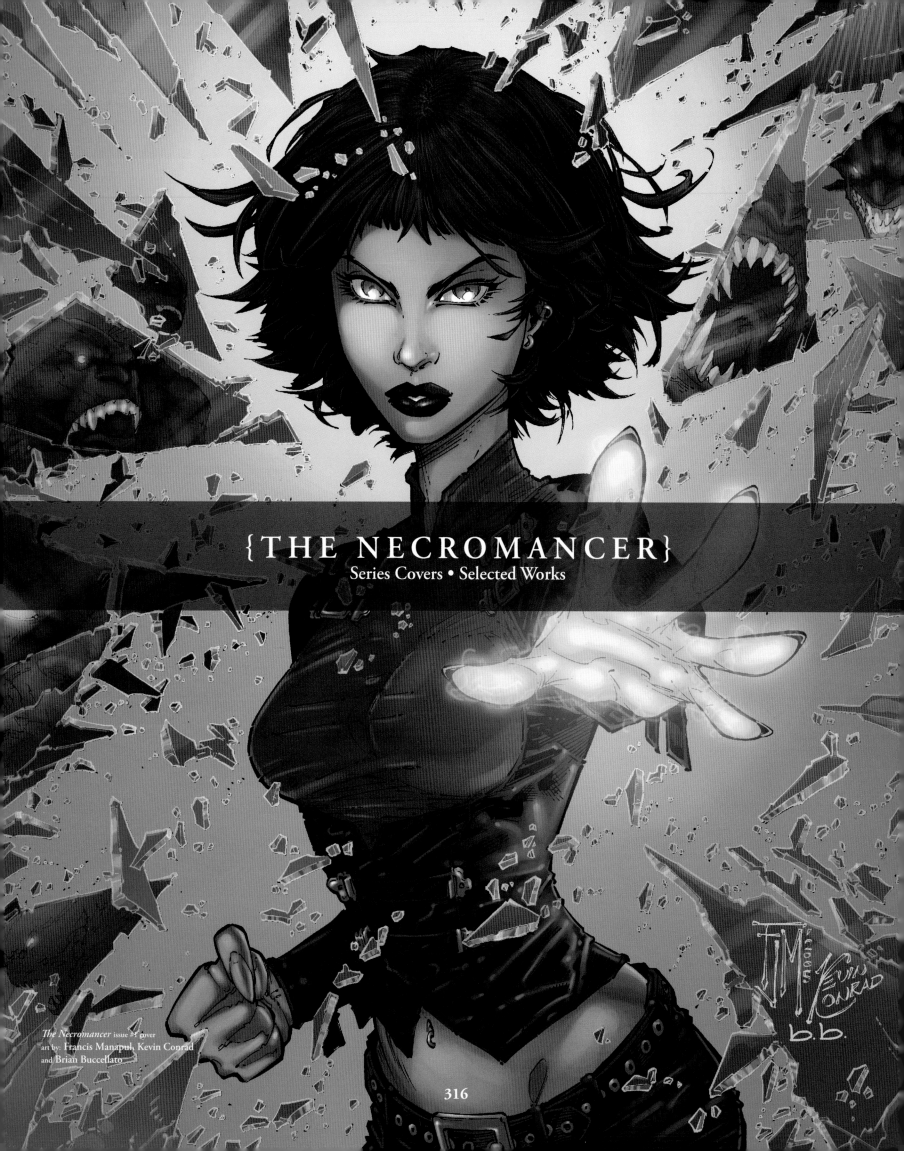

{THE NECROMANCER}
Series Covers • Selected Works

The Necromancer issue #4 cover
art by: Francis Manapul, Kevin Conrad
and Brian Buccellato

The Necromancer issue #1 cover variant
art by: Greg Horn

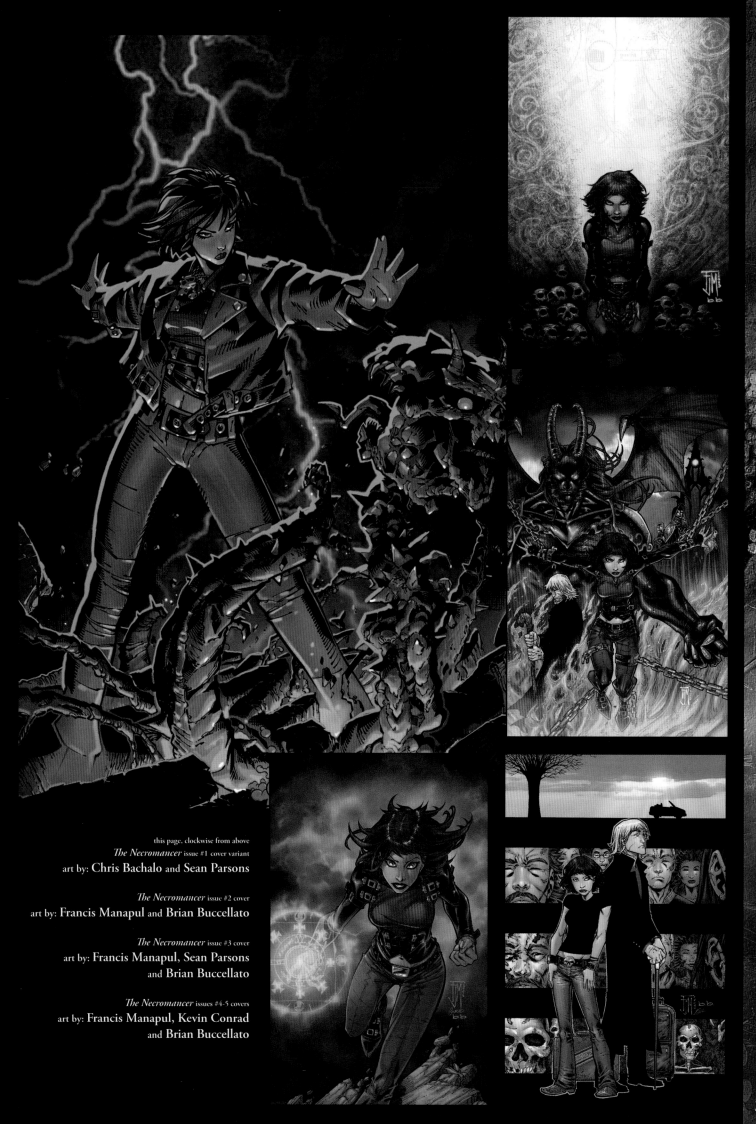

this page, clockwise from above
The Necromancer issue #1 cover variant
art by: **Chris Bachalo** and **Sean Parsons**

The Necromancer issue #2 cover
art by: **Francis Manapul** and **Brian Buccellato**

The Necromancer issue #3 cover
art by: **Francis Manapul**, **Sean Parsons**
and **Brian Buccellato**

The Necromancer issues #4-5 covers
art by: **Francis Manapul**, **Kevin Conrad**
and **Brian Buccellato**

The Necromancer issue #6 cover
art by: Francis Manapul and Brian Buccellato

{NO HONOR}
Series Covers • Selected Works

No Honor issue #1 cover variant
art by: David Finch, Joe Weems V
and Matt Nelson

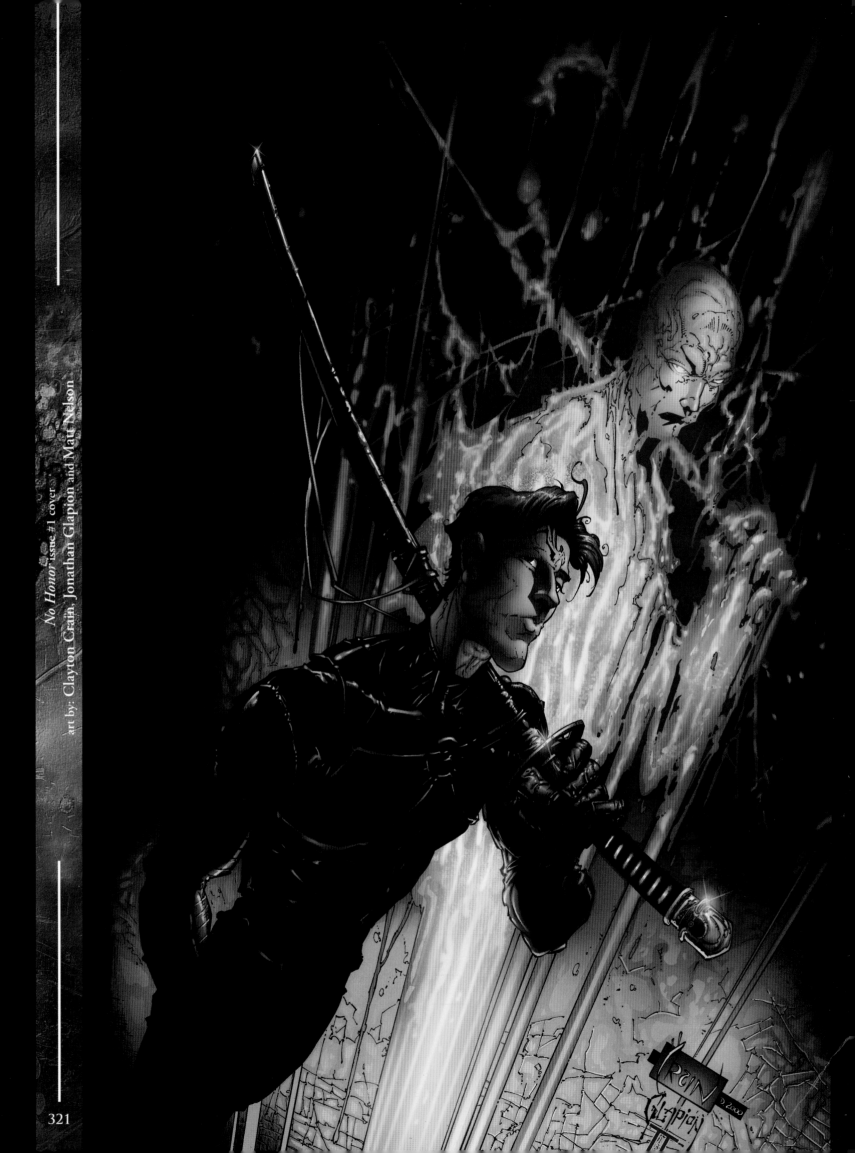

No Honor issue #1 cover

art by: Clayton Crain, Jonathan Glapion and Matt Nelson

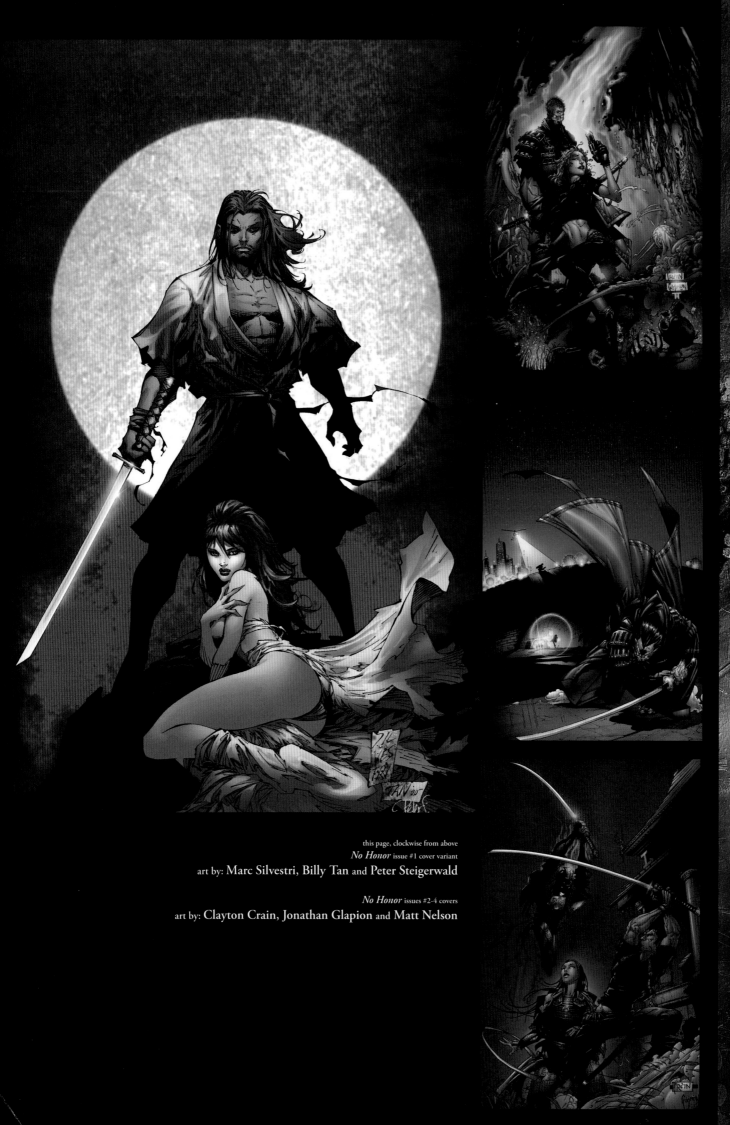

this page, clockwise from above
No Honor issue #1 cover variant
art by: Marc Silvestri, Billy Tan and Peter Steigerwald

No Honor issues #2-4 covers
art by: Clayton Crain, Jonathan Glapion and Matt Nelson

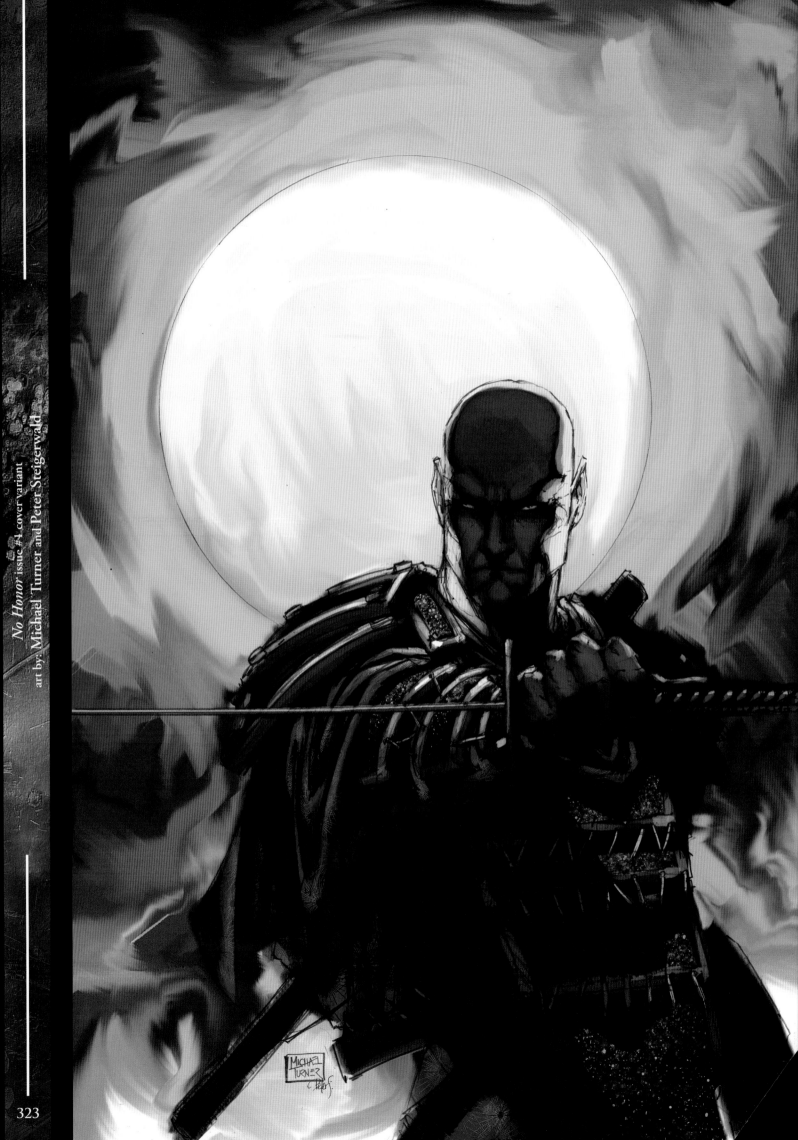

No Honor issue #1 cover variant
art by: Michael Turner and Peter Steigerwald

{ P I L O T S E A S O N }
Volume 1 and 2 Series Covers • Selected Works

Pilot Season volume 1 winner
"Cyblade" series issue #1 cover variant B
art by: Kenneth Rocafort

324

Pilot Season volume 1 trade paperback cover
art by: Kenneth Rocafort

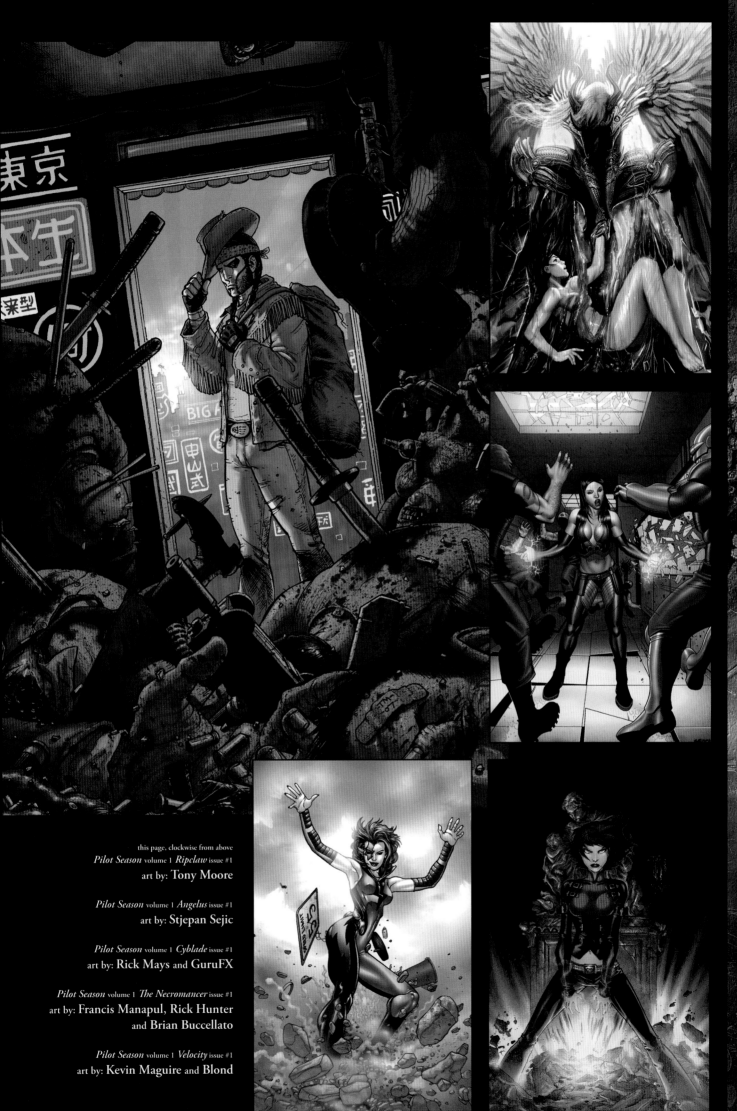

this page, clockwise from above
Pilot Season volume 1 *Ripclaw* issue #1
art by: Tony Moore

Pilot Season volume 1 *Angelus* issue #1
art by: Stjepan Sejic

Pilot Season volume 1 *Cyblade* issue #1
art by: Rick Mays and GuruFX

Pilot Season volume 1 *The Necromancer* issue #1
art by: Francis Manapul, Rick Hunter
and Brian Buccellato

Pilot Season volume 1 *Velocity* issue #1
art by: Kevin Maguire and Blond

Pilot Season volume 1 winner *Cyblade* issue #1 cover variant
art by: Kenneth Rocafort

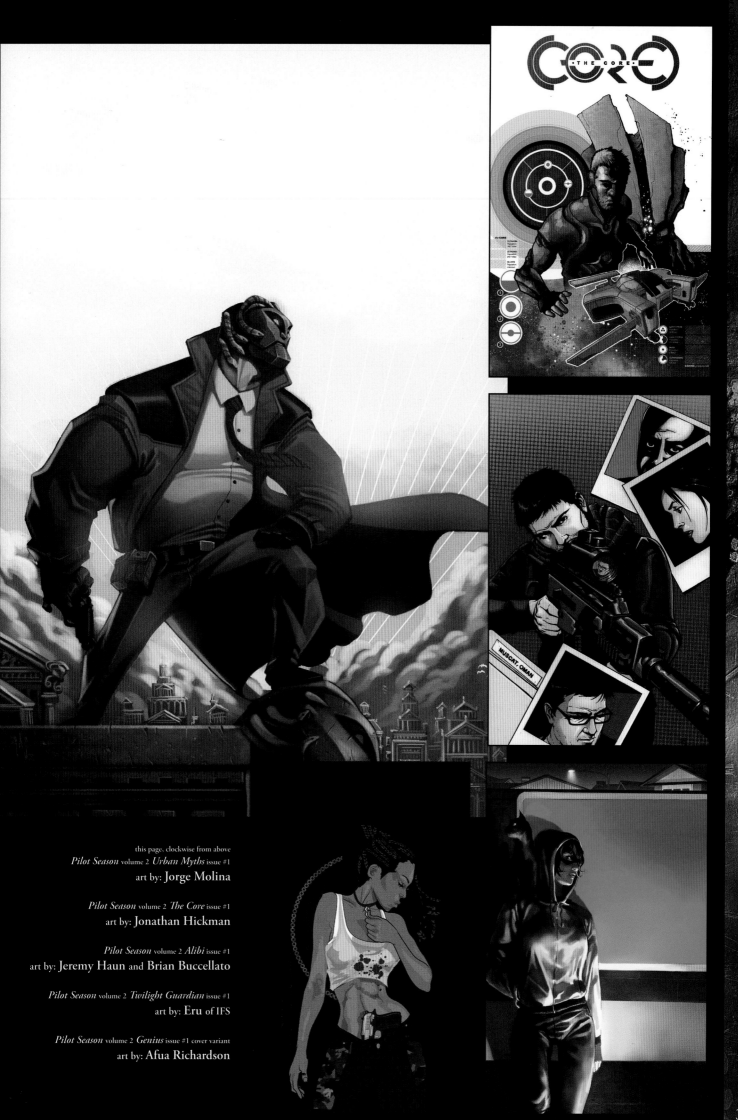

this page, clockwise from above
Pilot Season volume 2 *Urban Myths* issue #1
art by: Jorge Molina

Pilot Season volume 2 *The Core* issue #1
art by: Jonathan Hickman

Pilot Season volume 2 *Alibi* issue #1
art by: Jeremy Haun and Brian Buccellato

Pilot Season volume 2 *Twilight Guardian* issue #1
art by: Eru of IFS

Pilot Season volume 2 *Genius* issue #1 cover variant
art by: Afua Richardson

Pilot Season volume 2 *Lady Pendragon* issue #1 wraparound cover
art by: Drew Struzan

{RISING STARS}
Series Covers • Selected Works

Rising Stars Preview cover
art by: Keu Cha, Jason Gorder
and Liquid!

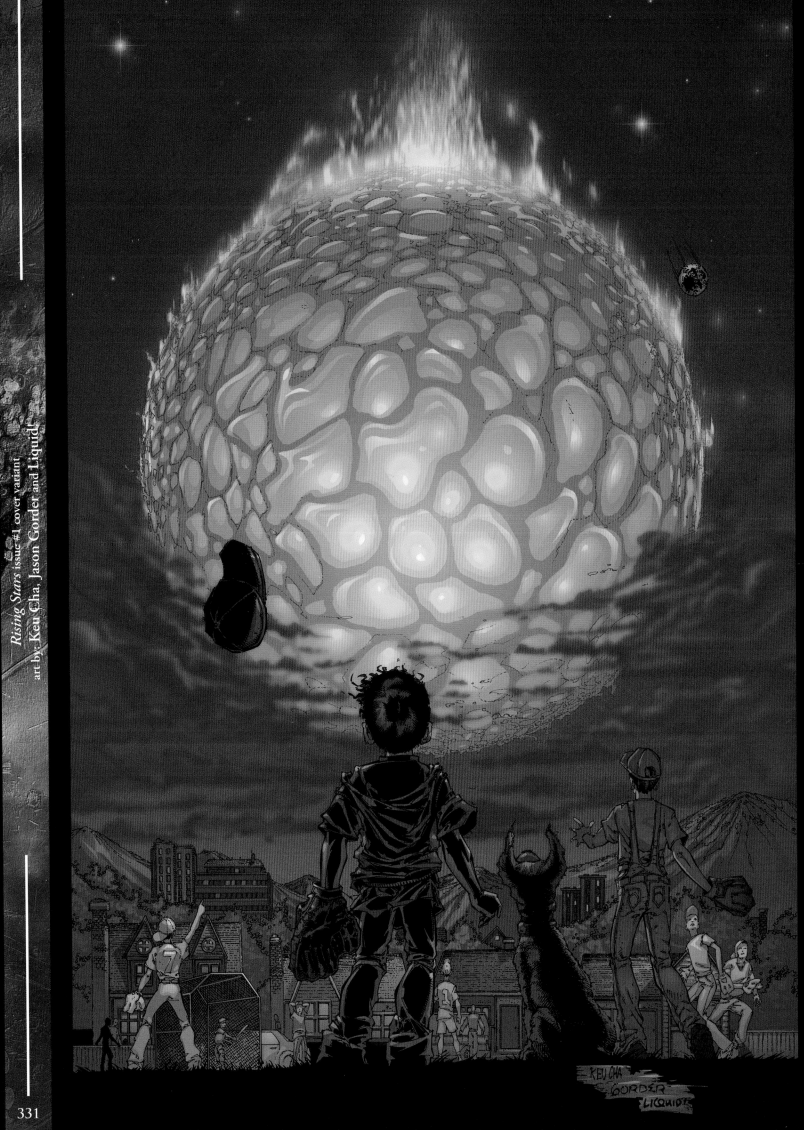

Rising Stars issue #1 cover variant
art by: Keu Cha, Jason Gorder and Liquid!

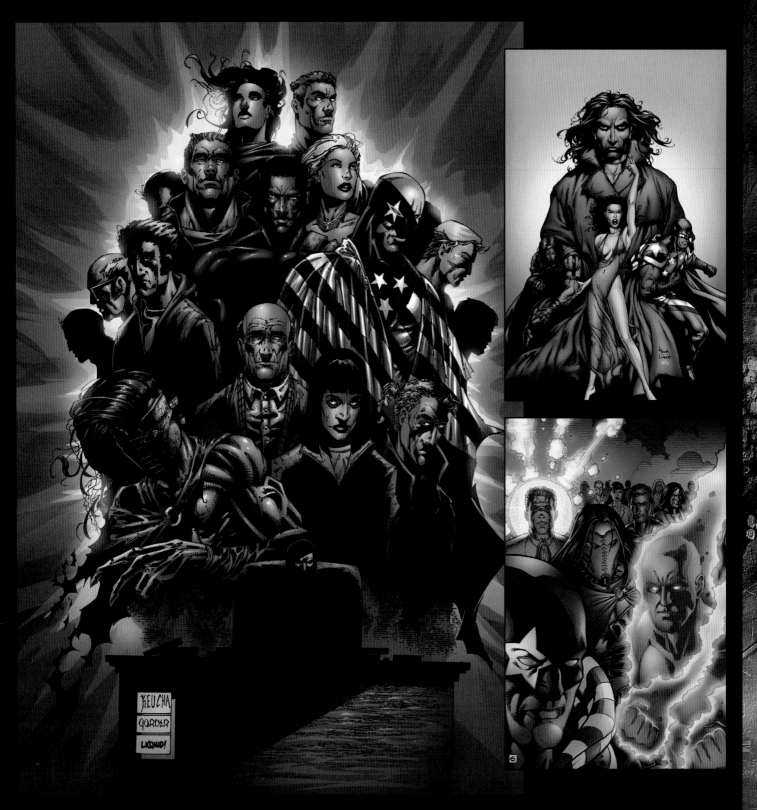

this page, clockwise from above

Rising Stars issue #0 cover variant
art by: Keu Cha, Jason Gorder
and Liquid!

Rising Stars issue #0 cover
art by: Gary Frank, Livesay
and Brett Evans

Rising Stars issue #9 cover variant
art by: Dave Gibbons, and Brett Evans

Rising Stars issue #1 cover variant
art by: Keu Cha, Jason Gorder
and Liquid!

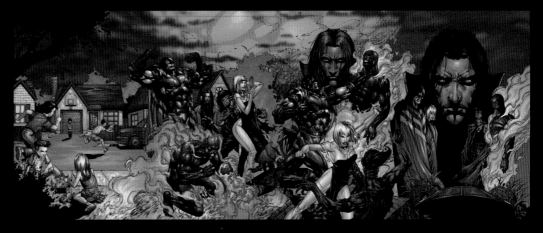

Rising Stars issue #12 cover variant

art by: Ken Lashley, Kevin Conrad and Dan Kemp

333

Rising Stars issue #16 cover variant
art by: Gary Frank, Jay Leisten and Peter Steigerwald

334

Rising Stars issue #17 cover
art by Brent Anderson and Peter Steigerwald

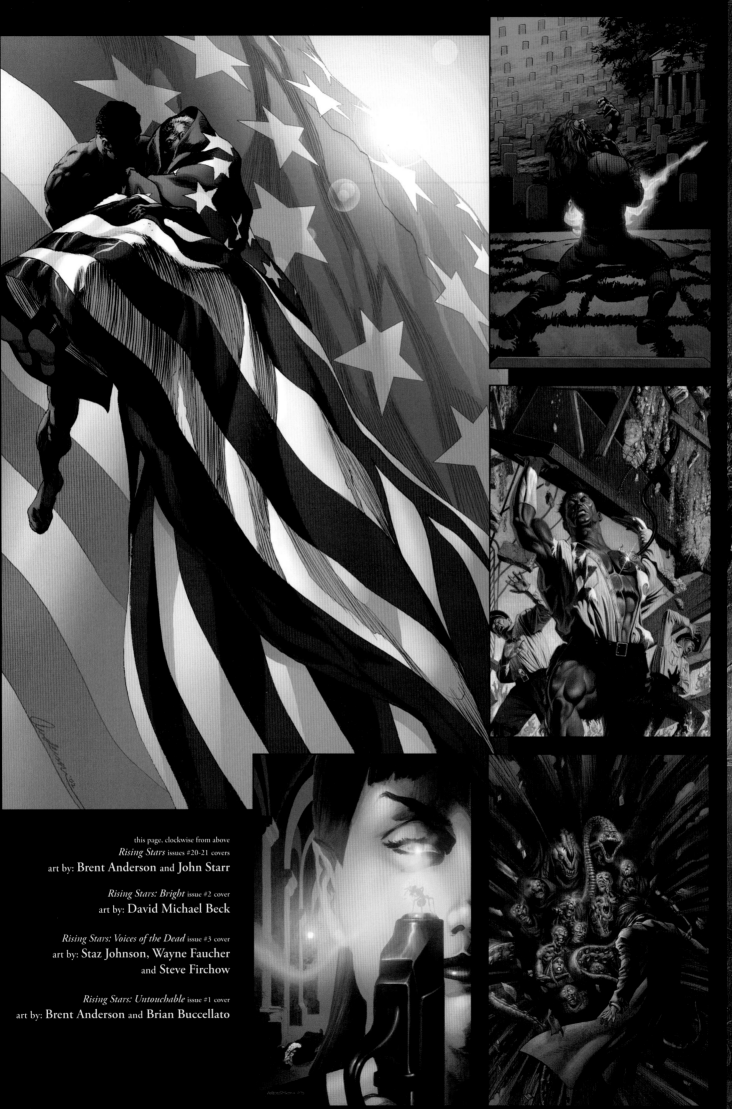

this page, clockwise from above
Rising Stars issues #20-21 covers
art by: **Brent Anderson** and **John Starr**

Rising Stars: Bright issue #2 cover
art by: **David Michael Beck**

Rising Stars: Voices of the Dead issue #3 cover
art by: **Staz Johnson**, **Wayne Faucher**
and **Steve Firchow**

Rising Stars: Untouchable issue #1 cover
art by: **Brent Anderson** and **Brian Buccellato**

Rising Stars

Rising Stars issue #23 cover
art by: Brent Anderson and Brian Buccellato

{ WANTED }
Series Covers • Selected Works

Wanted issue #1 cover
art by: JG Jones

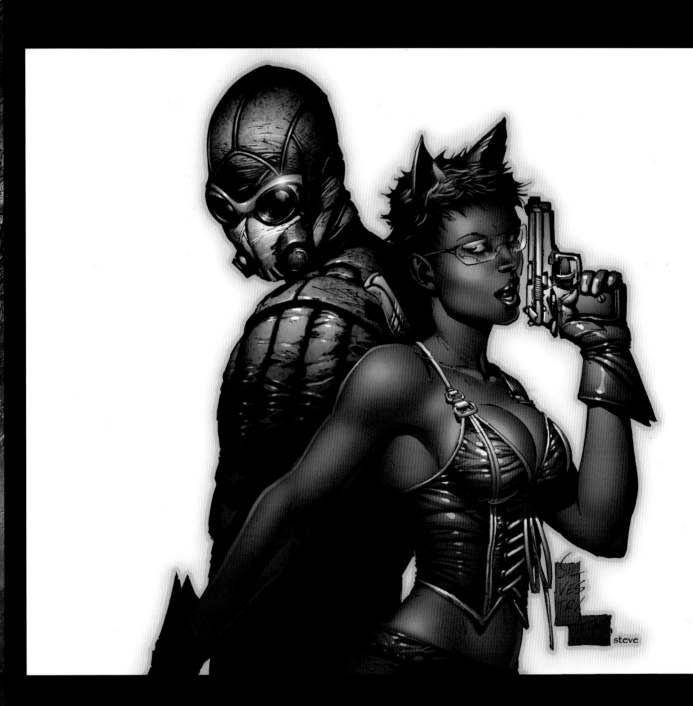

Wanted issue #1 cover variant

art by: Marc Silvestri, Joe Weems V and Steve Firchow

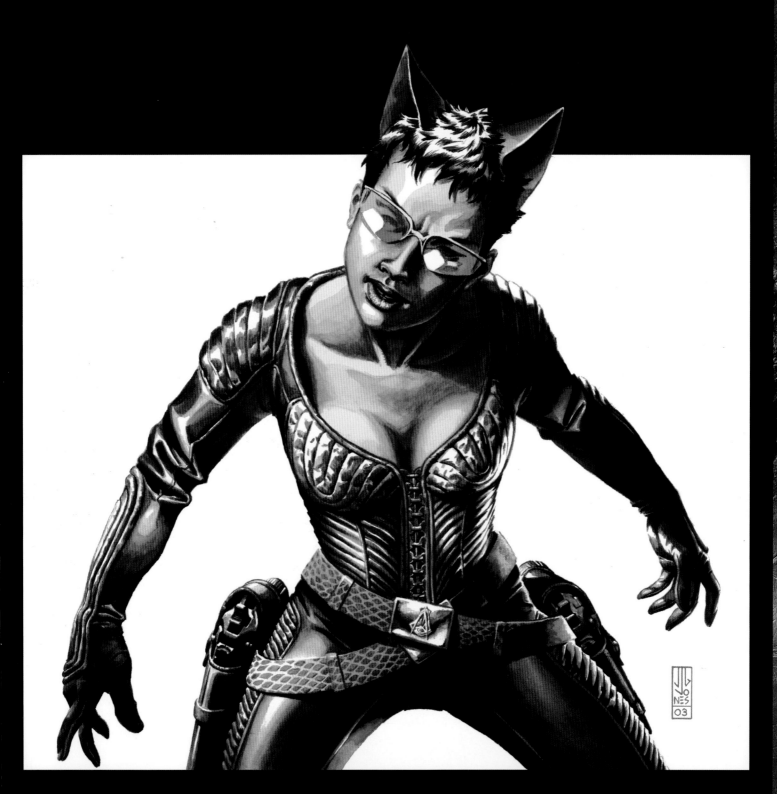

Wanted issue #2 cover
art by: JG Jones

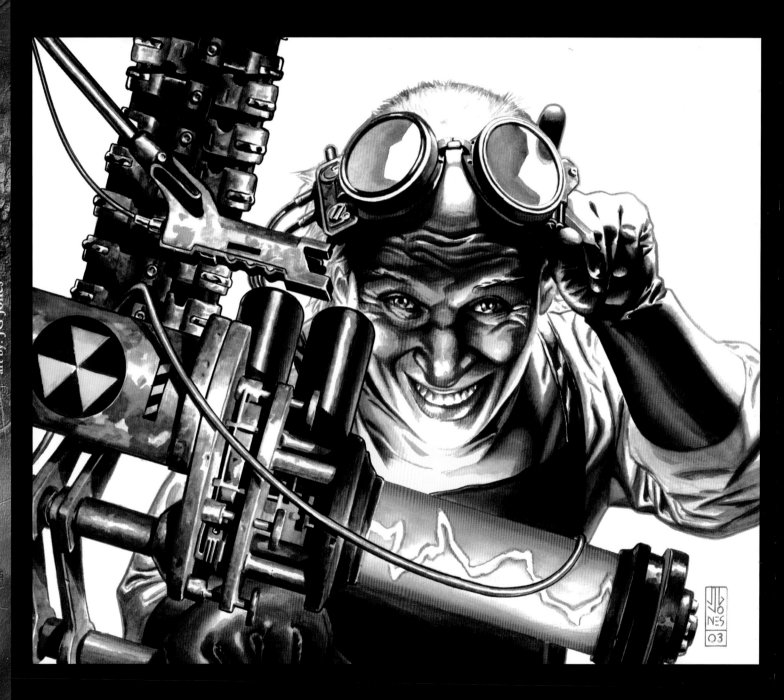

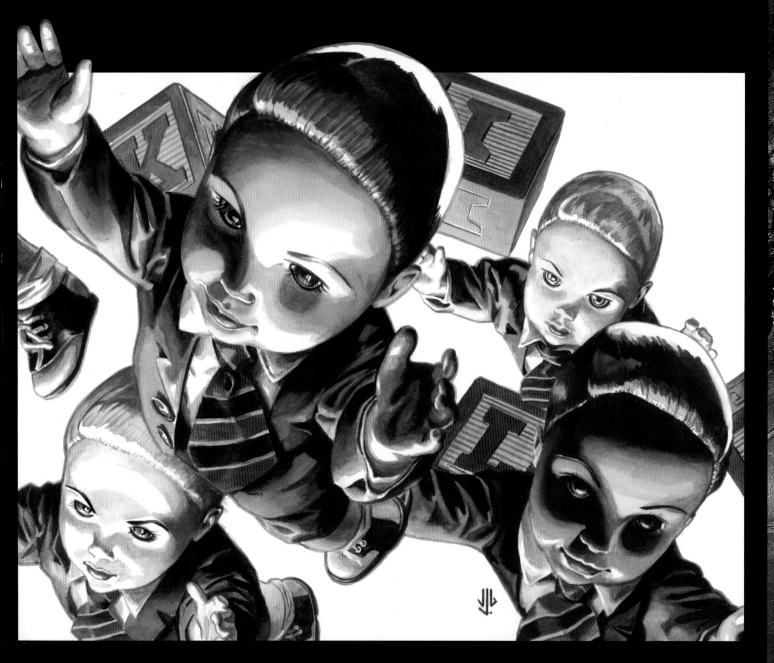

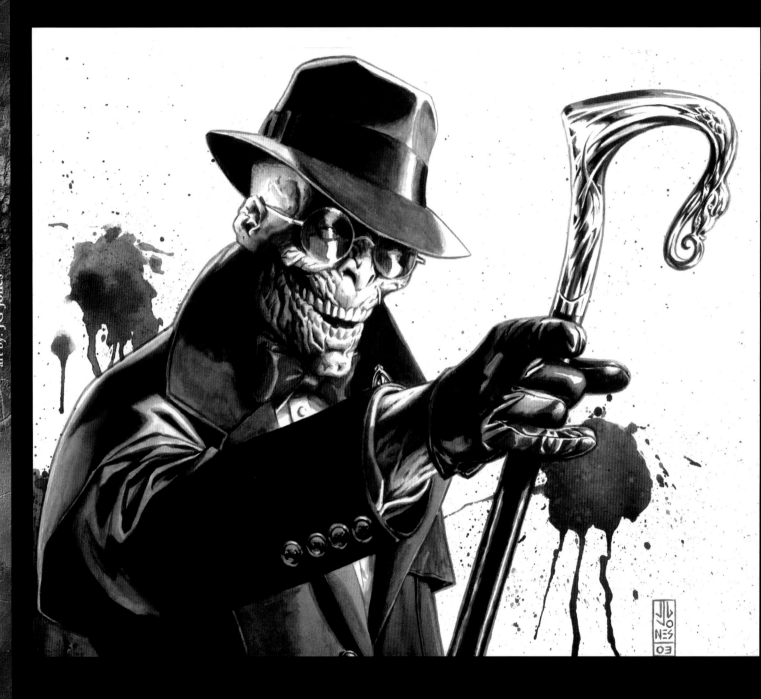

Wanted issue #5 cover
art by: JG Jones

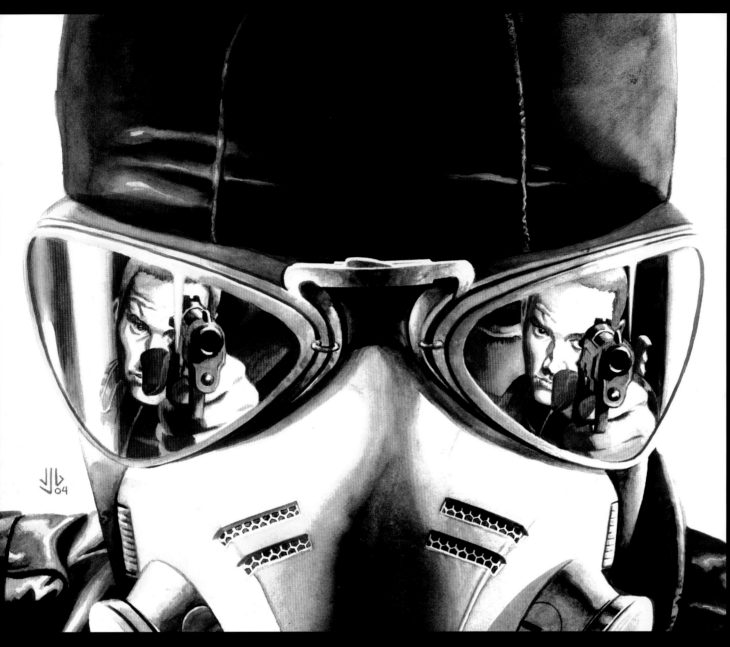

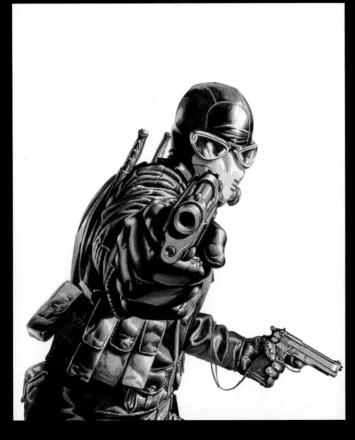

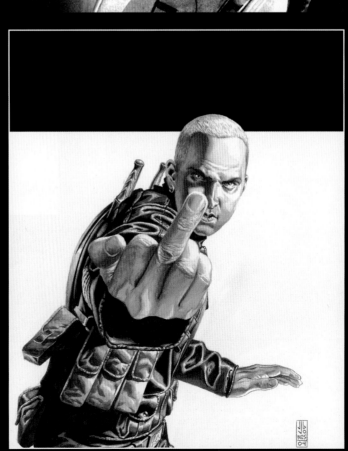

Wanted issue #6 cover and Wanted Wizard ACE Edition™ issue #1 covers
art by JG Jones

Wanted: Dossier "Original Killer"
art by: Tim Bradstreet and Paul Mounts

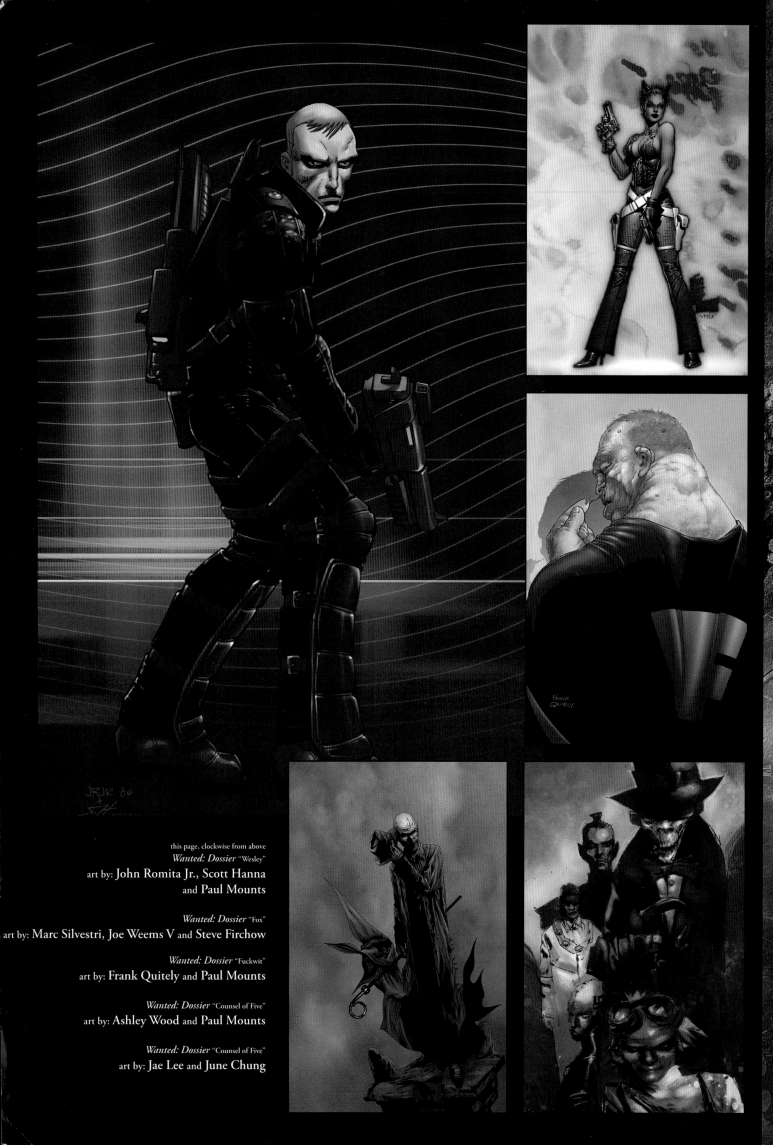

this page, clockwise from above
Wanted: Dossier "Wesley"
art by: John Romita Jr., Scott Hanna
and Paul Mounts

Wanted: Dossier "Fox"
art by: Marc Silvestri, Joe Weems V and Steve Firchow

Wanted: Dossier "Fuckwit"
art by: Frank Quitely and Paul Mounts

Wanted: Dossier "Counsel of Five"
art by: Ashley Wood and Paul Mounts

Wanted: Dossier "Counsel of Five"
art by: Jae Lee and June Chung

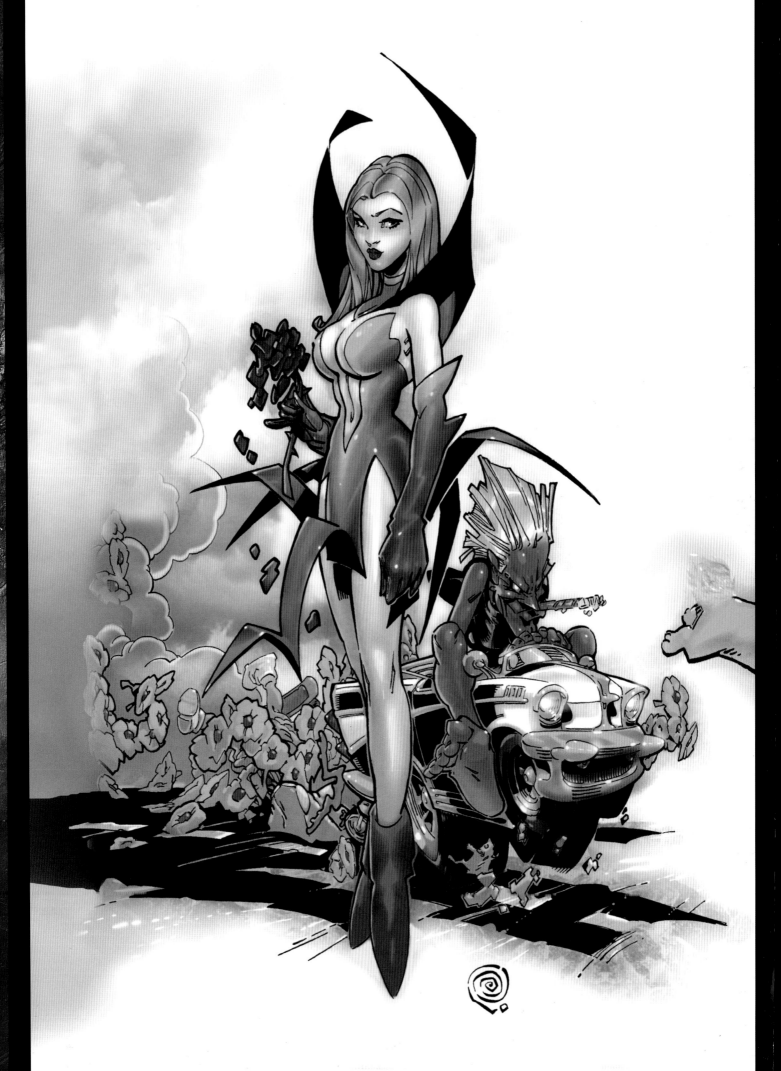

Wanted: Dossier "Imp" and "Deadly Nightshade"
art by: Chris Bachalo

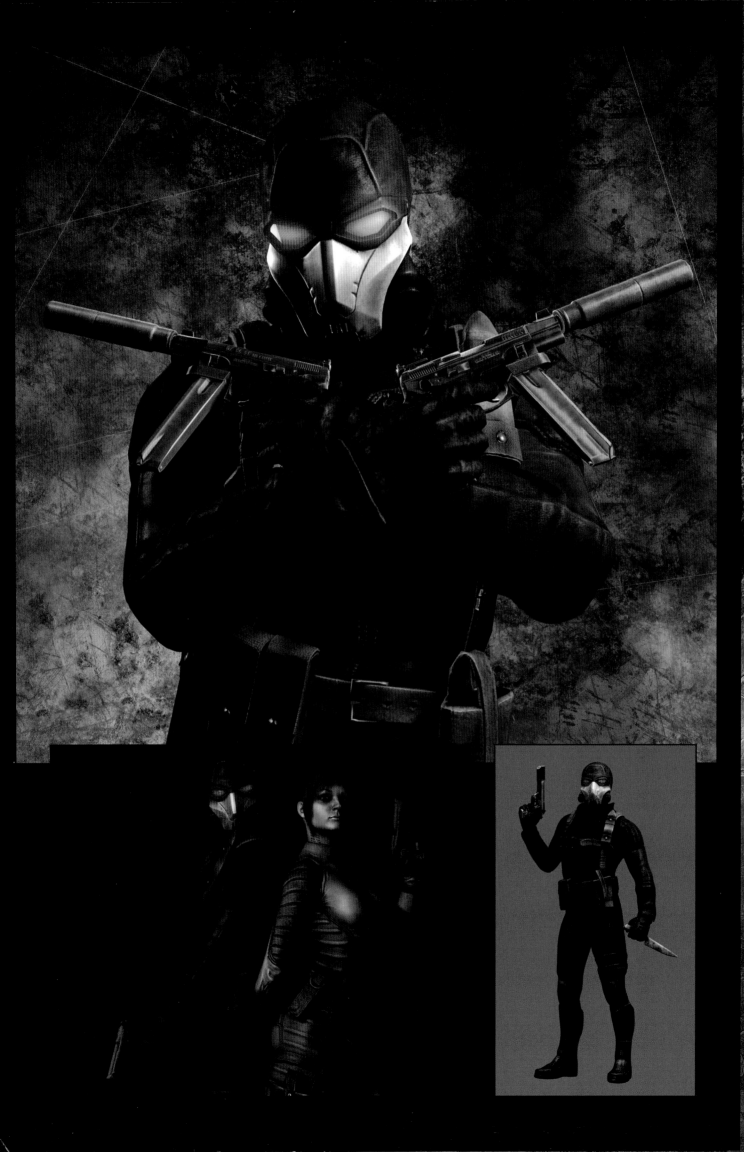

Wanted: Weapons of Fate video game concept art
courtesy of Universal Pictures Digital Platforms Group • created by: Grin Studios

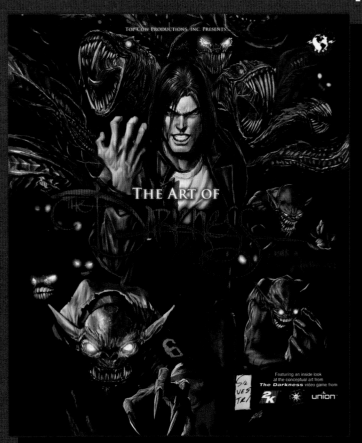
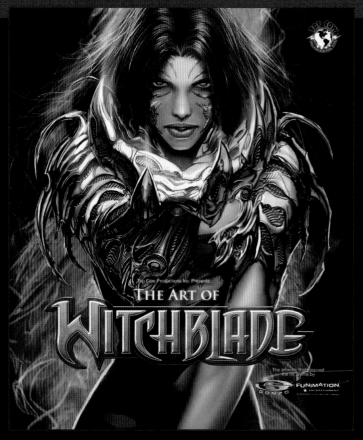
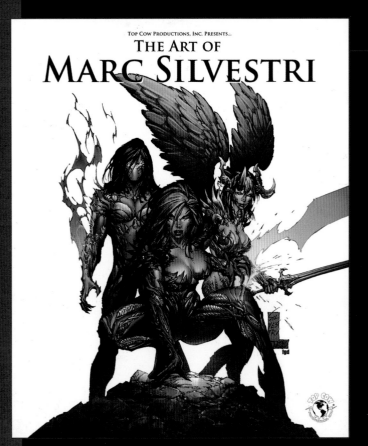

More from The Top Cow Library and introductory Top Cow Universe trades!

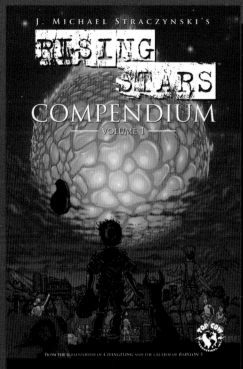

Rising Stars
Compendium vol.1

written by:
J. Michael Straczynski

pencils by:
Keu Cha, Ken Lashley
Gary Frank, Brent Anderson
and more!

The *Rising Stars* Compendium Edition collects the entire saga of the Pederson Specials, including the entire original series written by series creator J. Michael Straczynski, (*Supreme Power/Midnight Nation*) as well as the three limited series *Bright*, *Voices of the Dead* and *Untouchable* written by Fiona Avery, (*Amazing Fantasy/No Honor*).

Collects *Rising Stars* issues #0, #1/2, #1-24, Prelude, the short story "Initiations," the limited series *Bright* issues #1-3, *Voices of the Dead* issues #1-6 and *Untouchable* issues #1-5.

SC (ISBN 13: 978-1-58240-802-6) $59.99
HC (ISBN 13: 978-1-58240-032-1) $99.99

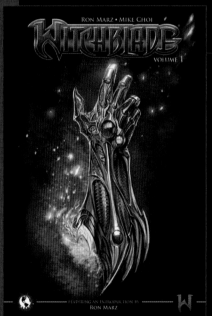

Witchblade
volume 1

written by:
Ron Marz

pencils by:
Mike Choi

Get in on the ground floor of Top Cow's flagship title beginning with this affordable trade paperback collection from Ron Marz's series re-defining run on Witchblade! Each subsequent volume collects a key story arc in the continuing adventures of Sara Pezzini and the Witchblade.

volume 1
collects issues #80-#85
(ISBN: 978-1-58240-906-1) $9.99

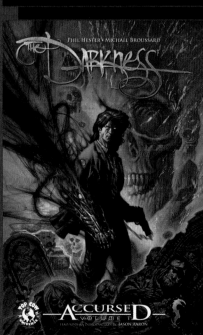

The Darkness
Accursed vol.1

written by:
Phil Hester

pencils by:
Michael Broussard

Mafia hitman Jackie Estacado was both blessed and cursed on his 21st birthday when he became the bearer of The Darkness, an elemental force that allows those who wield it access to an otherworldly dimension and control over the demons who dwell there. Forces for good in the world rise up to face Jackie and the evil his gift represents, but there is one small problem. In this story...they are the bad guys.

Now's your chance to read "Empire," the first storyline by the new creative team of Phil Hester (*Firebreather*, *Green Arrow*) and Michael Broussard (*Unholy Union*) that marked the shocking return of *The Darkness* to the Top Cow Universe!

volume 1
collects volume 3 issues #1-#6
(ISBN: 978-1-58240-958-0) $9.99

The Top Cow essentials checklist:

Aphrodite IX: Time Out of Mind
(ISBN 13: 978-1-58240-372-4)

Cyberforce: From the Ashes, vol. 1
(ISBN 13: 978-1-58240-708-1)

The Darkness: Ultimate Collection
(ISBN 13: 978-1-58240-780-7)

Witchblade, vol.1
(ISBN 13: 978-1-58240-906-1)

First Born
(ISBN 13: 978-1-58240-854-5)

Freshmen, vol. 1
(ISBN 13: 978-1-58240-593-3)

Hunter-Killer, vol. 1
(ISBN 13: 978-1-58240-647-3)

The Magdalena, vol. 1
(ISBN 13: 978-1-58240-645-9)

Midnight Nation
(ISBN 13: 978-1-58240-460-8)

Rising Stars: Born in Fire, vol. 1
(ISBN 13: 978-1-58240-172-0)

Wanted
(ISBN 13: 978-1-58240-497-4)